On the Graphic Novel

On the
Graphic Novel

Santiago García

Translated by Bruce Campbell

University Press of Mississippi / Jackson

www.upress.state.ms.us

The University Press of Mississippi is a member
of the Association of American University Presses.

Library of Congress Cataloging-in-Publication Data

García, Santiago, 1968– author.
 [Novela gráfica. English]
 On the graphic novel / Santiago García ; translated by Bruce
Campbell.
 pages cm
 Includes bibliographical references and index.
 ISBN 978-1-62846-481-8 (hardback) — ISBN 978-1-62846-482-5
(ebook) 1. Graphic novels—History and criticism. 2. Comic
books, strips, etc.—History and criticism. I. Title.
 PN6710.N6813 2015
 741.5'9—dc23 2014042192

British Library Cataloging-in-Publication Data available

To my father

Contents

Preface to the American Edition
After *La novela gráfica*

Five years ago, I published this book in Spain for the first time. My goal, as stated in the introduction to the original edition, was to learn about being a cartoonist during a time in which I felt the scenery was changing so fundamentally that nobody was quite sure what comics were and where they were leading us.

La novela gráfica fulfilled that goal for me. And it now helps me navigate these later years of my comic-writing career. After finishing it, I felt I had a grasp of where I came from and a clearer idea of the path I had set upon. It is with pleasure then, that I come back to this book to introduce it as *On the Graphic Novel* to a new audience, to those of my adopted country. I have lived in the United States for the past three years, and I think I have come to know firsthand the condition of comics in America and to better understand how the reception of this book will differ from the reception it had in my own home country.

I will therefore seize this opportunity to write a new introduction to *On the Graphic Novel* to approach two different sets of questions. Firstly, I will try to answer some of the more controversial aspects of this work that readers have presented to me during these past few years; secondly, I will write down some notes on how the graphic novel phenomenon has changed during the period subsequent to the original publication of the book.

One of the gripes that I have encountered most is that *On the Graphic Novel* does not present a clear-cut and precise definition of just what kind of thing a "graphic novel" is. Mostly, the critics understand a "definition" to be a set of formal parameters that unambiguously trace the shape and size of the graphic novel versus other, different kinds of comics. But while the graphic novel is "another, different kind" of comic, it is more properly "another, different formulation" for comics. The *obsession with a definition*

has been since its inception an albatross around the neck of the study of comics, bent on restarting the work from the ground floor. Like Sisyphus, comics scholars feel that they have to personally do it over again every time they approach the field. Usually, they feel the obligation to roll the unbearable boulder, and to review and judge the relative merits of ancient forefathers like the Egyptian pictograms, the Trajan Column, and various illuminated manuscripts before inevitably coming to the conclusion that our beloved art form does not properly begin until the arrival of Rodolphe Töpffer and/or *The Yellow Kid*. Then, typically, they top it off trying out some kind of partial, controversial and easily contested definition. These definitions usually attend solely to expressive features and semiotic concerns, but fail to acknowledge the basic material elements pertaining to a distinct art form- something that cannot be overly stressed when the discipline in which the study is inscribed is History of Art, as in my case.

This is why I am not interested in a regular "definition" of comics or, fine, be that way, the graphic novel—which really has no a priori stylistic features; but, instead in placing the object of study inside a functionalist history, such as described by David Summers in 1989, where we "would not proceed from the work 'essentially' understood in any way to context; rather it would be based on the assumption that works of art are radically cultural or historical and that they are therefore always meaningful in the circumstances in which they are made and that they continue to be meaningful in new circumstances into which they survive."[1]

And this is the question that this book answers: not what comics are, not what the graphic novel is, but rather what the meaning of comics for us was, what it is now, what different functions comics have performed in our society and culture, and how the idea of the graphic novel is related to that.

With this approach, we find the concept of the graphic novel deepseated in the institutional swing taking place over the last few decades, as the traditional publishing industry crumbles. This disintegration has been a universal phenomenon, but it is more clearly observable in Spain than in America, where the leftovers of an industry based on old-time superheroes cling to the illusion that traditional comics are the *mainstream*, while adult comics and art comics—i.e. the graphic novel—are *alternative*. In Spain, our local traditional publishers fell apart around 1986, and by the end of the nineties nothing that resembled any kind of commercial industry remained. During the last twenty years, *mainstream* comics in Spain have meant American and Japanese imports. And Spanish comics have had to reinvent themselves from the ground up, finally finding a proper venue in the advent of the graphic novel, especially from 2007 on. These were the

circumstances that moved me to research graphic novels, and this explains why it has been easier to observe this international land shift in comics from Spain than from the United States, which is perhaps more caught up in the internal dynamics of a highly polarized market.

To better understand the size and shape of this shift, it is useful to turn to the concept of *media* that Lisa Gitelman proposes and that we obtain through Henry Jenkins, where when a medium becomes obsolete, still "media persists as layers within an ever more complicated information and entertainment stratum."[2]

Jenkins reminds us that "a medium's content may shift," and in his listing of such media, he offers the example of comics, which changed their audiences "when moved from a mainstream medium in the 1950s to a niche medium today." What "moving to a niche" might mean is something that Marshall McLuhan explained, as Art Spiegelman quotes: "Every form, when it is no longer a mass medium, has to become an art or disappear."[3] That is what happened when newsstand comics gave way to bookstore hardbacks, and that is what concerns us, rather than a formal definition of graphic novel. We are not going to look for borders between graphic novels and comics, because graphic novels *are* comics. The graphic novel has received a legacy of styles and expressive techniques from traditional comics. Of course it might sometimes need to expand this formal arsenal, as it reaches for new and unusual subjects to broach, but oftentimes it returns to its comic roots in order to satisfy demands born of authorial anxieties, commercial needs, or even pure nostalgia.

There is a second battle into which *On the Graphic Novel* has been dragged. A whole current of scholars and critics consider the graphic novel an instrument for *legitimating* comics by discrediting the comics that came before. The graphic novel though could hardly be accused of affecting the reputation of traditional comics: you cannot really discredit that which never had any cultural credit in the first place. Indeed, we could go so far as to say that the worst enemy of comics has always been the comic industry, which for a whole century treated their productions as expendable and trashy. Furthermore, we could not even read a classic like *Gasoline Alley* until Chris Ware himself reclaimed it and promoted its reprint.

The prestige captured by the graphic novel, on the other hand, has in some way rubbed off on traditional comics, and traditional publishers have wasted no time trying to co-opt it by repackaging their old tired products as *brand-new graphic novels for mature audiences*, in the hope of bringing in unwary readers, as if you could go from *Persepolis* to *X-Men* just by switching formats.

This has been probably one of the most repeated arguments proffered against the graphic novel: "It is just a format." Setting aside that the purposed *format* is just *book*, as if book were a formal category, the argument brings to mind David Summers again, who observed that "a format may be a significant artistic invention in the first instance, but it is never *just* that, and formats are always subordinate to broader purposes."[4]

So even if we wish to consider the graphic novel *just* a format, it should be a matter of course that this *new format* would raise new questions demanding aesthetic analysis and critical studies. Far from this, many scholars and critics have found it more interesting to devote their energies to the politics of legitimization, as if we were still in 1973, instead of attending to the new trends, works, and creators that are transforming the medium right now. It is entirely possible that we have been looking too much at "the graphic novel" these past few years, and we have actually read too few graphic novels.

This brings us to our second question: in the past few years, what has happened in the graphic novel?

The sector has grown inside the publishing field, and nowadays almost every big publisher has a graphic novel division. That growing has been most evident in sectors that we barely touch upon on this book, like the young adult section. For the foreseeable future, it looks like the graphic novel, in its many different shapes, is a commercial success and is here to stay.

Though "graphic novel" is still a broad umbrella under which we can find anything that fits the label of "adult contemporary comics" (even if that adult is *young*), a significant part of the audience and the press identifies graphic novels with social narratives, autobiographical stories, memories, travelogues, and even tales about illness, not to mention literary adaptations. Many people think that graphic novels show simple or poorly rendered drawings and that they are in black and white. Glyn Dillon's *Nao of Brown* (2012) might be the perfect example of this trend in recent years, though beautifully rendered.

Even if this is now the face of the mainstream graphic novel, it is not the whole story. There are plenty of other options out there right now, such as unorthodox biographies like *The Hypo: The Melancholic Young Lincoln* (2012) by Noah Van Sciver, *Andre the Giant* (2014) by Box Brown, and *My Friend Dahmer* (2012) by Derf Backderf. We have whimsical and intensely personal works, like *My Dirty Dumb Eyes* (2013) by Lisa Hanawalt, *Mark Twain's Autobiography* (2011) by Michael Kupperman, and *Ant Farm* (2014) by Michael DeForge. The list would be too long and the catalogue would require a whole new volume to do justice to the productions of this last five years, but I do not want to forget a particularly vibrant strand. I am talking

about the art comics that show an intense graphic awareness and that delve into a variety of topics, sometimes very remote from the everyday realism of the canonical graphic novel. Extreme flights of imagination can be found in a set of cartoonists whom we could call "the cosmic primitives," and who include talents as different among themselves as CF, Jesse Moynihan, Lale Westvind, William Cardini, Josh Bayer, and Jesse Jacobs. This trend has grown online and in a new crop of fanzines, which are no longer a simple stepping-stone toward professionalism, but an end in themselves. This has given birth to thriving communities that gather around comic festivals like SPX, which has taken place every year since 1994 in Bethesda, Maryland. At SPX, the biggest names in the graphic novel business mingle with young self-published talents; and apparently the thing they most have in common is complete authorial freedom outside the boundaries of the traditional industry. Many similar events have emerged in Europe during the last few years.

Alongside this trend, the acknowledged masters of the graphic novel have intensified their formal quests as well, trying to break out of the *format* and establish an identity that will be ultimately as removed from the literary model as from the comics-industry tradition. Charles Burns keeps going back to *Tintin* in his last trilogy (*X'ed Out, The Hive, Sugar Skull*, 2010–2014), Daniel Clowes takes on a similar "album" format with *Wilson* (2010) and the reprinted *Death-Ray* (2011), Anders Nilsen and Joe Sacco try out the *accordion-book* with *Rage of Poseidon* (2013) and *The Great War* (2013) respectively, and Dash Shaw is constantly pushing the limits of printing materials and processes, jumping from huge hardcovers like *New School* (2013), to small-press, stapled mini-comics, and back again.

As in many other aspects of contemporary comics, it is Chris Ware who has better expressed this trend with his monumental "box of comics" *Building Stories* (2012). If *Jimmy Corrigan* (2000) is at the dawn of the contemporary graphic novel, *Building Stories* comes to complete the age of quest and ushers in the age of the post-graphic novel, where contemporary comics, previously liberated from the thralldom of the traditional industry, must now break free from the new shackles imposed by the imitation of literary models. These were useful in escaping the narrow framework cartoonists were forced to work in before, but now comics need to shed them and finally find their own voice. It might very well be now, after the graphic novel, that a new chapter in the history of comics will begin.

—Santiago García
Madrid, July 2014

Preface
The Graphic Novel and Adult Art

Juan Antonio Ramírez

I remember clearly how we had to make serious efforts, in our early youth, to convince the academic establishment that comics (in Spanish *tebeos*, or *historietas*) were an object of aesthetic study as worthy and respectable as any other. I am speaking of that Spain of the late 1960s and early 1970s: the dictator was still alive, alas, and with him there floated on the Spanish swamp a rancid cultural crust, hostile to all innovation. But that society was not as monolithic as official powers wanted it to be, fortunately. Art fans, for example, were familiar with international pop art, and some of its domestic representatives (Equipo Crónica, Equipo Realidad, Eduardo Arroyo) even enjoyed a broad esteem in some specialized media. As a consequence it was possible for Antonio Bonet Correa, a keen-minded and progressive professor of art history, trained in Paris, to agree to direct my doctoral thesis, which was focused precisely on comics produced in Spain from the end of the civil war through the 1970s, and which I defended at the Universidad Complutense de Madrid in 1975. I was (we were!) lucky: Franco died a few months later, and it immediately became clear that I had not committed suicide as a university scholar by dedicating several years of my life to the study of this medium. The cultural climate became more receptive and I was able to achieve, in fact, a certain academic recognition thanks to the books on the subject that I then published with the progressive Editorial Cuadernos para el Diálogo (books that focused on women's comics and humor comics).

Much time has passed, certainly, but the truth is that we were not able to open a permanent line of research on the subject within the Spanish university. As far as I know, only two doctoral theses dedicated to comics

have been defended in art history departments (Francisca Lladó's at the University of the Balearic Islands and Pablo Dopico's at the Autonomous University of Madrid), and perhaps another few in literature departments. Compare that tiny number to the numerous studies dedicated to the old artistic genres and to all kinds of visual and literary creators. How does one explain such disproportion? Although it may not be very gratifying, it appears that we must accept the idea developed by Santiago García in this book, that comics have been considered until very recently an artistic and literary by-product aimed at a "childish" audience. Forty years ago we believed that the pop art revolution had clearly established the elevated cultural and aesthetic values of this medium, and that it was no longer necessary to defend it in any special way, but such belief seems to be more of a willful exercise in historical optimism than an accurate appraisal of reality. Comics have always suffered from a powerful glass ceiling that even today I am not convinced has been entirely lifted.

The nature of the medium contributes to this situation, since it fits easily into neither the "art institution" nor into the institution of literature. Think of a contemporary art biennial, for example: it is easy to get an idea of one based on one or two days of reviewing the "galleries" or exhibit pavilions; but assimilating what appears in a "comics convention" requires many hours (or days or months) of solitary reading. The economic and promotional mechanisms that govern the world of comics are not much like those for the visual arts. Literature, for its part, has placed such an emphasis on language that even today it is studied in the universities under separate linguistic domains (French literature, German literature, Portuguese literature, etc.). In which department should one include a *drawn literature*, whose linguistic component is intended to be translatable? It is undeniable that the comic has been from its origins an interstitial medium, whose full recognition at the heart of high culture has been made impossible, paradoxically, by the consolidation and extension of the art system. What a grand contradiction: while contemporary visual-arts creation was achieving extraordinary heights of freedom, borders were being consolidated for the exclusion of what the art system did not know how to integrate.

In all likelihood, the powerful emergence of the graphic novel in recent years has something to do with this rejection: since they could not be truly recognized as great visual artists, comic book authors probably turned to the bosom of literature to see if they would be accepted as writers, winning Pulitzer Prizes and occupying the window displays of the big department stores and general-interest bookstores. It was necessary, as a consequence,

to extend things, with a book format, and with all the thematic pretensions of Literature with a capital L (autobiographical subjectivism, flash backs, different narrative tenses, etc.). The graphic novel movement (let's call it that) could thus be considered the latest of various attempts made by comics to assault the fortress of cultural respectability.

It may be that journalists are comfortable with this phenomenon, but I am not so sure in the case of art historians. We harbor no doubts that the comic is and has been a "great art" that has no need of latching onto other creative forms in order to achieve expressive maturity, emotion, and quality. It is quite instructive to see how Santiago García presents in a new way in this book the entire history of comics, and how he encounters the precursors of the graphic novel in the nineteenth century inventors of the genre. In every case we see the fascinating combination of analysis of highly interesting graphic forms with narratives of a certain length. With the passage of time there appeared industrial formulations and innovative aesthetics that allowed for the presentation of comics as books or novels, which seems to have caused upheaval in the cultural establishment of the moment. The common thread is the growing strength of an audience for the medium that will not be satisfied with the old thematic and aesthetic stereotypes, linked in some way to childhood, and relegated to "low culture."

It is quite clear, in conclusion, that this new kind of comics for adults has achieved a prodigious level of development. It is a world so rich and complex that it requires well-informed guides and exegetes, capable of selecting and evaluating. Santiago García adds to these qualities those of a sensitive and keen critic. Free of provincial hang-ups, he provides a clear account of the best of what has been done in the global graphic novel. Behold the evidence that, despite everything, something has indeed happened, and for the good, in the field of serious comics studies to which I alluded above.

July 28, 2009

On the Graphic Novel

Introduction

Comic books have accompanied me since childhood. This experience, which is very common among people born before 1985, is no longer so customary. What was also not customary, even back then, was that comic books would accompany us the rest of our lives, after we had grown up and were beyond the age deemed acceptable to leave them behind.

But I never left comic books behind.

In one form or another, they always accompanied me, not only as an entertainment medium or a collector's hobby, but also professionally. I have worked as a clerk in a comic book store, I have been a translator of comics, I have written criticism for both specialized and general-interest publications, and I have written scripts for comics. And if I have been able to maintain an interest in what used to be considered a children's leisure form, it has been because comic books have grown and developed along with me.

Over the past twenty-five years, we have witnessed a phenomenon that we might call a coming-to-awareness of the comic as an adult artistic form. Although the first steps in this direction can already be found in the 1960s and 1970s, during the most recent period, a set of circumstances have converged, such as the deep—unsolvable?—crisis of traditional commercial children's comics, and the coming to maturity of generations of comics artists formed with an author's vocation, who have helped give the phenomenon a qualitative leap forward. Undoubtedly, this contemporary adult form of comics is a continuation of the comics for-all-ages, but at the same time presents some characteristics of its own that are distinctive enough that it has been necessary to find a new name to identify it, and thus in recent years the expression *graphic novel* has become widespread.

Of course, "graphic novel" is just a conventional term that, like many others, can be deceiving, since we refer with this term not to comics that have the formal or narrative features of the literary novel, nor to a specific format, but simply to a kind of modern adult comic that demands

3

readings and attitudes that are distinct from those of traditional comics consumption.

What exactly is the graphic novel? When did it emerge and why? For me, as an author committed to contemporary comics, answering these questions was urgent. How can we know where we are going if we do not know where we are? There are those who believe that theoretical reflection is a useless burden and that only practice and action are necessary. To them I can offer the thoughts of Erwin Panofsky, one of the fathers of art history, the discipline from which the present study takes its focus, on the meaning of the humanities, when he was asked why we need the humanities if they have no practical purpose: "Because we are interested in reality." And he added, "Is the contemplative life less real, or to be more precise, is its contribution to what we call reality less important than that of the active life?"[1]

This book studies comics, then, starting from the premise that the comic is an artistic form with its own identity, and not a subgenre of literature. We thus distance ourselves from the analytical tendency that makes use of tools proper to narratology, in order to focus our attention instead on visual and material features. And, of course, on historical features. This volume could be defined as a historical essay, since it attempts to explain its object of study through each moment of that object's existence, and not on a purely abstract, ideal, and theoretical plane. What has happened has happened in concrete moments and places, in determined circumstances, and it is that story that we must reconstruct in order to arrive at the chapter we are writing right now, today, tomorrow.

In the course of this project I have learned many things, and the best proof of that is that I have reached conclusions I did not already have, conclusions that resulted from the research itself. What I have learned has not been solely new information but instead, more than anything else, how to organize, situate, and understand what I already had in my possession. How to understand the place of comics in society and in the history of the arts, and my own place within the field of comics. That is what I hope to be able to offer the reader of these pages: to the casual reader who is curious about comics, a point of entry into a world perhaps richer and more interesting than what they had imagined; to the practicing cartoonist, a reflection about their own situation that will allow them to relate to a tradition from which they might otherwise feel isolated; to the comics scholar, an argument for discussion, a point of departure for delving into new work in the analysis of this art.

When I write "comics scholar," an image of Juan Antonio Ramírez comes into my head. He has been in great measure the inspiration and reason for this project. Juan Antonio Ramírez began in the 1970s his long and brilliant career as an art historian with a pair of books about comics. If today the market for serious theoretical analysis of the comic book is still limited, then such a career decision might have been interpreted as a fatal error, from a commercial and academic perspective. On the contrary, Ramírez managed to develop from this starting point an incomparable trajectory in Spanish scholarship over the past three decades, studying a broad variety of themes. I discovered those first two volumes—*El 'comic' femenino en España* (Women's "Comics" in Spain) and *La historieta cómica de postguerra* (Postwar Humor Comics)—in the library of the Universidad Complutense when I was studying journalism. I immediately knew that this was what I wanted to do some day. After going around and around, I wound up going straight to the source—the art history department of the Universidad Autónoma, and Ramírez himself. Under his direction I carried out the academic work that serves as the foundation of this book, as part of the doctoral program in art history. A few weeks before we were to present my work to the Tribunal of Advanced Studies, Juan Antonio died unexpectedly, leaving an immense hole in the Spanish university system, in the discipline of art history, and, above all, in the hearts of those of us who knew him as the generous, kind, and enthusiastic person that he was. It is thus to him, and for so many things, that I express this first and most important thanks of all those thanks I owe for the completion of this book.

Despite the precariousness of comics studies in Spain, it would be unfair to forget that over the years many other people there have attempted to contribute to the history and theory of comics, almost always under adverse circumstances and with scarce or non-existent institutional support. That ongoing effort was always stimulating for me, since I was often just as interested in the texts *about* comics as in the comics themselves, and occasionally, even more so. Without the example of those people, I would have never been able to follow this path, and I am obligated to thank them, albeit with an incomplete list, from which I will undoubtedly omit some as a consequence of my faulty memory. Even so, it is better to name a few—representatives of them all—rather than none. Thanks, then, to Antonio Altarriba, Koldo Azpitarte, Manuel Barrero, Enrique Bonet, Juanvi Chuliá, Javier Coma, Luis Conde, Jesús Cuadrado, Lorenzo Díaz, Juan Manuel Díaz de Guereñu, Pablo Dopico, J. Edén, Pacho Fernández Larrondo, Carlo

Frabetti, Pepe Gálvez, Alberto García Marcos, Eduardo García Sánchez, Luis Gasca, Román Gubern, Toni Guiral, Breixo Harguindey, Antonio Martín, José María Méndez, Ana Merino, David Muñoz, Francisco Naranjo, Joan Navarro, Óscar Palmer, Pepo Pérez, Álvaro Pons, Juanjo Sarto, Antonio Trashorras, Salvador Vázquez de Parga, Enrique Vela, Yexus, and so many, many others, including not only those who came before us, but those who are with us now and those yet to come, all those willing to treat comics as art worthy of the name.

Some people have helped me in a more concrete and immediate way to complete this book. I am grateful to the editors at Astiberri for their trust in me. Manuel Bartual and Javier Olivares also gave me their feedback after reading the manuscript at various stages, which was very valuable to me, and for which I am very thankful.

But, more than anyone, if there is a person who has helped me write *On the Graphic Novel*, and who has helped me in *everything*, that person is, of course, María. Thank you, María; this is our book.

Chapter One

An Old Name for a New Art

It seems to me that comics have already shifted from being an icon of illiteracy to becoming one of our last bastions of literacy.[1]
—Art Spiegelman

Reading Comics is Highbrow

The view we have today of comics has changed enormously in the last twenty years. In 1992 it caused a sensation when a comic book won the Pulitzer Prize—despite being an unprecedented, special award—and the success of Art Spiegelman's *Maus*, considered a unique phenomenon, was attributed more to its serious content—a memoir of the Holocaust—than to the medium in which it was expressed. We might even say that *Maus* received such distinction not for being a comic, but despite being a comic. In 2008, the Pulitzer Prize for fiction was awarded to the novel *The Brief Wondrous Life of Oscar Wao*, by Junot Díaz, which opens with a quote from Galactus, a supervillain who appeared in *The Fantastic Four*, the comic book series by Stan Lee and Jack Kirby. That the novel of the year would quote a comic book is no longer surprising; it is not even surprising that the quote would not be ironic, but respectful and consistent with the content of the original work; nor does it surprise that the referenced comic book would be a *simple* superhero comic book, for kids. These days, in fact, to speak of a *simple comic book* is one of the quickest ways to be viewed as *simple* oneself.

Junot Díaz is not a rare case. The most recent generation of American writers is brimming with comics fans: Michael Chabon made use of the

golden age of the comic book as the setting for his most celebrated work, *The Adventures of Kavalier and Clay*, and later brought to the comic book format the fictional characters that appeared in the novel; Jonathan Lethem has written purely for pleasure a revival of the 1970s superhero *Omega the Unknown*; Dave Eggers invited Chris Ware to guest-edit the literary anthology *McSweeney's* so that Ware could show the world the splendor of the contemporary cartoon; Zadie Smith included Ware, Daniel Clowes, Charles Burns, and Posy Simmonds in her anthology of contemporary narrative, *The Book of Other People*. Graphic novels like *Fun Home* by Alison Bechdel and *Persepolis* by Marjane Satrapi have been selected among the best books of the year (without distinguishing between those that include drawings and those that do not) by prestigious journals and magazines.

The phenomenon affects not only the literary world, but the world of visual art as well. Comics expositions are no longer quaint events, but increasingly gain access to the spaces of high culture based on their own merits, and not as footnotes to "true art." In the first months of 2009, an exposition titled "Le Louvre invite la bande dessinée" presented original pages by comic book artists like Nicolas de Crécy and Marc-Antoine Mathieu in the most important art museum of Europe, commissioned by the museum itself. And none of this, as noted above, comes as a surprise anymore; the most important part of this news is that it is no longer news. From the special Pulitzer Prize for *Maus* to now, recognition of the value of comics within the worlds of art and literature has been growing, and not only in the United States and France, great creative and industrial centers of Western history, but also in countries on the periphery of cultural activity, such as Spain. In 2007 the Spanish government awarded for the first time a national comic book prize, and the main cultural supplements of the major daily newspapers have begun to regularly include reviews of comics alongside those for novels. The departments of literature and art history in the universities dedicate increasing attention to cartoons. Even our young novelists, like their American counterparts, are finding comics infectious. *Nocilla Lab* (2009), by Agustín Fernández Mallo, ends with a comic by Pere Joan.

Suddenly, reading comics is highbrow among intelligent adults. To be certain, this is not the first time comics have played an active role in society, nor the first recognition of their artistic value. Comics have always received a nod from their *older siblings*, such as James Joyce's fascination with Frank King's series *Gasoline Alley*,[2] Picasso's with the comics supplements of the American press, or John Steinbeck's with Al Capp, the author of *Li'l Abner*, who Steinbeck said was the best satirical writer in the United States and deserved the Nobel Prize in Literature.[3] In 1966, John Updike raised the

possibility that in the future a novelistic masterpiece might be produced by an artistic talent with a gift for both prose and images.[4] Even Goethe himself blessed the efforts of Rodolphe Töpffer, considered almost unanimously today to be the pioneer of modern comics. Thus it is nothing new for prestigious writers to confess themselves readers of comics, although it is indeed extraordinary that they should leap at the opportunity to write comic books with the true passion of fans.

One might argue that the situation has changed so profoundly that we must pose the question of whether a new phase has opened up, a way of thinking about comics different from how they had been thought of until now. Already twenty years ago Joseph Witek wrote:

> A critical analysis of the comic-book form is especially necessary now, when a growing number of contemporary American comic books are being written as literature aimed at a general readership of adults, not with the traditionally escapist themes of comics, but with issues such as the clash of cultures in American history, the burdens of guilt and suffering passed on within families, and the trials and small triumphs of the daily workaday world.[5]

Such a clear and—we might say—sudden inversion of values has its basis in the appearance of a kind of comic that until recently not only did not exist, but was practically inconceivable. Today, *author's comics* like *Persepolis*, by Marjane Satrapi, sell hundreds of thousands of copies worldwide (and that before the film adaptation was produced), and in a market as small as Spain's, Paco Roca's *Arrugas* sold more than twenty thousand copies in its first year (and more than seventy-five thousand to date). With good reason, bookstores and cultural supermarkets continuously expand their comics sections, often under the heading "graphic novel," and museums organize more and more expositions on comics. Something has happened, and the pages of this book will focus on examining that phenomenon.

A New Concept, a New Term

The Scottish comic-book artist Eddie Campbell has observed that "it's undeniable that there is a new concept of what a comic is and what a comic can be and what it can do that has arrived in the last 30 years."[6] Campbell knows what he is talking about, since not only is he one of the most outstanding graphic-novel authors of recent years, he has also dedicated time and effort to reflecting on the phenomenon, in numerous interviews as well as on his

own weblog, *The Fate of the Artist*.[7] That interest in theorizing the *new comic* brought Campbell to develop his "Graphic Novel Manifesto," ten points that posit, humorously and with the ironic wit for which he is known, some of the defining characteristics he has observed in this sort of comic. In his "Manifesto," Campbell begins by recognizing that the term "graphic novel" is not the most precise, but that it remains convenient as long as we do not forget that we cannot interpret it as a hybrid of the concepts "novel" and "graphics" in their original usage. It may be that the comic Campbell wants to talk about is indeed "new," but from the outset we recognize the misunderstandings and terminological problems inherited from the old "comic books." In more than a hundred years, we have not managed to establish a satisfactory definition of what comics are, let alone an agreed-upon name for them. This new era begins under the label of *graphic novel*, which appears as a name that provokes general distrust, even, and perhaps more than anywhere else, among practitioners.

Daniel Clowes, one of the most distinguished names among practitioners of the graphic novel, has been so resistant to the term that he even went to the trouble of inventing the expression "comic-strip novel" in order to identify his *Ice Haven*. (Ironically, the Spanish publisher of the work translated the term as "novela gráfica," ignoring with the stroke of a pen the author's intentions.) Although Clowes, who received an Oscar nomination for the screenplay of the film adaptation of his comic *Ghost World*, and who is currently a much sought-after presence in publications like the *New Yorker* and the *New York Times*, is in fact one of the cartoonists who have contributed most to the intellectual respectability of comics today, he has shown a fear of that respectability that makes him distrustful of new terms that might shift the comic book definitively into the high-culture imagination. After decades of comics being confined to the marginal position of a mass cultural product for children or a consumer-culture sub-literature, many of the best contemporary comic book artists fear the consequences of taking the step that would move them clearly toward cultural recognition, as if by gaining such prestige some of the most distinctive characteristics of comics might be lost. Clowes himself expressed this conflicted position in his theoretical pamphlet *Modern Cartoonist*:

> While we are certainly held at bay by the preconceptions of the general audience, we also stand to gain in ways that we are often unwilling to exploit. This aura of truthfulness that we speak of comes as a by-product of being thought of as unsophisticated and (culturally, financially) insignificant. The sophisticated

and significant cartoonist can for the time being twist this to his or her advantage, "having it both ways," with the awareness that if he manages to achieve any degree of acceptance alongside the more respectable sort of creator, this not insubstantial quality will be lost forever.[8]

Clowes was writing in 1997, on the threshold of what he himself expected to be a decisive moment in the development of the comic as an art form. His text begins by pointing to the comics of publishing house EC Comics in 1953, just fifteen years after the comic book format first appeared, as the first indication that comics had the potential to be something more than "lowest common denominator kid's stuff."[9] Clowes acknowledges the underground comix movement, fifteen years after EC, as the next step in that trend, and he identifies the explosion of "alternative" comics fifteen years after that, in 1983. Continuing with his theory of fifteen-year cycles, Clowes expected the next creative surge to begin in 1998. We now know that what Clowes expected has indeed arrived, and it is called the graphic novel. And it appears inevitable that it brings with it that respectability, as much desired as it is feared.

"Comic-strip novel," the designation that Clowes imposed on his *Ice Haven*, is not the only attempt by a celebrated graphic novelist to avoid the term "graphic novel." *Louis Riel*, by Chester Brown, is presented as a "comic-strip biography," seemingly following Clowes' example. On the covers of books published before Brown's, one could read the humble and often disdained term "comic book." *It's a Good Life, If You Don't Weaken* and *George Sprott*, by Seth, are "picture novellas," while *Blankets*, by Craig Thompson, is an "illustrated novel." *My Brain is Hanging Upside Down*, by David Heatley, is advertised as a "graphic memoir." Every combination seems possible, and they all seem to indicate an implicit tension between the aspiration of comics to creative nobility and the origins of comics in the gutter of mass culture, a tension inseparable from the so-called cultural industry. Comics are situated in that paradoxical position of a product viewed with suspicion by tradition, a vantage from which "mass culture is anti-culture,"[10] as Eco has observed.

In Defense of Reading

The apocalyptic response, as Eco would call it, of ruling elites to mass culture has been a constant from the Industrial Revolution onward. Greenberg's dread of *kitsch*[11] is just one more of many warnings against the

degradation of culture resulting from its mass production, or, what is the same, yet another episode in the resistance of a logo-centric cultural tradition besieged by the "civilization of the image."[12] Will Eisner, whom many consider the father of the modern graphic novel, has insisted that comics are literature,[13] an idea that has been affirmed enthusiastically by many, among them numerous scholars from the most recent crop of academics.[14] But it is precisely the fear of comics *as literature* that has been one of the most frequently cited concerns of the reaction against it. As Hatfield indicates, "The recent insistence on comics-as-reading seems designed to counter a long-lived tradition of professional writing that links comics with illiteracy and the abdication of reading as a civilized (and civilizing) skill."[15] It is worthwhile to consider a somewhat lengthy quote from Pedro Salinas, because he expresses the quintessential form of the fears of the cultured man confronted with the appearance of comics.

From [visual culture] have been derived such curious inventions as what is called in the United States *funny strips* or *comics*, and in Ibero-America *muñequitos* or *tirillas*. This genre merits, in my judgment, careful consideration. It is equivalent to a low-class narrative literature, of deliberately vulgar and pedestrian content, published in installments, and whose novelty consists in diminishing the role of the word, in favor of the role of the drawn image, of the graphic component. The language of the *tirillas*, pure dialogue, is like a final concession made to the human word, its final redoubt, in this struggle against verbal communication. The *tirillas* can be understood, and this is their success, by barely literate children, and almost by the illiterate. They are a form of reading without text, concealing language in its expressive function. It is curious that in an age that exalts instruction in the art of reading, and that takes pity on, as on a diminished being, he who cannot read, hundreds of millions of people, who have achieved the privilege of literacy, immediately upon opening the newspaper would skip precipitously over the printed pages until they arrive at that pleasurable section of the comics, where reading is unnecessary, and thought superfluous; and human language, a poor support for the drawings, reduced to infantile elementalism. A wonderful invitation to not read taken from the head of modern man, after paying homage to the idolatrous cult of the necessity of reading! In the *tirillas*, a point of convergence of children and adults, of the cultured and uncultured, who thus find community in the pleasure of a return to the mentality of a seven-year old, there appears further proof of that, at one and the same time, brutish and ingenuous materialism of modern man, who prefers to see a thing *for himself* instead of seeing it through the eyes of a great

artist who describes it for him above the level of his immediate reality. Why wade through that torrent of words with which Homer describes the struggles of the heroes at Ilium? Is it not easier, more practical, quicker, to find a cartoonist who can draw in four taps of the foot a couple of cartoon figures, Hector and Achilles, so that we can see them with our own eyes, without Homer deceiving us? In the same way that so many novels are being transferred from the pages of a book to the movie screen, a kind of transfer that inevitably sacrifices what is best and most beautiful about the novel, soon will come, for the greater glory of speed and realism, the cartoonization of the great works of literature, such that man, instead of spending hours and hours reading Tolstoy's *War and Peace*, can dispense with it in three installments, without worrying his head about it and while saving precious time and energy.[16]

Salinas's text, originally published in 1948 as a response to his "concern about the jeopardy in which one finds today some traditional forms of the life of the spirit, which I deem to be profoundly valuable,"[17] begins by warning against "the triumph of the visual" in contemporary society (a threat which includes photography and film). The reaction against the "pictorial turn," as Mitchell had christened it, is inscribed in the typical movements of iconoclastic reaction that every society experiences. If Salinas had done his research, he would have discovered that his fear of chaos unleashed by a possible adaptation of the great works of literature to the cartoon form was not unfounded: starting in 1941, the collection *Classics Illustrated* (Gilberton) [1] would turn out cartoon versions of *Don Quixote*, *Moby Dick*, *Hamlet*, *The Iliad* (of course), and other canonical titles of Western letters. Curiously, *Classics Illustrated*, which lasted 169 issues between 1941 and 1971, was not presented as a comic. "The name *Classics Illustrated* is the better name for your periodical. It really isn't a 'comic'. . . . It's the illustrated or picture version of your favorite classics."[18] Of course, the claims of the editors of *Classics Illustrated* could not fool Dr. Fredric Wertham, who in the mid-1950s was one of the most active intellectual forces behind criticism of comics for their alleged negative influence on the social and intellectual formation of youth.

Comic books adapted from classical literature are reportedly used in 25,000 schools in the United States. If this is true, then I have never heard a more serious indictment of American education, for they emasculate the classics, condense them (leaving out everything that makes the book great), are just as badly printed and inartistically drawn as other comic books and, as I have often

found, do not reveal to children the world of good literature which has at all times been the mainstay of liberal and humanistic education.[19]

The aim of using comics as an entryway to "true reading," which in Spain was reflected in the slogan "where today there is a comic book, tomorrow there will be a book," also produced adverse reactions. And it was feared that this sub-literature would irremediably damage the tender unformed minds of the young. Anxiety about the power of the image produced a panic described by McLuhan in generational terms:

> The elders of the tribe, who had never noticed that the ordinary newspaper was as frantic as a surrealist art exhibition, could hardly be expected to notice that the comic books were as exotic as eighth-century illuminations. So, having noticed nothing about the *form*, they could discern nothing of the *contents*, either. The mayhem and violence were all they noted. Therefore, with naive literary logic, they waited for violence to flood the world.[20]

We might say that the well-intended insistence on viewing comics as literature by authors like Eisner has done nothing more than harm the general view of comics, since it has made it possible to judge comics using criteria proper to literature, instead of criteria specific to comics. Comics are *read*, yes, but it is a reading experience completely distinct from the experience of reading literature, just as the manner in which we *look at* a comic has nothing to do with the manner in which we look at television or a film. Harvey explains this common critical error:

> Comics can be (and too often are) evaluated on purely literary grounds, the critic concentrating on such things as character portrayal, tone and style of language, verisimilitude of personality and incident, plot, resolution of conflict, unity and themes. While such literary analysis contributes to an understanding of a strip or book, to employ this method exclusively ignores the essential character of the medium by overlooking its visual elements. Similarly, analysis that focuses on the graphics (discussing composition, layout, style, and the like) ignores the purpose served by the visuals—the story or joke that is being told. Comics employ the technique of both the literary and graphic arts, yet they are neither wholly verbal in their function nor exclusively pictorial.[21]

The search for a model of analysis proper to comics is therefore one of the more important projects for current students of the comic book: a

model capable of explaining the relationship between comics and art and literature—including literary classics—not in comparative terms, but in alternative terms. Mitchell[22] has observed that "mixed" media, like comics, demand attention to how words and images relate, and not merely to the unique value of this or that medium. Perhaps that is the path toward understanding the postmodern reinterpretation that R. Sikoryak[23] makes of Dostoyevski [2] in a comic that would probably have given Wertham and Salinas nightmares. Sikoryak adapts *Crime and Punishment* in eleven pages, making use of the characters and graphic language of the Batman comics of the 1950s. Pastiche, parody, deconstruction or hallucination, whatever it might be called, *Crime and Punishment!* is not entirely explicable from the perspective of either literary criticism or art criticism, and if we find ourselves without adequate tools for analyzing it, that should not mean that we treat it as a literary abortion or a substandard artistic product, but instead should prompt us to develop the precise language that would enable us to engage it on its own terms.

A Mass Medium

The "original sin" of comics is essential for understanding the social function they have performed for decades. It is clear that not even students of the history of the medium can agree about its true origins, grouping themselves into two main tendencies. One of these recognizes as the inventor of comics the Swiss teacher Rodolphe Töpffer, who produced some *histoires en estampes* beginning in the late 1820s, while the other prefers to locate the seminal moment in the newspapers of Joseph Pulitzer (*New York World*) and William Randolph Hearst (*New York Journal*) in the late nineteenth century, and in particular in the discovery of cartoonists like Richard Felton Outcault, Rudolph Dirks, and Bud Fisher. As Ann Miller indicates,[24] this debate reveals a strategic maneuver on the part of those who want to define the comic as a mass medium and those who prefer to see it as part of the artistic tradition. The search for the *correct* roots is a common form of legitimating the present, and it is not surprising therefore that in recent years the figure of Töpffer has been forcefully reclaimed in a manner in line with the more refined image of the present day graphic novel. Nevertheless, one cannot skip over decades of comics that are the offspring of the sound and fury of the modern metropolis of Outcault and the other pioneers of the American press of the late nineteenth and early twentieth centuries.

It was they, more than anyone, who initiated that tradition that would be followed by American, European, and Japanese comics during the past hundred years, and comics cannot so quickly renounce their unruly ancestry. Ian Gordon identifies two factors that distinguished American comic strips from earlier European comics: continuity in their use of characters, and their appearance in periodicals with mass readerships, which "made them mass market products."[25] From the beginning, this duality of the comic strip has had contradictory consequences in its reception by society. The success of Outcault's *Yellow Kid* cartoons was so phenomenal that it came to define the newspapers of both Pulitzer and Hearst (for a time the strip was published in both at the same time), thus giving rise to the expression "yellow journalism."

> That the first character of American comics should have his chromatic signature appropriated by a journalistic movement was ample testimony to the power and popularity of the comics. But because that movement was wholly commercial, embodying reprehensible ethics and sensational appeals to baser emotions, the new art form was associated with only the lower order of rational endeavor—a circumstance that cast a shadow for a long time over any claims made for artistic merit and intellectual content in the funnies. How could anything that first surfaced in the jaundiced columns of the sensational press hold any interest for respectable, thinking readers?[26]

Ana Merino notes that "comics belong to industrial culture and, as such, construct modern narratives, although their legitimating capacity is in tension with lettered discourse," and adds that with its rejection by lettered culture, comic books "become marginal and from then on construct their own narratives."[27]

For years, this exile to the outskirts of culture meant a limiting of comics' artistic development as a medium for adults, but beginning in the 1960s, some of the most important underground authors would exploit the aforementioned tension in order to open an experimental route that took advantage of being positioned on the margins of the intellectual world, as Clowes claims. Bill Griffith, one of the pioneers of comix, finds in that ambiguity precisely one of the virtues of the comic book:

> I can't decide if I'm an artist who writes or a writer who draws. Comics nicely resolve that contradiction into a new, very satisfying form. It also embodies, for me, the unification of High and Low art. Comics are a formerly Low art medium

brought into the service of High art through a lineage beginning with Krazy Kat, progressing to the Kurtzman Mads to Crumb and the Underground to now.[28]

That is why for Clowes the *graphic novel* becomes the *comic-strip novel*, in an attempt to bring together the new ambitions represented by the *novel* with the affectionate popular term by which newspaper comics series have always been known: *strips*. The problems encountered by authors and theorists in agreeing on a name that defines what they do and what they read (editors appear to have already decided) demonstrate in part the novelty of these comics, but also the weakness of the intellectual tradition of comics and the unsatisfactory nature of the terms previously used. We cannot blithely declare that the name does not matter. Names matter a great deal, to such an extent that at the same time that they speak of our origins, they can determine our future, and the names that have been used to designate the art practiced by graphic novelists have typically been derogatory.

A Bad Name

Comics' "bad name" begins with Töpffer himself, who had the habit of using frivolous nicknames to refer to his own creations, from "scribblings" to "graphic follies." In the collection of his essays on the art, titled *Réflexions et menus-propos d'un peintre genevois* (Reflections and Passing Remarks of a Genevan Painter, 1848), "Töpffer is bubbling with theories that he cannot take seriously. He cannot, above all, imagine the reader taking him seriously for long."[29] Töpferr's desire to theorize, neutralized by the fear of seeming overly pompous, is echoed meaningfully in Eddie Campbell's "Graphic Novel Manifesto," which in its ninth point reads:

> Graphic novelists would never think of using the term graphic novel when speaking among their fellows. They would normally just refer to their "latest book" or their "work in progress" or "that old potboiler" or even "comic" etc. The term is to be used as an emblem or an old flag that is brought out for the call to battle or when mumbling an enquiry as to the location of a certain section in an unfamiliar bookstore. Publishers may use the term over and over until it means even less than the nothing it means already.
>
> Furthermore, graphic novelists are well aware that the next wave of cartoonists will choose to work in the smallest possible forms and will ridicule us all for our pomposity.

It is evident that, after more than a century of not taking themselves seriously, comic book artists are having a hard time starting to do so now. In France, where the most powerful publishing industry in Europe has accompanied the earliest cultural recognition of comics, the latter is known by the name *bande dessinée* (literally, drawn strip), perhaps one of the more clinical and descriptive of all the terms that have been applied to the medium in various languages. Nonetheless, Thierry Groensteen notes that this term was not established until the 1970s, which is to say, when comics were more than a hundred years old, and that the medium was previously known by names such as *histoires en estampes* (or engraved stories, an expression invented by Töpffer, as we have seen), *histoires en images* (picture stories), *récits illustrés* (illustrated stories), *films dessinées* (drawn movies), "and, of course, comics."[30] The delay in finding a name brings to mind an orphan art form, an art that is not yet recognized by society.

In Spain, the two most widely used names of Spanish-language origin make reference to the children's character or the scant cultural value of the medium. *Tebeo* derives from the popular magazine TBO, founded in 1917 and aimed at children's humor, while *historieta*, which itself means "short fable, story, or narrative of adventure or anecdote," is a term imported from Latin America, where Ana Merino notes that the name *muñequitos*[31] (in Cuba) is also used, which does not notably improve the social standing of the medium.*

The case of Japan merits some attention. Japan offers the world of comics—as well as contemporary popular culture, in its broadest sense—a very interesting set of contrasts and similarities. On the one hand, Japan represents the incomprehensible exoticism of the Far East; on the other, it is

*Translator's note: With reference to cartoons, *muñequitos* means "little drawn figures," but can also mean "little dolls" or "little toys." Importantly, the general lack of terminological precision in this arena of cultural production, discussed by García in this chapter, extends also to the terms in use for practitioners of these art forms. As a consequence, at least in part, of the fraught question of cultural status or prestige, these latter terms are disputed and unstable. In Spanish, *historietista* (a producer of *historietas*), *dibujante* (one who draws), and *artista* (artist) are often used interchangeably to designate comics artists, despite the terms' distinct connotations with respect to the prestige of the cultural practice they name. The corresponding English-language terminology for comics practitioners employed in this translation throughout—for which "cartoonist," "comics artist," and "artist" are frequently used interchangeably—recognizes this imprecision and the extent to which English-language discourse about comics is fraught with implicit "high" versus "low" cultural distinctions, but intends to reject such distinctions in a manner consistent with García's argument.

included in the sphere of mass culture and the Western collective imaginary. It is, in addition, the principal comics market worldwide, and since the 1980s it has continued to capture, little by little, more and more of the North American and European arenas, revitalizing both their readership and their publishing strategies, especially in the formats most similar to the traditional book, which depart from the typical magazine of our cartooning traditions, and in the use of black and white. These formal characteristics, together with an openness to themes and genres that go beyond adventure for kids and the superheroes that predominate in the West, have had a pronounced influence on the make-up of the current graphic novel, as we will see. Japan is a country where the overwhelming presence of comics in society reaches even to the highest social strata. Frederick Schodt noted that "in 1995, former Japanese prime minister Kiichi Miyazawa began serializing a column of his opinions, not in a newspaper or newsmagazine, but in the manga magazine *Big Comic Spirits*."[32] Schodt went on to explain that the respected seventy-five-year-old politician may not have been an habitual reader of manga, but that he knew that the magazine he had chosen was read by 1.4 million young workers. Even so, comics are still accompanied by a shadow of suspicion with respect to their true cultural stature in Japan, which at times seems not to know whether to take pride in or be ashamed of its gigantic comic-book offerings. Perhaps that conflicted posture harkens back to the confused and disparaging term by which comics came to be known, *manga*, invented by Hokusai in 1814, and which can be translated "irresponsible drawings."[33]

Every language has developed its own expression—*quadrinho* in Portugal, *fumetti* in Italy, *Bildgeschichte* in Germany—but the universal word that all languages use is the English word *comics*, which in Spain is accepted and included in the dictionary of the Royal Spanish Academy. "Comics," which in the United States eventually overtook expressions of the same tenor, like *funnies*, has nevertheless posed quite notable problems in the North American context, since it has always cast a shadow of doubt concerning those comics that have no intention of being comical. Already in 1935, at the dawn of the first drama and adventure comics, a journalist would write, "Some might more appropriately be called 'tragics' or 'pathetics' than comics, but technically they are all called 'comics.'"[34] The necessity of finding a word that could present the medium in a more neutral fashion, freeing it from humorous and juvenile connotations, has arisen alongside attempts at comics that go against the hegemonic current. Thus, in 1950, the editors of *It Rhymes With Lust*, a *noir*-genre comic book that extended to more than a hundred

pages and was sold in the format common to pocket-sized crime fiction books, presented it as a "picture novel." When in 1955 EC Comics attempted to overcome the limitations of the comic book industry's self-censoring comics code—a code that recognized that the industry's entire market was *exclusively* children—it tested a new format combining text and illustration, which it christened "picto-fiction." The examples are numerous.

A Comic Book By Another Name

Efforts to precisely locate the first appearance of the expression "graphic novel" have mentioned its inclusion in North American fanzines of the 1960s.[35] At the time, the term alluded to a hypothetical concept, which as yet did not exist: comics of greater artistic ambition than the standardized products of the big newsstand publishers. Even so, as we know, in the 1960s the times were changing, and it was precisely in the second half of the decade when the ruptures of the comix underground occurred, which would also have a liberating effect on conventional comics. Thus, by the end of the decade, efforts to produce comic books aimed at an adult audience, or at least *more adult* than the typical readership of *Batman*, *Archie*, and *Donald Duck*, became more frequent. All of these efforts, although they continued to be firmly anchored in genre paradigms (especially crime or action *thriller*, science fiction, and heroic fantasy), required a new name that would free them from the stigma of "comics," and in several cases the term "graphic novel" began to appear, with increasing frequency from 1976 on.[36] Of course, the expression was far from being fully established, and for the moment it coexisted with other attempts, like "*visual novel*,"[37] "*graphic album*," "*comic novel*,"[38] or "*novel-in-pictures*."[39] It was in 1978 when the expression "graphic novel" graced the cover of Will Eisner's *A Contract with God*, a book that anticipates to a much greater degree the true spirit of the phenomenon that we want to study here. One cannot conclude, however, that the term is rooted in that moment. When, in 1989, Joseph Witek undertook an academic study of the kind of comics in question here, he still did not use the name graphic novel, but instead made use of the even more arguable expression "sequential art," coined by Will Eisner a few years earlier.[40]

Nonetheless, during the 1980s there occurred a certain popularization of the term graphic novel applied precisely to genre products of the big publishers, only distinguished from the modest comic books on the newsstands by their more luxurious production qualities and binding. Marvel Comics,

for example, published a collection of "graphic novels" beginning in 1982, most of whose titles featured in-house superheroes. In reality, these supposed graphic novels were simply commercial albums in specialized bookstores. Even so, it is undeniable that the change in nomenclature denotes an attempt to differentiate the product from what is evoked by the word "comics": a cheap, disposable, and childish product.

In Spain, the term graphic novel, per se, had already appeared in the 1940s,[41] and enjoyed a certain widespread usage through the 1960s. But the term bore no relation to any kind of comics of greater artistic ambition, which in Spain only began to be conceivable in the final years of Franco's rule. Spanish "graphic novels" were simply romance comic books (or comic books representing other well-established popular genres) characterized by supposedly greater complexity. [3] Juan Antonio Ramírez notes:

> The stories are longer and more complex and the format is similar to that of any kiosk novel. The graphic novels were not aimed, in theory, at a youth or children's audience, but at "older" people; but it is surprising to see the limited capacity for story development demonstrated by the script writers: the hugs perhaps appeared with greater frequency, but the ideology and the situations remained invariable. With rare exceptions, the graphic novel has been a thick booklet in which the "intermediate conflicts" stage, between falling in love and the wedding, occupies a greater number of pages.[42]

In fact, traditional American comics had also invoked the label "novel" since the middle of the century, in order to distinguish those stories that, without departing from conventional content, had a greater than normal length. From its beginnings in the late 1930s, the norm was that every superhero comic book would include several self-contained stories about the titular character of the series, but when occasionally all of the pages of an issue were dedicated to just one lengthier adventure—normally divided into chapters, perhaps to give it a more literary look—it was common for such stories to be identified on the first page as "novels." Such was the case with many of the famous "imaginary tales" of Superman, analyzed by Umberto Eco,[43] which were presented as "an imaginary novel." The "imaginary" stories of Superman add another characteristic to the novelistic condition: because they occur outside the continuity of the character, grand stories could be told, with numerous catastrophic events and a defined and irreversible plotting, crisis and dénouement, breaking with the iterative narrative scheme of comics and approaching more closely the features of

a true literary novel. But, all things considered, they remained Superman's adventures, published in the same market and with the same audience in mind. Curiously, in Spain the label "graphic novel" would be applied very early on to Superman comics, as Dólar published them beginning in 1958 under that heading. Marvel comics published by Barcelona-based Ediciones Vértice beginning in 1969, in pocket-sized, black-and-white collections, would be defined in the same manner, with the additional caveat that the exploits of Spider-Man and The Fantastic Four were intended "for adults."

What's New?

If the sudden appearance on the scene of the term "graphic novel" has been viewed with suspicion by many authors, who consider it to be a pompous euphemism, and, as we have seen previously, prefer not to be exposed to the glare of public scrutiny alongside other, more serious media, the complex history of the term's genesis and usage over the decades, including its appropriation by publishers in order to sell commercial comics, has also provoked reactions that view its recent popularization as yet another commercial stratagem by industry entrepreneurs. This is the position of comics expert Manuel Barrero in an article titled quite expressively, "La novela gráfica. Perversión genérica de una etiqueta editorial"[44] (The Graphic Novel: Perversion of a Publishing Label), which reviews in detail the different meanings that have been given to the term "graphic novel." Barrero concludes that "book-length comics [libros de historietas] have always existed; is it necessary to complicate things with new labels?"

The issue is not so much knowing whether in prior historical periods the term graphic novel has also been used in relation to comics; rather, the issue is knowing whether there is currently a kind of comics distinct from what was made in the past, which is to say, different from the mass-produced children's comics governed by commercial criteria, and whether that distinct kind of comic requires a new name in order to be recognized not only as a new form, but as a new spirit. Pepe Gálvez, for example, emphasizes that the differences between the present day graphic novel and traditional comics need not be sought out mainly in their formal features: "The major progress, the great leap forward made by comics as a form of expression in recent years has not taken place as much in the area of language as in its expressive ambition, in the will to take on deeper and more complex narrative goals."[45] In effect, both graphic novels and traditional comics are

comic books, but that does not mean that *Mortadelo y Filemón* is the same thing as *Palomar*.

In his manifesto, Campbell explains that "graphic novel signifies a movement more than a form." Barrero, in the article cited above, criticizes this assertion, arguing that "this elitist posture generates gradations of judgment that can lead to differentiation among categories of target audience (educated vs. uneducated), segmentation in the medium's potential, subordination of the medium to genres or formats, or, finally, to prejudice against the very study of comics." Barrero's response is based on a common mistake that has also contributed to resistance to the term, since many people believe that saying that something is a "graphic novel" is making an a priori value judgment about its quality. On the other hand, for Campbell, if the graphic novel is a movement, that just means that it represents a different tradition from that of the comic book, but not that every graphic novel is better than every comic book: "I think that a failed graphic novel is a much less interesting thing than a good comic book,"[46] Campbell has said. And in fact, Campbell has produced superhero comic books on commission without it posing any problems of conscience for him as an author. As Andrés Ibáñez notes, "A comic does not become greater the more novelistic it becomes, just as a novelist is not a better writer if he knows how to shoot a rifle, nor a policeman a better policeman if he knows how to play the violin," and adds, "every artistic form possesses its own code."[47]

Hence, the traditions of comics, the forms that they have taken, in sum, the history of comics, is the only way for us to understand whether the graphic novel is really a new art. One of the pioneers of the graphic novel, Seth, wrote:

> Sadly, there is no real evolutionary comics chart. Looking back on the various narrative picture-novel attempts before 1975, you quickly realize that a sustained story told in picture form is simply a natural idea. Every few years an artist came up with the concept—either independently, or influenced by similar works—yet each new attempt seemed to sink quickly from public sight, and the idea of a narrative picture novel disappeared until the next such book surfaced.[48]

Behind every artistic development in comics, which is a mass medium governed by entrepreneurial logic, we cannot forget that there is a crisis in the publishing industry. In their origins, comics played a fundamental role as repository for the imagery of urban society in the first third of the

twentieth century, to such an extent that one could say without exaggeration that in that period comics "offer[ed] a more important key to an understanding of the American mind than many other better studied evidences of [that] national culture."[49]

The situation of permanent decline of popular comics throughout the West since the 1950s has resulted in the singing of dirges for an art whose demise is always imminent. Ana Merino observes that "the loss of audience has meant for comics the loss of their popular civic capacity. Now, comics, as has been noted, must compete with television, videogames or the Internet. But it is true that much of the aesthetics utilized by the new technologies is a product inspired graphically in superhero, underground, or classic comics."[50]

The importance of comics for the broader aesthetics of society had already been observed by Masotta in 1970, when he said, "All graphic design related to the comic book today is guaranteed a strong image."[51] But surviving in the palimpsest of the contemporary world's iconographic explosion is not exactly surviving. In order to continue as an art form in this situation of its crisis as a product—Merino reflected—it was necessary for comics to recognize their place within the cultural history of modernity:

> Recognition of its past and its uniqueness means construction of a canon on which to carve out its future. Students of comics will come face to face in the coming years with the ruins of a century of creation that needs to be catalogued and reconstructed in the libraries and archives. This canonical appropriation means its acceptance not only as mass consumer object, but also as an object of alternative [minoritaria] critical reflection.[52]

That acceptance of comics as "object of critical reflection" (alternative or not), brings us to the current moment of the graphic novel, undoubtedly one of the "spaces" of modernity that comics are proving capable of conquering at present.

This book aims to understand how we have arrived at the present day graphic novel, to understand its origins and its history, but in part, also, we aim to comprehend why that "natural idea" that Seth talks about has taken so long to materialize. In other words, this is a book about understanding why the graphic novel has emerged, but also why it did not emerge earlier. In order to do so, we will have to engage in a new "canonical appropriation," by which I mean we will have to re-write the history of comics from the point of view of the graphic novel.

1. "Don Quixote," in *Classics Illustrated* 11 (1944), Samuel H. Abramson and Zansky.

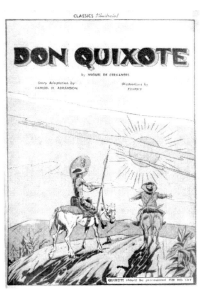

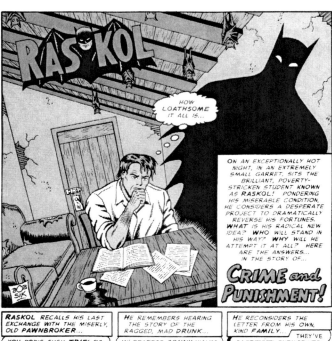

2. "Raskol," in *Drawn & Quarterly* 3 (2000), R. Sikoryak.

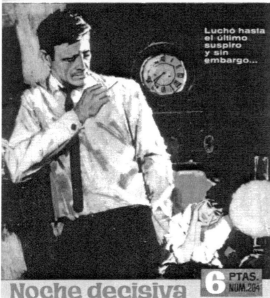

3. "Noche decisiva," in *Colección Novelas Gráficas*, Celia series 204 (1965), Enrique Badía. Reproduced in Regeuira (2005).

4. Scott McCloud's definition of a comic as presented in a Spanish-language edition of *Understanding Comics* (1993), Scott McCloud.

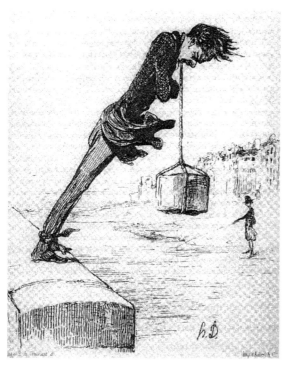

5. *Le dernier bain* (1840), Honoré Daumier. Reproduced in Carrier (2009).

6. *A Rake's Progress*, plate III (1735), William Hogarth. Reproduced in Smolderen (2009).

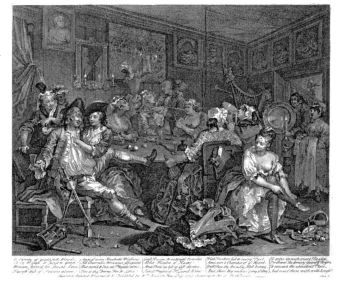

7. *Histoire de la Sainte Russie* (1854), Gustave Doré. Reproduced in Kunzle (1990).

La estanquera.—Son riquísimos; los de esta última saca han salido muy buenos.

—¡Demonio! ¡Qué humo hace, y qué sabor tan malo tiene!

—¡Otro fósforo! ¡El arderá!

—¡Caramba, si tiene una capa tan mala!

—¿Otra vez apagado? ¡Pues yo he de hacerle arder!

— Sudo la gota gorda; estoy rendido. ¡Mozo, mozo!

—Señorito, ¡si esto parece un poste telegráfico!

—¿Qué tal? ¿Tira, tira?
—¡De e paldas!

8. "Por un coracero," in *El Mundo Cómico* 22 (1873), José Luis Pellicer. Reproduced in Martín (2000b).

—¡Ya no puedo más!

—¿Otra vez? ¡Por vida de...! ¿Dónde habrá un fosforero?

—Que esté bien llena la caja, y que sean buenos.

—Sí, sí, ¡cualquiera le hace arder!

—Me arrimaré a la tapia para hacer fuerza.

—¡Ay de mí! ¡Que me muero!

¡A la casa de Socorro!

—Seis meses llevo de enfermedad. Siempre que veo al médico le digo: ¿Me da Vd. lumbre?

—¿Estanco nacional, eh? ¡Ah picaro! ¡No se me olvidará, no!

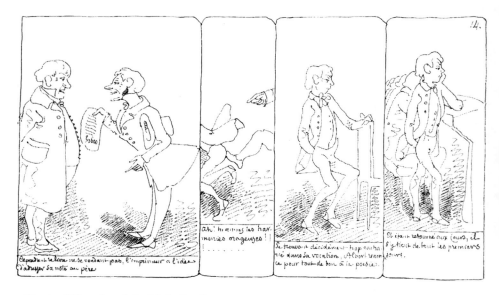

9. *Histoire d'Albert* (1844), Rodolphe Töpffer.

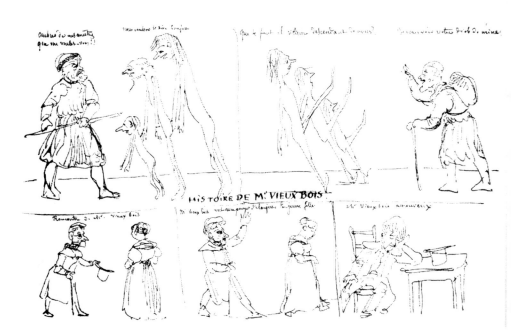

10. *Histoire de Mr. Vieux Bois* (original manuscript, 1827), Rodolphe Töpffer. Reproduced in Smolderen (2006).

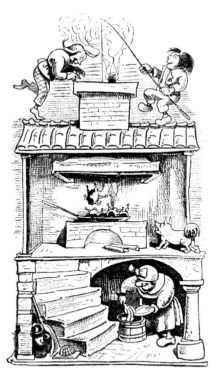

11. *Max und Moritz* (1865), Wilhelm Busch.

Schnupdiwup! da wird nach oben
Schon ein Huhn heraufgehoben.

Portrait of Herr Von Finck, an intellectual young German, who has resolved upon the study of the English language.

"The sound of 'th' is a somewhat peculiar one, but of course a little bit of practice is all that is wanted," says Von Finck, as he makes a first attempt.

"The tongue is evidently placed between the teeth in making this barbarous sound," thinks he to himself.

"Donnerwetter! Is a German, and above all, a Von Finck, to be beaten by such a simple little thing as this? It must be that a greater volume of sound is necessary."

"The Devil take such a hideous combination as that! However, just let me once seriously devote my mind to it, and it will come."

"Oho! I knew I should get it! How easy! Strange I should have had any trouble with it. 'De man, dis horse, dose vomans!'"

12. Cartoon in *Harper's New Monthly* (1879), A. B. Frost. Reproduced in Smolderen (2009)

13. "Fred Ott's Sneeze," (1894), Edison's kinetoscopic record. Reproduced in Smolderen (2009).

14. "Our Cat Eats Rat Poison," in *Harper's New Monthly* (1881), A. B. Frost.

15. "The Fifth Floor Lodger and His Elevator: A Lesson in Subtraction," F. M. Howarth. Reproduced in Gardner (2008).

16. *Hogan's Alley* (1896), Richard F. Outcault. Reproduced in Smolderen (2009).

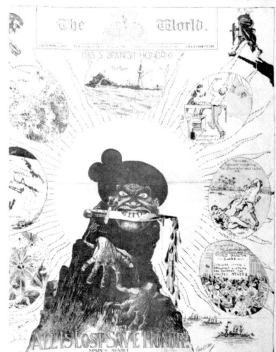

17. "All Is Lost Save Honor," cover of the *Sunday Comic Weekly* of *World* (1898), George Benjamin Luks.

18. *The Funny Side of the World* (1900).

19. *Happy Hooligan* (1905), Frederick Burr Opper.

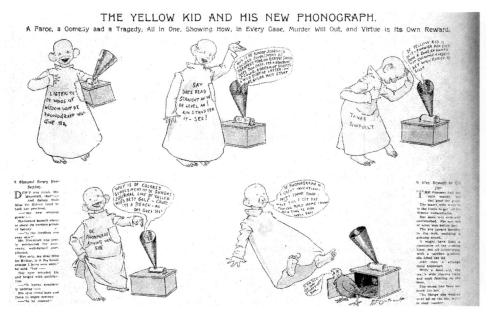

20. *The Kin-der-Kids* (1906), Lyonel Feininger.

21. "The Yellow Kid and His New Phonograph," in New York Journal (1896), Richard F. Outcault. Reproduced in Smolderen (2006).

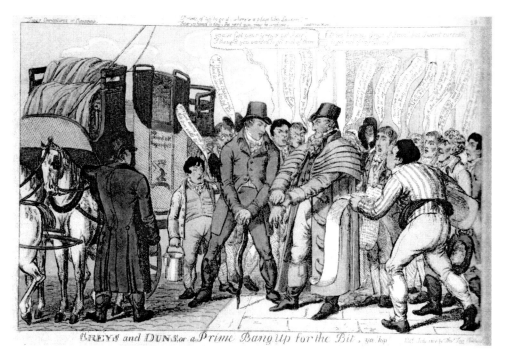

22. *Greys and Duns* (1810), George Cruikshank (attributed). Reproduced in Smolderen (2006).

23. "When We All Get Wise," in *Life* (1911), Harry Grant Dart. Reproduced in Smolderen (2006).

24. *Mutt and Jeff*, Bud Fisher.

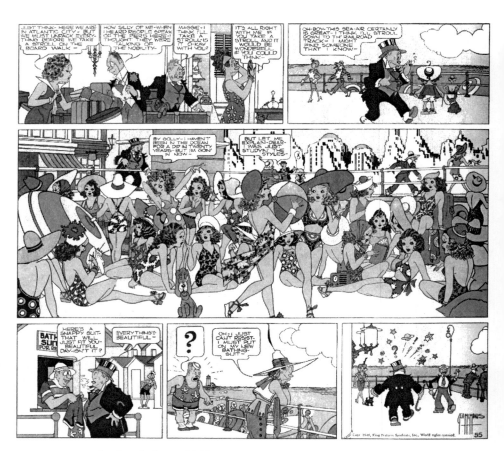

25. *Bringing Up Father* (1940), George McManus.

26. *Polly and Her Pals*, Cliff Sterrett.

27. *Gasoline Alley* (1922), Frank King.

28. *Mon livre d'heures* (1919), Frans Masereel.

29. *God's Man* (1929), Lynd Ward.

30. *Vertigo* (1937), Lynd Ward.

Adult Comics before Adult Comics, from the Nineteenth Century to 1960

I belong to low culture. This is my thing. Not only do I belong to low culture, I don't think low culture is low culture. It's all culture.[1]
—Bernard Krigstein

What Do We Call a Comic?

In order to rewrite the history of comics from the point of view of the graphic novel, as we suggested in the previous chapter, we will need to know which history it is that we need to revise, when it begins, and what its subject is. Thus, before taking on the history, we need to know what the definition of a comic is, and the latter has proven to be so slippery and thorny a question that specialized books are increasingly choosing to avoid the topic for fear of becoming bogged down in a quagmire of theoretical mush with no hope of resolution. Groensteen, perhaps in a moment of desperation, called it "the impossible definition."[2]

There currently exists a tendency to approach the ontological concerns surrounding comics through the concept of "sequential art," considered to be the most indisputable essence of the comic. The popularization of this idea undoubtedly has much to do with the resonance of *Understanding Comics: The Invisible Art* (1993), a theoretical book by Scott McCloud that caused great surprise in its moment by making use precisely of the comic form as a vehicle for expressing its argument. Without a doubt, McCloud's premise

was greatly influenced by Will Eisner's *Comics and Sequential Art* (1985), a book that is a mixture of theoretical essay and recipes for professional tricks, and which opens with the following declaration:

> This work is intended to consider and examine the unique aesthetics of Sequential Art as a means of creative expression, a distinct discipline, an art and literary form that deals with the arrangement of pictures or images and words to narrate a story or dramatize an idea. It is studied here within the framework of its application to comic books and comic strips, where it is universally employed.[3]

Eisner appears to distinguish, therefore, between "Sequential Art" and comics, as if the first are an instrument at the disposal of various media, among them comics; but he does not subsequently clarify the specificity of comics and what distinguishes them from other media that make use of "Sequential Art." Nor are these other media mentioned, although we can assume that among them are counted, perhaps, film, painting, advertising, or graphic design, all of which could fit within "an art and literary form that deals with the arrangement of pictures or images and words to narrate a story or dramatize an idea." McCloud tried to be more precise in his definition and to provide more solid argument to support Eisner's idea of "sequential art," attempting this definition:

> Juxtaposed pictorial and other images in deliberate sequence, intended to convey information and/or produce an aesthetic response in the reader.[4] [4]

There are numerous problems with this definition. In the first place, just as with Eisner's definition, it could be applied to many things that are not comics, which means that it is lacking in explanatory value. But it also ignores some of the most salient aspects of the comic, like the relationship between word and image. McCloud never mentions the text, which for other students of the comic, like Harvey, is fundamental. In Harvey's view, "The visual-verbal blend principle is the first principle of a critical theory of comic strips."[5] If Harvey's assertion encounters problems when faced with wordless comics, McCloud's does so by completely ignoring the role of words. Moreover, McCloud excludes from his definition any comic that is composed of a sole image, believing that the existence of a comic requires the existence of the "invisible space" between one image and another, relegating to the vague limbo of "graphic humor" or "illustration" all of that

output by comics artists that is resolved in a lone vignette, despite the fact that a simple caricature can also be narrative, since it requires for its resolution that we imagine a "a later moment of the action,"[6] as David Carrier indicates, illustrating the idea with a caricature by Daumier [5]. Does the image in the example make sense if we do not imagine the moment following the one shown to us? Is that act of completing the "story" different from the "closure" that McCloud posits as an indispensable element of the unique functioning of the comic? Without further belaboring the question, we will also mention that McCloud's definition includes the photo novella[7] just the same as if it were a comic. The priority given to sequentiality means that it is valorized over the specific nature of drawing, the strokes of which, especially as regards caricature, have always been completely organically linked to the meaning of comics, from their origins to the present. The photographic image has a completely distinct nature from the drawn image.[8] Barthes observed that the photograph authenticates the existence of that which is being portrayed,[9] while the drawing invents what does not exist.

But what matters to us is mainly that the success of McCloud's book, which takes refuge in a kind of theoretical idealism, has disseminated a definition of the comic broadened to such an extreme as to include almost any image that might be given a narrative sense. McCloud is faithful to his logic when he says that his definition allows him to "shed some new light on the history of comics."[10] Well, that new light makes comics out of Egyptian paintings, Trajan's Column, or the Bayeux Tapestry.[11] And we are speaking of comics, not proto-comics or examples of "Sequential Art" applied to other cultural forms. After reviewing pre-Colombian illustrated manuscripts, McCloud declares, "Is it comics? You bet it is!"[12]

This "expansion ad absurdum" of the history of the comic has encountered little resistance, due in part to the weakness of the tradition of theoretical study of the comic in the United States until very recently. American books about comics have existed at least since the 1940s, when the cartoonist Coulton Waugh wrote *The Comics* (1947), thereby opening up a line of research defined by academic comics artists and by historical reviews tilted toward anecdotes, nostalgia, and the professional memoir. Such is the case with Jim Steranko's *History of Comics* (1970–1972), Jerry Robinson's *The Comics* (1974), and *From Aargh! to Zap!* by Harvey Kurtzman, three cartoonists with intellectual interests, like Waugh (and like Eisner and McCloud). Whereas in France, Francis Lacassin was already teaching classes in the history and aesthetics of *bande dessinée* at the Sorbonne in 1971, the most popular reference book for two decades in the United States was the *World*

Encyclopedia of Comics (1976), edited by Maurice Horn, which was a diction-
ary of authors and comics characters.

Nonetheless, one of the works of greatest theoretical scope to date was
also published in the United States in the 1970s, and it framed the history of
the comic within more manageable limits than those proposed by McCloud.
The work in question is the monumental two-volume history of comics
(*The History of the Comic Strip Volume I: The Early Comic Strip* and *The His-
tory of the Comic Strip Volume II: The Nineteenth Century*) by David Kunzle,
a disciple of Gombrich who was inspired to immerse himself in the topic
on Gombrich's suggestion that he "follow the development of the picture
story, antecedent to the modern comic strips, from Hogarth to Töpffer."[13]

The definition of comic that Kunzle offered is based on four conditions
that serve to define a comic strip "of any period, in any country: 1) There
must be a sequence of separate images; 2) There must be a preponderance of
image over text; 3) The medium in which the comic appears and for which it
is originally intended must be reproductive, that is, in printed form, a mass
medium; 4) The sequence must tell a story which is both moral and topical."[14]
This definition has been strongly criticized, prominently by Thierry Groen-
steen, who considers it unacceptably normative and self-interested, since
"the third of Kunzle's conditions only serves to justify the fact that he chose
the invention of printing as a starting point for *The Early Comic Strip*."[15] Of
course, Groensteen's stance can be understood by situating it within French
comics studies, which is a much more robust and academic tradition than
the American one, especially in theory, where semiotics, structuralism, and
psychoanalysis have been influential in texts on the comic since the late
1960s. Thus Groensteen himself seeks a definition based on the "iconic soli-
darity"[16] of the comic's composite elements, dispensing with historical and
material issues.

For us, however, Kunzle's third condition is of particular interest,
since all of the formalist definitions turn out to be overly restrictive. The
definition based on sequence ignores the singular image, the definition
based on the image ignores drawing, and even Groensteen's definition
ends up eliminating from the list comics that we recognize as comics. It
turns out to be much more productive for our exploration of the question
to view the comic as a *social object*, and therefore "defined more by com-
mon usage than by a priori formal criteria."[17] And in its common social
usage, we identify the comic as an object in print. A book, a pamphlet,
a magazine, a booklet or a section of a newspaper or other publication,
but reproduced for mass consumption. In part, we can paraphrase Dino

Formaggio's famous definition of art and say that just as "art is whatever men call art,"[18] comics are whatever men call comics. Which serves us well in remembering that a comic is not a Lichtenstein painting which copies a comic book panel, and nor is it Trajan's column or Michelangelo's ceiling of the Sistine Chapel, which also tell us a story using sequential images. McCloud says, "As we focus on the world of comics as it is, it should be kept in mind at all times that this world is only one . . . of many possible worlds!"[19] With this in mind, we will remember to deal with comics that exist and have existed in this unique world, and not those that might exist in other possible worlds. We can begin, then, our history of the comic with the printing press.

The Prehistory of Comics

As we were saying, the printing press is the point of departure for the first volume of Kunzle's *History of the Comic Strip*. In that volume, the American author connected the comic's antecedents with numerous broadsheets that, making use of a combination of images and text, were published beginning in the fifteenth century in France, the Netherlands, Great Britain, and Italy, typically for the purposes of political and religious propaganda or moral instruction. Kunzle tracked down every possible collection of graphic narrative, whether printed or engraved, from Europe of the sixteenth and seventeenth centuries, including the work of artists like Callot, with his series on war, and even Rubens, with his series on the life of Marie de' Medici, until reaching the eighteenth century and William Hogarth.

Hogarth was the ideal place to put an end to the first volume of his history, since Kunzle considers him "the grandfather of the comic strip," because of his influence—the only influence he himself recognized—on Töpffer, "the father of the comic strip." Hogarth's series of narrative images—*A Harlot's Progress* (1732), *A Rake's Progress* (1735), *Marriage à-la-mode* (1745) [6]—not only anticipated some of the elements of the visual language of the comic, but also told tales with a certain popular circulation and established character types, of the sort that would later be common in comic book panels. Of course, despite the fact that his images were reproduced, Hogarth did not work in the mass cultural industry, on the margins of respectability, but was instead a great artist immersed in the dynamics of the "age of satire," as a unique representative of the figurative arts, alongside writers of the stature of Pope, Swift, and, especially, Henry Fielding.[20]

Hogarth, however, was still positioned a hundred years prior to the true appearance of comics, to which Kunzle dedicated the second volume, focused on the nineteenth century. Although the works of some Victorian caricaturist heirs to Hogarth's legacy—the most outstanding being Cruikshank, Rowlandson, and Gillray—also developed many of the elements we today recognize as characteristics of comics, at times anticipating Töpffer, it is the Swiss teacher whom Kunzle selects as the true inventor of the new art. Töpffer, a writer and educator who almost never left Geneva, created some picture stories accompanied by text in which most specialists have perceived a qualitative difference from the world of mere caricature and humorous illustration, which would be so fertile over the course of the nineteenth century.

Baudelaire said of Daumier in 1857 that he was "one of the most important men, I would say, not only of caricature, but also of modern art."[21] The nineteenth century witnessed the international spread of the conditions necessary for the triumph of caricature, which until then had only existed as a private diversion for artists or as a study tool for other pursuits. These conditions were a parliamentary political regime (with its related freedom of expression, as limited and controversial as it may be at times), a technology capable of producing serial print publications (lithography, invented in 1798 by Alois Senefelder, would facilitate the explosion of popular graphics over the course of the century), and a prosperous and dominant bourgeoisie to provide material and audience for caricature. Stated another way: in contrast to the traditional nobility's private joy in the ownership of works of art, the caricature became meaningful as a form of public art.

In France, these conditions emerged especially following the July Monarchy of Louis Philippe of Orleans, in 1830. Three months after the establishment of the regime, Charles Philipon founded *La Caricature*, to be followed in 1832 by *Le Charivari*, also founded by Philipon. It was in these publications and others like them where not only Daumier, but also Cham, Gavarni, Nadar, and others popularized a new aesthetic that, more than breaking with academicism, positioned itself on the margins of it, with the liberating consequences that doing so implied. Gombrich observes that "the license given to humorous art, the freedom from restraint, allowed the masters of grotesque satire to experiment with physiognomics to a degree quite impossible for the serious artist."[22] Certainly, caricature reveals to us the avant-garde that came before the avant-garde, or perhaps it reveals how the hegemonic tradition of art since the Renaissance served less as a stimulus than as a burden for the *great artists*. An interesting example

of the freedom enjoyed by the caricaturists can be found in the busts of parliamentarians that Daumier sculpted between 1832 and 1834. Created in baked and painted clay, they reveal a non-idealized vision of the artwork and its themes that not only clashes headlong with the norms of serious sculpture of their time, but anticipates by sixty years the avant-garde sculpture of Medardo Rosso, Edgar Degas, or Rodin himself. The poverty of the materials and the use of painting would have been radical gestures for any professional sculptor of the first half of the nineteenth century. Perhaps for this reason, Daumier benefitted from his lack of academic training, which he was unable to afford as the son of a Marseillaise glazier of limited economic means.

This fork in the road between serious art and popular art—or mass art—will be one of the most interesting routes for studying the development of the *image* from this moment on, and comics will therefore play an essential role at the dawn of modernity, as we will see.

Thus, in France, Robert Macaire, a hustler from the Paris of Balzac and Zola, of whom Daumier would produce more than a hundred lithographs between 1836 and 1842, represents "the decisive inauguration of the 'caricature of manners,'"[23] which would find fertile continuity in North American comics of the end of century. Meanwhile, in the rest of Europe there was also a proliferation of illustrated and humorous magazines, and in them there appeared comics and proto-comics. One foundational figure is the German Wilhelm Busch, author of the adventures of the twins *Max und Moritz* (1865); another is Gustave Doré, in whose *Histoire pittoresque, dramatique et caricaturale de la Sainte Russie* (1854) [7] text and image are contrasted with ironic purpose. Equally important are the works of the first great French comics artists, Caran d'Ache (1858–1909) and Christophe (1865–1945).

In England the most important magazine—and with international influence—would be *Punch* (founded in 1841), which "generally stood too much upon its dignity to feature comic strips."[24] It is precisely in England where what is considered to be the first recurring character in comics history appears: the picaresque Ally Sloper, who debuted on the pages of the magazine *Judy* in 1867, but who very quickly began to see his adventures reproduced in book compilations. And beyond that, he would appear as the protagonist of some of the first films of the new cinematographic medium, films which today have been lost, although there is evidence that two such films were screened in 1898 and two more in 1900.[25]

In Japan there was a long tradition of narrative art, and today we are expected to see present day manga as a continuation of that local tradition.

But the true origins of manga are also located in the nineteenth century, and in the cultural assimilation by Japanese artists of the Meiji era of the influence, first, of foreign magazines (in 1862 the British official Charles Wirgman founded *The Japan Punch*, based on the British *Punch*), and, later, of North American comics—George McManus's *Bringing Up Father* would be imitated in the 1920s. "In fact, manga—that is, comics—might never have come into being without Japan's long cultural heritage being soundly disrupted by the influx of Western cartoons, caricatures, newspaper strips and comics,"[26] observes Gravett.

In Spain, the most important studies on the origins of comics have been developed by Antonio Martín, director of the pioneering magazine of comic book studies *Bang!* (initiated in 1968 as a fanzine). In this country, the press—and much more so the satirical press—suffered from the same endemic backwardness as other cultural media (in 1860 the illiteracy rate was around 80 percent), which explains the fact that the first true comic that Martín identifies corresponds to a date as late as 1873.[27] [8] More recently, Barrero[28] has identified as a pioneering comic a page published in the Cuban magazine *Don Junípero* in 1864 by Víctor Patricio de Landaluze, a military officer from Bilbao. Although the Spanish nationality of the author is unquestionable, the work itself pertains to a social and political environment specific to the colony, which presents some difficulties for its integration within the historical discourse of Spanish comics. In any case, it is not essential to pick a winner in this race to be "the first Spanish comic." New research may propose new candidacies, and after all is said and done the differences established between these first comics and the proto-comics that co-existed with them only amount to nuances of language, which is to say, the degree to which a narrative relationship is produced between the panels and the relationship coordinated between drawings and text. Beyond that, what is essential is that with the Restoration in Spain—above all following the subsiding of the revolutionary climate, which gave way to a liberalization of law and a relaxing of censorship—one can begin to speak of a humorous and graphic press, and the appearance of the first local masters of comics, like Mecáchis (Eduardo Sáenz Hermúa, 1859–1898) from Madrid, and Apeles Mestres (1854–1936) from Barcelona.

Significantly, Kunzle's *History of the Comic Strip* does not include in its pages the origins of North American comics in the Sunday presses of New York in the late nineteenth century, as if that belonged to a second phase or tradition of comics. As we will see, this would be decisive in the development of the medium during the twentieth century and until today.

Comics as European Invention: Rodolphe Töpffer, Author

It was Gombrich who drew attention to Töpffer in the essay "The Experiment of Caricature" in *Art and Illusion* (1959), and his disciple Kunzle, as we have seen, developed that research in detail. Besides writing the two volumes of *History of the Comic Strip* mentioned above, Kunzle also edited in 2007 the monumental complete and critical edition of Töpffer's comics, as well as another volume of studies of the Genevan author to accompany it.

Töpffer was born in Geneva in 1799. His father was a painter fond of genre and landscape paintings who, with his enthusiasm for the arts, brought home engravings by Hogarth from England. Töpffer, whose painting ambitions were limited by his myopia, found in Hogarth—according to his own confession—the inspiration to develop a narrative form of his own through images more simple and spontaneous than those demanded by canvas. After working for several years as a teacher, Töppfer established his own boarding school in 1824, which took in young students from all over Europe, whom he took on frequent excursions to the Alps, an experience narrated by the author himself in *Voyages en Zigzag*, a book that met with success in its moment. Throughout his life, Töpffer maintained literary and academic aspirations, and he became an intellectual figure of a certain reknown in Geneva thanks to his novels, his poems, and his position as an educator. Nevertheless, today we remember him as important precisely for what he did as a private pastime, without greater aspirations than entertaining himself and his students, and something that he was always hesitant to make public for fear of damaging his professional and literary career. In effect, his comics were born as entertainment for his students, in front of whom he produced the first ones as live, off-the-cuff spectacle. *Les Amours de Mr. Vieux Bois*, published in English as *The Adventures of Mr. Obadiah Oldbuck*, was the first in 1827, but it would go unpublished until ten years later. In 1832 he received the approbation of an elderly Goethe, amused in his final and most painful hours by the sketch of *Le Docteur Festus*, which he had shown to Soret on the 27th of December, and the praise for which appeared in published form in *Kunst und Alterthum*, after Goethe had already died and when the work in question was still unpublished. With the passage of years Goethe's words have acquired a status of near sacred prophecy for later generations of believers in the expressive power of comics.

That is really too crazy [the adventures of doctor Festus], but he really sparkles with talent and wit; much of it is quite perfect; it shows just how much the

artist could yet achieve, if he dealt with modern [less frivolous] material and went to work with less haste, and more reflection. If Töpffer did not have such an insignificant text [i.e. scenario] before him, he would invent things which would surpass all our expectations.[29]

Töpffer, in effect, never dared to go beyond those "frivolous" subjects, limiting himself to the kingdom of "crazy stuff" for his entire career as a comics artist, and there are those who might argue that all the cartoonists who have come after him have found themselves working under the same limitations, until recently. Töpffer's themes were light and frivolous, satirical journeys in which the protagonist leaps from one strange adventure to another, pushed along by exaggerated happenstance. With their lively and even frenetic rhythm, today they still possess a surprising freshness. They are inscribed in a broader European satirical tradition; at times, they recall the adventures of the Baron von Münchausen, and Pierre Assouline[30] observes that Molière's *Le Bourgeois gentilhomme* (The Bourgeois Gentleman) lends its plot to *Histoire de Mr. Jabot* (The Story of Mr. Jabot). Töpffer made use of a curious landscape format that allowed, without any necessity whatsoever, for the first comic to appear as a "strip," [9] a publication format that in the future would be reserved for newspapers, where it would be imposed for practical purposes to make the most of the print space available. Töppfer did not use dialogue balloons—although in his sketches one can see that he played around with the idea—and instead placed text beneath the image, written in his own hand. Later comics artists would turn to typography, abandoning handwritten text, just as nobody—except those who deliberately imitate Töpffer at his moment of greatest success in France—would continue his sketchy and spontaneous style of drawing. Because of their length and their sense of being complete, self-contained works, Töpffer's comics are more like present day graphic novels than like the comics that enjoyed such success during the twentieth century, which are episodic and feature recurring heroes.

In later years, despite Goethe's blessing, Töpffer continued to pursue success in the world of prose and verse. In 1833 he self-published in lithograph form the aforementioned *Histoire de Mr. Jabot*, which he distributed among his friends, and only in 1835 did he put this work on sale in bookstores. In later years he printed other titles: *Mr. Crépin* and the old *Les Amours de Mr. Vieux Bois* in 1837. The latter, which had been plagiarized in Paris, was published in a second edition in 1839. In 1840, *Monsieur Pencil* (Mister Pencil), in 1844, *L'Histoire d'Albert* (The Story of Albert). In 1845 he

published *Histoire de Monsieur Cryptogame* (Story of Mister Cryptogame) in eleven chapters in *L'Illustration*, an illustrated Parisian weekly published by his cousin, Jacques-Julien Dubochet, becoming the first serialized comic published in a magazine and subsequently in a collection, a process that would become the norm in Franco-Belgian comics during most of the twentieth century, with *Tintin* and *Astérix* being prominent examples. Because Töpffer's poor vision did not allow him to work on woodcuts with sufficient speed, the drawings were executed by Cham, who had proved to be the best imitator of Töpffer up until that time. That same year, Töpffer published his *Essai de Physiognomonie* (Essay on Physiognomy), a compendium of his artistic thinking and his opinions about caricature—and the first theoretical text about comics in history. In 1846 he died, probably a victim of leukemia.

Töpffer's qualms about embracing his own graphic children were not entirely unjustified. Despite the initial benevolent opinion of Goethe, the criticisms of his comic strips were constant until the end of his days. In 1846, on the eve of the author's death, the *Revue de Genéve* condemned his comics "as a corruption of taste, for they were puerile, needed no work, fatigued by the constant repetition of the same figures, and constituted in fine a prostitution of undoubted literary talent."[31] It is only normal that the teacher would feel more reassured by the positive opinion elicited by his literary production than by the virulent reactions provoked by his "scribblings."

Despite his initial qualms, Töpffer sought an adult audience for his picture stories, or at least a general audience, of all ages, and at least in part it appears that he found it, although undoubtedly the lack of controversial themes and the innate innocence of the adventures they narrate made them seem ideal family reading. The 1860 Garnier edition of "Albums Töpffer" was presented for sale as "suitable to all drawing rooms, without shocking anyone, amusing all ages and constituting a suitable gift for ladies, girls, adolescents and even children."[32] Wilhelm Busch, the German master, also sought an adult audience, but one has to recognize that the nineteenth century saw the emergence of the concept of children's literature, represented eloquently by the expression "for children of all ages," which Kunzle cautions "points to a new audience of intersecting generations and social classes: the older (ten to sixteen years of age), educated child and the child-in-the-adult. To these we must add the lower social classes, struggling, like children, into maturity."[33] In Spain, Antonio Martín notes that "significantly, Spanish children's periodicals will not publish

comics, not even when this medium is well established in Spanish maga-
zines from 1880 onward."[34] It is very difficult to relate Töpffer to adult or
children's comics specifically, since, pioneer that he was, both his art and
his audience were yet to be discovered; nor would the commercialization
of his work be the decisive factor in the orientation given to the medium
in the work of his successors. But it seems clear that in the mid-nineteenth
century, the comic—like caricature—was not considered an especially chil-
dren-oriented medium.

The most decisive factor in the case of Töpffer's work, what distinguishes
it clearly from that which preceded it, can be found instead in his discovery
of the innate narrative capacity of drawing. Thierry Smolderen[35] explains
how Töpffer was aware of the difference between thematic variations and
narrative sequences. The practice of earlier caricaturists, like George Crui-
kshank, had been to counter-pose distinct aspects of a theme. As Töpffer
himself explained in a letter to the French critic Sainte-Beuve, "They make
suites, that is different sides of a same idea; these things are put end to end,
they are not tied by a thought."[36] Smolderen examines the original manu-
script for the first page of *Histoire de Mr. Vieux Bois* [10]. In the upper part
of the page appear two panels that show one of these thematic contrasts,
while in the lower part, and apparently completely unrelated to the first
two, three more panels compose what the scholar calls a complete "narra-
tive syntagm," starting off the story of *Histoire de Mr. Vieux Bois*. Is it a mere
accident, the result of making the most of a piece of paper for different
purposes, or is it a demonstration—perhaps carried out in person, in front
of his students—of the difference between the two processes? For Smol-
deren, this discovery by Töpffer is key, since it leads him to something else.
The doodle improvised as an example ends up developing into a full-fledged
story. In other words:

> The startling discovery Töpffer made on that occasion was really that such a
> narrative idea could be self-propelled by the autonomous dynamics of the visual
> world, the fact that once you initiated a narrative pictorial statement of that
> kind, it just naturally leads to another statement, then another, to the extent
> of generating a whole picaresque adventure from scratch. This is essentially
> because narrative images—unlike allegories, rebuses, thematic series, interpre-
> tative illustration, etc.—are pregnant with spatial and temporal developments.
> Their components are not symbols but actors bursting with spontaneous inten-
> tions and props asking for opportunistic use or inventive calamities.[37]

What we are talking about here is, simply stated, a kind of narrative in images that did not exist up until that moment. A kind of narrative in which, for the first time, "the pictures drive the narrative."[38] A kind of narrative in images that was inconceivable under the strict rules of the academic arts. Comparing Töpffer with his self-declared master, Lanier observes, "In Hogarth, the outcome is determined from the first. Sequence is inexorable. In Töpffer, you look at one scene, and the next, and you think: if he'd been in a slightly different mood—if a branch had brushed the window and distracted him for a couple more moments, his pen suspended above the page—something else might've occurred to him, and the story might've gone elsewhere."[39]

Thinking of Töpffer as the "inventor" of the comic is probably exaggerated, or at least irrelevant. Given the development of illustration and caricature in the nineteenth century, it seems inevitable that comics would have eventually appeared, sooner or later, and in the final analysis, comics are not just a language, but an entire tradition that owes more to what happens in the North American press in the late nineteenth century than to the collected works of this Swiss teacher, whose influence in the United States was much less than that of Busch. But his discovery of the innate narrative and expressive capacity of the "scribble" does situate him, looking back at him from our present, in a privileged position as a herald of modernity. Gombrich sums it up in the following way: "Töpffer's method—'to doodle and watch what happens'—has indeed become one of the acknowledged means of extending the language of art."[40]

Moreover, if the scribble frees Töpffer up to construct a discourse based on the drawing, and not on the text, he is for his own part able to arrive at the scribble precisely because he is already free in the first place. Free, that is, from any demands other than his own inspiration. The first author of comics in history is a vocational author, not a professional one. As we have seen, he creates his comics for private use and only later, and hesitantly, does he give them public exposure. After Töpffer, all cartoon practitioners will deal with editorial guidelines, commercial considerations, and technical limitations as they undertake their projects. The slavery of profession would only begin to be shaken up with the rebellion of the current graphic-novel "movement," where the foremost criterion in determining the form and content of a cartoon is the will of the author. It is this unique quality of Töpffer that has made him so attractive in recent years, and why a portion of the roots of contemporary comics undoubtedly belong to him.

Comics as American Invention: Yellow Kid, Product

The influence of Rodolphe Töpffer extended throughout Europe at mid-century, with great success in France, where he was published, republished, and copied. In 1841 a translation of *Les amours de Mr. Vieux Bois* was published in England, with the title *The Adventures of Obadiah Oldbuck*. This edition arrived to the United States, but had little effect. The decisive figure in the development of American comics would be the German Wilhelm Busch (1832–1908).

A painter, poet, and caricaturist, Busch collaborated with the humor weekly *Fliegende Blätter*—where the famous drawing of the rabbit-duck that would serve as the introduction for Gombrich's *Art and Illusion* was published—beginning in the late 1850s. In 1865 he published a comic titled *Max und Moritz*, [11] featuring two mischievous boys. Although Busch employed in this comic an agile narrative typical of modern comics and a very simple caricature style, he accompanied each panel with a pair of verses that added a musical rhythm to the story. Max and Moritz committed one prank after another, until meeting their end at the hands of a peasant, who trapped them in a sack and turned them over to a miller. The two little boys were ground down into meal, and in the end gobbled up by the miller's ducks. This story, without a moral—the children learn nothing, and are brutally punished in the end—and filled with black humor and violence, was situated at the antipodes of Töpffer's crazed but innocent pedagogical odysseys. It enjoyed immense international success, was distributed throughout Europe—it was even the first foreign children's book published in Japan, in 1887—and became a model for many local comics traditions. In the United States too it would become a benchmark.

American comics of the second half of the nineteenth century had the same main support as European comics: satirical magazines, most of them founded in imitation of their European counterparts, of which the British *Punch* ("The *Charivari* of London") was the most prominent. Among the North American magazines, the first was *Puck*, founded in St. Louis, Missouri, in 1871 by the Viennese Joseph Keppler, with editions in English and German. In 1876 he moved the German edition to New York, and in 1877 he finally brought to that city the English edition of the magazine, which used the same illustrations as the German edition.[41] Soon other leading competitors emerged, like *Judge* (1881), formed by illustrators who had split with *Puck*, and the first magazine titled *Life* (1883). These humor magazines included texts, illustrations, caricatures, graphic jokes, and also some of

the first experiences of authentic North American comics, which have been reviewed enthusiastically in recent years, in a rediscovery of an unknown treasure trove of American cartoon pioneers. The emphasis on the importance of Outcault and other cartoonists of the Sunday presses of the 1890s had caused names like A. B. Frost and F. M. Howarth, who started their careers in these magazines in the 1880s, to be overlooked. In Ron Goulart's extensive *Encyclopedia of American Comics* of 1990, for example, these two cartoonists are not even given their own entries. Today, however, they are considered key figures for understanding the development of comics art in the United States.

A. B. Frost (1851–1928), born in Philadelphia, was a painter and illustrator (he collaborated on two books with Lewis Carroll), and until a short time ago his work as a comics artist had gone unrecognized. In 1876 he joined the art department of Harper & Brothers (which today still publishes *Harper's Bazaar* magazine) in order to collaborate with various heads of the company. In December of 1879 he published (unsigned) what is already clearly considered a comic in *Harper's New Monthly*, and from that moment on he continued practicing and refining his art in other publications over the next ten years. Thierry Smolderen[42] observes a point of continuity between Frost and Töpffer: both suffered from "graphomania," a "priapism of the pen" necessary for drawing to flow by its own volition toward the graphic narrative of the cartoon. Nevertheless, there is an important difference from Töpffer that situates Frost on the threshold of a new era, at the end of the century, an era in which the concept of the image, and of the image repeated in series, would change radically from the reigning concept of the image in the first half of the century. We must remember that when Töpffer drew his first cartoon, in 1827, it was still twelve years before the introduction of the daguerreotype. Frost, however, studied in the Philadelphia Academy of Fine Arts with Thomas Eakins, the North American painter who had trained in realism with Gérôme in Paris. Frost's studies (1878–1883) at the Philadelphia Academy coincided with the moment in which Eakins was exploring most closely the relationships between photography and painting. The painter bought his first camera in 1880, and was fascinated by the work of the California-based English photographer Eadweard Muybridge. Eakins transferred to his paintings an obsession with capturing the movement reflected in the photographs Muybridge took with multiple cameras, even using a "magic lantern" to project images onto the canvas he was painting. Enthused, he wrote to Muybridge to suggest that he apply his photographic techniques to human movement. At the time,

Eakins was painting a carriage ride, following the new direction opened up by the photographer and his studies of horses. In 1883, Muybridge made a presentation of his work to the students of the Philadelphia Academy of Fine Arts using projections of the zoopraxiscope he had invented, which produced an animation effect.

It was precisely at this time that Frost produced his first comic in 1879 [12] (at least no one has yet discovered an earlier one), which is similar in many ways to the step-by-step movement studies of Muybridge's photographs (and, in addition, seems to anticipate the interest in observing changes in human expression that would be revealed by the famous film *Fred Ott's Sneeze* shot with Edison's kinetoscope in 1894) [13]. Smolderen observes that Frost introduced repetition in the panels and setting in a manner that had only previously been seen in Töpffer's work. As Smolderen argues, the reason that repetition of panels and background had been avoided in image-based narratives was simple: in traditional engravings, the use of metal plates required the production of images with a high density of graphic information to justify their steep price. One did not buy a print with six images that only offered step-by-step variations in the movement of the main characters: profitability lay in the ability to enjoy six different—albeit related—scenes that could be contemplated with aesthetic pleasure, and not so much in reading them quickly, as is inevitably the case with the comics by Töpffer and Frost. While Hogarth's series present a selection of *scenes* that can be *interpreted* as a narrative continuity, the comics of Töpffer and Frost present a selection of *moments* that are unavoidably *read* as continuous.

The humor magazines could not reproduce the complex metal engravings with their own printing presses, and instead used woodcuts, which were rougher but cheaper and more legible, and whose profitability lay in the greater number of images yielded to create the experience of reading the magazine. This is how artists like Frost—who had an exceptional natural gift for exploiting all of the subtle nuances of black and white, since he was colorblind—redeemed the scribbling approach pioneered by Töpffer (who had also been followed in his own way by Busch), leading to its explosion as a successful form. As Smolderen states, "The battle between the 'free-hand sketch' style of the designer, and the elaborate 'copper-plate' style will be central to the emergence of the modern comic strip."

But Frost was positioned a step beyond Töpffer because the world of the moving image was opening on his horizon, a world towards which painters like Eakins, photographers like Muybridge, and very soon inventors like

Edison would be moving. That meant that Frost's concern for reflecting the passage of time in the image caused him to delve in a very special way, as we have noted, into the repetition of frames and backgrounds, as in one of his most celebrated cartoons, "Our Cat Eats Rat Poison," published in *Harper's New Monthly* in July of 1881 [14]. Smolderen notes that this kind of reiterative design would be very important for the cartoonists of newspaper supplements, since the redundancy of graphic patterns—reinforced with the use of color at their disposal—would assist in distinguishing the strip from the stagnant combination of text and image that made up the newspaper page, and would also produce special aesthetic effects.

Nevertheless, Frost did not appear to especially appreciate the effect of this reiteration in page design, since when he compiled his cartoons in book form (he published three volumes of them, *Stuff and Nonsense*, 1884, *The Bull Calf and Other Tales*, 1882, and *Carlo*, 1913), he preferred to separate the panels, publishing one on each page. This seems to be the clearest demonstration of Frost's lack of interest in either page design—something common to modern comics—or the development of panel-by-panel, frame-by-frame movement. In other words, the art practiced by Frost can now be recognized as comics, but in his moment it did not yet have that name, nor any defined rules, and was instead located at the intersection of the multiple and sequential image from which film and animation would both arise.

F. M. Howarth (1864–1908), also a native of Philadelphia, is another one of the recently reclaimed pioneers of American comics who worked at the humor magazines. Equally influenced by Busch—in Philadelphia there was a large German-speaking population—Howarth developed his career in the 1880s at *Life*, *Judge*, and *Truth*. His comics [15], usually without dialogue, possess a distinctive caricature style, and situate American comics directly in the environment from which they would draw their main themes and characters in the 1890s: the new and vigorous urban milieu, with its new relationships between neighbors and its new marginal residents, like tramps. Jared Gardner notes that:

> There is a strong connection between the rise of sequential comic strips in the U.S. and Europe and the rise of the modern city, especially its most distinctive architectural feature: the apartment building. While tenements had been a fact of working-class life since the 1840s, urbanization in the 1880s brought about the rapid spread of apartment life to the middle-class. By the end of the 1890s, more than half of the city's population lived in apartment buildings.[43]

This relationship that Howarth established between sequential narrative—that is, the cartoon strip—and architecture (the floors of a building) would serve as a central metaphor more than a century later for *Building Stories*, a graphic novel by Chris Ware—still in development at the time of the writing of this book—which plays with the double meaning of the word "story": both a tale and the floor of an apartment building.

The humor magazines would be "the comics" until the end of the century, when a war over the daily press market was unleashed in New York between the two giants of journalism, Joseph Pulitzer and William Randolph Hearst. In 1883, Pulitzer, who had made himself a wealthy man with the *St. Louis Post-Dispatch*, acquired the *New York World*, to which he immediately began to apply a series of changes that would quickly turn it into one of the most widely read print media in history. Compared to the more sober *New York Press*, the new *World* proved to be an exuberant and overwhelming force to be reckoned with. A journalist of the period said of Pulitzer, "He came here as a whirlwind out of the West, and overturned and routed the conservatism then in vogue as a cyclone sweeps all before it."[44]

Pulitzer introduced a humor page—still in black and white—in the Sunday edition of the *World* in 1889, but the real revolution came in 1894, when the *World* began to use a color printing press. The next year, *Hogan's Alley* [16] began publication in the *World's* Sunday humor supplement, a series of illustrations drawn by Richard Felton Outcault, featuring the lively residents of a working-class neighborhood of New York. Practically at the same time, William Randolph Hearst acquired the daily *New York Journal*. A war began between the two giants of the American popular press, giving rise to sensationalism and the problem of the influence of the mass media in the unfolding of the very events they cover. The cover of the weekly humor section of the *World* on July 24, 1898, is an example of how Pulitzer and Hearst used the war against Spain, which they promoted ferociously in order to sell newspapers. [17]

Comics played a fundamental role in the competition between the two newspapers. *Hogan's Alley* did not take long to become popular, and this was especially true of one of its most distinctive characters, the rascally Mickey Dugan, who would quickly become known as *The Yellow Kid* because of the color of the nightshirt in which he was always dressed. In 1896, Hearst decided that the best way of publishing a Sunday supplement comparable to the one offered by Pulitzer was simply to hire away all of his competitor's staff, which is what he did. Among those who switched sides

was Outcault, who made the trip to the *New York Journal* with his Yellow Kid under his arm. The subsequent legal dispute was resolved in the courts: Pulitzer retained the rights to the title of the section, *Hogan's Alley*, and to the image of the character, while Outcault was allowed to continue drawing the yellow child, but under another title. And so for a time, in the *New York World* the Yellow Kid appeared in *Hogan's Alley* drawn by a different author, while in the *New York Journal* the Yellow Kid was drawn by Outcault and appeared under the title *McFadden's Flats*. The distribution trucks of both newspapers used the character as an advertising slogan (such was his popularity), which gave rise to the public's referring to them both as "yellow newspapers" and, by extension, to that color remaining associated with the sensationalist press.

The situation did not last long, since Outcault was hired back by Pulitzer in early 1898, and Hearst ceased publication of the adventures of the Yellow Kid. *Hogan's Alley*, in fact, would disappear soon after. The incident, nonetheless, would mark in a crucial way the later history of comics, both in the United States and in Europe. As the industry product that it is, and controlled by business, the ownership of the characters and of the series typically resided with the publishers, turning the cartoonists into mere wage workers in relation to their own creations, a situation completely contrary to the norm in art and literature, and which nevertheless relates comics directly to other mass media like film, animation, and television. Outcault, for his part, learned his lesson, and when he created his next character, Buster Brown, in 1902, for the *New York Herald*, he was careful to retain the copyright, which resulted in immense benefits to him in the commercial exploitation of the character, a landmark in modern advertising.

The comics that appeared in the *New York World*, the *New York Journal*, the *Herald*, and other newspapers throughout the country from 1895 on were decisive in giving definitive form to what the medium would become thereafter, not only in the United States, but also in Europe and Japan, where their influence was extremely important. In order to grasp in what sense the Sunday color supplements represented a new experience for their readers, one must understand that up until that moment nothing like it had ever been seen: circulation of the color print image, in a world where neither film nor television existed, and the photograph was still not established on a mass basis, altered the public's imagination. John Carlin points out that the newspapers of the time had a more dominant presence than that enjoyed by any present day medium, and that "they were not only the

sole source of news but also the place where the lifestyle of modern America was being represented and shared by millions of people. In that context, large, beautifully printed color comics jumped out at newspaper readers in a truly revolutionary fashion."[45]

The humor supplements were also a site for experimentation, and not because of the avant-garde concerns of the dailies, but because, as we stated before when speaking of Frost, this was a moment of graphic confusion, in which there were no norms or traditions yet established and little reflection on what was happening. One might take as an example the first page of the section *The Funny Side* in the August 26, 1900, issue of the *World* [18], which presents "an absolute novelty in comics," the "mutoscope," an apparatus (whose operation is illustrated by a caricature in the upper left corner of the page) that allows one to see "comics" in "movement." The page presents two simple jokes narrated sequentially in six frames that each contain photographs.

In effect, between 1896 and 1900, it was still not very clear what the comic was or what its function would be, but by 1910 many of the thematic and formal characteristics that have distinguished it up until today had been established. Foremost among these, the recurring character, had been established as the protagonist of serial comics, in contrast to the self-contained comics without set characters, which had been more common previously.[46] And the two primary characters of the first American comic were drawn from the noisy street life of the big city: vagabonds and children. In a certain way, both character types are contained in Outcault's Yellow Kid, and both types reflect the legacy of cruel and implacable humor that comes from Busch and by way of the humor magazines of the 1880s.

Happy Hooligan (1900) [19], created by Frederick B. Opper for the *Journal* and which ran for three decades, is the main example of marginal characters as cartoon protagonists, and is perhaps the *New York World*'s heir to Daumier's Macaire. But it would be the child protagonists, in particular, who would proliferate and have a more enduring effect on the development of the medium. After the Yellow Kid, as we already noted, Outcault would achieve enormous success in 1902 with Buster Brown, a child perpetrator of terrible mischief who became a popular image alongside his dog Tige, and sold millions of products during the first decades of the century.[47] Another of the more outstanding pioneers, James Swinnerton, began in 1904 his series *Little Jimmy*, which featured a naive child who sowed disaster by becoming distracted by all kinds of irrelevant things while carrying out errands that

others had assigned him. One of the fundamental series for the development of the medium, *The Katzenjammer Kids*, initiated in 1897 by Rudolph Dirks in the *Journal*, and which continues to be published today, is a version of Busch's *Max und Moritz*. *The Katzenjammer Kids* was an overwhelming success and became yet another pawn in the war between Hearst and Pulitzer, resulting in another case of duplicity. After a confrontation between Hearst and Dirks, the latter was replaced by cartoonist Harold Knerr. In response, Dirks continued publishing his characters in Pulitzer's *New York World* from 1914 on, although this version would be known as *The Captain and the Kids*.

Of course, the great "artistic" comics series of the next generation had children as their main characters: *Little Sammy Sneeze* (1904), *Hungry Henrietta* (1905), and *Little Nemo in Slumberland*, (1905), by Winsor McCay; and *The Kin-der-Kids* (1906) [20] and *Wee Willie Winkie's World* (1906), by Lyonel Feininger. But in the hands of McCay and Feininger, the street-wise cruelty of the Yellow Kid, the Katzenjammer Kids, and Buster Brown had been softened noticeably, displacing the rough setting of the working-class neighborhood with the sweetened environments of the middle class and the innocent fantasy world that the bourgeoisie had begun to design for its children. By emphasizing the graphic and design elements, McCay and Feininger (later to be joined by others, among the more outstanding being, of course, George Harriman and his *Krazy Kat*) moved comics away from the medium's lower class roots. Although there is no doubt that the comics supplements were read by the entire family, and aimed at all of its members, the presence of child protagonists continued to decisively reinforce the relationship between the medium and the childhood audience. While the tramp would disappear when the stereotype on which he was based ceased to be socially acceptable, the children would persist as central figures of the newspaper comic strip in the two most important series of the second half of the twentieth century: *Peanuts*, by Charles Schultz, and *Calvin and Hobbes*, by Bill Watterson.

The rough edges were sanded down even more once the system of syndication became the preferred means of distribution for comics. The syndicates distributed their contents to subscribing newspapers throughout the nation, and thus many local dailies with no capacity for producing their own comics were able to enjoy the same comic strips as the big New York City dailies. Hearst sold his comics together with other content from the very beginning. Pulitzer did so from 1898 on, but starting in 1905 he established his own separate syndicate for comics, and by 1906 comics were

already being distributed throughout the country.[48] Syndication, as a 1935 article explained, brought with it standardization.

> The standardization has had a marked effect upon the unification of American culture, for the interests of readers in Miami and Seattle and Los Angeles and Boston have been leveled to a common standard. The salesman on a transcontinental journey can follow the fortunes of *Little Orphan Annie* or *Bringing Up Father* or *Tarzan* every day whether he is in New York, or Illinois, or Nebraska, or California.[49]

Just as important as the definition of social types and themes was the definition of the formal features of American comics of this moment. At the beginning of the century, the main characteristics that we still recognize today as proper to comics had already been set in place. The use of sequential panel frames, which is to say, the narration of consecutive moments and therefore of action, was consolidated with *The Katzenjammer Kids*. Although it had occurred previously, it was this series that standardized it. The other great definitive characteristic—together with sequencing, the hobbyhorse of all efforts to define the comic—is the dialogue balloon. Despite the insistence on the visual character of comics, the speech balloon or bubble (that is, the use of the word integrated into the image) has been so closely identified with the comic that for many years its appearance was chosen as the foundational moment of the form, specifically in a *Yellow Kid* strip by Outcault published on October 25, 1896, in the *New York Journal*. [21]

The strip, in color and composed of five unframed images, each image with the same fixed perspective, includes the Yellow Kid and a phonograph, without any background or visual depth whatsoever, and displays a surprising, almost postmodern, meta-linguistic humor. The Yellow Kid speaks with the phonograph; the Kid's speech appears written across his nightshirt, the phonograph's in dialogue balloons coming from its speaker. The apparatus praises the virtues of the Sunday newspaper color supplement ("a rainbow of color, a dream of beauty, a wild burst of lafter") and those of the Yellow Kid himself ("funnier dan ever"), to which the kid's nightshirt responds, "Tanks awfully." In the final image the phonograph case is opened and out comes a parrot, the true voice of the machine, exposing the trick of the roguish Kid, who was trying to fool us, and who, surprised, interrupts in mid-phrase his final advertising proclamation: "De phonograph is a great invention . . . Nit' I don't tink." The Yellow Kid's

last exclamation also appears in a dialogue balloon, while his nightshirt appears free of text in the final image.

This *Yellow Kid* strip brings together both of the features mentioned above: sequential narration and dialogue balloon. Nonetheless, despite their importance for identifying the personality of the comic, the framed text in combination with an image does not appear for the first time in this strip by Outcault. Without even mentioning pre-Colombian speech glyphs, one can recognize that medieval imagery is rich in prints, emblems, and phylacteries that make use of these elements. More recently the jokes, caricatures, and illustrations that are the direct antecedent to nineteenth century comics also make use of them, as in the example reproduced here from Cruikshank. [22] But is there something distinctive and new about the meaning of the dialogue balloon in the Yellow Kid compared to its previous uses?

In Thierry Smolderen's view,[50] medieval phylacteries and other primitive artifacts are lacking in narrative sense and function solely in allegorical spaces fixed in time, without relationship to reality, while beginning with Outcault the speech balloon is integrated into the space of the image, creating a new reality, that of the air, and taking on a physical property of its own, that of sound. It is no coincidence that the first strip in which Outcault makes use of this "new speech balloon" takes as its lead character a phonograph, that is, that the comic strip revolves around the propagation of sound in space. Noise—street noise, the sound of the modern urban setting—had been one of the principal protagonists of the great scenes of mass society [23] produced by the caricaturists of the humor magazines of the end of the century, as well as by Outcault and others. And Outcault himself had worked as a technical draftsman for Edison, at the time that the phonograph was being developed (serial production of the device began in 1890). If the reading of text *adjacent* the image slowed down the rhythm of the reading of a comic (something demonstrated by Busch, who added verses to Max und Moritz precisely in order to prolong the reading and thus add value to it), American newspaper cartoonists encountered the problem of adding "sound" to their sequential pantomimes without causing the visual narrative to lose speed. The solution lay in the "new speech balloon," which was integrated into the visual space as "sound" in the air, something likely inconceivable prior to the appearance of recorded sound. Sound and image found mass distribution at the same time, and both were then understood to belong to the same new culture of "technical reproduction," as Benjamin would say. This would become a crucial element for the future

of comics, since it decisively affected how comics were viewed by society and, therefore, their development. As Smolderen astutely points out: "It is safe to say that until the last quarter of the 20th century the comic strip was, generally speaking, very much a part of the audiovisual culture it had helped to define thirty years before the talking movies and, consequently, far removed from literary preoccupations."[51]

If the comic had followed the path blazed by Töpffer, a teacher whose greatest admirer was none other than Goethe, the father of German letters, it is quite possible that it would have developed as a literary form, emphasizing its character as a print medium, and that the graphic novel would have appeared very early on. But its development from the Sunday supplements of the American newspapers of the late nineteenth century onward situated it at the intersection of audiovisual culture. A print medium, yes, but it does not belong to the world of the written word. In the same newspapers where *The Yellow Kid* and *Happy Hooligan* appeared, texts by Dorothy Parker and F. Scott Fitzgerald also appeared, *true literature*; the fact that they shared space in the same print medium did not make them alike, but instead separated them by contrast, since the newspaper was conceived as a synthesis of heterogeneous elements. By their very nature, the comics pages were opposed to the literature pages. By their very nature, the comics pages eventually formed part of the mass media conglomeration that today we call *infotainment*, the leisure and entertainment press, like a trial run on paper of the experiences the big screen would bring in the coming years, especially after the introduction of sound in film, in the 1930s, when, as we will see, a crucial change would be produced in newspaper comics. Comics belonged to the landscape of the mechanized and moving image accompanied by sound, born at the end of the nineteenth century, and wound up being notorious, throughout the twentieth century, not as a sub-literature or a minor literature, but as *anti-literature*.

That is to say, the origins of comics display two characteristics that are unequivocally definitive of modernity: with Töpffer, it is the appearance of the doodle and spontaneity as an end in itself, as a creative system, almost the "taste for the primitive" of which Gombrich speaks; with Outcault and his contemporaries, it is mass production and the creation of serial images, which would rapidly replace what had been known up until the twentieth century as "popular culture."

For decades, the main obstacle to conceiving the kind of work that today we call graphic novel would be the inability to overcome that original definition, still in place today, of comics as anti-literature.

Toward the Long-Form Story

One of the characteristics that tend to be mentioned as necessary to the graphic novel is the greater length of the comic. Although we shall see that this is not really necessary, we tend to associate the length of a story with its complexity and, therefore, with its capacity for expressing deeper and more sophisticated, and thus more *refined*, plots and themes. The American Sunday newspaper comics of the late nineteenth century, however, are expressed in shorter units: one page, or even just part of a page. Each comic is self-contained, and leads to a gag or a succession of gags, in an aesthetic experience that can be apprehended at a glance. We might say that the Sunday comics pages are extensions of the single image jokes, effective vehicles for conveying a simple anecdote where character development is based on immediately recognizable stereotype and repetition.

At the beginning of the century, however, the newspaper comic resulted in the daily strip: a horizontal row of images—three or four, generally—all of the same size, printed in black and white in the newspaper from Monday to Saturday. Although the cartoon strip had already appeared in discontinuous form in many newspapers, and even as a series continued from one day to the next,[52] it was Bud Fisher, with his series *A. Mutt*, published in the *San Francisco Chronicle* beginning on November 15, 1907, who would launch the new format. Fisher came from the sports pages of the newspaper, aimed at adults, which were regularly illustrated with caricatures, drawings, and cartoons referring to the sporting news of the moment: horse races, boxing, etc. In Fisher's case, creative genius came together with commercial initiative and enterprising character, and the idea of creating a continuous strip was born from the author's desire to acquire greater notoriety: "In selecting the strip form for the picture, I thought I would get a prominent position across the top of the sporting page, which I did, and that pleased my vanity. I also thought the cartoon would be easy to read in this form. It was."[53]

The main character in *A. Mutt* was a compulsive gambler, but the strip would achieve its full greatness when Fisher added a second character with which Mutt would form one of the most popular comics duos in contemporary American culture. *Mutt and Jeff* [24] was an overwhelming success that belonged entirely to its creator, who had had the presence of mind to register all rights to the characters and the series in his own name. Harvey notes that in 1916, magazines attributed some 150,000 dollars in annual income to the cartoonist, and that five years later, with the addition of animated cartoons and merchandising based on the strip, as well

as the growing distribution of the series, the amount rose to 250,000 dollars, making him "the profession's richest practitioner."[54] The daily strips would bring a new kind of popularity to the comics, since, while the Sunday pages were intended for the whole family and were especially attractive to children, the strips were particularly favored by the adults who bought the paper every day, and who encountered these comics series among the regular news sections.

But even more important: the daily strips brought with them continuity. Although each strip had to be a completely self-contained reading unit, it could also serve as a hook to attract readership the next day and thereby develop a fragmented but sustained story line. With the continuity of the daily strip, the apogee was reached by a genre that would triumph in the second decade of the century: the family series.

Aimed at a more adult audience than the Sunday pages, the family series grew as capitalist consumer culture extended itself throughout the United States, since comics and advertising often went hand in hand. A 1930 survey by Gallup[55] turned up the following results: the comics were more popular among women than among men, although a majority of both sexes read them; the new series attracted their followers slowly; continuous series had more followers than self-contained strips; and the audience was so heterogeneous that one could say that it included all of society, from teachers to farmers, and from lawyers to truck drivers.

Bringing Up Father (1913) [25] is probably the most important of the family series. Created by George McManus (1884–1954), it recounts the amusing situations that result from the efforts of a *nouveau riche* family to integrate into high society. The contrast between the naturalness of the father, Jiggs, who wants to remain faithful to the habits of his humble origins, and his ambitious spouse, Maggie, gave rise to a critique of social manners that would become part of that humorous mirror held up to society that newspaper comic strips offer their readers. Moreover, *Bringing Up Father* was one of the series that would have a crucial influence in the international expansion of American comics, both in Europe and in Japan. In the land of the rising sun, it was published beginning in 1923 in the weekly *Asahi Graph*, leading the way for some of the greatest successes of American comics. Very quickly, in January of 1924, a Japanese version of the adventures of Jiggs and Maggie began publication: *Nonki na Tosan*, which would appear in the newspaper *Hochi* with such phenomenal success that it became the object of numerous merchandising pieces and starred in radio series, and eventually in movies.[56] In Europe, *Bringing Up Father* left an indelible mark

on the two founders of French comics, Alain Saint-Ogan—who is considered to be the first cartoonist to regularly use speech balloons in Francophone comics—and, especially, the Belgian Hergé.[57] Despite the fact that *Bringing Up Father* was published in France with the name *La famille Illico*, Hergé would discover it in Spanish editions that Leon Degrelle sent him from Mexico when the two were collaborating with the Catholic weekly *La Vingtième Siècle*.[58] Perhaps for this reason McManus's influence was so distilled: more than the stories, which the young Hergé was unable to read, it was the strokes and the organization of the images, and the clarity in the sequencing of images understood as a system of readable elements that Hergé would transfer to *Tintin*, formulating the hegemonic paradigm of European comics during the middle decades of the twentieth century: the clear line.

Together with *Bringing Up Father*, other family series abounded, each with its own distinctive style. *Polly and Her Pals* (1912) [26], by Cliff Sterret, began with a *flapper*, a modern young woman, as protagonist, but soon the appearance of secondary characters—among whom figured notably a father as charismatic as McManus's Jiggs—ended up turning the leading role of the series into a kind of chorus. Sterret's graphic explosion in the 1920s, above all in the Sunday pages, put the series on par with the art comic par excellence, *Krazy Kat*, and made it a subject of veneration over the decades by leading-edge cartoonists like Art Spiegelman, who would define it visually as "a happy pop synthesis of Art Deco, Futurism, Surrealism, Dada, and Pure Cartoon."[59] Some of these series would become institutions of the American press, like *Blondie* by Chic Young, which began in 1930 and continues publication today, with its creator having drawn it for forty-three years, up until his death.

It is in the family series where a new kind of narration began to develop, one that was no longer based solely on the joke of the day, but that exploited continuity much more consistently. *The Gumps* (1917) by Sidney Smith was one of the first to open the way for this in the early 1920s. *Gasoline Alley* (1918) [27], by Frank King, underwent an even more profound transformation. Begun as a series based on a contemporary topic, the recent automobile fever, the series took a sharp turn of the wheel on February 14, 1921. On that day, Walt, the plump bachelor lead character, finds a baby abandoned outside the door of his house. Walt adopts the baby, whom he christens Skeezix, and from that moment onward the series passed into the territory of family experience—or even more simply, the territory of the flow of life itself. It is not just that *Gasoline Alley* exploited continuity, the story

line that flows day after day, but that we might say the series made continuity its own central theme. In *Gasoline Alley* there are neither great adventures nor extraordinary emotions, there is no intrigue or mystery, and the humor is of that kind that comes from an ironic but dignified view of everyday life. We might say that it gave birth to a new species of story that has neither beginning nor end. King seemed to be portraying the passage of time, and in fact if *Gasoline Alley* is distinguished by anything it is by time passing. The characters grow old, like flesh-and-blood human beings. Skeezix eventually grows up, goes to war, gets married, and has his own children, while for his part Walt marries and has biological children with his wife. Walt is an octogenarian widower at present, since the series still continues publication. *Gasoline Alley*, "the ongoing tapestry of a garage-oriented small town over decades of family-raising, small-scale enterprises, national holidays,"[60] has been the object of new interest on the part of contemporary graphic novelists. In 2007 a gigantic and respectful selection of his best Sunday pages[61] was published, all distinguished by King's inventive graphics. Two years earlier a complete re-edition of the daily strip from 1921 (when Skeezix appears) had been undertaken for the first time in the eight decades of the strip's existence. Under the title *Walt and Skeezix*[62] (because of copyright problems that prevented the use of the name *Gasoline Alley*), this collection, like the volume of Sunday pages, was designed by Chris Ware, many of whose comics have displayed King's influence.[63] Ware explained his experience of reading *Gasoline Alley*: "I rather felt I'd finally found the 'example' of what I'd been looking for in comics—something that tried to capture the texture and feeling of life as it slowly, inextricably, and hopelessly passed by."[64]

Obviously, it would be silly to say that this makes *Gasoline Alley* a graphic novel, but it would be equally rash to simply dismiss any relationship between King's series and the modern movement. As Campbell notes, the re-edition of *Gasoline Alley* by Chris Ware "has been assembled and produced within the sensibility of the graphic novel. To take that and say, 'Yes, but this is daily strips,' and then file it in the library in the humor section next to *Garfield* is not a productive thing to do. You would take *Walt and Skeezix* and file it with the graphic novels because it belongs to that sensibility."[65]

Ware also designed the recent reissue of George Herriman's *Krazy Kat*[66] by Fantagraphics, and Seth did the same for Charles Schulz's *Complete Peanuts*[67] with the same publisher. Art Spiegelman put his name—together with designer Chip Kidd—to a book that brought back Jack Cole's *Plastic Man*,[68] a superhero published in comic books of the 1940s. That does not

turn these comics into graphic novels, but it does show how graphic novel-
ists seek out their roots in comics traditions and how, in great measure, they
are rewriting from a current perspective that canon which we discussed in
the introduction.

Picture Novels

Over the course of the 1920s, the continued story took over as the domi-
nant model in the newspaper strips. Given impetus by captain Patterson,
who syndicated and edited many of the most important series of the period,
and by the so-called "Midwest school,"[69] comprising names like the afore-
mentioned Sidney Smith, Frank King, and some of the artists who would
be the most outstanding comics artists of the 1930s, like Chester Gould
(*Dick Tracy*) and Milton Caniff (*Terry and the Pirates*), this model would earn
a faithful audience of all ages with its mix of melodramatic situations and
storylines taken from the newspaper headlines. It was none other than an
assistant to Smith, the author of *The Gumps*—the first series to introduce
these elements as we noted above—who created one of the most popular
series of the decade: Harold Gray, who started *Little Orphan Annie* in 1924,
and continued drawing it for the next forty-four years. *Annie* took its inspi-
ration directly from contemporary realities in order to present situations
of Victorian melodrama whose pathos was accentuated by the defenseless-
ness of its main character, an orphan girl who seemed to anticipate the
economic and social misfortunes that would very soon befall most of the
North American population.

Nevertheless, even with continuity, the daily strips (and the pages in
color in which they are still published on Sundays) remain micro-units of
reading that adhere to the narrative logic of the series, that is, the perpetual
maintenance of a dramatic tension that is never resolved and that advances
indefinitely without a set direction. The experience of reading a long story
in comic form, a narrative that could cover several pages without being a
collection of separate pages or individual strips, did not yet exist. The comic
was still something that the reader took in with a single quick look and to
which mere seconds of attention were dedicated, until returning to have
the next narrative dose administered.

The first experiences with long stories—of true novels, in fact—in
printed images also emerged from the 1920s, but far from the milieu that
comics had made their own in the eyes of society, that of the newspapers.

These are the so-called *picture novels* or *wordless books*, a collection of books that told complete stories through images, without any supporting text whatsoever. The most famous ones made use of different printmaking techniques: engraving, woodcut, and linocut or etching on lead plates, although several were also produced using conventional ink drawing.

In the view of David A. Beronä,[70] there were three factors that influenced the appearance of these picture novels. First, the revival of the wood-block print brought on by the German expressionists (think, for example, of Kirchner and the *Die Brücke* group); second, the influence of silent film on the public; and third, the established position of comics in newspapers and magazines as a legitimate medium for presenting political and social critiques through narrative images.

The first picture novels were the work of Frans Masereel (1889–1972), son of a well-to-do family from Gante. After receiving his training at the Academy of Fine Arts in the city of his birth and then traveling to Paris, he joined the International Red Cross and the international pacifist movement during the World War I. He was a political caricaturist in Switzerland and illustrated numerous books, among them those of the Frenchman Romain Rolland, who was awarded the Nobel Prize in Literature in 1915. Masereel belonged to an intellectual world of artists and literati, quite distant from the popular culture associated with comics. Maserel was a friend of George Grosz and of Stefan Zweig—who once said of Masereel, "Should everything perish, all the books, the photographs and the documents, and we were left only with the woodcuts Masereel created, through them alone we could reconstruct our contemporary world."[71] The editions of his books published in Germany by Kurt Wolff included prologues by Thomas Mann and Hermann Hesse.

His first picture novel—in truth, a short story—was *25 Images de la Passion d'un Homme* (25 Images of the Passion of a Man, 1918). With twenty-five woodcuts, he shows the fate of a man born in a working-class neighborhood, without a father and without a fortune. Obliged to work from childhood, he is arrested for stealing bread. When he leaves prison, now a grown man, he confronts the temptations of the libertine life that have a stupefying effect on the working class—women, song, and wine—but rejects them in favor of study and family life. Soon, his classmates listen to him, and he leads them to rebel against the repressive forces at the command of the ruling classes. Imprisoned once again for his revolutionary activities, the final image shows him facing a firing squad with the body of another executed man at his feet. The parallel between the "passion" of the anonymous "man"

and the passion of Christ is obvious and underscored by the penultimate image, which shows him before a tribunal that judges him, presided over by an enormous crucifix. The concern for social themes from a leftist perspective that would dominate this genre is already clearly established in this first title.

Thomas Mann, who would write the prologue to *Mon livre d'heures* (My Book of Hours, 1919, published in English as *Passionate Journey*), Masereel's next work, related that when people asked him which film, of all the ones he had seen, moved him the most, he responded precisely that it was *Mon livre d'heures*.[72] The response might seem shocking to us, since at the end of the day, it is obvious that *Mon livre d'heures* is not a film, but a book, but Mann's answer reveals the extent to which narration through pictures relates the graphic print medium to the audiovisual story, especially at a time when film was silent and in black and white. The fact that only one woodcut appeared on each page further reinforced the kinship with film. As Seth has observed,[73] the wordless novels make an effort to avoid the two most basic elements of the comic, multiple images and dialogue balloons, and choose instead to associate more closely with the model of silent film, at a moment when its expressive development—its success among the public, which had already assimilated a standardized visual language—had reached its greatest height.

If there is a genre of silent film closest to wordless novels it is, most likely, the urban symphony, a cinematic construct in which the central character of the film is not the individual person but the collective entity of the modern city, a genre to which some of the best talents of the period applied their skills, like Dziga Vertov (*Man with a Movie Camera*, 1929), or Jean Vigo (Apropos de Nice, 1930). Masereel's second novel, the aforementioned *Mon livre d'heures* [28], was of much greater complexity than the first novel—in this case comprising 167 woodcuts—and made use of an anonymous protagonist as a pretext for conducting a *passionate journey* (this being, in fact, its English title), through the ups and downs of modern life, love, sex, family, social injustices, and death. The goal was to capture a moment in the collective life of society, more than to tell us the convincing tale of the adventures of an individual with his own personality. Significantly, the book opens with a quote from Walt Whitman, in the same way that the American poet framed, with his superimposed verses, *Manhatta* (1921), by Paul Strand and Charles Sheeler, one of the inaugural films in the urban symphony genre. *Manhatta* begins with the arrival of the masses into the city by way of a mode of modern transport, the ferry.

Mon livre d'heures begins with the hero arriving in the city on the mode of transport emblematic of modernity, the train. The train also appears in the first woodcuts of *La Ville* (The City, 1925), another later work by Masereel that abandoned any pretext of a plot in order to launch itself directly into offering us a panoramic view of the greatness and misery of the big city and its diverse inhabitants. One of the most emblematic urban symphonies of the period, *Berlin: Die Symphonie einer Grosstadt* (Berlin: Symphony of a Great City, 1927) by Walther Ruttmann, appeared shortly after to take up Masereel's ideas, including the beginning with the train's arrival at the central station. Without a doubt, the absence of text pushes Masereel's stories naturally toward this abstract plane, distancing them from the elaboration of individualized fictional characters. The same fascination and dread in the face of the velocity and violence of contemporary life was shared by the filmmakers of the moment.

Masereel produced several purely symbolic novels, where the ideas materialize in images that form narrative allegories: *Le Soleil* (The Sun, 1919), *Histoire sans paroles* (Story without Words, 1920), *Idée, sa naissance, sa vie, sa mort* (Idea, Its Birth, Life, and Death, 1920, published in English as *The Idea*). The last of these, a fable of the corruption of artistic ideas at the hands of businessmen, gave rise to an animated film by Berthold Bartosch in 1932. Masereel's *Das Werk* (The Work, 1928) continued along this line, using a metaphorical language to narrate the creative odyssey of a sculptor.

Frans Masereel's creative work inspired Lynd Ward, who popularized the format in the United States, where Masereel was barely known. Ward (1905–1995), native of Chicago, son of a Methodist pastor, writer and social activist, was educated at Columbia University, and later studied at the Academy of Graphic Arts in Leipzig, where he discovered Masereel's work. Upon returning to the United States, Ward began to work as an illustrator at the same time that he was producing his first wordless novel, in the style of the Belgian novels, but using xylography, which allowed him greater delicacy in the stroke and infinite nuance of line. *Gods' Man* [29] arrived in the bookstores the same week as the stock market crash of 1929. Despite such a disastrous portent, and despite being a completely unprecedented work, with nothing to compare it to at the time, it achieved surprising success, and sold twenty thousand copies in six editions over four years.[74]

Gods' Man, with its 139 woodcuts, is an extended allegory about the artist's devotion to his vocation over and above all the human passions, and the struggle to remain faithful to his art despite the corrupting influence of money and the temptations of modern life. The story is pregnant with an

archetypal idealism not unlike that seen in F. W. Murnau's *Sunrise* (1927), a film that had made a great impression on viewers of the time. In the opening pages, the protagonist receives a paintbrush that situates him in the eternal dynasty of artists from throughout history—from the Egyptian painters to the moderns, passing through classical Greece, the Middle Ages, and the Renaissance—and which would afford him success, but for which he would have to pay with his own blood. Undoubtedly, Ward saw himself linked to this category of immortal artist more than with caricaturists and cartoonists.

Ward created five more *pictorial narratives*—as he called them[75]—during the period of his greatest productivity, through 1937. The next one, *Madman's Drum* (1930), delved into dramatic elements with supernatural shadings that had already appeared in *Gods' Man*, but with a less allegorical tone. In most of the subsequent narratives, the Depression and its consequences for the disadvantaged classes would play a central role. This is the case with *Wild Pilgrimage* (1932), another wordless story with the premise of a journey (like Masereel's *Mon livre d'heures*), although in this instance, instead of moving the main character through the difficult routes of the city, he is launched into a discovery of national misery, starting with the lynching of a black man in the woods, and ending with the death of the main character in a confrontation between workers and police. In this title, Ward uses a reddish bi-tone in some of the sequences to differentiate them from conventional narrative, indicating with this technique that what we see is occurring in the imagination or in the dreams of the protagonist.

His next two titles were of a more moderate length. *Prelude to a Million Years* (1933), with only thirty woodcuts, returns to the theme of the artistic ideal, but incorporates into its background the setting of the Depression and a critique of militarist nationalism, while *Song Without Words* (1936, in what appears to echo Masereel's *Histoire san paroles*), one of his more symbolic works, is like a short poem of protest against the Depression and the threat of fascism that poses the dilemma of whether the world is an appropriate place to bring a child.

Ward's masterpiece was *Vertigo* (1937) [30], an impressive volume comprising no fewer than two hundred and thirty woodcuts, produced through countless hours of painstaking work. *Vertigo* is the final condemnation of the damage to society caused by the Depression. The symbolism, although still very intense, is a bit more grounded and allows for greater personal connection to the three main characters, who, although still anonymous, are individualized and differentiated into three types: the old man, the

young woman, and the child. Their interrelated adventures from 1929 to 1934 provide the plot to a much more complex story than the previous ones. Ward uses text integrated into the diegetic space of the story, stepping almost to the threshold of conventional comics. Profoundly somber and despairing, *Vertigo* closes with a troubling and open-ended image, the only image occupying the chapter titled "Sunday," which represents a scene at the fair where all of the joy and happiness suggested by the holiday and the rollercoaster are turned into irrational panic by the *vertiginous* speed of the rollercoaster ride. An open and dynamic ending which also contributed to a break with the stereotype of the moral fable of the earlier stories and calls to mind other final scenes of present day graphic novels where the final cut is produced in the middle of an uncontrollable movement on the part of the protagonists—see, for example, Alison Bechdel's *Fun Home* or Rutu Modan's *Exit Wounds*.

Otto Nückel, a native of Cologne transplanted to Munich, was another one of the artists who laid the foundations for the wordless novel, with his ambitious *Des Schicksal: Eine Geschichte in Bildern* (Munich, 1928), published as *Destiny: A Novel in Pictures* in New York in 1930. Nückel, an illustrator of books by authors like Thomas Mann, Alexander Moritz Frey, and E. T. A. Hoffman, and also a political caricaturist, introduced the use of lead engraving in print books. The graphic result of his technical innovation is located at an intermediate point between the rounded simplicity of Masereel and the sophisticated lines of Ward. *Des Schicksal: Eine Geschichte in Bildern* is another monumental undertaking, with more than 200 engravings that tell the tale of the unfortunate life of a poor woman, oppressed by the conditions to which society subjects her. Orphaned as a child and obligated to work from a young age, she is seduced by a traveler who abandons her soon after. She delivers her illegitimate child into the waters of the river—a scene resolved with an elegant ellipsis by Nückel— and is jailed for the crime. When she finally leaves prison, she becomes a prostitute, murders a man, and winds up shot to death, a victim of police violence. The social critique component seems to be essential to the work of the engraver novelists.

These works by Masereel, Ward, and Nückel provoked a small explosion of wordless novels in both Europe and the United States. Some were of a religious kind, like *The Life of Christ* (1930) by James Reid, or *Die Passion* (The Passion, 1936) by Otto Pankok. Charles Turzak created two biographies: *Abraham Lincoln* (1933) and *Benjamin Franklin* (1935). The Czech author Helena Bochořákavá-Dittrichová, trained in Prague, discovered Masereel while

expanding her studies in Paris. The Belgian's art served as inspiration for the creation of a work that, although formally similar to Masereel, represents an important thematic innovation. *Enfance* (Childhood, Paris, 1930) is a collection of prints that recall moments from the author's childhood and family life. Without Nückel's dramatic quality, without Masereel's symbolism, without Ward's epic aesthetics, Bochorákavá-Dittrichová takes the route of memoir and everyday social life and customs, tinged with nostalgia for a happy past. It is a road that for decades was barely traveled by comics. Norwegian comics artist and resident of Germany Olaf Gulbransson[76] also created two memoir comics, about his childhood (1934) and about his professional experiences as a cartoonist (1954). But in general, the theme remained largely unheard of until the arrival of the contemporary graphic novel, where it took on fundamental importance for defining the contemporary movement, and where there was an abundance of family memoirs by women, from Marjane Satrapi to Zeina Abirached, for which Helena Bochorákavá-Dittrichová's novel is in a way a precursor. The Czech illustrator also took up the religious genre in her second wordless novel, *Kristus* (Christ, 1944).

Although the novels based on engravings were magnificent in the 1930s, some of the best examples of the format would come in later decades. *White Collar* (1940), published by the Italian immigrant Giacomo Patri in San Francisco, consists of more than one hundred and twenty linocuts and returns to the theme of the ravages of the Depression. Engaged with the workers' movements of the left, it tells the story of a young employee of an advertising agency—a "white collar" worker, in contrast to "blue collar" workers—before whom lies the promise of a wonderful professional (and family) future. When the first signs of the Depression appear before his eyes, he ignores them, thinking they will not affect him. But soon after, he loses his job and begins his devastating fall: unpaid bills, eviction, even an abortion that he cannot afford. The protagonist finally becomes aware that liberal arts professionals are also workers, and that only united, like manual laborers, would they be able to confront the mistreatment they suffer as a class. Patri also includes text in the narration, like Ward in *Vertigo*, and even integrates them in a more sophisticated way than the latter.

One of the last blasts from the novel in engravings would come in 1951, when the Canada-based Englishman Laurence Hyde published in Los Angeles *Southern Cross: A Novel of the South Seas Told in Wood Engravings*. Comprised of 118 wood engravings, this novel denounces the atomic tests conducted in the South Pacific by the United States during the Second

World War. A native family that is not evacuated from an island affected by a detonation suffers the consequences of the radioactivity, which gives rise to images of terribly chilling, almost abstract, beauty. It is like a shadow in black and white of the fears of nuclear holocaust reflected in the work of his contemporaries, Jackson Pollock and the abstract expressionists.

Like an echo of the novels in engravings, there appeared at the same time a few books of drawings that presented narrations in images, in a kind of transferral into the world of caricature and cartoon of the discoveries of Masereel and Ward. This is the case with *Alay-oop* (1930), by William Gropper, cartoonist and illustrator, and author of a famous caricature of Hirohito that provoked the Japanese government to sue *Vanity Fair* in 1935[77]; or of *Eve* (1943), by Myron Waldman, animator for Fleischer studios, where he had participated in creating *Betty Boop*, *Popeye* and *Superman* cartoons. *Skitzy* (1955), by Don Freeman, uniquely anticipated themes and attitudes that are crucial for present day graphic novels. Musician, humorist, illustrator of children's stories, Freeman drew *Skitzy* as a very personal and artistic way of venting his frustration as a creator subjected to exploitation by business people. Dave Kiersh comments that the work "represents, in a humorous manner, perspectives of a working class man's fantasies" and that it offers "mature themes in a cartoon format to an adult audience."[78] The (veiled) autobiographical outlook and the final proposal of the self-published work as a solution for the artist confer a rare prophetic value on *Skitzy*, which received no critical attention at the time of its publication.

Probably the most important of these books was *He Done Her Wrong* (1930) [31], by Milt Gross. Presented explicitly as a parody of Lynd Ward's novels, *He Done Her Wrong* is a frenetic, humorous melodrama that serves as a bridge for establishing that seemingly impossible communication between the realm of *authentic comics* and that of the wordless novels. Somewhat forgotten today, Gross was, in effect, one of the most brilliant comics artists of his time, creator in his day of numerous successful series and coiner of warped expressions of the Yiddish language[79] that became a part of popular speech. In *He Done Her Wrong* he took up the typical elements of any Hollywood drama and turned them into an odyssey of the modern world which functioned as a funhouse mirror reflection of the noble and pathetic visions of Ward, whose *Gods' Man* Gross parodied explicitly at times. An innocent trapper is deceived by his cunning partner, who steals his girl. The trapper will travel to the big city to get her back, thus embarking on a series of escapades resolved in frenzied visual gags that, because of the accelerated narrative inertia of the drawing, recall the adventures of

Töpffer's characters. All of the arbitrary and contrived topics of Hollywood are exploited by Gross' perverse humor. *He Done Her Wrong* carries a subtitle articulated on two levels that seems to condense many of the issues we have been dealing with in these pages: *The Great American Novel . . . Not a Word in It; No Music, Too*. On the one hand, it proclaims (humorously, of course, and yet . . .) its aspirations to being a "Great American Novel." Why wouldn't such a title apply to a comic? In the final analysis, comics had been adopted as a genuine American artistic creation, along with jazz, animation and film, all of them sequential artistic forms, and had been consecrated by essayists like Gilbert Seldes in *The Seven Lively Arts* (1924). But the subtitle announced that this "great novel" lacked the most basic component of novels, words, and warned us that it was not accompanied by sound either, which once again linked the book to film. In reality, there is a close relationship throughout the novel between Gross' slapstick and the humor of Keaton and Chaplin. The setting of the mountains where the comic begins immediately refers to the English genius' *The Gold Rush* (1925).

There may be no better proof of the extraordinary reach of the idea of the picture novel during these decades than the unique connection that these books had with the sphere of *high art*. Max Ernst, Dadaist painter and, like Masereel, friend of Georg Grosz, produced three picture novels between 1929 and 1935 using the collage technique, which he had defined as "the systematic exploitation of the chance or artificially provoked confrontation of two or more mutually alien realities on an obviously inappropriate level— the poetic spark which jumps across when these realities approach each other."[80] *La Femme 100 têtes* (The Woman with 100 Heads, 1929) and *Rêve d'une petite fille qui voulut entrer au Carmel* (1930, later published in English as *A Little Girl Dreams of Taking the Veil*) combine in a striking manner clippings of images from popular culture (manuals, catalogues, nineteenth century newspaper and magazine serials) to create fantastical images, whose heterodoxy is further reinforced by the text accompanying them. The last and most famous of these novels, *Un semaine de bonté* (A Week of Kindness, 1935) [32], completely eliminates the texts and becomes, nonetheless, apparently more accessible in its narrative than the other novels. Juan Antonio Ramírez does not discount the influence of either film or comics (among them the picture narratives of the novelist engravers) on Ernst, in whom he draws a distinction between his collage vision in these books and his collage vision in previous works not intended for serial reproduction: while in 1922 Ernst was practicing *emblematic collage*, after 1929 he was focused on *narrative collage*.[81] This significant difference gives

us a clue as to why Ernst's visual novels are of more than anecdotal interest. On the one hand, they reveal that in the context of the late 1920s the idea that images had their own narrative language had matured, and that that idea was present both among the mass public that read the newspaper and among avant-garde writers and artists. Furthermore, Ernst's novels, with their recycling of materials originating in the most anonymous consumer imagery, converting these into artistic pieces, established in a unique way that link between high and low culture that has given rise, as we have seen, to one of the most characteristic tensions of the contemporary graphic novel.

For a long time, the novels in engravings have remained at the margins of the history of comics, like a strange element that had a certain kinship with the comic, but did not in the end fit into its historical discourse. In recent years, however, the interest in reviewing and recuperating them has been growing, and that interest has been linked to the rise of the contemporary graphic novel. The re-editions have been numerous, a few academic studies of the subject have appeared, and several comics artists have found them attractive. In his prologue to one of the latest editions of *A Contract with God*, Will Eisner situated these books at the very origins of the contemporary graphic novel: "In 1978, encouraged by the work of experimental graphic artists Otto Nückel, Frans Masereel, and Lynd Ward, who in the 1930s published serious novels told in art without text, I attempted a major work in a similar form."[82] And it is possible that many of the formal features that distinguish *A Contract with God*, as well as a good part of Eisner's later graphic novels, may have been inspired by them: the frequent use of only one image per page, the abandonment of frames for the image panels, or the sepia tone that evokes the older books, as well as the somewhat theatrical treatment of gesture and scenery, and the stereotyped character development to which this comics artist often takes recourse. Seth, for his part, wrote the epilogue for *Graphic Witness*, which re-published four novels by Masereel, Ward, Patri and Hyde, in addition to a study by George A. Walker, and Peter Kuper took on the prologue to *Wordless Books: The Original Graphic Novels*, by David A. Beroná.

It is precisely Kuper who, together with Eric Drooker, is the most direct current heir of the picture novelists. Kuper and Drooker, who collaborated on the magazine of comics and political criticism *World War 3 Illustrated* during the 1980s, have taken up the engraver novelists not only as a formal inspiration, but also in terms of the commitment to denouncing social injustice from a leftist perspective. Drooker has worked with Beat

Generation writers like William Burroughs and Lawrence Ferlinghetti, and has authored *Flood!* (1992), a "novel in pictures." [33] Composed in fact of three distinct, thematically connected pieces, *Flood!* is an authentic contemporary wordless novel, reflecting the novels of the 1930s both in its visual appearance and in its content. The author uses a scratchboard to achieve an effect very similar to that of the woodcut, although he does not abandon the effects that result from multiple panels per page, and in fact uses these occasionally with an expressive emphasis. Drooker, who was familiar with the works of Masereel as a child, thanks to his grandfather, found in Masereel's novels and in those of Ward the inspiration to approach his own experience of living in a society in crisis, as he would explain: "The tragic theme was informed by my experiences on the Lower East Side. I'd literally climb over people to enter my apartment each night. After Ronald Reagan was elected president in 1980, a tidal wave of homelessness overflowed onto city streets, on a scale unseen since the Great Depression of the 1930s—which was when Lynd Ward was active."[83]

Kuper, for his part, has had a much broader career as a comics artist, including numerous conventional comics, but he became well-known with works like *The System* (1996) [34], an updating of the collective social portrait in the style of Ward's *Vertigo* and of Masereel's *The City*, told without words, although with a page design divided into panels and in color.

The fascination with wordless comics is universal, not restricted to the United States, and it is often possible to discern in it the stamp of the novels in engravings, perhaps because the elimination of the word reinforces the symbolic value of the images and makes them appropriate for idealistic and critical works that more easily treat the collective than the individual. Thus, although situated in an aesthetic and formal universe quite distant from that of the woodcuts, *No Comment* (2009), by the French artist Ivan Brun, also finds its purpose in showing us the diabolic functioning of a political and social machinery for which individuals are simply interchangeable parts. His artistic affinity is with the underground and manga, but his spirit is that of the engraver novelists. The use of complex ideograms is also evidence of kinship with *Space Dog* (1993), by the German Hendrik Dorgathen, who despite recurring to fantasy for his fable, which features a dog who travels through space and returns to Earth gifted with intelligence because of the intervention of aliens, also has a critical message to transmit. The same elements—the (almost complete) abandonment of words, the use of ideograms and social critique—can be found in *Nazareto* (2009), by the Mallorcan Alex Fito, who plays the black humor card. Even from a cultural

context as distant as that of Australia, wordless comics continue with a certain social inertia, as demonstrated by the magnificent *The Arrival* (2007) [35], by Shaun Tan, a universal fable about emigration whose fantastical aesthetic has roots precisely in the style and fashion of the 1920s and 1930s.

It is quite possible that, if it were not for comics, the wordless novels of the 1930s would be completely forgotten today. It is neither the literary world nor the art world that have preserved their memory, but the world of comics. In 1999, *The Comics Journal* included *Madman's Drum*, by Lynd Ward, among the hundred best comics of the twentieth century. It was almost a kind of homecoming celebration for this curious family of orphan works. Their moral stature and their political positioning in the face of a threatening present day reality are, more than their formal innovations, the quality that causes today's comics artists to revisit them, knowing perhaps that, in the same way that those works of the past were marked in great measure by the consequences of the Great Depression, the new graphic novel may have to confront an economic depression of even greater and more urgent proportions.

Exotic Realism

If throughout the 1920s newspaper comics adopted continuity as the predominant model, at the end of the decade continuity crystallized in a new genre, the adventure comic, which would prove decisive in the development of the comic book, a format that arose soon afterward and became the vehicle of choice for comics over the next seven decades.

The turn toward adventure derived naturally from the very mechanics of continuity. In order to leave the reader hanging with respect to the resolution of the conflict posed in a strip, there was no better way than to make that conflict a dramatic one. As Al Capp, cartoonist of the satirical series *Li'l Abner*, said, "Newspaper publishers had discovered that people bought more papers, more regularly, if they were worried by a comic strip than if they were merely amused by one."[84] We also must not forget that the 1920s were the golden age of the film serials, which were issued a chapter at a time on Saturday mornings, and in both theme and imagery were closely related to adventure comics, which would frequently be adapted to film beginning in the 1930s.

The humor series were the first to lean toward adventure. If leading comics like *The Gumps* or *Little Orphan Annie* had already shown the way, others

like *Wash Tubbs*, by Roy Crane, would find themselves dragged irreversibly in this direction by the force of gravity of the new genre. *Wash Tubbs*, which had been started as *Washington Tubbs II* in 1924, featuring as its main character a zany wealthy heir, changed in tone and style with the introduction in 1929 of Captain Easy, a rough, flat-nosed adventurer who was later given his own series, *Captain Easy, Soldier of Fortune*, in 1933. Something similar occurred with *Thimble Theatre*, the humorous series with multiple lead characters created by E. C. Segar in 1919, which was later invaded, also in 1929, by a rowdy sailor destined for stardom: Popeye. From that moment onward, Segar proved to be one of the great narrators of American comics, leaving humor in the background. Also debuting in 1929 (in fact on the same day, January 7) were two series that ended up revolutionizing the panorama of the newspaper strips: *Buck Rogers* and *Tarzan*.

Buck Rogers, a creation of Philip Nowlan and Dick Calkins, was inspired by a story written by Nowlan that appeared in a pulp magazine, a kind of popular literature publication that was successful in those years and which we will discuss further on. It was the first science fiction series, and despite the fact that it was of lower quality than the better series of the moment, from it emerged one of the more important trends in comics in the following decades, fantasy comics. *Tarzan*, for its part, adapted for comics another work of pulp literature, in this case by Edgar Rice Burroughs—who also had become famous for his science fiction titles, like *John Carter of Mars*. *Tarzan* brought to the cartoon panels the myth of the wild man and of unknown and unexplored Africa, but in this case its impact went far beyond the genre and affected also the general aesthetics of the medium. *Tarzan* was commissioned to an advertising illustrator, Harold Foster, who drew it in a style of romantic realism taken from the world of commercial illustration, distant from—and even in conflict with—the more or less stylized caricature typical of comics up to that moment. Waugh has said that "The appearance of Harold Foster's work, while it started a new period in strips, almost finished it; the man was so good at his particular job that there remained little for subsequent workers to improve on, and very few have had the ability to come anywhere near him. For the first time, Foster brought to the strips a complete mastery of figure drawing. Tarzan, in spite of his giant chest and arms, was lithe, loose, and moved freely in space."[85] Of course, this leap forward in academic drawing came with a price: one could argue whether such a style was appropriate for the language of comics, and the first to argue it was Foster himself, who considered himself an illustrator of a literary story and not a comics cartoonist. Significantly, he rejected the use of

the dialogue balloons, which, as we have already seen, belong to the space of the comics panel, but have no place in the topography of illustration.

With a more or less caricaturesque style, from that moment on "serious comics" abounded. On October 12, 1931, Chester Gould would start his *Dick Tracy* series, a marvel of black and white contrasts that applied the radical stylization of caricature to a detective series, inspired by the boom in gangster stories during the years of Prohibition. *Dick Tracy* initiated the *noir* genre in comics, and provoked horror because of the frankness with which it presented scenes of violence. *Scorchy Smith*, created by John Terry in 1930, was set in what for the time was the exotic world of aviation. In 1933, Terry's illness resulted in the strip passing into the hands of the brilliant Noel Sickles, who with it laid the foundations of the new school that soon after would be consolidated by Milton Caniff. Masked and supernatural adventurers also began to appear with some frequency, anticipating the superheroes, who were waiting just around the corner. We can count among these adventurers Popeye himself, who not only exhibits disproportionate super strength, but for the first time, as Carlin notes, emerges victorious from his battles,[86] while up until that moment comics characters had been the victims of pranks and dirty tricks on the part of their antagonists. That feature brings him into the family of Superman and his ilk, always triumphant over evil. The playwright Lee Falk wrote two proto-superheroes: *Mandrake the Magician* (1934), drawn by Phil Davis, and the avenger of the jungle *The Phantom* (1936), a kind of Tarzan in a mask, drawn by Ray Moore.

In 1934 there debuted two series that would finally confirm the formal turn that had started with Foster's *Tarzan*. The first was *Flash Gordon*, which was published as a Sunday color page with scripts by Don Moore and drawings by Alex Raymond; the second was *Terry and the Pirates*, written and drawn by Milton Caniff as a daily strip with a Sunday page.

Raymond, Caniff and Foster would be the three great points of reference for adventure comics going forward, the three models that all of the professionals attempted to follow. *Flash Gordon* [36] was the powerful King Feature Syndicates' answer to the success of *Buck Rogers*, but its influence over science fiction and fantasy has been far superior to that of the latter. Raymond followed Foster's line, with an elegant style with the feel of illustration, but more romantic and dynamic. His great visual imagination and the freedom given to him by the invented worlds where Flash Gordon's adventures unfolded allowed him to create a fascinating *art deco* fantasy, which in its peak moment of refinement brought him to eliminate dialogue balloons, just like Foster. Although Raymond's influence was—and

continues to be today—incalculable, his career was quite brief, because he died in an automobile accident in 1956, at the age of forty-six.

Foster, for his part, created his own series in 1937, *Prince Valiant* [37], where he applied his classicist style to the recreation of medieval settings, in which the protagonist traveled about experiencing majestic adventures straight out of a Walter Scott novel. In *Prince Valiant*, Foster abandoned dialogue balloons once again, although he did not always do the same with sequential narration, creating a strange hybrid between illustration and comic. In any case, it was not his narrative model, but his drawing that was idealized as a standard of perfection for generations of later cartoonists.

Milton Caniff was, of the three, the one who would have the most vital influence on the language of comics. His series *Terry and the Pirates* [38] featured as its main character a youth who experienced adventures in China and in the South Seas, accompanied by the adventurer Pat Ryan, cut from the same cloth as Roy Crane's Captain Easy. During the twelve years that Caniff remained with the series, until 1946, the conflicts became increasingly sophisticated, the relationships between the characters more and more true to life, and Terry himself became a man and participated in the Second World War. Even more important was the development of Caniff's narrative tools. His use of *chiaroscuro* turned out to be quite practical in the confined space of the daily strip, producing notably realistic effects with a minimum of strokes, and the alternation of perspective, near and far, brought comics closer to the language of film and made it an extremely easy and dynamic read. Caniff brought into his panels the essence of Hollywood's so-called *narrative model of continuity*, the goal of which "was transparency, which is to say, the [editing] technique would be hidden behind the representation that it constructed."[87] Foster and Raymond represented an ideal; Caniff represented something more important, a master from whom to learn. Winsor McCay or George Herriman, Carlin observes, had created unparalleled master works, the envy of all cartoonists, but inimitable, while "Caniff created a style both masterful and eminently imitable."[88]

In *Terry and the Pirates*, the panel frame is an impenetrable window that defines the limits of the drawn image, and of what happens in it, just as what happens on the movie screen is a simulation of reality that commands exclusively all of our attention. No more panels broken into shards by a sneeze in McCay's *Little Sammy Sneeze* [39]. In other words, Caniff shattered all of those incursions into the meta-language of the frame that played around with the medium's conventions. Now all that mattered was to bear witness to the drama unfolding before our eyes without any formal

element distracting us. Caniff created, in fact, the formula for American comics—and, by extension, for Western adventure comics—for the better part of the twentieth century. Even today the style created by Caniff continues to be considered the standard style, and it has been so internalized by authors and the public that, despite its great sophistication, it tends to be viewed as a natural and anti-formalist style.

The fact that Caniff's style was patterned after the Hollywood model of film narrative contributed even more to reinforcing the separation of comics from the literary world and their insertion into the tradition of audio-visual entertainment, despite being a print medium. Caniff's model would be the model adopted by the comics that were soon to arrive, and we can therefore say that the comic book inherited from Caniff the status of *anti-literature* that the newspaper strip had had since Yellow Kid.

With the adventure series, comics were homogenized with film and lost their uniqueness. *Little Nemo* and *Krazy Kat* offered a kind of experience—a spectacle, if you will—that only comics could offer, but the adventure series would be, in the best of cases, relatives of film, and in the worst, poor substitutes. The most immediate effect was their popularization as "poor man's film," but in the long term this relationship turned out to be damaging for comics, when they were forced to compete with television on its own terms.

Finally, the adventure series distanced comics from everyday life and reality, from contemporary politics and society, from social norms and from the family as both theme and audience, and oriented them toward children's consumption. Paradoxically, the formal change toward a representational style viewed as more realist brought with it a greater degree of unreality than what one could find in cartoons when caricature was the hegemonic paradigm of representation. It was from this moment on, more than ever, that comics really began to be aimed at children. And they were so even more with the appearance of the comic book.

The Comic Book that Came from Another World

The name comic book is applied, not to a *book of comics*, but to what we in Spain customarily call *tebeos*: a stapled booklet, generally in color, between thirty-two and sixty-four pages, sold at newsstands at a price accessible to children's pockets, and collected in series. The comic book would represent a crucial step in the evolution of comics, since it allowed the comic to detach itself from newspapers and humor magazines and achieve autonomy as a

medium, in addition to serving as a vehicle, finally, for lengthier comics, or at least longer than one page. Gordon, who has studied the role of comics as a consumer product in capitalist society, indicates that, in the newspapers, comics had served as a tool for publicizing a whole range of products, but that, "with comic books the art form became an entertainment commodity in its own right."[89]

The comic book is born, in fact, as an advertising medium. With various formats, book compilations of comics had existed since the second half of the nineteenth century, and in the first thirty years of the twentieth century there had appeared numerous proto-comic books that usually reprinted newspaper comic strips.

But the comic book as we know it today begins to be conceived in 1933. It was then when someone at the Eastern Color Printing Company (probably two employees in the sales division, Harry Wildenberg and Max Gaines) realized that with the same plates used for printing the Sunday pages one could print two pages of comics at a reduced size. They managed to sell the idea of using the new format for printing booklets that other commercial enterprises could give to their customers, and so it was that they produced ten thousand copies of *Funnies on Parade* for Procter and Gamble, a manufacturer of soaps that because of its practice of sponsoring radio serials gave rise to the expression "soap opera." The new magazine included re-prints of newspaper cartoon series, the publishing rights for which were not costly, and that was also the content of the subsequent comic books that they published in the following months, to be gifted to manufacturers of tooth paste or of shoes. Gaines thought that there was a market for these new comic books, beyond their value as commercial incentives. With the backing of the Dell publishing house, Eastern Color printed thirty-five thousand copies of *Famous Funnies* [40], the first comic book to be sold in stores for a cover price, which was marked at ten cents. Although the print run sold out, Dell disassociated itself from the enterprise, and Eastern continued on alone. For *Famous Funnies* number 2, two hundred and fifty thousand copies were printed, which were distributed at newsstands. By number 6, the publication was already turning a profit.[90]

Over the following years gradually more comic books would appear, all of them reprints of comics previously published in the newspapers. Even the syndicates took to directly publishing their own titles. But there was still something missing before the format would be able to take off, an added value that would provide its own appeal, beyond being a simple vehicle for recycling previously consumed cartoons with which the reader was already

familiar. The essential component that would give the comic book its own life would not come from the world of newspaper comics, but from a completely foreign world, that of the *pulp* novels.

The pulps were popular newsstand novels. Jim Steranko describes them like this:

> Pulps were untrimmed magazines, named for the soft paper flecked with shreds of wood fiber on which they were printed. Publishers used pulp paper because there was nothing cheaper available. Pulps had little to do with quality! The key word was quantity! Publishers became successful by relentlessly asking themselves this question: How can I print more books, more often, more cheaply?[91]

With their emphasis on genre fiction—adventure, Western, crime, mystery, science fiction and fantasy—the pulps set the first stone in the foundation of the entertainment subculture that would be so important for the development of the comic book. They were the beginnings of what Henry Jenkins has termed "participatory culture."[92] Around the magazines of Hugo Gernsback, who founded the first title dedicated to science fiction, *Amazing Stories* (1926), rose a movement of fans (known in the United States as fandom) and networks for the exchange of correspondence and ideas, an authentic precursor of the present day "social networks" of the Internet. Some of the main promoters of this original fandom of the pulps would wind up becoming important figures in comic book publishing, to which they would bring that obscure and sectarian culture.

The pulps, moreover, gave rise to a good number of colorful characters that anticipated those that soon after would arrive in the pages of the comic books: the Shadow, Doc Savage, Spider, Black Bat, and so on. Many of them had a dual personality, wore a mask or enjoyed superhuman powers, and were among the ingredients that would give shape to the superheroes.

It was in the pulps where a character straight out of a picaresque novel made a name for himself, Major Malcolm Wheeler-Nicholson, who had written a few stories for these publications in the 1920s and 1930s. Wheeler-Nicholson, who told extraordinary tales of love and war to anyone who would believe him, began to edit comics in 1935, when he published a magazine titled *New Fun*, with the insides in black and white. *New Fun* would be the first comic book to publish completely new material, instead of reprints of newspaper strips. The comics, of course, were not of great quality, since the Major tended to pay late and poorly, but he offered as incentive the possibility of using the magazine as a hook to interest some syndicate so that

young unknown cartoonists—many of them practically teenagers—would sign a real professional contract. Wheeler-Nicholson called his enterprise National Allied Publications and he gradually added titles to his list, all of which were nourished with whatever he had available that would cost him little or nothing at all. Of course, it was not the same owing money to an innocent cartoonist who lived on the other side of the continent as owing money to the printer, and more so at a time, after Prohibition, when printers and distributors had strong ties to the Mafia. When Wheeler-Nicholson had problems keeping up with payments to his distributor, Independent News, the latter acquired part of his company, initially, and eventually took over entirely. This was in 1938, and the year before National had begun to publish a comic book dedicated to detective stories, *Detective Comics*, whose initials would eventually provide the name for the publishing house: DC. When the company passed into the hands of Harry Donenfeld and Jack Liebowitz—the owner and accountant for Independent News—a new title was in mid-production: *Action Comics*. It still lacked the main comic, the one that would go on the cover. Vince Sullivan, the editor of the new collection, decided to include a newspaper strip rejected by Max Gaines, who had passed it along to him from his editorial position at the McClure Syndicate. The strip in question had bounced for years from one syndicate to another, but none had shown an interest in acquiring it. Sullivan decided that it could be adjusted in order to adapt it to the pages of a comic book and that it could go on the cover. Its authors, two young guys from Cleveland and fans of Gernsback's pulps, Jerry Siegel and Joe Shuster, decided to take advantage of the opportunity to see it published and finally sold it— together with all of the rights over the main character—for just 130 dollars. The title of the series was *Superman*.

Action Comics number 1 appeared with a cover date of June 1938, and its 200,000 copies sold out. Despite that, Donenfeld was horrified by the ridiculousness of the main character, who on the cover of that first issue appeared lifting an automobile over his head [41], and he ordered it removed from the covers of subsequent issues. Nonetheless, by number 7, *Action Comics* was already selling 500,000 copies a month, and a survey of the newsstands revealed the reason: children were asking for the magazine that featured Superman. The latter not only returned immediately to the cover page, but in 1939 he debuted his own collection, *Superman*, the first comic book dedicated to a sole character, while continuing to appear in every issue of *Action Comics*. The comic book had found the thing that would be its own, and had begun a new era for comics.

The heyday of the comic book came quickly, and coincided with a steady decline for the newspaper strips, which beginning in the 1940s lost space and reproduction quality in the newspapers. Few new important series would emerge until *Pogo* (1948), by Walt Kelly, and *Peanuts* (1950), by Charles Schulz. The comic books and their publishers, however, multiplied at a frenzied pace. In 1942, 143 different comic books were published each month, and were read by more than fifty million people. Many of them were soldiers mobilized because of the entry of the United States into the Second World War. Despite wartime restrictions on paper, comic books continued to increase their circulation. The most prevalent genre was that of superheroes. This was a new figure, one that inherited characteristics from earlier traditions, but that in its precise formulation, as represented by Siegel and Shuster's Superman, was different from anything that had come before. Gerard Jones explained it in the following way:

> Whatever antecedents for Superman's powers, costume, or origin we can find in Edgar Rice Burroughs or Doc Savage or the Phantom or Zorro or Philip Wylie or Popeye, nothing had ever read like this before. The racy mix of slapstick, caricature, and danger is familiar from Roy Crane's *Wash Tubbs*, but Crane never leapt into such pure fantasy. Hollywood had made breathtaking moments out of natural disaster, and Douglas Fairbanks had let us feel the same joy in physical liberation, but they had nothing to equal the immediate pleasure of these bright, flat colors and fiercely simplified forms. This was a distillation of the highest thrills in the purest junk.[93]

For Amy Kiste Nyberg, the superhero was a new concept:

> So new, in fact, that the term *superhero* was not coined until several years after the appearance of Superman, the first comic book superhero. Superhero characters set comic books apart from the other media and contributed to the comic book's growth from a newsstand novelty item to a mass medium. In hindsight, it is easy to see the impact these superheroes had on American popular culture as the superhero is updated and reinvented for each new generation.[94]

Of course, DC was the first to imitate its own success, with Batman and with many other characters, but it was not the only one, far from it. Between 1939 and 1941 hundreds of superheroes appeared in all shapes and colors, and situated at the head of the pack was Captain Marvel, a unique rival for Superman (in fact, he was the reason for a plagiarism suit by DC that

remained in the courts for a decade) published by Fawcett, and a character who was distinguished by his naive and almost self-parodying character at a moment in which most superheroes were characterized by their brutality. In 1944 the comics industry reached its peak in a period that has come to be known as the *Golden Age* of the comic book. *Captain Marvel Adventures* sold 14,067,535 copies that year.[95]

The comic book business inherited many of the features of the pulps business: the publishers were outsiders and of dubious background, and their only objective was to produce material rapidly and to recuperate their investment as quickly as possible. There emerged a production system organized in "shops," studios or "workshops" that functioned like real assembly lines where entire comic books were produced for the publisher that commissioned them. Will Eisner, barely twenty-one years old with almost no professional experience, would set up one of the most famous shops with businessman Jerry Iger. Years later, in his graphic memoir of those years, *The Dreamer* (1986) [42], he would recall how the system functioned. The cartoonists contracted by the studio worked in the same room, on adjacent tables. Eisner, as head of the studio, sat in the middle and planned the stories, passed the lettered pages to the left, and from there the inked pages were sent to the right to have the backgrounds added and to be cleaned up. As his partner observed, "Looks more like an Egyptian slave galley . . . than a comic book studio!" It would have been more accurate to say that it looked like a modern factory, since the comic book was nothing more than an industrial production. For Harvey Kurtzman, the comic books were a creation of the accountants, and not of the cartoonists:

> Accountants brought the cartoon business into being. And they thought with accountants' mentalities. The artist was nothing. There was the printer, there was the distributor, there was the newsstand guy and of course there was the accountant and somewhere at the bottom of the totem pole there was the artist. All that was needed was a guy with a brush to fill in the pages. It worked with or without the artists! I mean, they could have put shit on the pages.[96]

That is where all those who did not meet the standards for the newspaper strips ended up, along with professional illustrators who had lost their jobs in the Depression, and young people who were still too green to aspire to a better position. Nick Cardy, who would make a career for himself for decades as a cartoonist of romance and superhero comics, explained how

he had given up on his desired career as a painter to take refuge in the comic book:

> I found. first of all, that I couldn't afford the oil paints. To buy oil paints, they were very expensive, and I couldn't afford the canvas. Then I thought I could go into illustration. There was some beautiful illustration, excellent work being done in illustration in the 1930s—Harold von Schmidt, Dean Cornwell, Howard Pyle. Good artists—not Degas, but good. That was a step down from fine art, but that would be all right, but I realized that I couldn't do that, either. I didn't know what to do or where to go. I didn't have a suit to wear to see anybody, and I think those shops were pretty closed. I didn't think I had a chance at breaking in, and I needed to make a living. I needed money—right away, to live. So I went into comic books, and I liked it there.[97]

If the newspaper strips had had trouble gaining the respect of society, comic books lowered even further society's view of comics. The comic book was, clearly and without argument following the triumph of the superheroes, a medium aimed at children, and one that did not appear to be particularly beneficial or to possess any redeeming quality in the eyes of parents and educators. If for many people comics in and of themselves were bad, comic books were *bad comics*. Even though comic books were in fact read by many adults, this was not something acknowledged without some embarrassment. Gerard Jones observes that "When the press wanted to paint the murderous gangster Dukey Maffetore as mentally subnormal, they had only to report that he read Superman comics."[98] This, despite the fact that a 1950 survey produced some surprising data, including that 54 percent of all comic books were read by adults over twenty years old, and that the average adult read some eleven comics per month.[99]

The superheroes peaked during the war, and with the end of the conflict they entered into rapid decline, which might be interpreted as confirmation that a large part of their audience could be found among the soldiers called up to fight. Between 1941 and 1944 comic books sales had gone from ten to twenty million copies per month[100] (in order to estimate their true distribution one must take into account the fact that each copy was read by an average of six to seven people), but with peacetime, the superheroes beat a rapid retreat. Over the next fifteen years, only the "sacred cows" of DC would survive: Superman, Batman and Wonder Woman. Captain Marvel, symbol of the Golden Age, was abandoned by Fawcett in 1953. When their sales dropped, the editors decided it was no longer profitable to maintain

the legal defense against DC's suit and they discontinued its publication. Ironically, it would be none other than DC that would end up buying the rights to the character, who today forms part of DC's repertoire and shares adventures together with Superman.

Love, Crime, Horror: Comics Almost for Adults

Nevertheless, while the superheroes were essential to launching the comic book format, their decline did not diminish the medium's boom. Other genres began to proliferate, broadening the supply of comics in ways never before seen in the United States. Teen comics, funny animal comics (featuring anthropomorphic animals, mimicking those of Disney), Westerns, detective comics, romance, terror, war comics, and so on. The post-superhero era seemed to offer something for every sector of society. Some of these genres carried within them the seed of a true adult comic that just needed a little time to definitively mature.

One of those genres was the romance. The inaugural title was *Young Romance* [43], published by Crestwood in 1947. The title's authors were Joe Simon and Jack Kirby, a team that had achieved great success with one of the bigger superheroes of the war period, Captain America, and they had signed a somewhat rare agreement with the publisher to share the profits on this new comic dedicated to the world of love. Joe Simon explained: "It had long been a source of wonder to me that so many adults were reading comic books designed for children, and now I was finding myself increasingly wondering why there was such a dearth of comic book material for the female population."[101] With this in mind, we can identify two noteworthy details on the cover of the first issue of *Young Romance*. First, despite the fact that the title of the publication included the word "young," a banner strip just below indicated that the comic was "designed for the more ADULT readers of COMICS"; second, a text embedded in the drawn image announced that the content was "all TRUE LOVE stories." The goal of appealing to an *adult* audience and of telling *true* stories had not only never been asserted by a Mickey Mouse comic, it became one of the most important features of the contemporary graphic novel, which has derived a good part of its personality from the memoir and the autobiography. Although of course, we must not overstate the meaning of either of the declarations in *Young Romance*: by "adult," we should understand what in the Anglo-Saxon world is known as "young adult," which is to say, teenagers on the verge of

adulthood, and by "true" we should recognize the confessional tone of the comics. Evidently, there is nothing autobiographical in *Young Romance*, since the comics are not the creative work of teen girls in love, but of grown men. But from the very first story—"I Was a Pick-Up!"—the texts are written in the first person. Moreover, the romance comics return comics—we might say for the first time in comic books—to contemporary society, to the world of amorous relationships and work life, presented plausibly and recognizably for the reader. Formally, the romance comics do not represent a significant departure from action and superhero comics. After all, Jack Kirby and most of the professionals who worked on these comics had already spent several years maturing and refining their own style and language. But with the introduction of new thematic elements and with the appeal to an older female audience, they opened the way for taking the comic book out of the realm of childhood. In John Benson's view, the moment of splendor for romance comics occurred between 1949 and 1955,[102] a period during which a billion copies were sold and as many as 150 different titles were published in just one month, representing approximately 25 percent of the entire comic book market.

Another one of the important genres was the crime comic. The inaugural comic book for this trend was *Crime Does Not Pay* (June 1942) [44], published by Lev Gleason, under the editorial direction of Charles Biro. *Crime Does Not Pay* was a title of moderate sales during the boom of the superheroes, but once these lost steam, its circulation began to increase, reaching a million copies per month in 1948. Of course, this provoked a rush of imitators who, as in the case of the romance comics, promised to offer *true* crime cases, a claim already made by *Crime Does Not Pay* from its first issue. Not even present day autobiographical and documentary comics insist to such a degree on the veracity of their stories. The crime stories were, generally speaking, stark, and not only included high doses of violence but did not shy away from showing the ravages of drugs and a *dissolute life*. Just as with the romance comics, they were aimed at a reading public that had probably cut its teeth on superhero comics, but that now had entered into adult life and maintained its comics-reading habit. With this audience in mind, and with the goal of taking advantage of the popularity of the crime genre, there appeared one of a number of works that could legitimately claim the right to be recognized as the first American graphic novel: *It Rhymes With Lust*.

It Rhymes With Lust [45] was published in 1950 by Archer St. John, one of the main publishers of romance comics. It was 128 pages in black and

white, and in the small format typical of pocket novels, including a spine. It was probably the first time that an original comic was presented as a book in the United States. On the cover, a strip across the top identified it as a "picture novel"—a term that recalls the one used by Lynd Ward to describe his own works, "picture narratives"—and the use of the word lust, the largest word on the cover, together with the tempting image of a woman with ample cleavage, warned from the outset that the story was not addressed to the same audience that followed the adventures of Donald Duck. *It Rhymes With Lust* was a *noir* genre story that revolved around corruption in a small mining town, Copper City. To this town comes the protagonist, Hal Weber, a journalist called there by the widow of the town's boss, who has just died. She, whose name is Rust (thus rhyming with lust), was an old friend of Hal, who would find himself trapped between the loyalty to the truth, required by his journalistic profession, and his servitude to Rust's manipulations, in the same way that he would be forced to decide between allowing her to seduce him and committing himself to his pure love for Audrey, the innocent daughter of the deceased local boss. The story, which recounts electoral frauds, murders, and miners' strikes, had more or less the same adult tone as any *noir* genre film of the period. In fact, Arnold Drake, one of its authors, would declare that the picture novels were designed to be "action, mystery, Western and romance movies on paper," and that "*Lust* would have made a good Joan Crawford or Barbara Stanwyck film."[103] The script was attributed to Drake Waller, a pseudonym behind which hid Drake, who would have a long subsequent career as a writer for comic books, and Leslie Waller, who would further develop his activity in Hollywood. The drawing was the responsibility of a team formed by Matt Baker and his favorite inker, Ray Osrin. Baker, one of the first African Americans to make a name for himself in the comics industry, was the star draftsman for the romance comics published by St. John. In later testimonies, Drake has not hesitated to attribute to himself the conscious and deliberate invention of the graphic novel, by explaining that the reasoning that led him to the creation of *It Rhymes With Lust* was the idea that "for the ex-GIs who read comics while in the service and like the graphic style of story telling, there was room for a more developed comic book—a deliberate bridge between comic books and book-books."[104]

Despite this statement, it was the film model, more than the model of literary genre fiction, that *It Rhymes With Lust* imitated. Gilbert comments on the extent to which the big screen was the frame of reference when he points to how the artists employed screen-tone sheets, known as Zipatone,

a transparent paper with printed dots that could be applied over the draw-ing to achieve effects such as shadow and nuances added to the simple black and white contrasts. *It Rhymes With Lust* [46], Gilbert explains, "uses white zip throughout to make selected visual planes recede. As a result, the remaining artwork pops forward, subtly directing the reader to areas of particular importance to the narrative, much as a camera lens does in film. If a movie camera focuses on the foreground, the background becomes fuzzy. As a result, the viewer's eye instinctively moves to the sharper image in front. It's a simple but surprisingly sophisticated technique—one Baker and Osrin may have used to make the reader feel he was looking at a movie on paper. And indeed, that was the point."[105]

It Rhymes With Lust was simply attempting to discover a new format that would reach a potential audience, the very same young adult audience that Joe Simon and Jack Kirby sought with *Young Romance*. Evidently it shared none of the literary or artistic aspirations that today are common in the contemporary graphic novel, even though the change in format in and of itself produced interesting transformations of the narration. Because of the smaller page size than was usual for comic books, the number of panels per page was reduced, typically no more than three, and many pages carried just one image panel. It is a kind of narration that would only begin to be practiced in the United States with any frequency forty years later, when Frank Miller applied to *Sin City*, his revival of the *noir* genre, the lessons learned from studying the masters of Japanese comics. In *It Rhymes With Lust*, however, this page design is only an unconscious result of the adapta-tion to the reduced format size. There is evidence of the weight of the film model that had imposed itself as invisible dogma on the language of comics since the mid-1930s, but nevertheless, there is also evidence of an effort to offer a somewhat more sophisticated product for a more adult audience. The would-be line of picture novels failed almost before taking off. A second title died without a trace, if in fact it was ever published, and the memory of *It Rhymes With Lust* was lost until its recovery, significantly, in recent years, a time when every nook and corner of history has been searched to uncover the predecessors of the graphic novel.

The phenomenon of the inclination toward a certain realism and a more adult audience through genres like romance and crime in the 1950s had an international reach. In Spain, as we have already noted, it was during that period that the format denominated "novela gráfica" was experimented with, and women's comics aspired to a greater realism. A "false reality from an ideal world, in which love and success always end up asserting

themselves,"[106] as Martín warns, but in any case a kind of "realism" that assumes "something like the openness of Spanish women to the 'new professions,'" as a result of which the heroines move out of the world of fairytales and into that of "administrative secretaries, airline attendants, high fashion models, journalists, manicurists and hair stylists, nurses, university students, models, employees of the big department stores, even pop singers."[107]

The *noir* genre, for its part, would be the pretext for incursions into more adult scenes and characters, as with the book series *Dick Bos* by Alfred Mazure (Maz) in Holland, started in 1941, or with *Diabolik* (1962) by the Milanese sisters Angela and Luciana Giussani, which, despite being an adventure story with a masked protagonist, has a serious and erotic tone that goes beyond the bounds of a children's audience. *Vito Nervio*, the most famous Argentine detective, emerged in 1945, in the pages of *Patoruzito*.

In Japan, the 1950s witnessed the appearance of a new and more realist kind of comics, derived from the *kashibonya*, rental bookstores popularized during the post-war period as a means for obtaining cheap entertainment. It was in this circuit, and in the *kamishibai*, a kind of street theater in which stories were narrated with the aid of drawings, where those who later became masters of the alternative *manga* sharpened their skills: Shigeru Mizuki, Sanpei Shirato, Tatsuo Nagatmatsu, and Yoshihiro Tatsumi [47], who in 1957 christened the new genre *gekiga*.[108] Once again we find ourselves in need of a term other than the official "comics" in order to be free of the infantilizing restrictions imposed by the latter: *gekiga* can be translated as "dramatic pictures," and it has taken on a meaning similar to that of "graphic novel" in the West. The *gekiga* became the genuine germ seed for adult comics in Japan, not only because they presented more realistic stories and characters, more grounded in the contemporary world, where the representation of sordidness and violence was not spared, but because when the *kashibonya* rental bookstores disappeared in the 1960s, because of the country's economic recovery and the increased purchasing power of Japanese consumers, these artists moved into comics magazines, and put their names to the first author's mangas.

Today, many of those comics are being discovered in the West, aided by the stamp of prestige related to the contemporary graphic novel. Thus, with the enthusiastic support of the cartoonist Adrian Tomine (of Japanese descent), the Canadian publisher Drawn & Quarterly is publishing not only Tatsumi, but also Susumu Katsumata and Seiichi Hayashi, while in France, Shigeru Mizuki is collecting awards.

The Japanese case is perhaps the clearest example of how this kind of story possessed the potential for opening up comics to all of society and to all ages. It is another thing altogether whether that potential was ever fulfilled. In the United States, *It Rhymes With Lust* remained a rarity. But perhaps this was only a problem of opportunity, perhaps the format was premature, since the success of romance and crime comic books among an adult audience seemed to presage the consolidation of the comic book as a medium that could aspire to respectability, or at least to the reasonable respect achieved by their older siblings the newspaper strips. Many of the professionals who worked on the comic books had matured after ten to twelve years of continuous activity, and the medium was beginning to bear measurable artistic fruit.

This is when the rise of EC Comics occurs on the shoulders of the horror comics, the third and final triumphal genre of the 1950s. EC Comics had been founded by Max Gaines (who, as we have seen, had been instrumental in the creation of the comic book and who later had steered *Superman* toward *Action Comics*), under the name of "Educational Comics," a category under which he published such edifying titles as *Picture Stories from the Bible* (note, once again, how the term "comics" was avoided, perhaps as too undignified for the Holy Scriptures), divided into "Old Testament Edition" and "New Testament Edition," *Picture Stories from American History*, *Picture Stories from Science*, and *Picture Stories from World History*, in addition to funny animal children's titles. Gaines died in a sailing accident in 1947, and the publishing house passed into the hands of his son Bill, a young man twenty-five years of age who did not show much initial interest in the business he inherited. Gaines hired Al Feldstein, scriptwriter and cartoonist, to be his right-hand man in restructuring the publishing company, which, without changing its initials, became Entertaining Comics. Feldstein awoke in Gaines a passion for comics. His educational and funny animal titles were quickly transformed into collections that fit better with the direction of the market: Western, fantasy, and adventure. Finally, in 1950, the company launched what has come to be known as the New Trend of EC, which included crime collections in the style of those of Lev Gleason/Charles Biro—*Crime SuspenStories*—and action and adventure titles—*Two Fisted Tales*, which would later become war stories—as well as science fiction—*Weird Fantasy* and *Weird Science*—and, above all, the horror collections, which would unleash a new frenzy of interest in the reading public: *The Vault of Horror*, *The Crypt of Terror*, and *The Haunt of Fear*.[109]

EC operated under the same severe conditions of production as most other publishing houses at the time: it was necessary to move forward with as many pages as possible in the least amount of time feasible. Al Feldstein was in charge of developing scripts and directing all of the magazines, tasks that imposed a work rhythm that at times required he write a story a day. In order to facilitate this labor, he wrote scripts directly onto the pages, which were then turned over to the cartoonists already lettered. This method, obviously, limited the ability of the artists to play with the page design and the narrative pacing, and produced comics that frequently slipped into an illustrated story format and text-image repetition. [48] But the surprise endings and the truculence of some of the situations—a good example of the extremes to which the storylines would go is the story in which a base-ball team plays a night game using the organs of one of its dismembered teammates as equipment[110]—hooked the readers, and the cartoonists felt stimulated to give their best. Young, enthusiastic, and better paid than the competition, the artists at EC offered the most exquisite cartoons ever seen in the comic book up to that moment. Their range of aesthetic regis-ters encompassed everything from caricature to romantic realism: Johnny Craig, Graham Ingels, Wally Wood, Jack Davis, Al Williamson, Jack Kamen, Bill Elder, George Evans—legends today. Although officially EC continued producing disposable material, cheap and quickly consumable comic books, the sense that it could aspire to greater things permeated its editorial staff. Stories with political content—denunciations of racism or of false patrio-tism, for example—were not rarities, and in the science-fiction collections they began to adapt stories by writers such as Ray Bradbury. All of the car-toonists at EC signed their work, something that was not a common prac-tice in the rest of the profession, but represented an incentive for taking greater care with the craft. Two of them rose directly up to status of artists and authors, testing the limits of the comic book at the time: Bernard Krig-stein and Harvey Kurtzman.

Bernard Krigstein, the First Artist

Bernard Krigstein (1919–1990) discovered Cézanne at a very young age and from that moment forward wanted to be a painter. After studying fine arts at Brooklyn College, he felt compelled to seek work in the comic book indus-try, since neither gallery sales nor illustration commissions were enough to support him. Krigstein had what he called "a prejudice that comic books, as

a form of art, were beneath my serious attention."[111] Even though as a child he had greatly enjoyed reading comic strips in the newspaper, he held in low regard the adventure comics that filled the pages of comic books. Krigstein thus fit the familiar profile of the professional cartoonists who found themselves forced by circumstances to work in an industry that offered them no artistic inspiration and that they saw, initially, as a step down in prestige. The standardized production that characterized the shop where he started out—run by Bernard Baily—was also of no help to someone who had dreamed of following in the footsteps of the impressionists. Nonetheless, after the war his attitude toward comics changed, and he began to consider them a legitimate artistic form in their own right. "I found that comics was *drawing*, and it became the only serious field for me at the time,"[112] he would say of that period. The passion that Krigstein brought to his work from then on was so intense and sincere that it baffled his own colleagues. For them drawing comics was just a job, one in which the economic compensation was more attractive the sooner it arrived. For Krigstein, comics were a form of personal expression. He studied the cartoon artists he most admired (some as disparate as Jack Kirby and Alex Raymond), he developed an awareness of the history of the medium, and he tried in vain to establish a cartoonists union, thinking that this would not only result in better working conditions for the trade, but that it would also raise the level of artistic production. In the late 1940s, his works—included in the same stacks of magazines as his peers, and following the same formulaic scripts—made him stand out as an exceptional cartoonist. Someone as technically gifted as Krigstein seemed destined to make the leap into the newspaper strips, to create a syndicated series and gain the prestige and financial reward that his talent merited. But Krigstein was still so committed to the medium that he preferred to continue with comic books, given that it had become more artistically satisfying for him to develop stories of six to nine pages than to have to work within the limitations of a single strip. In other words, Bernard Krigstein demonstrated a number of behavioral traits that ran contrary to those typical of his colleagues.

After passing through numerous publishing houses, Krigstein came on board with EC Comics somewhat late, in 1953, when the group of cartoon artists that would define the publisher was already practically established. The insistence of Harvey Kurtzman, a grudging admirer of Krigstein, whom he had already attempted to recruit previously, convinced Gaines to accept Krigstein into the fold. Krigstein found himself for the first time in an environment that was receptive to his interests. The scripts by Feldstein, Craig,

and other collaborators usually turned out to be more stimulating than the schlock he had been forced to put into images over the previous ten years. But even more importantly, at EC individual styles, the personality of each cartoonist, were encouraged, and that became the overriding incentive for Krigstein to let loose his creativity.

He very quickly began to demonstrate his concern for page design and narrative rhythm, altering the rigid layouts suggested by Al Feldstein's compressed scripts. In "Monotony" (*Crime SuspenStories*, April 1954) [49], he started to break with the conventions of comic book narration, presenting a first page as monotonous as the story title implies. Krigstein explained that this method was the clearest demonstration of how opposed he was to clichéd perspectives, which were "anathema" to him:

> Instead of using these six panels for "exciting" and "varied" angle shots for the purpose of "creating interest," or making the "camera" approach nearer and nearer to the character in order to "create movement" (the primitive Eisner-Kurtzman style), I deliberately kept the exact same setting, *without* changing the angle, *without* changing the distance, the result of which was to *multiply* and *intensify* the slightest change of attitude and expression of the character; to *focus attention* upon the crucial aspect of storytelling and *real* movement—the movement of character.[113]

In "More Blessed to Give" (*Crime SuspenStories* 24, August–September 1954) [50], a story about the duplicity of two characters with two parallel narratives, he splits into two, and even three, panels what in the original script was presented as only one.

Krigstein experimented not only with sequencing, but with drawing as well. His virtuosity allowed him to change styles, test different finishes, use powerful black contrasts or screen-tone sheets, or leave entire comics without areas in black, so that they relied for support solely on line and color. His influences went far beyond the endogamous world of comics, and at times were ideal for the work he needed to do: to"Pipe Dream" (*Shock SuspenStories* 14, April 1954), a story whose lead character is an opium smoker, he was able to add an Asian touch thanks to his interest in Chinese and Japanese painting.

Although Krigstein never lost his passion for testing the limits of the medium, all of his efforts were moderated by the inherent limitations of the business in which he worked. The number of pages available to him was scant—he always dreamed of having an entire "book" to develop a

complex narrative—and the scripts, as advanced as EC might have been, never ceased to be basic and pitched to the tastes of an adolescent or very young readership. As a result, when he was presented with the opportunity in March 1954 to do something that would go beyond these limits, Krigstein recognized and pounced on it. The script that Al Feldstein had submitted to him dealt with a truly uncommon theme: an encounter on the subway of a Nazi extermination-camp survivor with the camp's commander. The story, which was titled "Master Race" [51], was wonderfully subtle: practically nothing happened, at least not outside the main character's head. On the first two pages we see how the former Nazi commander Reissman descends the stairs that lead to the subway—a shot for which Krigstein created a model by photographing his wife—and how he takes his seat on the subway car. The entrance into the car of the survivor triggers Reissman's memories, which occupy almost completely the next four pages, a summary of the barbarity that swept over Europe a mere ten years before. Finally, the survivor recognizes him, and Reissman flees along the platform, but falls onto the tracks ahead of the arrival of the next train, which crushes him. In the last strip of the comic, the survivor states enigmatically that he does not know the man crushed by the train, "a perfect stranger."

The Holocaust was an unusual theme for a comic book—in fact, it was an almost unheard of theme in Western mass media; *Night and Fog*, Resnais' documentary film, would not be produced until a year later—and the Jewish Krigstein took it on as a serious issue that could put to the test the real value of all of the graphic experimentation he had been conducting over the previous years. "Master Race" was to be a demonstration of the artistic power of comics.

The first thing that Krigstein did was to ask Feldstein for more pages. The story was conceived to occupy six pages in *Crime SuspenStories* 26. Krigstein asked for double that, which he was of course denied; in the end he got eight pages, despite the resistance of his editor. He dedicated a month of work to the comic (twice the norm), and submitted it too late to get it to the printer. Gaines and Feldstein were impressed with the result, but they kept the story on ice until they could find room for it.

In their famous analysis of "Master Race," Benson, Kasakove, and Spiegelman observed that, despite the fact that the script was what inspired Krigstein, it is the latter's contribution that raises the story "out of the context of the twist-ending comic book story and makes it a memorable artistic experience," precisely by using "a style which is the antithesis of standard comics storytelling."[114] That style could be summed up in the

eschewing of melodramatic visual perspectives and the breaking up of the image sequence into a greater number of panels. If Feldstein "compressed" his scripts with his generous verbosity, Krigstein proceeded by decompressing them, at times drawing three panels out of what was just one in the script. The story's resolution, narrated in a succession of eleven panels without text, was unheard of at the time, and much more so in an EC comic, which were always weighed down with verbal excess. The multiplication of images—as in the final panel of the first page—seems in part to be based on the futurists' experiments with the representation of movement, but at the same time has an iconic value that projects the repetition of the image in pop art.

What Krigstein did in "Master Race" was, in fact, to break with the model of cinematic narration, Caniff's model ("*Terry and the Pirates* was an abomination to me," he once said), in order to reclaim the inherent values of narration in drawn images, experimenting with the form in a way that had not been seen since the times of Winsor McCay and George Herriman. But Krigstein did something more than McCay and Herriman: he applied that work to *extended* narratives, several pages long, to stories more complex than a simple self-contained gag, which is to say, to systems of iconic solidarity, as Groensteen would say, in which relationships could be established that would go beyond page design, and could communicate across separate pages, like the faces that repeatedly punctuate "Master Race." Krigstein understood the comic as *form* in a way that it has not since been understood until recently, thanks to the work of authors like Chris Ware, whose words about *Gasoline Alley* might be perfectly applied to Krigstein's comic: "It made me realize that the mood of a comic strip did not have to come from the drawing or the words. You got the mood not from looking at the strip, or from reading the words, but from the act of reading it. The emotion came from the way the story itself was structured."[115]

Lamentably, the delayed submission of "Master Race" meant that it was not published until March of 1955, almost a year after it was turned into the publisher, in issue number 1 of a new collection, *Impact*. In the meantime, American comics had been shaken up by the most important blame campaign that it had ever suffered, a campaign that, as we shall see, altered dramatically the course of the history of comics, and that practically finished EC. When *Impact* arrived at the newsstands, ironically, it had no impact at all.

"Master Race," however, continued to be rediscovered over subsequent decades by comics artists with authorial aspirations, who have sought a historical model to latch on to. It is no accident that Spiegelman, as we

have already mentioned, would co-author one of the first and most important articles about "Master Race," twenty years after the publication of the comic, and that none other than Spiegelman would set the foundation stone for the contemporary graphic novel with a comic about the Holocaust. A fine thread runs from "Master Race" to *Maus*.

Krigstein's career, nonetheless, was frustrated, like those of so many of his contemporaries, by the unforgiving conditions of the industry in which he felt the need to work. While we might think that perhaps he dedicated himself with such passion to comics in order to compensate for his failure to make a career for himself as a painter, thereby rechanneling his artistic aspirations, in the end he was unable to reach his goal. "But if only—and I felt this for years afterward—if only they would have let me continue on this track, where I could have expanded the material [as in "Master Race"]. I felt I could have done very new and good things. And all these years, frankly, I've been nurturing that frustration: this feeling that something tremendous could have been done if they'd let me do it."[116]

Following the anti-comics witch hunt of 1954, the working conditions at the few publishers that remained active became even more restrictive, and Krigstein abandoned the profession to focus exclusively on painting, illustration, and teaching. The first comic book artist found himself forced into retirement at barely thirty-six years of age. There was a long road ahead to maturity for the medium.

Harvey Kurtzman's Truth

Harvey Kurtzman (1924–1993) arrived at EC in 1950. He had passed through several post-war publishers, among them the future Marvel, where he produced a series of one-page humorous comics titled *Hey Look!* between 1946 and 1949 that even today are surprising for their modernity, freshness, and intelligence. At EC he wasted no time in becoming editor of a collection, *Two Fisted Tales*. Created originally as an action and adventure title, it quickly came to focus on war comics. Kurtzman represented a completely different kind of editor from Feldstein. While the latter wrote the text, and had no problem with allowing freedom of graphic interpretation for those cartoonists who sought it (like Krigstein), Kurtzman wrote by drawing, and expected the artists to faithfully follow his sketches. Kurtzman controlled not only the text and the plot of the stories that he wrote, but the page design and the visual perspective of every panel. His sketches were, in fact,

complete comics in the rough, to which the cartoonist only needed to add the polish of his own personal style of drawing. [52] This method meant that every one of Kurtzman's comics was perfectly recognizable, regardless of its graphic appearance, but it was also very limiting for those cartoonists with more creative ambitions. Significantly, the only time that Kurtzman collaborated with Krigstein,[117] sparks flew between the two, despite their professed mutual admiration.

In 1951, Kurtzman added a second war title to his workload: *Frontline Combat*. If the war genre, in its broadest sense, could be confused with history, and include every kind of period, from classical Rome to Napoleon, as well as the American Civil War or the Second World War, *Frontline Combat* placed its emphasis on an active conflict in the historical present: the Korean War, to which it devoted several special issues. Rocco Versaci has compared the war comics of the period with films of the same genre,[118] and has observed that the comics were harsher in their representation of the conflict and less inclined to follow the official line toward which Hollywood productions were bent. A pacifist and anti-war message has even been attributed to Kurtzman's comics, which contrasted sharply with the exaltation of militarism typical of the historical moment. That, however, may be going a bit too far. Kurtzman injected the human factor into his war comics, giving even the enemy his own face as a victim of war. In that sense, his comics, which otherwise preserved the ending with a twist in the style of O. Henry, the formula established by Feldstein for EC, were disturbing and thought-provoking. But Kurtzman never proposed that war was not necessary or just, only that it had unpleasant consequences that should not be forgotten. Kurtzman explained:

> So what I did was, I had to determine a certain attitude that I'd approach
> war stories with, and I decided that if there was anything to be said, I had to
> describe as well as I could, within the bounds of—what?—responsibility, good
> taste, what to tell kids about war, if I was going to tell kids anything about war,
> and A-B-C logic led me to research actual war and tell kids about what was true
> about war.[119]

The key word is *true*, and truth is the element that Kurtzman introduced into comics—as an element critical of the twentieth century mass spectacle. In contrast to the saccharine vision offered by comics—and of course, also by film and television—of all of its content, whether romantic relationships or war, Kurtzman explored the side that remained in darkness,

and from there something began to break open. When he later created the satirical *Mad*, he opened the eyes of generations of North Americans, many of whom, like Paul Auster, an avid reader of the magazine, would grow up with the solace of finding in its pages kindred spirits who mocked the icons of American culture.

Mad, "the most influential magazine in comic-book history,"[120] arose from Kurtzman's economic needs. The obsession with the truth—or at least factual verisimilitude—led Kurtzman toward increased research. His research sessions in the libraries became interminable, and getting *Two Fisted Tales* and *Frontline Combat* out on time was increasingly difficult. Since the editors paid per submitted work, Kurtzman always earned less than Feldstein, who produced his scripts—many of them directly copied from literature, high and low—at lightning speed. Gaines was unable to increase Kurtzman's compensation, since that would have required that he pay Feldstein more also, and that would have broken his budget. The solution that occurred to them was to create a new collection for Kurtzman to edit and thereby augment his income. And in order for the project to not absorb too much of his energy or require endless hours of research, it was best that it be a humor comic. In theory, Kurtzman would increase his income by a third, and producing a humor comic book—a genre for which he had demonstrated some talent in *Hey Look!* and other previous works—would not take him more than a week, which would practically represent a break between an issue of *Two Fisted Tales* and an issue of *Frontline Combat*.

And so *Mad* was born, the first issue of which was published with a cover date of October–November of 1952. It was a comic book in color, with the same format as the rest of EC's collections, presenting four different comics. Each of them was a parody of a comics genre, drawn by the usual house cartoonists. Issue number 1 included satirical versions of horror, science fiction, crime, and Western comics. It was as if EC were mocking itself. But number 2 went even further, abandoning the generic in favor of the concrete. "Melvin!" (with art by John Severin) was a parody of Tarzan. The way had been cleared for taking direct aim at comic book characters or at television series and movies of the day, like *Dragnet* ("Dragged Net," art by Will Elder) in issue number 3. When "Superduperman" appeared (art by Wally Wood) in *Mad* number 4 (May of 1953) [53], a ferocious satire of Superman that *deconstructed* all of the clichés of the character, it confirmed that Kurtzman had hit upon a brilliant formula for stripping away all of the myths of the *global village*. Carlin has observed that "Kurtzman's understanding of

how mass media was coming to dominate postwar American reality made his parodies more profound and disturbing than even their harshest critics claimed them to be. In that sense Kurtzman anticipated what critics such as Marshall McLuhan described as the impact of media on people's perception of existence within everyday life."[121]

With Kurtzman, the medium really was the message. The cover of issue number 12 (June of 1954) [54] did not include any artwork, just the title of the magazine and the table of contents, and at the bottom of the page, a text that read, "This special issue is designed for people ashamed to read this comic-book in subways and like that! Merely hold cover in front of face making sure it's not upside down. MAD cover design makes people think you are reading high-class intellectual stuff instead of miserable junk." The cover of issue number 14 (August of 1954) reinterpreted the Mona Lisa in the style of Duchamp, the cover of number 19 (February of 1955) was the cover of a composition notebook, and number 21 (March of 1955), a page of advertisements, these last two jokes strongly recalling Chris Ware's *Acme Novelty Library*. The cover of the final issue in comic book format, number 23 (May of 1955), included only the title, a blank background and a one-word command: "THINK." [55]

Of course, the original plan went awry. *Mad* not only did not allow Kurtzman to conveniently augment his income, it also absorbed his energies in such a way that he felt completely incapable of handling all three collections at the same time. In 1953 he abandoned *Two Fisted Tales*, and a year later *Frontline Combat* was shut down. In 1955, he convinced Gaines to change the format of *Mad*. The comic book did not represent what Kurtzman was aiming for, and it tied him to a tradition and an audience that he found limiting. He wanted to see his work at the newsstands alongside the general interest magazines, in a publication with production values more worthy of an adult audience than of the acritical children's sector. Gaines, faced with the threat of Kurtzman's departure, agreed to turn *Mad* into a magazine, which he did, starting with issue number 24 (July of 1955). Nevertheless, the coexistence of owner and editor continued to be difficult, and Kurtzman left EC and *Mad* at number 28. The magazine would continue, edited by Feldstein, establishing itself as a landmark of American culture with its ongoing presence at the newsstands over the past fifty years. When Gaines decided to end publication of all of EC's comics collections, only *Mad* survived, in part because its magazine format had placed it out of reach of the terrible restrictions that the *Comics Code* had imposed on comic books in the second half of the 1950s.

Kurtzman continued his quest for the ideal satirical magazine, and left in his wake a number of excellent publications that were never able to establish themselves. First was *Trump* (1957), of which he published two issues financed by Hugh Hefner. Then, allied with some of his cartoonist colleagues, he self-published *Humbug* (1957–1958), curiously at the same time that in Spain several artists from publisher Bruguera were creating a cooperative through which they would publish the humor magazine *Tío Vivo*. Neither *Humbug* nor *Tío Vivo* would be successful (although the latter would eventually be acquired by Bruguera). Kurtzman's third effort would be *Help!* (1960–1965), published by Warren. On *Help!* he gave a first opportunity to some of those who would soon after become the most outstanding cartoonists of the comix underground, among them Robert Crumb. It was also there that he created the character Goodman Beaver, an innocent modern-day Candide whom Kurtzman made use of in order to contrast the idealized view of society sold to us by the mass media with the dark reality—always blissfully ignored by Goodman Beaver—that hides behind that image. When Hefner asked him to do a series for *Playboy*, Kurtzman turned Goodman Beaver into a stunning bunny, and with the parodical name of *Little Annie Fanny* [56] he continued his exploration of mass-media naiveté, now with a strong dose of naughtiness. *Little Annie Fanny*, produced in collaboration with his favorite cartoonist and childhood friend Will Elder, was published between 1962 and 1988.

Among the projects that Kurtzman completed after leaving *Mad*, one in particular anticipates what would become the graphic novel. Ballantine Books had been publishing reprints of *Mad* in collected volumes. When the publisher lost the rights, the editors searched for something that could fill the void, and they asked Kurtzman for a book of original material. He responded with *Harvey Kurtzman's Jungle Book* (1959) [57], a curious volume of extended format and 140 pages in black and white, completely written and drawn by Kurtzman himself. It included four stories that, once again, parodied television series of the day (the memory of which the parodies have, paradoxically, outlived). *Jungle Book* is a much clearer forerunner of the graphic novel than *It Rhymes with Lust*, since not only is it presented as a book, it was also published by a book publisher (not a comics publisher), which distributed it through general interest channels. Most importantly, it is an author's work, in which not only does Kurtzman write and draw with total creative freedom, his name even forms part of the title. Eddie Campbell would say about his discovery of *Jungle Book* in 1970, "I remember this was the first time I ever thought to myself of a comic having an authorial voice, the voice of an author."[122]

Kurtzman belongs to a generation of Jewish comedians who transformed humor in the United States in the second half of the twentieth century. Perhaps the best remembered today is Lenny Bruce, but Kurtzman's influence has been the most lasting even though his name is not well-known outside the comics industry, where he is revered on both sides of the Atlantic: in the United States with annual "Harvey" awards, and in France with the memory of his influence on René Goscinny, the father of French adult comics, who worked with Kurtzman in New York. Kurtzman developed a critical and satirical language for a timely theme, the mass media, and questioned the veracity of the media's representation of reality; he created the image of the cartoonist as author, and opened the doors for talents like Terry Gilliam, Woody Allen, Gilbert Shelton or Robert Crumb, all of whom would publish in *Help!* His role as a go-between for the comic book tradition and new and innovative, and in the final analysis, adult comics makes him a central figure in the history of the graphic novel.

The Repression of the Comic Book

In the mid-1950s the comic book industry was selling hundreds of millions of copies per year, testing out new genres, like romance and crime, with the potential for developing them for adult audiences, and had in fact a large number of adult readers, fans of comics since childhood. The professionals who had started as teenagers in the late 1930s had established themselves, and cartoon artists with an authorial personality of their own were beginning to appear, like Harvey Kurtzman or Bernard Krigstein. And that was when it all came crashing down, due in large part to a nation-wide campaign against comics.

The persecution of comics had existed since the origins of comics in the nineteenth century, and it inherited the features and complaints of other earlier persecutions of emergent cultural forms. As Amy Kiste Nyberg has indicated, the accusations leveled against comic books paraphrased the criticisms directed at dime novels or popular novellas since the mid-nineteenth century, newspaper comics since their first appearance, and film in the initial period of its popularization. And we might add that many of the accusations hurled at the comic book have been subsequently reproduced in response to the spread of television, video games, and the Internet. Newspaper comics were the object of intense campaigns of criticism between 1906 and 1911, and comic books received their first attack on a national scale[123] from Sterling North, a literary critic at the *Chicago Daily News*, who

published a column on May 8, 1940, entitled "A National Disgrace." North's criticism, based on an elitist view of cultural decadence caused by the dissemination of mass art, enjoyed considerable resonance, but to no great effect, probably because the entry of the United States into World War Two distracted the public's attention. Comic book professionals worked, in fact, with a freedom unparalleled in any other American mass medium. Film and radio complied with official regulations, but the comic book was too beneath the attention of adults to merit any guidelines or controls. The situation began to change in the post-war period, when youth culture began to make itself more visible. Adults, surprised by the presence in the streets of young people who adhered to new and incomprehensible fashions, were alarmed. Panic broke out about juvenile delinquency and the culprits were sought in those distinctive elements of youth culture, like comic books. In Nyberg's view, the fear of comic books contains a component of generational conflict, just as with rock 'n' roll. There perhaps exists no better image of how the association between these two youth fetishes invoked fear among adults than the scene in *Scorpio Rising* (1964), by Kenneth Anger, in which one of the young bikers entertains himself by reading comics while he waits to go out partying.

Although some publishers, like DC or Fawcett, had approved codes for internal control since the early 1940s, and had advisory councils complete with educators and psychologists, the industry was not capable of organizing itself to establish effective self-regulation, despite the social and legislative pressure to do so. Toward the end of the 1940s, there were efforts to approve restrictive laws for comic books in the state of New York (they did not succeed) and citizens groups were organized—often out of a local church—which throughout the country carried out supervision of the comics read by their children and attempted to root out at the point of sale all those titles that they did not consider healthy. On occasion, there were even public burnings of comics. The rise of crime comics and the high-profile appearance of terror comics in EC's wake did nothing to help reassure parents, who were concerned by the voices of alarm raised by educators and librarians.

In 1948 doctor Fredric Wertham, a renowned psychiatrist, charged into the debate, becoming the first person to suggest the possibility that there could be a link between comic books and juvenile delinquency. Wertham, who had worked with troubled children and had discovered that all of them shared a fondness for comics (of course, at the time practically all children, troubled or not, read comics), launched an intense campaign in the popular

press and through professional seminars demanding the prohibition of sales of such a harmful product. Although most of the fears centered on horror and crime comics, Wertham blamed all comics, including superhero comics, in which he identified a tendency to deform the proper psychological development of children and to undermine their ability to face reality. In April of 1954 he finally published a collection of his essays and conference presentations, titled *Seduction of the Innocent*, which had an immediate impact on the public. Also in the spring of 1954 an investigation of the comic book industry was conducted by the Senate Subcommittee on Juvenile Delinquency.

The Subcommittee, which had been formed at the beginning of the previous year, was chaired by senator Robert Hendrickson, although the most salient personality on the committee was Estes Kefauver, who aspired to the presidential nomination for the Democratic Party, and was hoping to burnish his public image with an issue of low political risk. The Subcommittee held its sessions in New York over the course of three days, during which it heard dozens of testimonies and reviewed evidence in order to determine whether horror and crime comics (all of the rest were assumed to be inoffensive) were truly directly and demonstrably linked to juvenile delinquency. Among those who testified were comic books editors and experts in juvenile delinquency, but the star witnesses were the two men who represented the extreme opposing positions in the debate: Fredric Wertham and Bill Gaines, editor of EC Comics.

Both men testified on the first day, after lunch. The first to testify was Wertham, whom the committee treated with great deference and to whom committee members posed questions "meant simply to clarify, rather than challenge, any of his testimony."[124] Gaines was questioned next, and he found himself in a much more awkward situation. An exchange with Kefauver leapt into the headlines of the next day's newspapers and has since passed into the history of comics. Responding to the question "Is there any limit you can think of that you would not put in a magazine because you thought a child should not see or read about it?" Gaines answered that his only limits were the limits of good taste. It was then that Kefauver held up the cover of *Crime SuspenStories* number 22 (May of 1954) [58], which showed a man with a bloody axe in one hand and a woman's severed head in the other, and the woman's body laying on the floor, and asked if Gaines considered that to be in good taste. Gaines managed to respond only with: "Yes, sir, I do, for the cover of a horror comic."[125] The damage done to the public image of the comics industry was irreparable. The Senate hearings

offered other proofs of the perversity of EC's comics, some of them complete distortions. For example, Wertham presented the story "The Whipping" (*Shock SuspenStories* number 14, April–May of 1954) as an example of racism—"I think Hitler was a beginner compared to the comic book industry. . . . They teach them race hatred at the age of four before they can read," proclaimed the psychiatrist—because of the use of derogatory terms for Hispanics, when the intention of the story was precisely to show the horrors of racism. Despite the awful public image for the comic book industry that resulted from the Subcommittee's investigation, in the end the findings absolved comic books. The senators recommended that the editors put their business in order, but in effect they found no evidence that linked comic books with juvenile delinquency, nor any justification for repressive legislation. Control of the medium should remain in the hands of the stakeholders themselves.

Of course, the persecution of comics was not a phenomenon exclusive to the United States, although this country was to a great degree the epicenter from which persecution extended into other regions. In Great Britain, EC comics imports, which had been re-issued in black and white, caused Parliament to approve a law that prohibited entry to the country of harmful comics. The prohibition was maintained from 1955 until 1959. In Canada legislation was also approved to ban horror and crime comics, but that simply led to the appearance of a kind of saucy comic that was deemed even more pernicious for young people. In Holland, the *beeldromans*—small format comics often of the crime genre, such as *Dick Bos*, which we mentioned earlier—incited a wave of protests in 1948 and even public burnings of comic books. In France, the re-appearance of American comics in the post-war period stirred fears of their corrupting influence and resulted in the approval of the law of July 16, 1949, concerning publications intended for youth audiences, a law that continues in effect today. In Japan, perhaps because of American influence, since the Occupation lasted until 1951, in the mid-1950s there was a wave of protests against erotic magazines and "bad reading," which also included comics. Kosei Ono goes so far as to state, "I have been able to confirm through research that the revolt against violent comics was transmitted from North America to Japan. There was a magazine for children called *Shukan Manga Shinbun*, which I read every week in elementary school. In one of its editorials, it states that 'we must learn from the American movement against violent comics and eliminate here also the manga with harmful content.'"[126] In Spain under Franco's regime the pressure of censorship was always constant, but it is interesting to note

as Antonio Martín has that 1952 was also a decisive moment in Spain for the regulation of comics, with the creation of the Advisory Council on Children's Publications (Junta Asesora de la Prensa Infantil) and some initial Regulations on Children's Publications. Of course, censorship in Spain did not let up until the end of the Franco regime, and even in the 1960s American comics imported by the Mexican publisher Novaro—among them titles as apparently innocuous as *Batman* and *Superman*—were banned, although in this case there may have been an ulterior motive in economic protectionism for Spanish publishers.

In the United States, the net result of the campaigns against comics in the 1940s, of Wertham's public condemnations and of the Senate Subcommittee's investigation, was the industry's self-regulation. In the fall of 1954 the Comics Magazine Association of America was formed, one of the main objectives for which being to draft a self-censorship code that all members would strictly follow. Not all of the publishers, however, submitted to discipline. Dell, the largest publisher of the day, thanks to Disney characters, sought to distance itself from the rest of the industry, as it believed that its comics were perfectly healthy and that the more dubious editors simply wanted to take refuge beneath the umbrella of Dell's prestige. Gilbertson, the editor of *Classics Illustrated*, also refused because he continued to insist that his adaptations of classics were not comic books. The third and most significant absence was that of the rebel Bill Gaines and his EC Comics. Gaines gave up his best-selling horror comics and also closed down his crime collections. In their place he launched a battery of titles under the stamp of "New Direction," based on contemporary themes, like journalism and psychoanalysis. Nonetheless, by refusing to accept the new Comics Code of self-censorship and therefore not carrying the seal of approval on the cover, many packs of his new collections were returned unopened. Among them were issue number 1 of *Impact*, which included "Master Race" by Al Feldstein and Bernard Krigstein. Gaines had no other choice but to give in, join the Association and accept the censorship of the Comics Code.

The Code for comics, inspired by the Hays Code that oversaw the purity of Hollywood productions, imposed restrictions not only on the representation of crime and acts of violence, but on the tone with which these could be depicted. Thus, section three of the part-A general criteria for editorial content reads that "policemen, judges, government officials, and respected institutions shall never be presented in such a way as to create disrespect for established authority"; and section six ordered that "in every instance good shall triumph over evil and the criminal punished for his misdeeds."

In addition, the use of the word "crime" on the cover was limited and the words "horror" and "terror" were explicitly prohibited in titles, among many other guidelines.

The prohibition of the words "horror" and "terror" appeared to be directed so specifically at the collections of EC Comics—after all, many considered Bill Gaines to be the main culprit in all the uproar—that there is a current of opinion that views the Comics Code as nothing more than a pretext used by the main publishers—with DC leading the way—to purge an oversaturated market and, especially, to eliminate Bill Gaines, an upstart who had risen too far, too fast. Frank Miller, in a way one of the current heirs to the EC legacy, and particularly of Johnny Craig's crime stories, is one of the proponents of that theory:

> As I understand it, though, the Comics Code itself was proposed by publishers. Ironically, it was created when Bill Gaines called a meeting of publishers to fight censorship. The other publishers wrote it, and enforced it as much as the distributors. They wanted Gaines out. . . . It was no accident they went after the best publisher the industry had ever seen. It's the best work that you lose, bringing in any kind of censorship.[127]

Nyberg, however, believes that there were other motives that combined with self-censorship to cause the collapse of the American comic book in the latter half of the 1950s. Additional important factors were the saturation of titles and publishers, the growing competition of television and the loss of the primary national distributor, American News Company, which was the target of an anti-monopoly lawsuit by the U.S. Department of Justice in 1952, leaving a good number of small publishers without a distributor.

Whatever the cause, the consequences for the industry were devastating. While 650 different titles had been published in 1954, in 1955 the figure dropped to a few more than 300.[128] At the end of his book about the anticomics panic during the 1950s, *The Ten-Cent Plague*, David Hajdu includes an appendix with the names of writers and artists who never worked in comics again following the purge. The list of "victims" is fifteen pages long and includes over four hundred and fifty names.

Without a doubt, the most memorable loss was that of EC Comics. Following the failed attempt to launch "New Direction," Gaines made another effort by shifting into the magazine format, which allowed him to avoid the Code, since this only applied to comic books. In that new format he experimented with a formula that combined text with illustration, but it was a

desperate and final death rattle. EC closed down all of its publications except *Mad*, which, reorganized as a magazine in 1954, continued its long journey on the margins of the world of comic books, where it had been rejected.

With the Comics Code, the comic book industry had been expressly recognized as a manufacturer of children's products. There would be no further toying with themes or ideas that might be of interest to an adult audience. In this sense, it is significant that there would be a return of the superheroes, beginning slowly in the second half of the decade and definitively in the early 1960s, with the revival of some of DC's old characters and, especially, with the new formula of "human superheroes" that brought the Fantastic Four, Spider-Man, and other Marvel characters. The comics industry had determined its destiny, had expelled those who did not conform to that destiny, and had left no door open for renewal. If renewal were to happen, it would have to come from somewhere else. And that is what would happen, by way of the comix underground, which would remain connected to the comic book tradition through one shared link: Harvey Kurtzman.

Chapter Three

The Comix Underground, 1968–1975

Underground comics are more like art and less like comics.[1]
—Gilbert Shelton

The Comix Underground: Comic Books for Adults

At the beginning of the 1960s, the comic book was in ruins. Following the disappearance of many of the publishers who competed during the middle of the previous decade and the mass exodus of professionals to other fields, the few surviving enterprises contented themselves with squeezing a profit from their children's audience with bland products that would avoid the attention of the censors and watchdogs of morality. But it was no longer necessary to make much of an effort to go unnoticed: the number of homes that owned a television set in the United States went from 0.5 percent in 1946 to 90 percent in 1962. If comics had always been considered a contemptible children's product, they were now deemed irrelevant. In fact, the predominant attitude among comic book professionals of the period was that one needed to flee to other fields before the medium ceased to exist in relatively short order. This is how Jack Kirby remembered his own arrival to Marvel's editorial staff in the late 1950s: "I came in and they were moving out the furniture, they were taking desks out—and I needed the work! I had a family and a house and all of a sudden Marvel is coming apart. Stan Lee is sitting on a chair crying. He didn't know what to do, he's sitting in a chair crying."[2] The scene is likely more mythical than real, but it reflects fairly well the climate of the time. Of course, Kirby and Stan Lee, the editor

98

and writer for Marvel, would soon launch a wave of new superheroes that would revitalize the industry and serve as attraction for the latest generations of comic book readers. But the market would continue to be a youth market. When the modern authors of the graphic novel turn their gaze toward the second half of the 1950s, they find little to inspire them, and all of it published in the general press: Walt Kelly's *Pogo*, a *funny animals* series where senator McCarthy had made a caricatured appearance as a wild cat, the modernist humor of Charles Schulz's *Peanuts*, and the neurotic satire of *Sick, Sick, Sick* by Jules Feiffer in *The Village Voice*. The young authors who wanted to start their careers had nowhere to start them, because the comic book had closed its doors and retrenched in a crisis economy.

But young authors there were, and they started to publish, even if through unorthodox channels. The lowering of the costs of printing facilitated the appearance of the so-called underground press beginning in 1965, with left-leaning titles like *Los Angeles Free Press*, the *Berkeley Barb*, and the *East Village Other*, continuing in the tradition started by Paul Krassner's alternative satirical paper *The Realist*, which had begun publication in 1958 in New York. Krassner, a collaborator on *Mad*, had decided to bring the satire typical of Kurtzman's magazine to an adult audience, and he brought to the project some of those who would later become underground comix cartoonists, like Jay Lynch. Another avenue for publication for future underground cartoonists were the university humor magazines. Over the first half of the decade these were very active, and some of them even paid enough that their editors could make a living from them. At the University of Texas in Austin, Gilbert Shelton was in charge of the *Texas Ranger* in 1962, the year of the first appearance of *Wonder Wart-Hog*, the pig that parodied superheroes. Also in Texas, Jack Jackson—under the pseudonym Jaxon—self-published *God Nose* (1964) [59], on whose cover appeared the heading "Adult Comix," and Frank Stack published *The Adventures of Jesus* (1964). These comic books, like Rick Griffin's surfer stories of the same period, were the almost artisanal product of the personal initiative of their authors, who occasionally found a small but faithful audience. They were produced and distributed on the margins of the comic book industry, without commercial expectations, and that logically brought with it creative freedom. Even so, the true comix underground would not establish itself until the second half of the decade, with the launch of Robert Crumb's *Zap Comix*, the comic book that would become a symbol of the post-acid hippy generation.

Robert Crumb (1943), native of Philadelphia, spent his childhood drawing comics together with his brother Charles, with whom he created in

1958 *Spoof,* a parody of Harvey Kurtzman's *Humbug.* In the mid-1960s he had set up shop in Cleveland, where he worked for the American Greetings Company drawing greeting cards. It was during that period that he created one of his most famous characters, Fritz the Cat; it was also when he began to collaborate on some publications of the underground press, like *Yarrowstalks,* and Kurtzman himself published some of Crumb's work in *Help!,* which for many was "the first underground comic book,"[3] because not only Crumb, but also Gilbert Shelton, Joel Beck, Skip Williamson, and Jay Lynch published in its pages. In 1965, Crumb began taking LSD, and the experience altered him profoundly: "That changed my head around. It made me stop taking cartooning so seriously and showed me a whole other side of myself. I was married, working in this dreary job and getting drunk every night. I'd take acid on weekends and go back to work on Mondays and they'd say, 'What's wrong with you?' . . . The difference between the early 'Fritz the Cat' stuff and what I did in '67 was because of acid."[4] That difference can be explained by saying that while the first Fritz was simply a satire by a typical sex-obsessed college student, after taking acid the creatures that Crumb drew were "more bestial, maniacal—and even more dangerous."[5] In 1967, Crumb took a decisive step for the birth of underground comix. He moved to San Francisco, apparently following a spontaneous and irresistible impulse: "One day in January, 1967, after work I used to go to this bar. There were a couple of friends of mine there who said they were on their way to San Francisco. I got talking to them and, without even thinking about it, I went with them. I didn't go home. I left my wife, my job, didn't tell anybody anything."[6]

Toward the end of the same year, Crumb had already completed a new comic book, *Zap* number 0, drawn in San Francisco. Sadly, the editor disappeared with the original pages and the issue was never published. By November, Crumb had already finished *Zap* number 1 [60], which was finally printed by Charles Plymell, a Beat poet who had shared a house with Allen Ginsberg and Neal Cassady. The Fifties counterculture was helping the next generation takes its first steps. In early 1968, Crumb, together with his pregnant wife (who had followed him from Cleveland) and a few friends, sold *Zap* number 1 in Haight-Ashbury, the very heart of the hippy revolution, using a baby stroller to transport the copies. This quaint scene was a staging of the Bethlehem for the birth of the underground comix.

The success of *Zap* served as an inspiration for cartoonists like Shelton, Jackson, and Lynch, who had spent years pondering the best formula for developing their own material completely outside the industry. The magnet

of San Francisco's flower power attracted comics artists from all over the country, just as it did with musicians. Crumb opened up subsequent issues of *Zap* to other artists, turning it into an anthology of sorts, and very quickly a quite diverse range of comix began to proliferate.

For Don Donahue, who published the first issues of *Zap*, the magazine's appeal was "its curious mixture of old and new. . . . The thing about Zap, about underground comix in general, is here was this whole medium of expression that had been neglected for so long or relegated to this very inferior position and nobody had done much with it. And all of a sudden someone did start doing something with it, and then there was this explosion."[7]

Crumb's novel contribution was the themes of the hippy generation, the spirit of the times embodied in his character Mr. Natural, a sarcastic guru who quickly became iconic. In addition, Crumb brought a creative freedom that contrasted surprisingly with the old tradition of drawing and narration of comic books, a life-long tradition that had run naturally in Crumb's veins since childhood. The grand school for Crumb had been *Mad*, with Harvey Kurtzman and his partner Will Elder at the helm, but also the funny animals for children, among them the stories of Carl Barks' Donald Duck and E.C. Segar's Popeye, from which he had taken his popular "bigfoot" style. As an iconic figure of the underground, Crumb was striking. He never grew his hair long, and with his thin mustache, black frame glasses and hat, he looked like an escapee from a Buster Keaton movie. He acted more like a witness than like a participant in the revolution, an accidental passenger on the underground's train. Crumb was an obsessive collector—especially of jazz and blues records of the 1920s—and was practically a walking archive of the history of the comic book, which he recycled and made available to a new sensibility with his amazing drawing ability. Crumb did not draw out of professional dedication, but for personal pleasure, and we might say that he shared the "priapism of the pen" of the tradition of Töpffer and Frost. What Kurtzman had done with *Mad*, Crumb expanded on with *Zap*, creating "a reflexive comic-book commentary on comic books,"[8] but without commercial masters or editorial limitations.

This detail is a fundamental one for understanding the true revolution represented by underground comix. First of all, these were comic books published without the seal of approval of the Comics Code, which is to say, completely outside any mechanism of censorship (a position which inevitably resulted in frequent confrontations with the law and accusations of obscenity). Secondly, many underground comix were self-published, meaning that authors did not have to answer to any editorial staff, nor did they need

to adapt themselves to formulaic plotlines or someone else's commercial interests. Before long, underground "publishers" emerged, some of them important ones (Last Gasp, Rip-Off Press, Print Mint, Kitchen Sink), but all of them run by colleagues of the same generation as the authors, with whom they shared ideas, principles and goals. Whether self-publishing or publishing through one of the underground presses, the comics artists retained the rights to their comics, and collected royalties on them, instead of the fixed rate per page paid to commercial comic book professionals. When a conventional publisher paid an artist for the work he had completed, the publisher became the eternal owner of all the material, of both the original pages and the rights to reproduce and profit from the characters. But the young artists of the underground had learned their lesson from Jerry Siegel and Joe Shuster, who had plunged into poverty after selling Superman for little more than a hundred dollars. As Denis Kitchen has noted, "royalties treated cartoonists like literary authors."[9] This alone led to bringing the *theory of the author* to the comix underground, where, of course, the figure of the artist who produced his work by himself—scriptwriting, drawing and lettering together as an integrated art form—replaced the assembly line of professionals who worked as a team on the conventional comic book—scriptwriting, drawing, inking, coloring, and lettering as distinct trades. When the underground cartoonists collaborated, they did it in *jams*, a term inspired by the *jam sessions* of jazz and psychedelic rock: each cartoonist improvised his own image or character as part of an ensemble in which one could easily discern each individual hand. This creative system, together with remuneration via royalties, had two additional consequences for the comix books. The first of these was the impossibility of the cartoonists adhering to regular submission periods. We have to remember not only the enormous work load it represented for just one person to be responsible for all aspects of the creation of a comic, but also the relaxed environment of the psychedelic communes in which most, if not all, of these cartoonists lived. This meant for the first time that enslavement to the periodic serialization of American comics was broken, and thus the first step was taken toward viewing a comic book as a full-fledged work of art. Many titles never went beyond the first issue, and those that did came out on an irregular basis. This was not a problem for the underground economy, since it was not based on keeping in constant motion an enormous industrial machinery of production and distribution of printed material that was replenished every week, but instead obtained its returns on investment on a more moderate basis and over the long term. The most successful underground titles were re-issued

and remained on sale for years, something that never happened with con-
ventional comics. The most successful underground cartoonists managed
to accumulate significant income thanks to the royalties paid to them by
continuous re-prints, although those with lower sales earned much less. In
1971, after the underground comix had already been established, the average
print run of the more popular titles could reach twenty thousand copies.[10]
In 1973, Shelton's *Freak Brothers* number 1 reached two hundred thousand
copies sold, and the whole series would sell more than a million.[11] These
are very important figures, although when we situate them in relation to
comparable figures for the comic book industry—and let us not forget that
the latter was in clear decline—we can appreciate that the underground
continued to be a peripheral market: in 1970, the best selling comic book
was *Archie Comics*, which reached 515,356 copies per issue, followed close
behind by *Superman* (511,984). *Amazing Spider-Man*, Marvel's best selling
title, reached 373,303 copies.[12]

This marginal position affected not only the processes of production
and publication of the underground comix, but their distribution as well.
Because they lacked the seal of approval of the Comics Code, these titles
were not sold at newsstands, supermarkets, convenience stores and other
typical points of sale for children's comic books. Nor were there any book-
stores yet that specialized in comic books. Their main distribution outlets
were the head shops, stores selling hippy paraphernalia, where one could
just as easily buy a marijuana pipe as a set of bongos, rolling paper or the
latest issue of *Zap*. While comic books were distributed to newsstands on
deposit, meaning that the vendor paid nothing to receive them, returned
the unsold copies (with the cover torn off) and paid a percentage only on the
copies sold, just like with newspapers, the underground comix were paid for
upon receipt, could not be returned, and their price was much higher. This
would be the sales system adopted soon after by comic book publishers,
after a network of comic book stores was established in the United States,
and that system would wind up being crucial for the survival of the comic
book industry as well as for maintaining the tradition of alternative comics,
as we shall see.

Underground comix quickly distinguished themselves by their furious
rebellion against received morality. Sex was the shortest route toward artic-
ulating that rebellion and toward differentiating themselves from childish
traditional comic books. They were not the first comics that bordered on
pornography. Between the 1930s and the 1950s there were the very popu-
lar so-called "Tijuana Bibles," clandestine and anonymous comic books in

which sexual acts were depicted, and where gays and lesbians appeared for the first time, albeit in stereotyped form. The Tijuana Bibles did not take long in including among their themes caricatures of well-known personalities and famous characters from the newspaper comic strips, from *Bringing Up Father* to *Little Orphan Annie* and *Popeye*. There are those who view the Tijuana Bibles as "the missing link in American comic satire."[13] Art Spiegelman wrote about them: "Without the Tijuana Bibles there would never have been a *Mad* magazine, and without *Mad* there would never have been any iconoclastic underground comics in the '60s."[14]

Underground comix recognized their indebtedness to their irreverent ancestors, in some cases as directly as in *Air Pirates Funnies* (1971) [61], a group comic featuring Disney characters that was discontinued by legal order following a lawsuit brought by the company that owns the rights to Mickey Mouse, a case that was appealed as far as the Supreme Court.

Together with sex, the other recurring theme common to the underground comix was drugs, the grand unifying force of the counterculture of the period. But underground cartoonists would waste no time in giving these basic themes quite different generic coloring. If Robert Crumb applied the lessons of social portraiture from the news strips of the beginning of the century to the acid generation and liberated the unconscious in cartoons where the author's sexual fantasies were materialized with remarkable shamelessness, other cartoonists went on to add nuances to that model. Gilbert Shelton, for example, opted for depicting social manners with his trio of drug-addicted hippies, the Fabulous Furry Freak Brothers [62], and became the great humorist of his generation, while S. Clay Wilson [63] incorporated a dark and paranoid vision to the explorations of the subconscious undertaken by Crumb, whom he directly influenced, more by personal contact than through his work:

> I learned a lot from Wilson. He was more sophisticated than me in certain ways. He had evolved and articulated his artist-rebel thing to a high degree. He lived the role. By comparison, my conception about what I was up to as an artist was murky, unformed. Meeting Robert Williams was also very enlightening. I felt mildly like an idiot-savant around those guys. Part of it was that they'd gone through art school and had absorbed and regurgitated the whole fine-art game. They had this image of themselves very clearly as art out-laws, sticking it to the booshwah, the big lie, the mass delusion of mainstream culture, both high and low. I was coming from a rather more conventional cartoonist-as-entertainer background.[15]

Crumb's most direct frame of reference had been *Mad* and Kurtzman's other publications, but EC Comics, generally speaking, became the grand model for most of the underground cartoonists, who expressed their opposition to the system through their rebellion against the impositions of the Comics Code. For some of the cartoonists, underground comix even served as *revenge* for the destruction of EC at the hands of institutionalized censorship. That was Spain Rodríguez's interpretation: "It makes me feel good that we made our blows in the cultural war. We were able to kick the despicable Comics Code in the teeth. We were able to make a living. We were able to reflect our times."[16]

EC did something more than set the tone for cover art, titles and slogans used by underground cartoonists, it also gave them the horror and science fiction genres. The first of these, mixed with eroticism, promptly trended toward a kind of bloody pornography, and at the same time gave way to some of the most extreme comics ever published, like those of Rory Hayes [64], the James Ensor of comics, as Crumb called him.[17] Science fiction comics—also, naturally, with an erotic charge—drifted toward ecology. This genre opened up to cartoonists like Richard Corben [65], distant from the underground scene physically (he lived in Kansas), ideologically (he had no interest in the counterculture) and aesthetically (his detailed textures typical of professional illustration were polar opposites to Hayes' brutal naiveté). Corben did not take long in becoming one of the most sought-after artists in conventional comics. EC offered, in addition, another example for the underground artists to follow: it had brought together cartoonists of a wide range of styles and personalities with no intention of homogenizing them artistically, and individual expression, even within the group context (many underground titles were anthologies of variety of authors), was one of the inalienable principles of the comix.

Despite its preeminence, EC was not the only model reclaimed by underground artists, who were interested in all of the pre-Code comics. Bill Griffith and Jay Kinney created in 1970 one of the most long-running and best selling series, *Young Lust*, which adapted the standardized language and topics of 1950s romance comics to the liberated sexual relations of its own time. To a great extent, cartoonists like Crumb and Griffith applied to comics the same mechanisms that Lichtenstein and Warhol had applied in the visual arts, but without moving from one medium to another to do it. The comic book reflected upon the comic book from within its own form.

The underground comix also witnessed the arrival of gender consciousness to the comic book. Women cartoonists had been the exception in the

history of comics. There had been isolated cases, like Kate Carew, who had practiced the art in the early twentieth century in the New York Sunday papers, or Tarpé Mills, who created the first super heroine in 1941, but these were the exceptions in a predominantly masculine world. The underground cartoonists, with their emphasis on sex and violence, often in combination and culminating in fantasies that victimized women (one of the specialties for which Crumb was best known, for example), did not treat women any differently, but the latter managed to create an opening for themselves in the new landscape. Trina Robbins published the first women's comix in 1970, *It Ain't Me, Babe* [66], and soon titles like *Wimmen's Comix* or *Tits & Clits* allowed Roberta Gregory, Aline Kominsky, Lee Marrs, Melinda Gebbie, and many more to take their first steps. As Robbins explains, "We tackled subjects that the guys wouldn't touch with a ten-foot pole—subjects such as abortion, lesbianism, menstruation, and childhood sexual abuse."[18] The underground, with its ferocious resistance of the taboos of the Comics Code, would also be the ideal impetus for the first gay and lesbian comics, since homosexuality was prohibited by the censorship code. If the rebellion of the male underground cartoonists at times seemed to drift into scandalous adolescent pranks, the gay comix and women's comix injected a more rigorous political consciousness.

But without doubt, the most important genre that the underground comics artists introduced, and the one that in fact would lay the foundation for construction of the contemporary graphic novel, was the autobiography. In Crumb, fiction had already been mixed with confession, by introducing himself as a character and addressing himself directly to the reader in the first person, revealing his true obsessions, in particular his sexual ones. Aline Kominsky—who eventually would end up marrying Crumb—also produced, in the early 1970s, what are considered by some to be the first autobiographical comics.[19] But Kominsky herself recognized the real point of departure for autobiographical comics in Justin Green's *Binky Brown Meets the Holy Virgin Mary* (1972) [67]:

> Right around that time, when I was in art school, I saw the first Zap comic and I couldn't believe it. I just couldn't believe it. And shortly after that I saw [Justin Green's] *Binky Brown Meets the Holy Virgin Mary*, and that was just the ultimate thing for me. When I saw Justin's work, I knew how I could tell my story. When I saw Zap Comix I was completely impressed by them, but those guys were so good that I couldn't imagine myself doing what they were doing. It was too good; it was too hard. But when I saw Justin's work, it gave me a way to see

how I could do it. It helped me find my own voice, because it rang so true for me. The drawing was so homely and it was so personal, and I thought it was the greatest thing I'd ever seen in my life. I realized I just wanted to do something like that. I didn't care, I didn't think about who would read it or why they would, but I just wanted to do something like he did, for myself.[20]

If sex, violence and the parody of or homage to genres of the past like horror and science fiction, or even the mixture of all of these elements, had predominated in most of the underground comics, almost always justified with humor as the ultimate goal, *Binky Brown* presented a story of another kind that eluded generic definitions and went beyond ironic referencing of other texts. Although apparently humorous in orientation, *Binky Brown* (a thinly disguised alter ego for Justin Green) was mainly a memoir. The comic was forty pages long—a substantial length for the time—and narrated the struggles of the main character with his adolescent sexual anxieties, suffering from what today is known as Obsessive Compulsive Disorder. The sincerity and seriousness with which the story was told opened up the possibility of using comics as something more than a tool for facile provocation against the system and for tearing down outdated morality. *Binky Brown* was more constructive than destructive. Art Spiegelman discovered in its pages the keys for escaping from the topics that the underground itself had generated during its rapid development, and he was able to use it as a guide for confronting his own family memories. Spiegelman himself would say that "without *Binky Brown* there would be no *Maus*."[21] And without *Maus*, we might add, the graphic novel as we know it today would not exist.

The countercultural climate and youth rebellion of the 1970s were essential for the appearance of underground comix in the United States, but so too were the breakdown of the conventional comic book industry and the creative wasteland that resulted from the impositions of the Comics Code, which had channeled comics inevitably toward a children's audience and toward possible extinction in the medium term. Many of the underground cartoonists tried initially to make a living through the means available in the first half of the 1960s, and were not able to, which then forced them to invent and manage their own financial supports. Perhaps if the imposition of the Comics Code had not finished off EC Comics in 1954, the publisher would have continued to develop its genres for an increasingly adult audience, and in 1965 would have integrated the contributions of Crumb, Wilson, Rodríguez, and others into commercial comics with a broader perspective. But that did not happen. Instead, the breakdown of the publishing

model brought on by the crisis of the industry forced emerging cartoonists to almost completely reinvent the comic book, preserving their income, but refashioning the comic's industrial premises, its processes of production and distribution, as well as its contents and forms of expression. We might say that this rupture was equivalent to the rupturing of the hegemonic academic model by the artistic avant-garde. In other words, an authentic paradigm change. From this moment forward, there existed not only comics for adults, but comic books for adults, and *exclusively* for adults. As Hatfield indicates, "Underground comix did not single-handedly make comics reading safe for adults—after all, newspaper strips had long had an adult audience—but they did make *comic books* an adult commodity."[22]

The International Spread of Underground Comix

The 1960s youth revolution resonated throughout the world to greater and lesser degree and with varied forms of politicization, and along with the ideas, the psychedelic rock and the fashions, came the underground comix, which, translated in many countries, rapidly gave rise to processes of imitation and adaptation from which local traditions of adult comics would emerge.

It must be said that the underground comix's first influence would be seen in the United States. The comic book industry, increasingly polarized between two superhero publishers, the enormous and veteran DC of Superman and the much smaller but vigorous Marvel of Spider-Man, reacted extremely slowly to the changes experienced by society, and particularly by the country's youth, who constituted their primary audience. Aside from the anecdotal presence of characters who reflected hippy speech and aesthetics—symptoms of the obvious lack of first-hand knowledge, as was to be expected from scriptwriters and cartoonists already getting on in age—there was no evidence of an opening up of the processes of creation, production and distribution of the large publishers during the 1960s. Some professional cartoonists, however, did begin to sense the need to express themselves in a more personal manner, and took notice of the activity of the underground cartoonists in order to launch their own self-publishing efforts outside of the big companies. Wally Wood, a veteran cartoonist who had been one of the big names at EC, remembered mostly for his science fiction comics, in the summer of 1966 started *witzend*,[23] a *prozine*, or self-published magazine, but authored by professionals instead of by fans (the term contrasts with *fanzine*). Wood, after a long career of artistic servitude

and editorial limitations, wanted to publish without outside restrictions, and was able to involve other professionals, like Steve Ditko (co-creator of Spider-Man), Gil Kane, and some old acquaintances from EC, like Frank Frazetta and Angelo Torres. As a self-publishing adventure, *witzend* anticipated the explosion of the underground comix, some of whose cartoonists, like Art Spiegelman, it would eventually publish. Nevertheless, the creative freedom that Wood and his colleagues so desired translated into little more than the presence of nude figures, since most of the material fell back on the formulas of science fiction and fantasy. Despite this, *witzend*'s example, together with the underground cartoonists' demonstration soon after that an alternative economy was sustainable for self-published comic books aimed at adults, resulted toward the end of the decade in increased efforts on the part of the more restless professional cartoonists to open up new avenues for their work. The aforementioned Gil Kane, with the aid of scriptwriter Archie Goodwin, tested in 1968 a predecessor of the graphic novel by producing a story in forty black and white pages, published in magazine format and titled *His Name Is . . . Savage!* [68]. It was a thriller featuring a main character inspired by the Lee Marvin of *Point Blank* (1967) and in which the abundance of text and the use of typesetting sought to give a more literary flair to the product. Kane was back at it in 1971 with *Blackmark*, once again with Goodwin's assistance and this time in the heroic fantasy genre and with a pocket-sized novel format. *Blackmark*, 119 pages long, was in black and white and combined text with images to a greater extent than *His Name Is . . . Savage!*. Fantasy and science fiction were the favored genres for these kinds of experiments, which, as we saw in chapter one, by the mid-1970s were moving in the direction of the graphic novel and commercial comics for adults: *The First Kingdom* (1974), by Jack Katz, *Star*Reach* (1974), by Mike Friedrich, and other titles in this vein. The circle traced in two converging lines by initiatives arising from the conventional comic book and the underground comix came to a close with Richard Corben's *Bloodstar* (1976) [69]. The theme was heroic fantasy with pulp roots; the author made a name for himself in underground comix; the product was commercial while at the same time exempt from the limitations and censorship to which comic books were subjected by the Comics Code. And, as we have seen, it is one of the first titles to which the term *graphic novel* was directly applied.

In France the reception of the underground had an early phase directly related to Harvey Kurtzman and *Mad*, such that a certain parallel can be established between the point of origin for the adult comic book in the

United States and its influence in the Gallic country. The primary figure for the development of a comic that could open up some distance from the purely children's comic book in the Francophone market was René Goscinny, who in the late 1940s had worked in New York with Harvey Kurtzman, whose influence was crucial in the conception of a magazine that would make history for European comics: *Pilote* (1959) [70]. Working with talents like Jean-Michel Charlier, Albert Uderzo and Jean Giraud, Goscinny turned *Pilote* into a platform for the renewal of French youth comics. "I knew the *Mad* team of the first issues really well," remembered Goscinny, "during the Harvey Kurtzman period. In effect, the difference [between *Mad* and *Pilote*] is that the former was always very American."[24] Perhaps the clearest expression of the passage to Europe of Kurtzman's and Elder's satire was *Asterix*, which became from the very beginning the magazine's emblem. With the events of Paris in May 1968 and the discovery of American underground comix, which had been translated in magazines like *Actuel*, the authors of *Pilote* propelled the magazine toward a more adult audience, and entered into competition with publications inspired directly by the American underground, like the satirical *Hara-Kiri* (1960) and *Charlie Mensuel* (1969). The dabbling of cartoonists like Wolinski with adult themes resulted in the same confrontations with the law experienced by American underground cartoonists, and magazines like *Hara-Kiri* were subjected to court-ordered seizures.

It is also during this period that a wave of science fiction heroines of an erotic character emerged, headed up by *Barbarella* (1962), by Jean-Claude Forest, and followed by *Hypocrite* (1972), again by Forest, and by the dazzling *Les aventures de Jodell* (The Adventures of Jodell, 1967), by Pierre Bartier and Guy Peellaert, and *Pravda la Survireuse* (Pravda the Overdriver, 1968) [71], by Pascal Thomas and Guy Peellaert. Comics by Peellaert, who would achieve fame, among other things, with rock music album covers, are Warholian fantasies dominated by a garish use of flat color and finished off with a certain commercial eroticism. Despite being sold to an adult audience, they did not really turn comics into a respectable medium in which to develop adult-oriented artwork, but instead simply inserted comics into the post-adolescent consumer culture that emerged in the 1960s. We might say that they commercialized the revolution. A more sophisticated effort is *Valentina* [72], by the Italian Guido Crepax, appearing for the first time in the Milanese magazine *Linus* (1965). Crepax was conscious of the artistic value inherent to the elements proper to comics: the panel sequence and the page design are to be valued over the drawing. He makes use of pastiche, deliberately attempting to turn the comic into a pop art object that references

Flash Gordon or *Little Nemo*, but also the artistic and political debates of the moment. In his dialogue balloons, there is talk of Godard, Pasolini, epistemology, and dodecaphonic music, in a very *nouvelle vague* style. Even so, *Valentina*, no matter how much it is presented as an intellectual reinvention of comics subject matter, remains fantasy. Like all the other pop heroines, she is ironic, adult (or at least "not for children"), and referential, but fantasy. After all, there is a fundamental difference between this first French and Italian adult comic and the American underground comix: while the latter emerged on the periphery of the industry, completely independent from it, and directed itself to a distinct audience from the conventional comic book consumer, in France and Italy this movement was a development of the industry, was integrated into it and aimed to expand an already existing audience, and one with which it coexisted. What in the United States was a revolutionary rupture, in France and Italy did not go beyond a situational reform. That forced European authors who leaned toward adult comics in the 1960s to adapt their proposals to formats, traditions, and sales systems imposed by the industry, while the Americans, without commercial restrictions, had the ability (and the necessity) to reinvent themselves and create their own ecosystem of production and audience.

Thus, even though with the authors of the late 1960s and early 1970s like Bretécher, Mandryka, Gotlib, Druillet, and Moebius we see that "for the first time, it seemed, cartoonists were creating work with a cultivated disposition that they explicitly hoped would be recognized as art,"[25] it is also true that their efforts were channeled toward the conventional market. The humor magazines *L'Echo des savanes* (1969), *Fluide Glacial* (1975), and the science fiction magazine for adults *Métal Hurlant* (1975) [73] did not pose a threat to the traditional system as much as they helped it to renew itself, in the same way that the most innovative cartoonists polished their skills in close competition for the general public.

Perhaps the most fertile reception for the comix underground occurred in Holland, thanks to the spread of magazines like *Tante Leny*. The Dutch knew how to absorb the American influence and integrate it into their own Franco-Belgian tradition inherited from Hergé. Joost Swarte (1947), the main representative of this tendency, was the one who christened it *ligne claire* (clear line), one of the key aesthetic movements in European comics of the 1980s. Swarte would end up being one of the primary points of reference for independent American comics, because of his presence on the pages and covers of *Raw*, the New York magazine directed by Art Spiegelman and Françoise Mouly.

On the same stage defined by the pop reinvention of comics in the style of Forest, Peellaert, and Crepax, is situated an exceptional work that, if it were published today would be labeled, without the slightest room for doubt, a "graphic novel."[26] *Poema a fumetti* (Cartoon Poem), by the writer Dino Buzzati, is a version of the Orphean myth passed through the filter of striking colors, publicity posters, and rock music as a modern practice of youth rebellion. Buzzati (who, curiously, was sixty-three years old when he published the work) experimented with a way of using the comic—at the limits of narrative—that is so disconcerting and unorthodox that it was unusable for other authors. Instead, it sank into oblivion like so many other out-of-step comics that since have been recovered thanks to the present day interest in reconstructing the history of the graphic novel. It appears that only today can this artwork be understood.

In Spain[27] adult comics were inconceivable until the final death throes of Franco's regime, which had kept the comic book frozen in an eternal state of infancy in the form of humor, romance, and adventure comics presided over by the all-powerful Bruguera publishing house, leading to a delayed development. Three anthologies would eventually translate the pages of Crumb, Shelton, Robert Williams, Victor Moscoso, S. Clay Wilson, Skip Williamson, Justin Green and other West Coast luminaries. The first of these, *Comix Underground USA* volume one (1972), published by Editorial Fundamentos, was edited by Chumy Chúmez and OPS, the pseudonym for Andrés Rábago (currently known as El Roto), who also served as translator. The two subsequent volumes appeared in 1973 and 1976, and can be viewed as the spark that set the underground fire for young cartoonists who would make their mark on this movement, the Nazarios, Max, Mariscal and the Farriol brothers, who came together in 1973 on the magazine *El Rrollo Enmascarado* (which could be translated as The Masked Scene). "When I found myself with these people [the group that would form *El Rrollo Enmascarado*], and discovered the comics of Robert Crumb published by Fundamentos, it was a shock. I suppose that I had never thought about doing comics because the stories I had read up until then hadn't interested me too much. But when I saw Crumb's stuff I realized that one could do anything," recalled Max, who emphasized the influence of the American authors' themes, as well as the graphic impact of "the American underground artists as a group, the combination in one comic book of Crumb, Shelton, Spain Rodríguez."[28]

A second current of influence came from satirical French magazines like *L'Echo des Savanes* and *Hara-Kiri*, and was visible in the Spanish humor weeklies like *Mata Ratos* (during its final period, 1974) and *El Papus* (1973).

The young Spanish underground cartoonists (in addition to those mentioned above one can add names like Gallardo, Mediavilla, Martí, Montesol, Ceesepe, Pons, Azagra, Roger and El Cubri) would eventually be brought together at commercial magazines like *Star* (1974) and, ultimately, in what would become the "official" magazine of the Spanish underground (as paradoxical as that might be): *El Víbora* (The Viper, 1979) [74]. During the 1980s the publishing houses that had sustained the traditional Spanish comic book, with Bruguera in the lead, collapsed, and there was a boom in modern Spanish comics organized around a series of new titles that carved the market up into different trends: *El Víbora* represented the underground spirit, *El Cairo* the tendency known as "clear line" that championed a certain iconic recuperation of adventure comics from francophone Europe, while magazines like *Cimoc*, *1984*, *Creepy* and *Comix International* worked with new international genre comics for adults (with science fiction and horror comics once again at the top of the list). In other words, the Spanish case, though delayed, turned out to look more like the French than the American, since the new cartoonists only worked, in the final analysis, toward the reactivation of a moribund industry.

Japan, as we have seen, had its own idiosyncrasies. The authors of *gekiga*, the rougher and more realist tendency that had in the 1950s presented an Osakan alternative to Tokyo's powerful industry, were absorbed into the latter in the 1960s. Some of them in fact chose to publish in experimental magazines, far from the big commercial titles. Such is the case of Sanpei Shirato, who brought *Kamui Den* (The Legend of Kamui) to *Garo* in 1964, the magazine's first year. Shirato left *Garo* in 1971, leaving behind the best circulation in the magazine's history, eighty thousand copies.[29] *Garo*, a magazine of extremely limited sales in a country where the main titles have print runs in the millions, would become the center of Japanese cutting-edge comics, the founding landmark for which was *Nejishiki* (Screw-Style,[30] 1968) [75], a comic by Yoshiharu Tsuge that defined the comics tradition "for an entire counterculture," such that "The only comparable figure in Western comics would be Crumb."[31] The comic, a dream-like fable about the desolation of post-war Japan, opened the door for personal expression in the manga without the strict editorial controls of the big magazines. *Sekishoku Elegy* (Red Elegy, 1971), by Seiichi Hayashi, whose work also appeared in *Garo*, is a true graphic novel about love and art centered on a young couple, and narrated in an oblique way that recalls the experimental approaches of the *nouvelle vague*. Even Osamu Tezuka, the father of modern commercial manga and the most influential figure in Japanese comics, felt an attraction

to this kind of artistic comic, and in his magazine *COM* (1967) he published what would be his most personal (and unfinished) work, the ambitious *Hi no Tori* (The Phoenix).

Chikao Shiratori observes that while "the division between major magazines and 'other' magazines was very, very clear in the 1980s,"[32] in the 1990s the boundaries became blurred. The incredible capacity of the manga industry for assimilating themes, formats and languages made it possible for the formal discoveries of avant-garde comics to be taken up with increasing ease by the conventional comic, which continued expanding its audience until it reached practically the entirety of the Japanese population. Today, the diversity of form and content offered by the Japanese industry is such that the underground current has been almost completely diluted within the mainstream. Some of the authors who could be associated with that current, like Kiriko Nananan, Kan Takahama and Suehiro Maruo, blend in with the proposals of the Western graphic novel.

The Decline of Underground Comix

The American comix underground was not built to last. Necessity had driven its principal figures into self-publishing and minor publishing enterprises, but its success soon attracted the big companies: general interest magazines, literary publishers and Hollywood production companies heading the list. For Crumb, a couple of experiences with *serious* publishers like Ballantine and Viking were enough to renounce once and for all the temptations of the system: "The more money involved, the greater the chances for corruption."[33] Crumb represented something more than just an alternative aesthetics; he represented an alternative ethics:

> People told me I was "sabotaging" my chances for success, wealth and so on. I didn't get it. It seemed to me I was fabulously successful already! What more could I want? Here I was achieving recognition on my own terms—wasn't that success enough? If I could keep drawing underground comics, which meant complete artistic freedom, and make decent money at it, and still have enough free time to hang out with Spain, Kim, and Wilson, and occasionally get to play with cute girls who were impressed by my fame. . . . It still looks like a good deal![34]

But Crumb's success—extended over the past four decades—could not be reproduced formulaically. His success was the success of an individual

artist, and although others also encountered such success, in particular Gilbert Shelton, most of the underground comix cartoonists only managed to survive as long as the inertia of the movement lasted. Harvey Kurtzman observed that the underground was destined for self-destruction, and as proof he quoted Shelton: "If we succeed, we've failed. But if we fail, we're successful." For Kurtzman, "The underground cartoonists had a suicidal philosophy, and the ones I knew were all very frustrated guys, torn between a desire for material success and a contempt for it."[35]

Nevertheless, external factors were a decisive influence in the decline of the comix underground. In 1973 the movement reached its high water mark when it celebrated the first comix convention in Berkeley. But that same year marked the beginning of the downward slide. Some of the factors that contributed to this emerged from the underground's internal dynamics. Bill Griffith, one of the cartoonists with a greater artistic sensibility, raised a criticism of his fellow cartoonists, who had grown accustomed to repeating the clichés of terror, fantasy and pornography, no longer with any ironic intent. Griffith believed that comix should be more than that.

More important were the external factors: on the one hand, a saturation of unsold titles threatened the stability of the stores that offered them, because of a distribution system that did not allow the return of unsold copies. In 1973 an historic judgment was handed down by the Supreme Court of the United States declaring that obscenity was subject to "community standards," which placed in the hands of local authorities the opportunity to go after anything perceived to be out of the bounds of accepted moral standards within their jurisdiction. This caused the *head shops*, which had been targets of frequent complaints, to exercise increased caution and to eliminate from their shelves many comix that, because of their highly erotic content and the stubborn association of the medium with a children's audience, made them especially vulnerable to legal action.

Comix began to languish and lose vitality, as with almost all of the youth protest movements of the 1960s. The energy crisis of 1973 had delivered a hard blow to the idealism of *flower power*, and the United States' departure from Vietnam in 1975 deprived the revolutionary movements of a target for their rebellion. Free love was in retreat, and apathy, conformity and anodyne routine were returning.

By mid-decade, underground comix had been absorbed, and had begun to be turned into a *genre*. The animated film *Fritz the Cat* (1972), directed by Raph Bakshi, and which Crumb would disown for his entire life, had enjoyed enormous success in the theaters, especially surprising given that

it had been rated X. The underground was no longer in the shadows, on the margins, or clandestine; it was exposed to the eyes of the consumer public alongside all the other products. Perhaps the most significant event in this process of assimilation was the launching by Marvel of the collection *Comix Book* in 1974. Edited by Denis Kitchen, the volume included cartoons by Art Spiegelman, Skip Williamson and Howard Cruse, among others. Crumb flatly refused to participate. Stan Lee, the editorial director at Marvel, thought that in the 1970s his company should broaden its offerings beyond superheroes, and in the same way that he was attempting with martial arts, heroic fantasy and terror comics, he decided to cover the underground spectrum.

The swan song of the underground was thought up by *Arcade*, a magazine edited by Bill Griffith and Art Spiegelman—undoubtedly the most restless of the whole group—which attempted to offer a broader vision of the artistic comics generated by the underground while at the same time recovering the past, "from Little Nemo to the Tijuana Bibles."[36] In its approach, *Arcade* anticipated to a great degree *Raw*, edited once again by Art Spiegelman, this time from New York, which in the 1980s would be one of the pillars upon which alternative comics were built. *Arcade*'s approach, however, was wrong. While *Raw* only aspired to be an alternative magazine and influential for an elite minority, a kind of avant-garde guerrilla commando, *Arcade* tried to do battle at the newsstands with nationally distributed satirical magazines, and it failed. Its seven issues were the last great adventure of the underground. In the latter half of the 1970s, comics like *Sabre* (1978), by Don McGregor and Paul Gulacy, a science-fiction thriller with nudity, announced the arrival of a new age in which a non-children's audience could access comics that broke with the limitations of the Comics Code, but not with those of the traditional genres. "Underground" thus resulted in a style that barely survived in the pages of the few veterans of the golden age of comix who remained active with individual titles. But out of the ashes of that comix underground would be born alternative comics.

31. *He Done Her Wrong* (1930), Milt Gross.

32. *Une semaine de bonté* (1935), Max Ernst.

33. *Flood* (1992), Eric Drooker.

34. *The System* (1996), Peter Kuper.

35. *The Arrival* (2006), Shaun Tan.

36. *Flash Gordon* (1940), Alex Raymond and Don Moore.

Prince Valiant

IN THE DAYS OF
KING ARTHUR
BY
HAROLD R. FOSTER

SYNOPSIS: SATISFIED WITH HIS LOOT AND PRISONERS, THAGNAR SETS SAIL FOR HOME. VAL AND ILENE, GAZING LONGINGLY AT THE FADING SHORES OF ENGLAND, SEE A PURSUING SAIL ON THE FAR HORIZON.

IT IS PRINCE ARN IN SWIFT PURSUIT, SAILS SET AND EVERY MAN STRAINING AT THE OARS.

ARN'S SHIP GAINS RAPIDLY AND IS SOON IN PLAIN SIGHT—IF ONLY VAL CAN HOLD THE SEA-ROVERS' ATTENTION UNTIL ARN IS WITHIN STRIKING DISTANCE!

SEIZING A LYRE FROM AMONG THE PILE OF LOOT, VAL RUNS FORWARD AND LEAPS INTO THE SHROUDS.

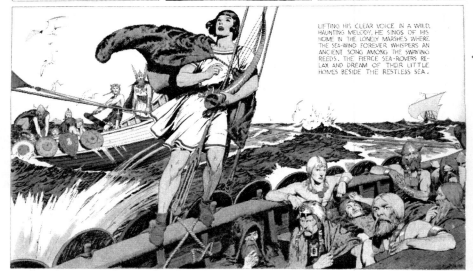

LIFTING HIS CLEAR VOICE IN A WILD, HAUNTING MELODY, HE SINGS OF HIS HOME IN THE LONELY MARSHES WHERE THE SEA-WIND FOREVER WHISPERS AN ANCIENT SONG AMONG THE SWAYING REEDS. THE FIERCE SEA-ROVERS RELAX AND DREAM OF THEIR LITTLE HOMES BESIDE THE RESTLESS SEA.

AND CLOSER AND YET CLOSER GLIDES ARN'S SHIP, UNNOTICED UNTIL THE BEAT OF THE OARS CAN BE PLAINLY HEARD.

THEN THE PIRATES AWAKE WITH A START AND ORDERS ARE SHOUTED BY THE ANGRY THAGNAR.

THE SECOND SHIP SHORTENS SAIL AND TURNS TO INTERCEPT THE DARING PURSUERS.

NEXT WEEK—THE SEA FIGHT

37. *Prince Valiant* (1938), Hal Foster.

38. *Terry and the Pirates* (1943), Milton Caniff.

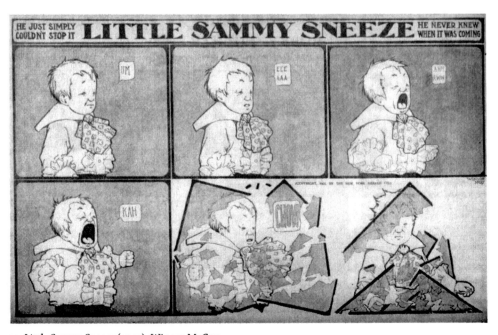

39. *Little Sammy Sneeze* (1905), Winsor McCay.

40. *Famous Funnies* 1 (1934).

41. Superman in *Action Comics* 1
(1938), Jerry Siegel and Joe Shuster.

42. Factory-like comics production, including unemployed cartoonists seeking work, assembly-line shop organization, and an emphasis on efficiency over aesthetic quality in *The Dreamer* (1986), Will Eisner.

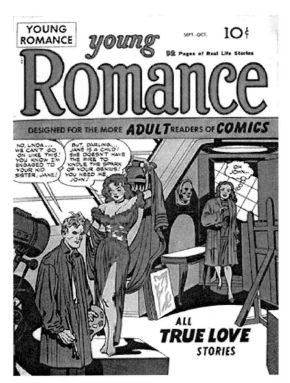

43. *Young Romance* 1 (1948), Joe Simon and Jack Kirby.

44. *Crime Does Not Pay* 22 (1942), Charles Biro.

45. *It Rhymes With Lust* (1950), Drake Waller and Matt Baker.

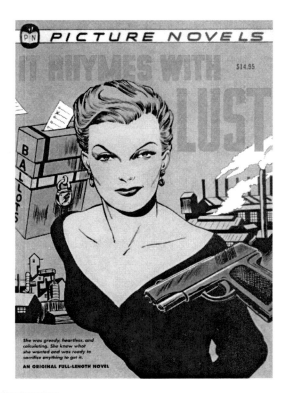

46. *It Rhymes With Lust* (1950), Drake Waller and Matt Baker.

47. In a Spanish-language edition of *A Drifting Life* (2009), Yoshiro Tatsumi depicts himself in March of 1957 working on three stories at the same time.

'BEN'D REACTED EXACTLY AS I'D *EXPECTED* HIM TO REACT. I WATCHED HIM ROW ACROSS THE LAGOON TO A SMALL DOCK AND TIE-UP. A MINUTE LATER HE DISAPPEARED INTO THE DARK, RAT-INFESTED TOWN OF THE *ORIENT'S ISLAND DUMPING GROUND FOR ITS CONDEMNED...* CONDEMNED TO *DEATH*, THAT IS, BY *BUBONIC PLAGUE! THE BLACK DEATH! ROTTING DEATH...*'

'IT WAS ALMOST DAWN WHEN MY FIRST MATE RETURNED TO THE SHIP, EXHAUSTED BUT PLEASED WITH HIMSELF. HE'D HUNTED DOWN AND GOTTEN' WHAT HE WANTED. HE'D GOTTEN *MORE* THAN HE WANTED! IT TOOK TWO DAYS, THEN BROKE OUT...'

...CAN'T PICK MYSELF UP OUT OF M' BUNK, MATT. HOT... FEVER... CHILLS. I'M SICK...

YOU'LL HAVE TO DOCTOR YOURSELF, BEN. WE'RE A THOUSAND MILES FROM THE NEAREST PORT...

'BEN CAME DOWN FAST. HE STARTED SWELLIN' AROUND HIS ARMPITS AND OTHER PLACES. SOON, A FESTERING, GREENISH-YELLOW SCURF COVERED HIM AND A STINKING, NAUSEATING SUBSTANCE OOZED FROM HIS FLESH. I KEPT CLEAR OF HIS QUARTERS FROM THEN ON AND ORDERED THE CREW TO DO THE SAME...'

'AT THE MENTION OF THE DREAD, HIGHLY CONTAGIOUS DISEASE, THE CREW PALED AND SHUDDERED AS ONE MAN. IT WAS PART OF MY PLAN LETTIN' THEM KNOW... REMINDIN' THEM. BUT ONE DAY, THEY FOUND SOMETHIN' ELSE TO OCCUPY THEIR MINDS. I FOUND 'EM TOSSIN' GARBAGE OVERBOARD...'

I KNOW THE *SYMPTONS*... THE SCALY SKIN, POISONIN' OF THE BLOOD, AND THAT COUGH. THAT'S WHEN IT'S *DANGEROUS*. THE *PLAGUE* IS IN HIS *LUNGS* NOW. A MAN CAN CATCH IT EVEN *TALKIN'* T' HIM...

BUBONIC PLAGUE... GASP... *THE BLACK DEATH!*

WHAT'RE YOU MEN *DOIN'*?

FEEDIN' THE *WHALE*, CAP'N STARKE. HE'S BEEN *FOLLOWIN'* US ALL MORNIN'! I SEE?

'I'D SEEN WHALES BEFORE BUT NEVER SO CLOSE AS THAT GREAT BULL SPERM. HE KEPT UP WITH THE SHIP... OPENIN' HIS YAWNIN' CAVE OF A MOUTH TO LET THE GARBAGE IN...'

'WHAT KEPT BEN HARPER ALIVE, I'LL NEVER KNOW. MAYBE HE WAS RACIN' AGAINST DEATH JUST TO SEE EILEEN ONCE MORE. ANYHOW, THE NEXT FEW DAYS WERE TENSE ONES AND I TRIED TO RELAX BY TOSSIN' CHUNKS OF MOLDY BEEF AND OTHER REFUSE TO THE WHALE TAILIN' US...'

'THE WHALE STAYED WITH US. SOMETIMES HE'D ROLL AND DIVE AND WE WOULDN'T SEE HIM FOR HOURS. THEN SOMEBODY'D YELL "THAR 'E BLOWS!" AND HE'D BE BACK CHASIN' ANOTHER GARBAGE FEAST...'

6

48. "Forever Ambergris," in *Tales from the Crypt* 44 (1954), Carl Wessler and Jack Davis.

49. "Monotony," in *Crime SuspenStories* 22 (1954), Bill Gaines, Al Feldstein, and Bernard Krigstein.

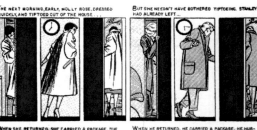
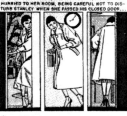

50. "More Blessed to Give," in *Crime SuspenStories* 24 (1954), Jack Oleck and Bernard Krigstein.

MASTER RACE

YOU CAN **NEVER FORGET,** CAN YOU, CARL REISSMAN? EVEN **HERE**...IN **AMERICA**...TEN YEARS AND THOUSANDS OF MILES AWAY FROM YOUR NATIVE GERMANY... YOU CAN NEVER FORGET THOSE **BLOODY WAR YEARS.** THOSE MEMORIES WILL HAUNT YOU FOREVER...AS EVEN NOW THEY HAUNT YOU WHILE YOU DESCEND THE SUBWAY STAIRS INTO THE QUIET SEMI-DARKNESS...

YOUR ACCENT IS STILL THICK ALTHOUGH YOU HAVE MASTERED THE LANGUAGE OF YOUR NEW COUNTRY THAT TOOK YOU IN WITH OPEN ARMS WHEN YOU FINALLY ESCAPED FROM BELSEN CONCENTRATION CAMP. YOU SLIDE THE BILL UNDER THE BARRED CHANGE-BOOTH WINDOW...

TWO TOKENS, PLEASE.

YOU MOVE TO THE BUSY CLICKING TURNSTILES...SLIP THE SHINY TOKEN INTO THE THIN SLOT...AND PUSH THROUGH...

THE TRAIN ROARS OUT OF THE BLACK CAVERN, SHATTERING THE SILENCE OF THE ALMOST DESERTED STATION...

YOU STARE AT THE ONRUSHING STEEL MONSTER...

YOU BLINK AS THE FIRST CAR RUSHES BY AND ILLUMINATED WINDOWS FLASH IN AN EVER-SLOWING RHYTHM...

51. "Master Race," in *Impact* 1 (1955), Bill Gaines, Al Feldstein, and Bernard Krigstein.

52. "Lost Batallion!" in *Two-Fisted Tales* 32 (1953), Harvey Kurtzman and Johnny Craig. Comparison of Kurtzman's sketches and Craig's drawn and inked page, without color. Reproduced in Kitchen and Buhle (2009).

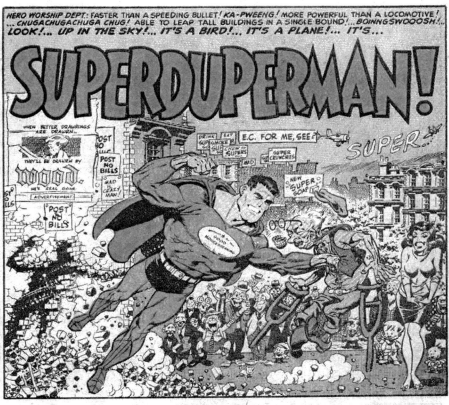

53. "Superduperman," in *Mad* 4 (1953), Harvey Kurtzman and Wally Wood.

NUMBER 12 HUMOR IN A JUGULAR VEIN JUNE

SPECIAL ISSUE *

***This special issue is designed for people ashamed to read this comic-book in subways and like that! Merely hold cover in front of face making sure it's not upside down. MAD cover design makes people think you are reading high-class intellectual stuff instead of miserable junk.**

54. *Mad* 12 (1954).

Chapter Four

Alternative Comics, 1980–2000

Alternative comics waver between these two positions—between the punk and the curator, so to speak.[1]
—Charles Hatfield

A New Network

At the end of the 1970s, the comix underground was running the risk of being remembered only as the movement from which Robert Crumb emerged, a colorful incubator that could explain the emergence of an inimitable genius of comics art. Of all the original cartoonists of the underground, he was the only one who remained visibly active and relevant. The first generation of comix cartoonists had never seen a changing of the guard. As Spiegelman pointed out in 1979, "The people who broke turf in 1967, '68, '69, myself included, are still appearing in underground comics," which meant that, unfortunately, there was little room "for new talent."[2] The lack of generational changeover, together with the exhaustion of the alternative circuit of distribution and the decline of the counter-cultural ecosystem, had left the comix underground, if not dead, nearly comatose.

But commercial comics were also experiencing serious problems. The slow decline suffered by superhero sales from the beginning of the decade had worsened in the decade's latter half. In 1978 there was the "Implosion" of DC, in which the main publishing enterprise suddenly shut down dozens of collections, contracting to a bare minimum offering. The comic book seemed incapable of competing at the newsstands and the old prophecy

about the end of the industry threatened to finally be fulfilled. The lifesaver for the business was a new sales and distribution network, which would come to be known as the direct market.[3]

Comic books had been sold traditionally in the same way as newspapers in general, distributed on deposit at newsstands, super markets and convenience stores, indiscriminately. The vendor could not order more copies of the collections that sold best, nor fewer of those that sold poorly. That resulted in some titles selling out when they reached their distribution ceiling, while others were returned by vendors in massive numbers. At any rate, comics were so cheap that their sales were of little interest to the newsstand vendors, since the profit margin they allowed was very limited. They were simply a bonus, and occasionally they were used to cushion the stacks of more valuable magazines and thus protect them from damage during transport. "Why was it done that way?" wondered Phil Seuling, who would be a key figure for the establishment of the direct market. "Because you can't sell newspapers any other way, and comic books are an offshoot of newspapers. They never were considered anything else. Therefore, the way comic books are sold is the way newspapers are sold."[4]

Underground comix had already demonstrated that it was possible to obtain profits from an alternative system, distributing comic books through specialty bookstores, based on orders, and with no returns. Since the 1960s, there had been a steady consolidation of fandom, which had begun to seep into the professional publishers. If the original fandom, that of the science fiction and fantasy pulps of the 1920s and 1930s, had generated some of the professional cartoonists who would shape the comic book for decades, like Julius Schwartz and Mort Weisinger, who would be crucial in molding the fate of Batman and Superman, the 1950s had seen the emergence of a second fandom around EC, stimulating the relationship among its readers through letters sections and a fan club. Stan Lee took up that idea at Marvel in the 1960s, publishing the addresses of readers who wrote letters, allowing direct contact to be established between readers and generating a "Marvel culture." It was also during that period that comic book fans began to gain access to the publishing houses, as happened with Roy Thomas, who would be Lee's right hand man for years and who, since the early 1960s, had published his own fanzine, *Alter Ego*,[5] about the history of superheroes. This weaving together of fans who were aware of the history of the medium would create the community of serious collectors that garnered attention by the 1970s. The collectors traded old comic books, sometimes sold in the stores that sold underground comix. Some of these stores

were shifting their interests toward comics in general, such that one could find in them the latest underground titles alongside second hand comic books (in fact, this was how the youngest underground comics artists, like Rory Hayes, were able to discover EC, which then served as their inspiration). The coincidence of comic books collectors and the underground comix distribution network gave rise to the growth and spread of a network of bookstores specializing in comics throughout the United States.[6] The mixture of these two strange elements would have consequences for each of them in their own way.

Phil Seuling was one of the first to convince the big publishers—Marvel and DC, mainly—that a store-based distribution network was a viable way of saving a business in decline. With the direct market, the publishers would save the cost of returns: they would print only what the stores ordered from them, and those copies would not be returned. The risk was shifted from the editor to the bookstore owner, freeing up the editor to experiment with less conventional comics, but at the same time turning the bookstore owner into the true filter for the market and its trends. The advantage for the bookstore owner was the ability to manage the material according to his own judgment—he only received what he ordered, and he could obtain larger discounts. The disadvantage was that the unsold titles were charged against his account and accumulated on his shelves, taking up valuable space.

The direct market proved to be profitable and saved the comic book, but by doing so it definitively changed the comic book's appearance. Over the course of the 1980s the new distribution network developed into a complement to traditional distribution and became the main support for the publishers. This resulted in material increasingly being produced deliberately for the clientele of the specialty bookstores, which was an extremely faithful audience—collectors—but also a very demanding one. Comic books became increasingly self-referential, esoteric, and hermetic for the occasional reader, and began to be aimed at an increasingly older audience. It is not that comics became more adult, but that they were forced to age with their buyers, who were not giving up the "hobby" of collecting comics, so that a thirteen-year-old buyer of *Spider-Man* would continue buying it at thirty-five and, although he expected everything to remain the same, he also expected the material to vary enough to hold his interest as the years went by. It was these "veteran fans" that dictated the creative evolution of the comics, and increasingly, it was other veteran fans like them who would produce the comics they read. In short, in order to survive in the

direct market, publishers were forced to attend to the needs of their most enthusiastic supporters, isolating themselves more and more from the outside world. They were able to escape death, but they wound up hooked to an IV drip.

The reorientation toward the nucleus of fans had an important consequence for the development of narration in the comic book that would assist in preparing the ground for the graphic novel. One of the publishing formulas that editors tried out in order to survive the crisis in a defensive economy was the "limited series" or "miniseries." The first such series was published by DC in 1979 (*World of Krypton*) and it had three issues. The limited series is distinct from normal comic book collections in that it is not created with an indefinite story arc, but with a built-in ending. Although stories that comprised different issues of a collection had existed since the 1940s, this concept was new, because the limited series was conceived as a complete and finished story, independently of whatever the sales might be. Even in the event that a limited series were successful, it would end with the pre-established final issue, while if it were a failure, it would still be carried out to completion, without being cancelled prior to its final issue. Each limited series usually told a complete story divided into chapters (the minimum standard was established at four, and the maximum at twelve), which helped cement the concept of the "extended story" among a reading public accustomed to serialized narrative with no beginning or end. With the consolidation of the direct market, the limited series became the perfect material for collected volumes, and they were one of the essential elements in the first boom in the graphic novel, with the so-called "generation of 86." As we shall see further on, together with Art Spiegelman's *Maus*, the titles that gained recognition at that time were *Watchmen*, by Alan Moore and Dave Gibbons, and *Batman: The Dark Knight Returns*, by Frank Miller and Klaus Janson. Both were superhero comic books that had been published by DC as limited series.

The approach of the conventional comic book to the sales network of the comix underground also aided to some degree in changing the thinking of the former. Some elements of the underground philosophy, like the recognition of the author's rights and the cult of the creative personality, began to be introduced at the big publishers. Scandals over the treatment of past authors wound up changing the behavior of the companies. During the 1970s, a media campaign by cartoonists of the period forced DC to finally recognize the authorial rights of Jerry Siegel and Joe Shuster—who were living in precarious economic and health circumstances—as the creators of

Superman, at precisely the moment when the machinery of Hollywood had been set in motion to promote the great film production in 1978 based on the character, starring Christopher Reeve. In the 1980s, it was the magazine of comics art criticism *The Comics Journal* that led the protest against Marvel, demanding that the publisher return the author's original pages to Jack Kirby, who had been the main cartoonist for the publisher when it launched its new superheroes in the early 1960s. As a consequence of all of this, beginning in the 1970s Marvel and DC began to pay royalties to writers and cartoonists, and even published collections that remained property of their creators, which meant that the latter could continue publishing with other companies when circumstances permitted. The concept of authorship, which was born out of the comix underground, was now filtering into the commercial comic book, despite how complicated it was to adapt it to an environment in which most cartoonists worked with characters owned by the publisher, having been developed collectively over the course of decades.

But if the direct market had significant consequences for the business of the commercial comic book, it was even more important for the continuation of adult comics in the aftermath of the comix underground. The direct market opened up the possibility of publishing comic books that could have a distribution outside the newsstands. In fact, they did not even need to be sold at the newsstands. Thus, while the big publishing houses maintained a double network—still in place today—that included newsstands and specialty bookstores, which is to say, both mass market and direct market, a group of new small publishers was able to insert itself into the market through exclusive sales to bookstores. These new companies saw their peak in the early 1980s, and were known as "independent" or "alternative." Both terms were intended to distinguish them from the big publishers, Marvel and DC. "Independent" meant that they did not depend economically on the large publishers, but did not imply differences with the latter in terms of artistic and commercial objectives. "Alternative" meant that they offered material distinct from what the big companies offered, but occasionally the differences were limited to issues of censorship (in the 1980s the Comics Code was still in force, albeit in revised form) or of ownership of the copyright, since the independent and alternative publishers offered a kind of comics very similar to that of the big publishers, at times even produced by the same authors. Perhaps the most significant example is Pacific, which published comics by Jack Kirby, the cartoonist who had made it big at Marvel and was a superhero comic book legend.

But at the same time as these "alternative" publishers (which might have been better characterized as "substitutes") were emerging, the door was opened for the appearance of other small enterprises that could publish comic books with form and content that were truly "alternative" to the hegemonic conventions. These publishers showed a clear spiritual continuity with the comix underground, even though many of their authors belonged to generations that were younger and of a distinct aesthetic outlook. Their comics were sold in specialty bookstores, alongside the comics of Marvel, DC and the other "alternative" publishers that imitated them, forcing them to adopt many of the forms and formulas of the commercial comic book—beginning, of course, with the very format of the comic book—and to define themselves as a genre that, if lacking homogeneous features, at the very least could be clearly distinguished as *different* from the dominant superhero comics. The most important of those publishers would be Fantagraphics, which published *The Comics Journal*, a magazine of criticism and information about comics, and which would begin to publish a collection titled *Love and Rockets* that, along with the magazines *Raw*, by Art Spiegelman and Françoise Mouly, and *Weirdo*, by Robert Crumb, would define the framework within which occured the transformation of the underground comix into alternative comics, the threshold for the graphic novel.

Raw, Weirdo, Love and Rockets: The Brain, the Guts, and the Heart of Alternative Comics

After the frustrating experience of *Arcade* (1975–1976) together with Bill Griffith, Art Spiegelman swore to never edit another magazine. With the decline of the West Coast hippy culture, he returned to New York, where he met Françoise Mouly, a French student of architecture who was on a one year sabbatical. Mouly, who would eventually marry Spiegelman and start a family with him, discovered in New York her passion for the graphic arts, and convinced the cartoonist to make another effort to launch a cutting edge comics magazine. But *Raw* [76], as it would be titled, would not be a continuation of either *Arcade* or of the comix underground. On the contrary, *Raw* presented itself as a way "to do something that *wasn't* underground comics,"[7] to use Spiegelman's own words. In contrast with *Arcade*, which aspired to turn the underground into a product for the general public, *Raw* had an intentionally rarefied vocation, aspiring to be an elite magazine for a small, but select, audience that would thereby exercise a top-down influence, inverting the direction historically followed by comics.

"I don't know how things work in an electronic age," Spiegelman would say, "but that's the way in which we'd like to reach a mass audience. If we only had 5,000 readers but they're the right 5,000, that's great."[8] In its eagerness to differentiate itself from the underground—facilitated somewhat by physical distance from the West Coast—*Raw* avoided the big names of the comix and chose instead young unknowns who displayed novel aesthetic interests. Each completely different from the others, Charles Burns, Mark Newgarden, Ben Katchor, Mark Beyer, Kaz, Chris Ware and Gary Panter only coincided in their shared interest in graphic experimentation and their rejection—institutionalized by the magazine—of the genres that had been associated with the comics of youth and consumer culture: fantasy, science fiction, superheroes, and so on. Gary Panter [77] may be the figure that best exemplified this new aesthetic. Having started out in the punk magazines of Los Angeles, Panter was more of an illustrator and designer than a cartoonist. His crude and anti-professional drawing style was furiously contemporary. Despite referencing some of the characters he revered from the classic comics tradition, every one of his image panels was a manifesto against the inbred conformism of commercial comics. Panter was, above all, the face of something new, and it was an aggressive and disconcerting face.

In *Raw*, the comic was one of the Fine Arts, not only because of the drawing, but because of the way in which it played with the very form of the comic, which practically had not been done since the more daring pages of the pioneers of American comics, with McCay and Herriman in the lead. Of course, the cartoonists of *Raw* engaged that practice as a more deliberate instrument of reflection on the medium than their ancestors had. We might say that they applied an ironic and *postmodern* treatment to the cartoon. The magazine itself adopted many subtitles, but in most of them the formula "Graphix Magazine" was included, which placed more emphasis on the visual aspects than on the literary features of comics.

Alongside the experimental perspective and the dedication to discovering new aesthetic values, *Raw* added two elements that would be essential for the future of alternative comics and that are even more relevant in the current panorama of the graphic novel: the desire for internationalization and the look to the past.

Mouly and Spiegelman had traveled to Europe (they later also traveled to Japan) and had made contact with the most prominent cartoonists of Holland, Belgium, France and Spain. Thus, at *Raw* they opened the doors to international authors like the Argentines Muñoz and Sampayo, the Spaniards Mariscal and Martí, the Congolese Cheri Samba, the French Tardi

and Loustal, the Italian Mattoti, the Dutch Joost Swarte, and the Japanese Yoshiharu Tsuge. It was the first time that an American magazine demonstrated such an international profile, and those links established among the authors, beyond borders, would create a shared space that has reached its pinnacle in recent years, with movements like the Franco-Japanese nouvelle manga. Today it is more appropriate to relate cartoonists by their aesthetic and thematic affinities than by their national locations.

The turn toward the past has been another one of the more important features for constructing the present day identity of the graphic novel. As we have said, the rediscovery of the adult tradition, at times hidden in plain view, at times rescued from the debris of commercial junk, has been essential for providing tools to authors who wanted to say things that could not be captured by the resources of youth action comics. That has been made possible by recovery through ever-improving re-issues of cartoon classics, but at the same time those re-issues have been driven by the interest of new generations of cartoonists in seeking good models for their own investigation and experimentation. Spiegelman and Griffith had already dedicated space to the past in *Arcade*, but *Raw* did not limit itself to recuperating pages from time-honored authors—even if quite forgotten by the early 1980s—like Winsor McCay, George Herriman and Gustave Doré, but added the discovery of outlandish and unknown cartoonists, like Fletcher Hanks and Boody Rogers, whom it confirmed as "outsider artists" of the comic book tradition. It is not surprising that Henry Darger, one of the most extraordinary outsider artists, would also be given space in *Raw*. The effort to suggest kinship was deliberate.

As a final differentiating characteristic from "comics as mass culture," *Raw* offered in each issue some artisanal, hand-made, element. The most striking was undoubtedly the corner torn off by hand in issue number 7 (1985), but other issues included stickers and other objects that revealed an individual manipulation of the magazine and thereby rediscovered the magazine as material object, and not as mere invisible support for drawn simulation. In other words, what was important was not just the drawings, but also the pages in which they were inscribed.

Once the personality of *Raw* was clearly established and differentiated from the comix underground, the moment arrived to open its pages to the best survivors of the 1960s: Robert Crumb, of course, but also Kim Deitch and Justin Green. Thus, finally, *Raw* completed its map of adult comics, linking the pioneers with the new alternative generation: all of them with their own style, and at the same time, all of them embarked on one and

the same project, which consisted of changing the role of comics in society, liberating comics from servitude to industrial production.

Raw had two phases, and significant change occurred from one to the next, since there is a correlation between the format and the editorial responsibility for each of them. The first phase (issues number 1–8, 1980–1986), edited by Mouly and Spiegelman, was the "Graphix Magazine" phase, with a large magazine format that favored visually powerful comics. At the same time, it was in those issues when the first part of *Maus*, Spiegelman's graphic novel, was published in chapter installments—as a booklet insert. Even though in the context of *Raw*'s first phase *Maus*, with its graphic sobriety and its literary density, was a rarity, it had such an impact that it ended up being identified with the magazine more than any other material (except perhaps the pages of Gary Panter). Hence, when *Raw* initiated its second volume (issues number 1–3, 1989–1991), this time published by the literary publisher Penguin, the format changed to pocket book, a smaller size and greater number of pages, reflecting the shift from visual culture to textual culture. If the first *Raw* had been presented as a demonstration that comics are art, *Maus* had ended up showing that they were literature. The subtitle of issue number 3 of that second volume would be telling: "High Culture for Lowbrows."

Naturally, *Raw*'s avant-garde position was overly cold and experimental for many, even among those who believed in comics as a medium of adult expression. Such was the case with Robert Crumb, who would say that *Raw* was "too arty for me."[9] Crumb, who, as we have seen, had felt overwhelmed by his underground peers who had gone through Fine Arts programs, had in mind a different model for the magazine, and threw himself into editing *Weirdo* [78] in the spring of 1981. He described his inspiration for the title in the following way: "I was performing my daily meditation exercise one day when the vision of this kooky, screwball magazine erupted in all its tacky, low-life, dumb-ass essence, a style-mix of the old 1940s-1950s girlie-and-cartoon 'joke books,' Harvey Kurtzman's early *Mad* and *Humbug*, and their sleazy imitators, and the self-published 'punk' 'zines of the period."[10] With his direct references once again to the Kurtzman school, Crumb created a magazine that took recourse more obviously to the aesthetics of the comix underground than to *Raw*, but the resemblance was owed, above all, to the fact that Crumb was the most recognizable image of *Weirdo*, and also the most recognizable image of the comix underground.

Weirdo, published by Last Gasp, one of the classic imprints of the underground, was more a product of Crumb's obsessions than of his thoughtful

reflections. Crumb, on the verge of middle age (he was thirty-eight when he started the magazine), was already accepted as one of the most idiosyncratic personalities in comics worldwide. Only he could get away with publishing bawdy photo novels, in which he presented himself as a lubricious buffoon alongside young models, true to his rounded standard of beauty. This outlandishness disappeared from *Weirdo* when Crumb ceased editing the magazine, which beginning with issue number 10 (1983) passed into the hands of one of his biggest discoveries, Peter Bagge. The latter had gotten his start in *Punk Magazine*, but made a name for himself with *Weirdo*. Later, his series *Neat Stuff* (1985–1989) and *Hate* (1990–1998), both published by Fantagraphics, would turn him into one of the great stars of alternative comics. Bagge was the missing link between the underground and punk: his style of over-the-top caricature and his contemporary social criticism aligned him with Crumb, whose teachings applied to Generation X. Like Crumb, he felt more like an entertainment business professional than an artist, and that was what most distinguished *Weirdo* from *Raw*. Although both magazines ultimately shared many authors, *Weird*'s perspective always came closer to recognizing where comics were coming from than did *Raw*'s, which was more interested in finding out where comics were going. The face-off between the two magazines was artificial: more than competing, the two titles complemented one another.

The final phase of *Weird* was edited by Aline Kominsky-Crumb (issues number 18–28, 1993), and emphasized women cartoonists, taking up to some degree the feminist politics of Trina Robbins' *Wimmen's Comix*. Julie Doucet, Carol Lay, Mary Fleener, and Phoebe Gloeckner occupied pages alongside recouped greats of the underground, like Spain Rodriguez. The departure of the Crumbs (Robert, Aline, and their daughter Sophie, also a cartoonist) for France, where they still live today, ended up facilitating an international perspective for the last issue of *Weirdo*, bringing it even closer, finally, to *Raw*.

While *Raw* and *Weirdo* defined to a great extent the aesthetic horizon of the 1980s and brought the underground legacy up to date, linking it directly with new generations of American cartoon artists and with the international scene, it was another publication that served as the primary model for the new alternative comics. *Raw* and *Weirdo* were anthologies of various authors in a magazine format, but the medium that allowed the new alternative cartoon to prosper was the comic book in black and white with a sole author. *Love and Rockets* (Fantagraphics) was to lead the way.

Published initially as a fanzine in 1981, *Love and Rockets* [79] started up as a professional series by the following year. It was a stapled comic book in black and white and of a size somewhat larger than usual, and its contents were written and drawn entirely by the Hernandez brothers, Gilbert, Jaime, and Mario, the last of these in a secondary role. Each of the brothers produced his own comics, developing his characters within his own particular universe, so that in reality *Love and Rockets* functioned like a magazine anthology, but one in which participation was limited to the family trio (and, occasionally, to some invited cartoonist friend). This limitation meant that, despite its heterogeneous content and its unorthodox format, *Love and Rockets* would be viewed as the first author's comic book of the new alternative comics.

The joint authorship under the collective nickname "Los Bros" was unfair to Gilbert and Jaime. Despite their family connections and a few points in common—aesthetically, the use of a highly contrasted and expressive black and white; thematically, a taste for choral narratives with strong-willed female lead characters—Gilbert and Jaime have developed two of the richest and most profound imaginary universes to arise from comics to date, and each one quite distinct from the other.

Gilbert created the fictitious town of Palomar [80], "south of the border," a sleepy shantytown in a remote corner of civilization, "where men are men, and women need a sense of humor." There, around the powerful maternal figure of the bather of men, Luba, whose strength is underscored by a phallic hammer, Gilbert wove together the stories of the town's inhabitants, leaping around in time, showing us the characters as children and as grown-ups, threading together short tales into a tapestry without defined contours. The stories of Palomar, occasionally with convoluted plots in the manner of television soap operas, soon drew comparisons to Gabriel García Márquez's magical realism, a comparison that has been criticized by Andrés Ibáñez: "I would not relate Beto with García Márquez's 'magical realism,' which is a narrative style based on the redundancy and exaggerations of oral tradition, but rather with the art of the U.S. postmodern novelists, with their elegant concentration, their elusive syntax and their oblique and hermetic fragmentation of information."[11]

Jaime, for his part, narrates in the saga that has taken the general name of "Locas" [81] the story of Maggie and Hopey, two teenagers who are living the life of nightclubs and concerts during the explosion of the punk scene in Los Angeles. Their neighborhood, Hoppers 13, is the urban version of

Gilbert's Palomar: a wasteland on the margins of society that functions as a microcosm with its own autonomous history.

Gilbert and Jaime have broadened their catalogue of stories over the years—especially Gilbert, the most given to experimentation, even when this draws him into commercial comics with the big publishers or into the pornography genre—without discontinuing the stories of "Palomar" (or of the characters of Palomar, outside the context of the town) and of "Locas," both now transformed into incredibly vast novels that, in their very immensity, seem to be a representation of life itself on a natural scale. In 1996 they ended the first volume of *Love and Rockets* when they reached issue number 50, but later they reopened the collection on two occasions, the most recent in 2008.

The Hernandez brothers brought to alternative comics something that neither *Raw* nor *Weirdo* could offer: the genetic combination of two schools of cartoon art that seemed irremediably contradictory, that of the conventional comic book and that of the comix underground. Of equal importance for Gilbert and Jaime were influences that ranged from Steve Ditko and Jack Kirby, the architects of Marvel, Hank Ketcham, cartoonist of *Dennis the Menace*, and Dan DeCarlo, one of the main artists responsible for developing *Archie*, to Robert Crumb and Spain Rodriguez. The Hernandez brothers had read all of them with the same passion, and they had assimilated all of them in a natural and seamless fashion. The end result was intensely personal stories, true *author's* works written with the same lexicon comic books had always been written with, but with a new syntax. With Gilbert and Jaime Hernandez, the alternative comic was presented in a completely new and different way: it was no longer fringy like the underground, and it was no longer inaccessible like the avant-garde. It was, instead, a liberated comic that had assimilated all of the previous tendencies, and that now simply proposed to *tell stories*. But the question of which stories—that would be decided by the authors, and not by editorial management. From Los Bros flows one of the most abundant currents of the present day graphic novel.

With *Raw*, alternative comics had a brain; with *Weirdo* came the guts; the heart was finally put in place by *Love and Rockets*.

The Alternative Comic Book: A Strange Body

Throughout the 1980s and 1990s, in the wake of *Love and Rockets*, alternative comics grew within the format of the black and white comic book. Titles

by new authors became a niche of their own in specialty bookstores, amid the mass of projects by Marvel, DC, and the new "independent" publishers, which in practical terms limited them to a marginal audience, composed of fans of superhero and generalist comics who had broader interests. But it was difficult to gain access by way of a specialty bookstore to a general adult audience that was not already part of comics fandom.

After *Love and Rockets*, the first alternative comic books to achieve success were those of Peter Bagge and Daniel Clowes (who, in fact, had debuted with a short story as an invitee in *Love and Rockets*). Bagge, who had a satirical bent comparable to Crumb but also similar to Matt Groening's *The Simpsons*, with its acidic view of American family and social institutions, made a name for himself in *Weirdo*, as we have seen; but he then launched *Neat Stuff* (1985–1989) and, later, *Hate* (1990–1998), which reached thirty issues and became one of the bestsellers among author's comics in the 1990s. Clowes, meanwhile, would start a career that led to his becoming one of the two or three most respected graphic novelists today, with *Lloyd Llewellyn* (1986–1987), a humorous pop fantasy based on the decadent aesthetics of the cocktail bars of the 1950s and 1960s. In 1989 he launched *Eightball*, where he published short comics of every kind and style, and where he also brought his style to maturity and serialized his most important graphic novels, from *Like a Velvet Glove Cast in Iron* to *Ice Haven*. The final issue of *Eightball* (23) was published in 2004.

With Bagge, Clowes, and of course Los Bros as references, authors from all over North America sought to publish their own comic books, many of them on the seminal Fantagraphics imprint, which was followed close behind by the Canadian Drawn & Quarterly. Although anthologies also existed, these played a secondary role. Generally, every author's name was associated with the name of a comic book: Chester Brown was *Yummy Fur*; Seth, *Palookaville*; Joe Matt, *Peepshow*; Julie Doucet, *Dirty Plotte*; Roberta Gregory, *Naughty Bits*; Charles Burns, *Black Hole*; Eddie Campbell, *Bacchus*; David Mazzucchelli, *Rubber Blanket*; Chris Ware, *Acme Novelty Library*; Adrian Tomine, *Optic Nerve*; and even the veteran Robert Crumb joined the wave with *Self-Loathing Comics and Mystic Funnies*.

But the comic book was a survival format, inadequate in reality for the goals set by the alternative cartoonists. Although many of them had gotten their start with short satirical comics, soon their ambition for developing more complex narratives stumbled over the limitations of the medium. Of course, not everyone encountered the same difficulties. Peter Bagge developed an episodic narrative in *Hate* that followed

the models of the conventional comic book series, successfully adjusting the medium to his purposes. The Hernandez brothers used an elliptical narrative formula that allowed them to gather up short stories that were woven together in a "novel of life" or "river novel" with no defined structure, resulting in the comic book format's not seeming contrary to their work either. Nevertheless, when Gilbert attempted to tell the story of Luba's origins in *Poison River*, a tale more than a hundred pages long that could not be broken up and that jumped around abruptly between the past and the present, readers who encountered it in segmented form in separate issues of *Love and Rockets* were unable to follow it. Gilbert was accused of being excessively opaque and complex, and in the book edition of the work he was forced to add pages in order to clarify the story. Not even he had been able to detect the deficiencies of the story when he was publishing it while it was being drawn.

Daniel Clowes also endured the deficiencies of the serialized comic book as a format for treating more ambitious stories. His first lengthy narrative, *Like a Velvet Glove Cast in Iron*, was a pseudo-surrealist odyssey that picked up where David Lynch's *Blue Velvet* left off. It was published in installments in issues number 1 through 10 of *Eightball* (1989–1993) and ended up provoking a sense of exhaustion in both the author and his readers. For his next long narrative, *Ghost World* (*Eightball*, numbers 11–18, 1993–1997) [82], Clowes opted for a different formula and chose to create self-contained chapters. In other words, he chose to create the appearance of a series instead of that of a segmented graphic novel. Thus, each installment would convey the sense of being a complete narrative unit. The formula worked—*Ghost World* is one of the greatest successes of Clowes' career, amplified further by its triumphal adaptation to film, with a script co-written by the cartoonist himself—but at the cost of giving in to the old formulas of conventional comics. In his subsequent efforts, Clowes tried everything to escape those conventions, even if he remained tied to the comic book. Hence, *David Boring* occupied just three issues of *Eightball* (19–21, 1998–2000), with an increased page size, unaccompanied by any other complementary story. Of course, *Eightball* was no longer presenting itself as an "author's magazine," but as book installments. The final two issues of *Eightball* were once again dedicated to a single story: issue number 22 (2001) to *Ice Haven* and number 23 (2004) to *The Death-Ray*. In other words, from the end of the 1990s (when *Hate*, its fellow traveler, had already concluded), *Eightball* demonstrated a desire to discard its identity as a miscellaneous comic book and reposition itself as a vehicle for longer and more uniform narration.

Other authors had already made attempts before with the comic book dedicated to serializing exclusively one long story. Two noteworthy cases were those of Charles Burns and Chester Brown, distinguished figures of reference in the alternative scene. Burns, who emerged from *Raw*, undertook a tale of more than 200 pages in length titled *Black Hole*, serializing it in segments in a comic book of the same title. The enterprise continued for twelve issues over ten years, which suggests that it practically lost coherence. When Burns started *Black Hole* in 1995, all of his contemporaries were publishing in stapled comic book form; when he concluded it in 2005, the format was in decline and the graphic novel was on the rise. Meanwhile, the publisher of the original series (Kitchen Sink) had disappeared, and the work had to be continued by Fantagraphics. The comic book form had allowed Burns to produce *Black Hole* slowly over the course of a decade, but those comic book installments of *Black Hole* were not really *Black Hole*. The work only attained its true meaning when it was published as one complete volume by Pantheon in 2005. It had been a graphic novel cross-dressing as a comic book.

The case of Brown with his ambitious *Underwater* was even more frustrating. In *Underwater*, Brown set out to tell the story of a child from his birth until early maturity, from the point of view of the child. The initial pages, therefore, would depict the state of confusion, disorientation and lack of linguistic articulation typical of a newborn. The result was a confused, disoriented, and inarticulate comic that moved forward at an extremely slow pace, to the frustration of readers, who were acquiring new pages in small installments that did not seem to add up to a meaningful story. The comic book, moreover, allowed authors to improvise with their long-form stories at the same time as they were producing them. Unlike a graphic novel, which is produced and published as one coherent unit, the extended story in comic book form is born as a project, but is never finished prior to publishing its successive installments. That was one of the reasons for which Brown's plans would change, to the point of abandoning *Underwater* after eleven issues and four years of effort (1994–1997). The project was never completed.

Throughout the 1990s, with the coming of age of the first generation of alternative comics and the inclination among many of the most outstanding alternative cartoonists toward taking on serious and lengthy stories, it was becoming increasingly evident that the comic book form was inadequate. The graphic novel was a format waiting to come into existence. Nevertheless, until almost the turn of the century publishing a serious comic directly

in book form was nearly unimaginable. Will Eisner had already attempted it, and failed.

Will Eisner and *A Contract with God*

Currently, it is a widely accepted notion that "the first graphic novel" was Will Eisner's *A Contract with God* (1978). This recognition is a result of a process of canonization of Eisner, who over the past twenty years has been chosen to play the part of patriarch of American comics. It is significant that at present the two most important awards bestowed by the comics industry in the United States are the Harvey Award (as in Kurtzman) and the Eisner Award, both instituted in 1988.

Will Eisner (1917–2005) belonged to a generation of comic book pioneers. From the beginning he stood out for the way he combined a marked entrepreneurial shrewdness with an extraordinary visual inventiveness. At the age of barely twenty-one he took over with Jerry Iger one of the shops that supplied materials to the first comic book publishers of the 1940s. But Eisner, always restless, soon left the lucrative business to throw himself into a completely new adventure: creating a supplement entirely in the form of a comic book to be sold to newspapers. For this weekly supplement he created the Spirit, a crime fighter whom, as required by the superhero phenomenon, Eisner outfitted with a mask. Eisner had control of his creations from the outset, and he retained the rights to the character. *The Spirit* (1940–1952) [83] turned into a testing ground for playing around with the expressive possibilities of the medium. With one foot in the tradition of cinematic narrative and Milton Caniff's *chiaroscuro*, and the other in the whimsical page designs of Winsor McCay, Eisner and his team (which included cartoonists as brilliant as Jules Feiffer) tried out all kinds of unusual solutions that even today hold up as modern. It has been said that *The Spirit* was the *Citizen Kane* of comics, but Eisner's achievements were often autonomous, or in tune with his time's environment of experimentation with expressionist narrative, and were not merely indebted to film. Speaking precisely of Orson Welles' film, Juan Antonio Ramírez notes that the latter's obsession with showing the ceilings of the stage sets was "almost a stylistic marker of the 1940s: perhaps the aesthetic 'coincidence' between these techniques and the unusual frames of *The Spirit* drawn by Will Eisner between 1940 and 1950 are no accident."[12]

Eisner left the comic book business before its collapse following the establishment of the Comics Code in 1954. For twenty years, he labored in

obscurity—today many of his works of that period are beginning to be recognized—providing educational and instructional comics to the army and to private companies. As a consequence Eisner was practically an unknown when Feiffer published in 1965 *The Great Comic Book Heroes*, a book homage to the comic books of his childhood that included the re-print of a comic from *The Spirit*. It was the first time that a generation of cartoonists was able to see those pages.

In 1971, Eisner was invited to a comics convention in New York where he met the young underground cartoonists. One of the most active figures of the movement, Denis Kitchen, who had discovered the existence of *The Spirit* thanks to an article by Harvey Kurtzman in the magazine *Help!* in the early 1960s,[13] proposed that Eisner re-issue his series for the new alternative audience. Eisner accepted, although Kitchen would publish only two issues of *The Spirit*, as the editorship would soon pass into the hands of another editor (Jim Warren, who had been the editor of *Help!*). The veteran fifty-something cartoonist, who had spent the previous decades drawing a salary from comics sales to the armed forces, was a strange travel companion for the irreverent cartoonists of the underground, but Eisner was accepted by them, among other reasons because they saw him as a precursor of the author who retains ownership of his work and controls his own fate. Soon, Eisner would draw The Spirit on the cover of *Snarf* [84], one of the most successful titles of the underground comix.

Influence went both ways. For Eisner, isolated from the world of comics for such a long period, the discovery of the ethics and aesthetics of the underground was a revelation. Eisner would declare:

> First time I met the underground people, and I realized something revolutionary was happening. It was very much like the revolution that occurred when we started, way, way back, where we were taking daily strips and making complete stories out of them. These people were using comics as a true literary form. They were dealing with social problems. Yes, they were raunchy, and they were crude, and gritty, but they were using comics as a literary form! As a matter of fact, I admit that those encouraged me to go back into the graphic novel.[14]

Thanks to his instructional manuals in cartoon form, Eisner had years of first hand experience testing the validity of the language of comics as a medium of communication for adults. Why not take the leap of addressing himself directly to that audience with works of fiction whose content was of interest to them? There was nothing inherently juvenile about the comic *as artistic form*. As Eisner said:

> And what was happening is something that I realized when I started, in 1974
> or '75, *A Contract with God*, I rationalized something very realistic, people who
> were reading comics, the major bulk of the comic reading audience, from the
> early days, were now (in 1974–1975) about 25 or 30 or older! As they got older,
> this whole early comic book reading audience, had nothing for them. They
> couldn't continue to read stories about superheroes at age 35 or 40. That was
> what encouraged me to go ahead and do *Contract with God*. I felt that was where
> it was all going, and I felt fairly safe in attempting it at that time.[15]

Eisner, always part entrepreneur and part artist, knew that he needed
literary respectability in order to achieve success with his enterprise, which
consisted not only of creating comics for adults with adult themes, but of
ensuring that his comics reached that audience which was not the tradi-
tional audience for comics. Therefore, his main challenge was getting *A Con-
tract with God* published by a literary publisher, and not a comics publisher.
Eisner would always remember that he made use of the term "graphic novel"
as a desperate effort to sell his work to book publishers who would never
look at what he was offering them if he told them it was *simply* a comic
book. Not without difficulty, Eisner managed to publish *A Contract with God*
in 1978 with Baronet, a publisher that did not specialize in comics. None-
theless, as Hatfield notes,[16] he was unsuccessful in his ultimate objective.
Baronet closed down some time later, and *A Contract with God* was not able
to enter the market of general interest bookstores—it was a unique work,
without a location of its own. The only thing that Eisner accomplished was,
paradoxically, to create a new format for comics publishers. Eisner's sub-
sequent "graphic novels," in fact, would be published by comics publishers
and in comic book format. This was still ten years before the first boom
for the graphic novel, and the latter would arrive through the coincidence
of works as antithetical as Art Spiegelman's *Maus*, on the one hand; and
Watchmen by Alan Moore and Dave Gibbons, and *Batman: The Return of the
Dark Knight* by Frank Miller and Klaus Janson, on the other.

Autobiography, the Alternative "Genre"

Although the relationship between Will Eisner and the alternative move-
ment of the 1980s was minimal, *A Contract with God* does contain one of the
most characteristic features of alternative comics, a feature that continues
to be the central thoroughfare of the present day graphic novel: the intro-
duction of the autobiography, or at least of memoir and autobiographical

elements. *A Contract with God* was a volume comprised of four independent stories, which is to say, a collection of short stories, strictly speaking, rather than a graphic "novel." Although none of the stories was explicitly autobiographical, there was a personal motivation for the first of them, for which the book was titled. The protagonist rebels against God [85], with whom he believed he had a private contract, when his adopted daughter dies. From then on, he changes from being religious and charitable to selfish and cruel, since he believes the contract has been broken. Eisner would declare that the idea emerged as a result of the death by illness of his daughter Alice. "A Contract with God is essentially a result of Alice's death. I was a very angry man when she died. I was enraged. She died in the flower of her youth, sixteen years old. There were heart-wrenching moments to watch this poor little girl die. The material I chose was all emotional—it was from my life."[17] Eisner not only chose an intense personal experience as the theme for his first graphic novel, he also searched his memory for the settings and characters of his own childhood, in the New York of the 1920s. Throughout his career, Eisner would return time and again to the memory of lived experience, filtered though it may have been through literary doubles.

To greater or lesser degree, resorting to autobiography was essential for escaping conventional genres, which aspiring alternative comics artists identified with the old tradition of children's comics of the big publishing houses. Autobiography was the "anti-genre"; it was defined by opposition to the superheroes as a story without formulas, absolutely sincere and personal. Of course, reality was more complicated than all of that.

In some cartoonists, like Daniel Clowes and Charles Burns, the autobiographical elements could only be found in highly encrypted form. They evoked environments, periods and personal haunting grounds that could be deciphered if the reader knew the proper code. Clowes reflected at times about the sincerity of autobiographical comics, as in "Just Another Day" (1991) [86], where he represents himself successively with different faces, all of them equally fictitious. In the end, the autobiographical comic poses an additional problem to autobiographical prose, since it establishes a visual representation of the third person narrator, which is presented as "objective" when in truth it is really an artistic invention. Clowes, however, would only approach autobiography tangentially.

Peter Bagge projected in his alter ego Buddy Bradley, the protagonist of *Hate*, the generational portrait of his times, lagging five years back. Buddy was always five years behind Bagge, which allowed the latter to reflect upon his experiences and select whatever was most interesting as spectacle.

Seth constructed one of the first great graphic novels (serialized in comic book format, of course) from the imposture of reality, capitalizing on the popularity of autobiography: *It's a Good Life, If You Don't Weaken* depicted the author's search for Kalo, an old and unknown humor cartoonist for *The New Yorker*. Only after the work was finished did the reading public discover that Kalo had been Seth's own creation. The artifice had worked because the audience had become accustomed to the shameless sincerity of autobiographical cartoonists, whose main premise was authenticity. Joe Matt, a friend of Seth and of Chester Brown, whom he used as characters in his own comics, recounted his greatest interpersonal and sexual failings in *Peepshow* without any apparent self-censorship. This road of abject revelation was followed by many women: Debbie Drechsler related in *Daddy's Girl* [87] the sexual abuse to which she was subjected by her father when she was a child, while Julie Doucet bared herself through her most intimate dreams and also in the form of a cartoon diary.

As stated previously, autobiographical comics had already begun to be practiced among underground cartoonists. Robert Crumb, Aline Kominsky and above all Justin Green had taken the first steps in that direction. The most important figure, however, had been Harvey Pekar [88]. Strictly speaking, he could not be considered underground, although he had started to publish at the instigation of Robert Crumb, who drew his first cartoons. The two had known each other from when Crumb lived in Cleveland, and they shared a passion for collecting old jazz records. Pekar worked as an administrator at a hospital, and was more than thirty years old when he started making comics. Incapable of drawing, he always depended on other artists to bring the image to his stories. In 1976 he began to self-publish his own comic book, *American Splendor*. The ironic title stood in contrast with the content, which could not have been farther from any "national splendor." On the contrary, Pekar's comics focused on everyday routine, on the moments in which nothing was happening, ordinary moments without drama, in the flow of life lacking any kind of special grandeur. Hatfield remarks that "Pekar's achievement is to have established a new mode in comics: the quotidian autobiographical series, focused on the events and textures of everyday existence."[18] In that sense, Pekar's autobiography diverged from that of Justin Green, who, after all, recounted real events, but "interesting" ones. Despite his link with Crumb and with other cartoonists of the underground, like Frank Stack, Pekar lacked any relationship with counter-cultural life and thinking. His project of developing a hyperrealist narration of everyday life almost in real time was without

compare in any other comic. As Joseph Witek would observe, "*American Splendor* refuses to fit into any of the main categories of American comic books."[19] Pekar is Pekar. And, nevertheless, this assertion is paradoxical, because if authenticity is the principal value that governs *American Splendor*, that same authenticity is placed in question when we consider that all of the cartoons are drawn by other cartoonists, with clear stylistic differences. And moreover, how authentic is everything narrated in the storyline, when what is narrated is life itself, and the narrator knows at the moment of experiencing the events that those same events are material for writing his next comic? This same doubt led to crisis for Eddie Campbell, the Scottish author of one of the longest autobiographical works in worldwide comics, which features his alter ego Alec, who has been appearing in numerous comics since the 1980s. Faced with the pretense of living a life to be narrated in a comic that only tells the story of life itself, Campbell attempts to make himself disappear in *The Fate of the Artist* (2006), where he is erased as a character, and, therefore, disappears as well from his own life. Campbell has resolved (or eluded) this autobiographical crisis with a turn toward fiction, since his two subsequent works have been exercises in genre removed from personal intimacy.

This would be one of the great problems faced by autobiographical comics, especially that of Pekar and his followers, which began to proliferate in the late 1980s. As already noted, the survival of the author's comic book depended on its presence in specialty bookstores, which catered mainly to an audience of superhero fans. In order to mark off its own territory in those bookstores and in the eyes of that audience, the alternative comic had to redefine itself as a genre, and it also, therefore, redefined autobiography. Autobiographical comics, as Hatfield indicates, were a form of rebellion against commercial genre comics, but at the same time it also attended to the consumer habits of the typical readers of comics, since "autobiographical comic book series are well adapted to the market's emphasis on continuing characters, ongoing stories, and periodical publication."[20] We might say that the authors replaced the superheroes as characters, and individualism as rebellion against society thus became simply another consumer product that recognized itself as "alternative."

Thus, we can say that the power of the comic book form imposed itself tenaciously on the content. No matter how distinct that content might be, alternative comics remained tied down in many senses by the formulas of traditional comics. The conventional medium, the specialized distribution network and the fan base fenced it in. The escape route—in retrospect it

appears obvious to us—represented by the graphic novel would be formulated with Art Spiegelman's *Maus*, a comic where autobiography is the cement that holds together the entire edifice.

The Generation of '86 and the First Graphic Novel Boom

In 1986 the first volume of *Maus* appeared in publication, with the subtitle "My Father Bleeds History," under the editorial seal of a literary publisher, Pantheon. *Maus* had been published in chapter installments as a booklet insert in *Raw*, but from the beginning it had been conceived as a work with closure and with a complete structure, a true graphic novel. For Spiegelman, who was thirty-eight years old when the volume appeared, *Maus* was a mature work. His prior production had been characterized by testing all of the limits of narration and representation in cartoons, and he had sought to question all of the medium's conventions. In *Maus*, however, he placed himself at the service of telling a story in the most effective way possible. Although *Maus* is a comic of enormous formal complexity, this complexity is not apparent, as in the pages of *Breakdowns*, but instead is rendered invisible.

The story was lived by his parents during the Second World War, Jews who survived the extermination camp at Auschwitz. But more than that, it was also the story of how in the present his father told Spiegelman what happened [89]. In other words, *Maus* was not so much the story of the Holocaust as it was the story of the legacy of the Holocaust. The survivor was not just Vladek, the father, but Art, the son. For Vladek, life had been divided into the period before and the period after the war. Art however, born in 1948, had always lived in the shadow of that war. The memory of Art's older brother, who died during the conflict, had forever weighed upon the family, and especially upon Spiegelman himself, whom his father calls "Richieu"—the brother's name—in his final dialogue in the book. A slip that Huyssen explains as a product of "deep memory," but which provides Spiegelman's balance between the past and the present with all of its meaning. The father's "misrecognition of Artie as Richieu is highly ambiguous: it is as if the dead child had come alive again, but simultaneously the traumatic past proves its deadly grip over the present one last time. . . . This last frame of the comic is followed only by the image of a gravestone, by the signature 'art spiegelman 1978–1991,' years that mark the long trajectory of Spiegelman's project of approaching a project that ultimately remains beyond reach."[21]

Spiegelman's mother had committed suicide, an event that the cartoon-
ist depicted in an underground comic, "Prisoner on the Hell Planet" (1972),
later included within *Maus*. That same year, Spiegelman took the first steps
toward approaching the traumatic past of his parents, in a three-pages long
comic already titled "Maus" [90] where he used anthropomorphic mice and
cats to represent some of the stories that his father had told him as a child.
The first "Maus," however, was little more than an experiment compared to
what *Maus* would ultimately become. Witek observes that the main differ-
ence between the two comics is that "the first version is an allegory, thinly
disguised at best, while the second is an animal comic book."[22] The repre-
sentation of the characters of the story as anthropomorphic animals—the
Jews as mice, the Nazis as cats, the Poles as pigs, etc.—was from the very
beginning one of the most controversial and disconcerting elements of
Maus. Was it not enough that the Holocaust was being *trivialized* by turn-
ing it into the theme for a *comic book*? Did it also have to have animals as its
main characters? demanded the critics. Or even worse: was the allegory of
the animals in effect a veiled justification for the Holocaust? After all, it is
natural for cats to exterminate mice, which amounts to the same as what
the Nazis believed about the Jews. The mistake made by those who were
thinking along these lines was the failure to discern the crucial difference
underscored by Witek. The definitive *Maus* was no longer an allegory with
animals, it was not a fable, but rather an anthropomorphic animal comic
in the tradition of Carl Barks' Donald Duck, despite its much more sinis-
ter theme. And in a *funny animals* comic, the animals behave like people,
they *are* people, independently of what species of animal they belong to.
But for many of the literary critics who felt unsettled in the face of the
potency of *Maus*, the comic that dared to treat the most traumatic subject
for the West of the entire twentieth century, it was impossible to compre-
hend this, since their first reaction upon finally accepting the work was to
say that "*Maus* is not a comic." A reaction that, as Wolk points out, has been
repeated with alarming frequency each time a comic breaks with the chil-
dren's framework within which most cultural critics view comics. "Another
common error is to assert that highbrow comics are, somehow, not really
comics but something else . . . different not just in breed but in species
from their mass-cultural namesakes."[23] On the contrary, not only was *Maus*
indeed a comic, but it worked *precisely* because it was a comic and because
it had its roots firmly planted in the tradition of mass cultural comics. One
of the great problems of the Holocaust has been the impossibility of repre-
senting it adequately: images, and especially photographic images, erode

its meaning, their meticulously detailed brutality winds up trivializing it and desensitizing us. As Hatfield[24] indicates, indirect representations have often been the only way of depicting the Holocaust, as in Resnais *Night and Fog* (1955), in Lanzmann's *Shoah* (1985) and even in Spielberg's *Schindler's List* (1993), where the use of black and white was almost a necessity for reconfiguring the images to give them new meaning and freshness in the eyes of the viewer, stylizing them and thus making them unreal and once again comprehensible. Spiegelman could have chosen to tell his story with *people*, but from the start he understood that that would have been the wrong path to take:

> I think it actually would have put the book into a different key. And the key that it would have put the book in would have been flat. At that point I would have been trying to do an ersatz historical reconstruction, and I could never match the actuality. By putting these masks on, everything takes place in a netherworld where things exist as commentary. It allows one to go through the comic into looking at the event, as opposed to trying to replace the event with the comic.[25]

The issue of "reality" that was so important for the autobiographical comics became in *Maus* a truly urgent matter. Spiegelman included a photo of his father in a concentration camp prisoner's uniform toward the end of *Maus*, as a proof of the reality of the story. But the photo was a studio portrait, and raised the question of the extent to which not only *Maus*, the comic, was real or constructed, but also the story originating from Vladek's memory. In Versaci's view, "Spiegelman constantly challenges his own project by raising questions about his animal metaphor. In so doing, Spiegelman shows an awareness that his book exists as representations and that looming behind his images is a larger, more imposing reality that can be approached only indirectly."[26] As Didi-Huberman has stated: "In order to know, we must imagine for ourselves. We must attempt to imagine the hell that Auschwitz was in the summer of 1944. Let us not invoke the unimaginable."[27] By reshaping memory as a fantasy of talking mice and cats, Spiegelman not only allows us to imagine what happened there, he *obliges* us to do so, perhaps for the first time.

Maus arrived at an opportune moment, as "Memory discourses accelerated in Europe and the United States by the early 1980s, energized then by the ever-broadening debate about the Holocaust (triggered by the TV series *Holocaust* and, somewhat later, by the testimony movement), as

well as by a whole series of politically loaded and widely covered fortieth and fiftieth anniversaries relating to the history of the Third Reich."[28] The book edition of the first part of *Maus* gained enormous attention, which was transferred to the overall comics scene. Where had that extraordinary comic book come from? Was it an exceptional phenomenon or did it form part of a new wave of adult comics? Spiegelman would have liked to present himself as the leading edge of a new era of authors of comics that were serious, intellectual, artistic and literary, who, with works like *Maus*, would be definitively categorized as high art. But when he looked around, he saw that in his own introduction to the general public he was escorted by two superhero comic books.

Those two superhero comics were *Watchmen* and *Batman: The Dark Knight Returns*, both of them published by DC. Watchmen [91] had appeared as a limited series of twelve stapled comic books between September 1986 and October 1987. Its authors were two Englishmen, writer Alan Moore and artist Dave Gibbons, accompanied by colorist John Higgins. Conceived as a complete and self-contained story, *Watchmen* intended to offer a realistic and adult view of superheroes and their influence over our world if they were to truly exist. *Watchmen* was surprising for its political overtones, its contrast between the psychology of the characters and their stereotyped function, and for the density of the reading that it offered, with constant interplay between word and image. In addition, every episode was supplemented by a section of text originating from some corner of *Watchmen*'s fictitious universe, which complemented the main narrative. The finishing touch of intertextuality was the inclusion of a pirate comic book that was being read by one of the characters within the comic. In short, *Watchmen* made use of superheroes as an excuse for a cynical, polysemic and multi-layered narrative quite in tune with 1980s tastes.

Watchmen marked the culmination of the process of take-over of the specialized comics market (already identified with superhero comics) by veteran fans. In *Watchmen*, all of the adults who had had to justify their loyalty to *X-men* and *Spider-Man* as a charming eccentricity, found their alibi for defending the artistic validity, not only of comics as a medium, but of the superhero genre. Thus, *Watchmen*, which had been created as an ironic, postmodern deconstruction of superheroes, became in fact their justification and renewed validation for the future, in addition to confirmation that there was a way to continue creating superheroes that were acceptable for adults.

Batman: The Dark Knight Returns [92] was almost the exact opposite of *Watchmen*, a reconstruction of the heroic myth, updating it for a new era.

It had been published originally as a limited series of four issues between February and June of 1986, using a new format that would enjoy great success from then on, a format called, meaningfully, *prestige*: forty-eight pages in color, on superior quality paper and with cardboard covers and a spine. A project like this would have been unimaginable prior to the direct market era. Its author, writer and artist Frank Miller (accompanied by inker Klaus Janson and by colorist Lynn Varley), took up the publisher's most successful character, Batman, and imagined his latest adventure, now as a fifty-something retiree, in a dystopian future in which Miller reinvented and breathed new life into the icons of the DC Universe. Miller, unlike Moore and Gibbons, did believe in the heroic myth, and his work clearly served more to rearm it than to question it.

Just like *Watchmen*, *The Dark Knight Returns* was a complete story unto itself. Although its main character was a household name (unlike *Watchmen*, whose characters were versions of other pre-existing characters, but distinct and independent), he was situated outside the character's own official continuity, which gave Miller the freedom to do whatever he wanted with the story. If the Joker, Batman's historical nemesis, had to die, he would die. After all, the events described therein would have no repercussions for the day-to-day reality of DC's Batman collections. That meant that *Watchmen* and *Batman: The Dark Knight Returns* would be an immediate success once they were compiled in a single volume. Both titles, like *Maus*, had a big impact in the media. For *Watchmen* and *The Dark Knight Returns*, the consequence of being presented to the public alongside *Maus* was that they would be immediately considered respectable "graphic novels." For Maus, the consequence of being presented to the public alongside *Watchmen* and *The Dark Knight Returns* was that it would be associated with those comics and its respectability would be diluted. Commenting on how the attention of the public and the media centered on superhero comics like *Watchmen* and *The Dark Knight Returns*, Alan Moore himself would say: "We were caught on the main street of culture wearing our underwear on the outside,"[29] a reference to the classic outfit of Superman and his colleagues.

Nevertheless, if we take reflection a bit further, we will understand that, no matter how much it might pain Spiegelman, and probably even Moore, the three works shared an essential feature that had a decisive influence on their immediate success with the public. Although all three were introduced as something new, they were easily recognizable as comic books, not only because of their form, but because of their use of the most powerful topical characters in the comics imaginary: funny animals and superheroes. These

had been the figures that had established the children's profile for comics, and these were the figures that now rose up to demand a different kind of attention from a more sophisticated reader.

For whatever reason, *Maus*, along with *Watchmen* and *Batman: The Dark Knight Returns*, provoked a graphic novel and "adult" comics fever in the late 1980s and early 1990s in the big comics publishers. Marvel and DC made use of secondary publishing imprints like Epic, Piranha and Paradox in order to attend to this segment of the market. Thus were published titles like *Brooklyn Dreams* (1994), by the long-time superhero writer J. M. DeMatties, along with Glenn Barr, who was a childhood memory; *Stuck Rubber Baby* (1995), by Howard Cruse, which told the story of the protagonist's discovery of his own homosexuality—a class of underground gay comix—in the context of the civil rights movement in the United States; and *A History of Violence* (1997), a *noir* genre tale by John Wagner and Vince Locke later adapted to film by David Cronenberg. Restless cartoonists who usually collaborated with the big comics publishers encountered opportunities to create graphic novels, with those same publishers or with others. Such was the case of Kyle Baker (*Cowboy Wally Show*, 1988; *Why I Hate Saturn*, 1990) and Bill Sienkiewicz (*Stray Toaster*, 1988). Dave McKean, a poly-faceted artist who had made a name for himself by illustrating the covers of the "sophisticated superhero" series *Sandman* (1989–1996), written by Neil Gaiman, would publish in installments the ambitious *Cages* [93], compiled in 1998 in a single volume of more than 600 pages. Projects with an adult and artistic look featuring lifelong superheroes proliferated, often signed by Miller and Moore, and by their imitators, a good many of who came to the United States from the British comics scene. The big publishers attempted to capitalize on the prestige magically conferred by the term graphic novel through books with luxurious production values, some even painted, like the adaptation of Lang's film *M* by Jon J. Muth, that coexisted with spectacular Batman storylines like *Arkham Asylum*, written by the Scottish scriptwriter Grant Morrison and drawn by the very same McKean. It seemed that the interpretation implemented by Marvel and DC of the term "graphic novel" was "ostentatious comic book."

The movement, then, was led by and absorbed by the large publishers of conventional comics, which mixed more personal works by their usual professional artists with mere adaptations of their usual products. From the alternative side, which is to say, from the terrain from which *Maus* had emerged, the activity was not comparable. Publishers like Fantagraphics and Drawn & Quarterly were not established enough to make the

investment required for the direct publication of graphic novels. Moreover, the best alternative authors had still not matured sufficiently to undertake their most ambitious works. In 1986, Daniel Clowes (25 years old) and Chris Ware (19) had not even begun to publish *Eightball* or *Acme Novelty Library*. Spiegelman, who had been accepted by the general interest bookstores, but who felt alone in them, as had happened in his day to Will Eisner with *Contract with God*, attempted to generate graphic novels so as to surround himself with a set of materials sufficiently numerous that he could delimit his own territory on the bookshelves. He was able to promote the publication of *City of Glass* (1994) [94], an excellent adaptation of Paul Auster's novel by Paul Karasik and David Mazzucchelli, but the effort ended there. The graphic novel balloon deflated, smothered by pseudo-superhero material and at the hands of conventional comics publishers, which continued selling mainly in specialty bookstores and continued profiting more from *X-men* than from *Stuck Rubber Baby*.[30] When the second and final volume of *Maus* was published in 1991 and it received a special Pulitzer prize in 1992, it appeared that Spiegelman's work would remain a unique and unrepeatable phenomenon, the comic book that dared to grow up.

Alternative Comics in France

As we saw in the previous chapter, the influence of the American comix underground in France produced editorial outcomes very different from those that had occurred in the United States. While the West Coast comix underground had generated an alternative market that developed completely outside the established publishing houses, distributors and audience, in France the new forms and contents were assimilated into projects that competed for the same audience as the conventional comics. Unquestionably adult authors like Lauzier and Bretécher were integrated into the commercial structures. The "alternative" route never came to be, because the industry knew how to absorb the new proposals as part of its offering.

Certainly, the Franco-Belgian tradition of comics had always been closer to recognizing the author and the book format than the American tradition. The typical way of selling comics in France had been through their prior serialization in magazines followed by their compilation in so-called albums, large-sized and hard-cover books in color and with a standard number of pages (typically forty-eight or sixty-four). While from the 1940s to the 1960s, in the United States Superman had been property of

his publisher, DC, and had been published anonymously, during that same period in Europe Hergé's name had been firmly tied to Tintin. So much so that, in fact, with the artist's death, the adventures of the famous reporter would come to an end, even though they could have easily been continued by his production team. In this way *Tintin* was recognized, despite being an industrial production, as also being the *work of an author*.

The French industry was able to assimilate the trends toward renewal into an evolutionary model, instead of a revolutionary one like the American model. Youth adventure comics, which had revolved around the Belgian-French axis, with the rivalry between the École de Bruxelles of *Tintin* and the Atome style of the École de Charleroi of *Spirou*, were eventually transformed into adventure comics for adults. Perhaps one of the best examples of this journey is the long voyage of Corto Maltese, Hugo Pratt's character that debuted in *Una ballata del mare salato* (Ballad of the Salt Sea, 1967), a story that began to be serialized in the Italian adventure magazine *Sgt. Kirk*. Beginning in 1970, the exploits of Corto, a romantic adventurer of the early decades of the twentieth century, would appear in the French children's magazine *Pif Gadget*. *Una ballata del mare salato* is for many a forerunner of the graphic novel because of its dimensions (more than 160 pages), its serious tone and the psychological subtlety of its characters, but the reality is that it is clearly a product of the commercial tradition of adventure comics, no matter how much one discerns in its pages the personal mark of a great comics artist.

Even the efforts at self-affirmation by the French authors wound up joining the industry, instead of breaking with it. In 1975, a group of cartoonists including Druillet, Moebius and Dionnet founded Les Humanoïdes Associés and launched the magazine *Métal Hurlant*, which through its English-language version, *Heavy Metal*, would become the focal point for diffusion of European comics in the United States during that decade. But *Métal Hurlant* was still a science fiction and fantasy magazine that added more product to the market. The figure of Jean Giraud/Moebius exemplifies better than any other the dichotomy of French adult comics: as Giraud or Gir he is the successful cartoonist of the Western series *Blueberry* (from 1965) [95]; as Moebius, he is the author of personal fantasies like *Le Garage hermétique* (The Airtight Garage, 1979) [96], *Arzach* (1976) and *L'Incal* (The Incal, 1981–1988), this last title together with Jodorowsky. By contrast, Robert Crumb offers just one face, and all of his works are entirely personal; his contact with the industry and conventional genres is null.

The development of the traditional children's genres into comics for adults over the course of the 1970s eventually resulted in the idea of "graphic

novels" pre-published in magazines, whose best example would be the magazine *(À Suivre)*, a tool of Casterman (the publisher of *Tintin*) for producing stories longer than the standard forty-eight pages. "These were called 'novels in bande dessinée' and divided into chapters, to emphasize their literary qualities."[31] Obviously, this approach was completely antithetical to the approach of the alternative cartoonists and to the approach that gave rise to Art Spiegelman's *Maus*, but very similar to that of Marvel and DC when they saw the success of *Watchmen* and *Batman: The Dark Knight Returns*. The French graphic novels were produced pursuant to a mass-market logic, with the aim of achieving the equivalent of literary best sellers. In fact, during the 1980s this standardization would lead to a certain saturation of the market, which began to show signs of fatigue when it proved incapable of supporting the increasing number of overproductions, lavish in appearance but in reality formulaic and repetitive. This is the period in which grand historical or fantastical sagas prevailed, establishing a name for authors like Bourgeon (*Les Passagers du vent* (Passengers of the Wind), 1979–1984; *Les Compagncns du crépuscule* (Twilight Companions), 1984–1990), Juillard (*Les Sept vies de l'Epervier* (The Seven Lives of the Sparrow Hawk), 1982–1991), Yslaire (*Sambre*, 1986–1996, 2003), Rosinski and Van Hamme (*Thorgal*, 1980 to present), Bilal (*La Foire aux Immortels,* 1980, published in English in 1999 as *The Carnival of Immortals*, the first of three novels in *The Nikopol Trilogy,* by Humanoids) [97]. The drop in sales in the late 1980s (legendary titles like *Pilote* and *Tintin* ceased publication) resulted in the large editorials adopting more conservative strategies. Once again, the crisis of the industry, as happened in the United States in the 1960s, would pose problems of access for the younger generations. This would cause new authors in the early 1990s to find themselves forced to create their own model, for the first time truly alternative, which would take shape around L'Association.

The origins of L'Association must be sought in Futuropolis, one of the first bookstores specializing in comics in France, which was also an editorial house, founded in 1972 by Étienne Robial. Futuropolis was, in the words of Jean-Christophe Menu, a founding member of L'Association, "the first 'adult' publisher in comics to also have an 'adult' conception of the books."[32] Robial took a radical stance in his defense of comics as art, to the point of refusing to sell *Astérix* in his store. He distinguished between "BD," a term that defined commercial production, and *"bande dessinée,"* which was the artistic cartoon. Futuropolis adopted all of the strategies that we recognize today as part of the adult comics movement: it published "serious" cartoonists of the 1970s, like Crumb, Tardi and Swarte; it placed emphasis

on the figure of the author, ensuring that the author's name would become the only distinctive element of the cover; it published young and unconventional authors (one of them, Badouin, would be the pioneer of Francophone autobiographical comics); and it also re-issued comics classics, both European and American, which it treated with the dignity appropriate for resituating them as key elements in the definition of comics as art: *Krazy Kat*, *Bringing Up Father*, Alain Saint-Ogan, Calvo, and so on.

Futuropolis would eventually be absorbed by Gallimard, and today its name defines a line of commercial publishing (Soleil), completely unrelated to Robial. But in the final years in which the latter still maintained control of the publisher, he set in motion the project of launching a magazine that would serve as a vehicle for young cartoonists who had self-published in fanzines and photocopied mini-comics during the 1980s. The project, directed by one of those young cartoonists, Jean-Christophe Menu (1964), would then bear fruit in *LABO* (1990), of which only one issue would be published. Nonetheless, from *LABO* emerged the group who would soon afterwards create L'Association, an enterprise of independent cartoon artists whose founders would be Menu himself as well as Stanislas, Mattt Konture, David B., Killoffer, Lewis Trondheim and Mokeït. In November of 1990, L'Association would launch its first publication, *Logique de Guerre Comix* (War Logic Comix).

L'Association positioned itself in direct opposition to everything that the French comics industry represented, an industry perceived as decadent by the group's members in the early 1980s. The hegemonic format of the album was the main target: "The only thing we were certain of at the beginning was that we wanted to produce books that in no way resembled the classic comics 'album,' the hardcover 48-pager in color, which I'd later call '48CC'—CC for Color and 'Cartoné,' which means hardcover," Menu would say.[33] David B. would reaffirm those same intentions: "There'll always be a demand for images and in the '80s, the parameters of the comics that were being released were so reductive. That's why we created L'Association; in order to rebel against that, to do something different."[34]

Behind the idea of opposition to the industry as a first resort, the two stated principles of L'Association were "integrity and long term," the latter being consistent with Eddie Campbell's expectations for the graphic novel: "You may not sell them now, you may sell them 30 years from now, but in this new era of comics, there is no 'now'; it's an indefinite, ongoing 'now.'"[35] Integrity was, of course, consistency with the vision of the cartoonist understood as an artist.

L'Association turned into a real hotbed of ideas, many of them already expressed in the earlier the meetings of *LABO*, as Menu would acknowledge: "The ideas were for example to create comics on a literary basis and never again to do them in the teenage-BD mainstream mold. To talk of *reality*, to use comics to talk about the real world, the one we were living in, and never again to do fantasy or 'genre' bullshit. To experiment with comics structure. To provide a place for criticism in a magazine presenting artwork."[36]

The use of black and white and the immersion in autobiography connected L'Association to the American alternative comics of the 1980s and 1990s, but other elements set them apart. For example, while the Americans submitted to the industry's format—the comic book—in order to survive in camouflage among the superhero comic books of the big publishers, L'Association, as we have seen, deliberately rejected the hegemonic format of the album in color and presented instead an enormous variety of sizes and formats, among which could perhaps be established a sole connection: they had a more literary air, thanks to their sober and often monochrome covers. This general family resemblance of the projects of L'Association also reveals a sense of community quite superior to that of the American cartoonists, which is markedly more individualistic. The cartoonists of L'Association—who quickly welcomed with open arms many other kindred spirits, even when these came from earlier generations like Baudoin, or from abroad—maintained a certain collective spirit, certain principles and shared expressions around which they are organized, in great measure because of the tireless theoretical work of Menu. This theorizing labor has a political side—with regard to analysis of the market and its trends—and an experimental side, which has led the members of L'Association to become involved in projects like OuBaPo, based on the system of formal restrictions applied by the group OuLiPo to literature, but transferring it to comics. For example: the requirement of creating a cartoon without a human character. Lastly, and as is common in the Franco-Belgian scene, unlike the American one, most of its main figures moved between alternative productions for L'Association and clearly commercial works for the big editorial houses. It would be precisely Menu who most forcefully clung to his independent roots—which will earn him much antipathy, even among his colleagues— but David B., Lewis Trondheim, and Stanislas, among the founders, and Joann Sfar and Emmanuel Guibert among the most important later collaborators, have enjoyed extensive careers with the conventional publishers, where they have produced numerous "48CC," the standardized forty-eight page, hardbound and in-color series.

Of course, that dual career has flourished because the talent and creativity of the authors of L'Association meant that the group did not take long to draw the attention of the large publishers, who were interested in discovering new formulas that could pull the industry out of the crisis of the 1980s. L'Association had to hire its first full-time employee in 1994, and by the next year its revenues had doubled, and they continued to rise for the remainder of the decade until reaching their peak with the unexpected best-seller brought to them by David B.: *Persépolis*, by his friend Marjane Satrapi, a book that had already sold more than 100,000 copies in 2002.[37] The publisher's own inertia was turning it into something it had tried to avoid: a professional enterprise, almost a big publishing house. The appearance of other publishers similar to L'Association was inevitable. Some, like Seuil, Cornélius and Amok, were viewed by L'Association as comrades, and not as competitors. One distributor, Le Comptoir des Indépendants, of which L'Association was majority owner, would eventually take over the distribution of material for these small publishers, in a move that calls to mind the origins of the direct market in the United States out of the parallel distribution networks of the comix underground.

But the big publishers also undertook their own projects with an "independent" look in order to take their piece of the market pie discovered by L'Association, provoking a much less accepting response on Menu's part: "Yes, it's the same thing emptied of its substance. . . when every idea becomes merchandise. With this mindset, you can do any kind of book, small-sized, black and white, with facile autobiography or a sound-bite pitch, and then call it 'bande dessinée Indépendante.' You see it in the bookstores now: these fake or third-rate products on the same shelves as ours, sometimes already replacing ours."[38]

In 1999, L'Association published a project of high symbolic importance, which economically could easily have sunk the publisher had it been published at a loss: *Comix 2000*. The book, which comprised a selection of material received in response to an international call for submissions, contained 2000 pages of wordless cartoons, and its goal was to offer a panoramic view of alternative comics throughout the world. The final product, which indeed included samples from cartoonists all over the planet, from the United States to Japan, passing through Europe, could be deemed an editorial extravagance, but it amounted to material evidence of an obvious reality: the international success of alternative comics. Established on both sides of the Atlantic, these comics aimed at the adult audience had fed on mutual support, attending more to cross-border affinities than to local traditions.

The Americans had influenced the French, but these latter had also influenced the Americans, and in the end everyone had found fruitful common ground in collaboration. The international revitalization provoked by the activities of L'Association had their effect on many peripheral traditions. In Spain, two cartoonists based in Mallorca who had started their careers in the magazines of the 1980s, Max and Pere Joan, assisted by the younger Alex Fito, published a cutting edge comics magazine titled *Nosotros somos los muertos* (We Are the Dead, 1995) in its first phase, and *NSLM* (2003) [98] thereafter.[39] The project, initiated in a fanzine as a form of individual protest against the passivity of the European governments in the face of the Balkan war, later became a vehicle for articulating that kind of international alternative comics that brought together L'Association with Fantagraphics. In its pages, new Spanish cartoonists (Linhart, Paco Alcázar, Miguel Núñez, Gabi, Javier Olivares, Santiago Sequeiros, Portela/Iglesias) joined veterans returning after the debacle of the 1980s (Keko, Martí, Gallardo, Del Barrio), and all of them were able to rub elbows with the likes of Chris Ware, David B., Art Spiegelman, David Mazzucchelli, Julie Doucet and other important names on the international scene.

The proliferation of international comics festivals, together with declining printing costs and ease of contact between authors and of diffusion of works offered by the Internet, helped to reinforce the "international alternative." Somewhere around the year 2000, there was an awareness that this type of adult comics was sufficiently established that it could aspire to something more than the crumbs left to it in the specialty bookstores by increasingly exhausted conventional comics. The first alternative authors began to enter into their mature phase as creators. *Comix 2000* seemed to symbolically bring to a close a period that ended with the century and allowed serious cartoonists to recognize themselves in an international family photo. The moment had arrived to cease viewing themselves as "alternative" and to move on to bigger undertakings. In 2000, the first installment of *Persépolis*, by Marjane Satrapi, published by L'Association, appeared in France, and in the United States Pantheon published Chris Ware's *Jimmy Corrigan, The Smartest Kid in the World*. Finally, the graphic novel's moment had arrived.

55. *Mad* 23 (1955).

56. Little Annie Fanny in "The Artist" (1963), Harvey Kurtzman and Will Elder.

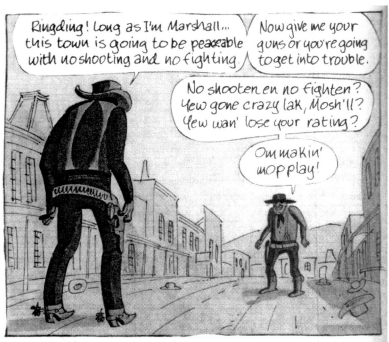

57. *Jungle Book* (1959), Harvey Kurtzman.

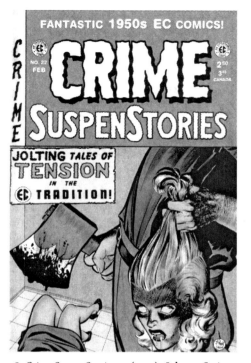

58. *Crime SuspenStories* 22 (1954), Johnny Craig. Reissue of 1998.

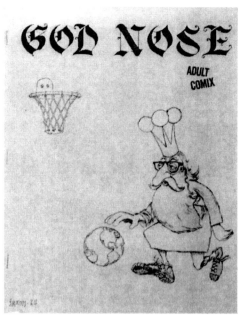

59. *God Nose* (1964), Jack Jackson. Reproduced in Rosenkranz (2002).

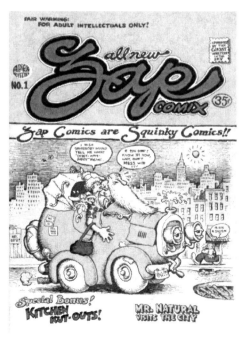

60. *Zap Comix* 1 (1967), Robert Crumb.

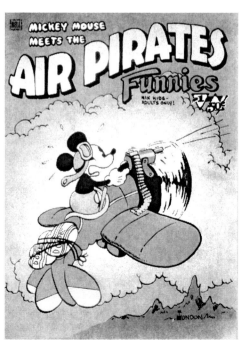

61. *Air Pirates Funnies* 1 (1971), Bobby London. Reproduced in Danky and Kitchen (2009).

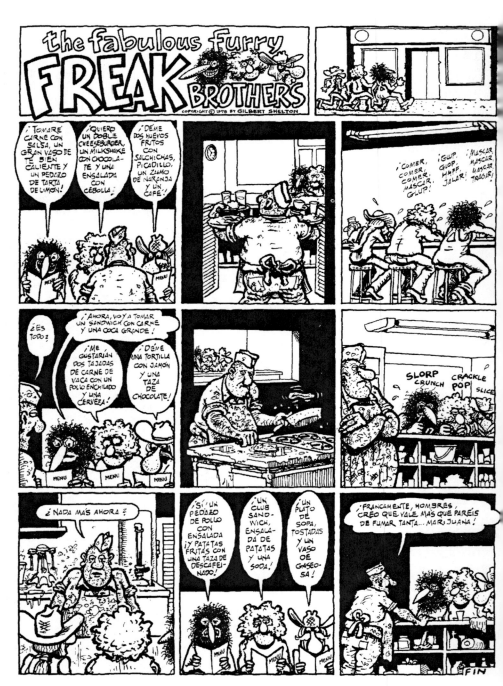

62. "The Fabulous Furry Freak Brothers," from the Spanish-language collected volume *Obras completas 4: Vida campestre* (1984), Gilbert Shelton. The brothers try the patience of a short order cook after ordering three consecutive meals to satisfy their marijuana-inspired "munchies."

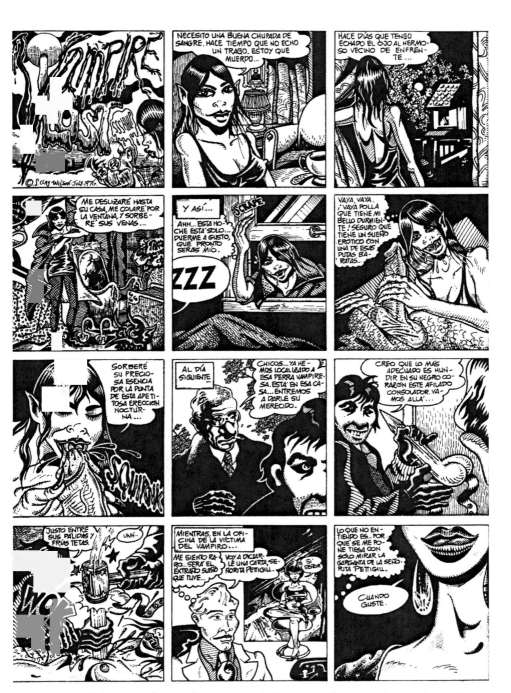

63. In this Spanish-language edition of "Vampire Lust," which originally appeared in *Arcade, The Comics Revue* 7 (1976), S. Clay Wilson renders the vampire genre explicitly sexual.

64. "Bits of Flesh," in *Bogeyman Comics* 1 (1969), Rory Hayes.

65. *Rowlf* (1971), Richard Corben.

66. *It Ain't Me Babe* (1970), Trina Robbins. Reproduced in Danky and Kithen (2009).

67. *Binky Brown Meets the Holy Virgin Mary* (1972), Justin Green.

68. *His Name Is . . . Savage!* (1968), Archie Goodwin and Gil Kane.

69. A page from a Spanish-language edition of *Bloodstar* (1976), Richard Corben.

70. *Pilote mensuel* 49 (1978), F'Murr.

71. *Pravda la Survireuse* (1968), Pascal Thomas and Guy Peellaert.

72. A page from a Spanish-language edition of "Hola, Valentina" (1966), Guido Crepax. In the panel at upper right, Valentina reminds the male character (and the reader) that she is the protagonist of the story.

73. *Métal Hurlant* 1 (1975), Moebius.

74. *El Víbora* (1979), Nazario.

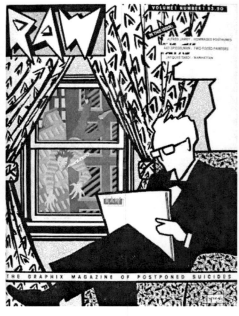

76. *Raw* 1 (1980), Art Spiegelman.

75. *Nejishiki* (1968), Yoshiharu Tsuge. Reproduced
in *The Comics Journal* 250.

77. *Jimbo: Adventures in Paradise* (1988), Gary Panter.

78. *Weirdo* 1 (1981), Robert Crumb.

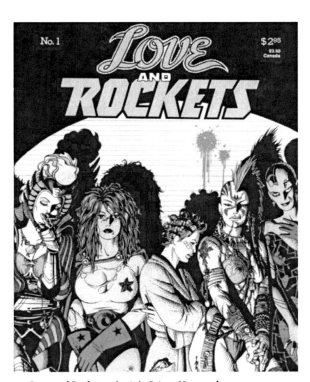

79. *Love and Rockets* 1 (1982), Jaime Hernandez.

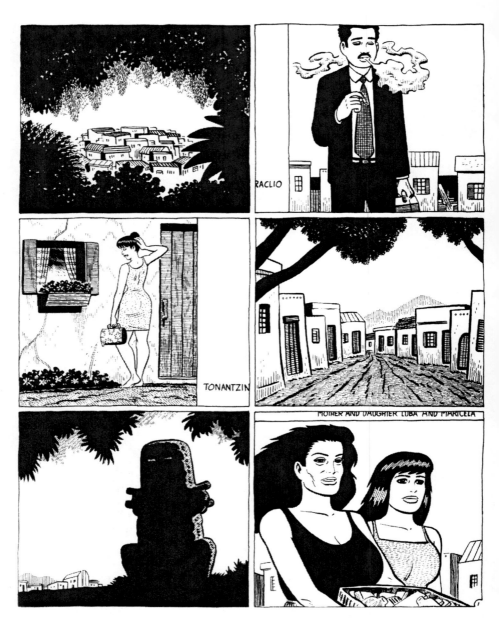

80. "Chelo's Burden" (1996), Gilbert Hernandez.

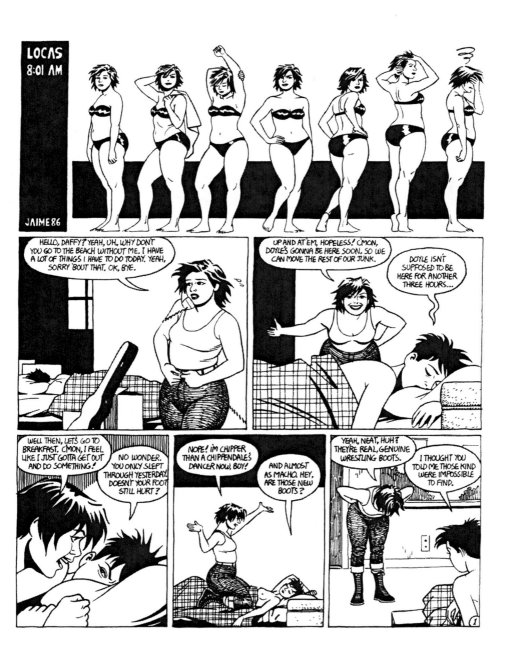

81. "Locas 8:01 a.m." (1986), Jaime Hernandez.

82. *Ghost World* (1997) Daniel Clowes.

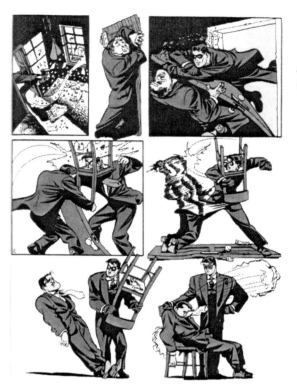

83. The Spirit in "Beagle's Second Chance" (1946), Will Eisner and studio.

84. *Snarf* 3 (1972), Will Eisner.

85. *Contract with God* (1978), Will Eisner.

... I GUESS I'M JUST ASHAMED OF MYSELF FOR GETTING SO SWELL-HEADED WHENEVER I GET ANY "MEDIA" ATTENTION...

BUTT BRAIN

...IT'S WEIRD TRYING TO DO COMICS ABOUT YOURSELF... IT'S ALMOST IMPOSSIBLE TO BE OBJECTIVE...THE WAY YOU DEPICT YOURSELF REALLY DEPENDS ON HOW YOU FEEL ABOUT YOURSELF AND THAT CAN CHANGE EVERY TWO MINUTES...

BUT IT'S EVEN MORE COMPLICATED THAN THAT... LIKE, YOU HAVE TO DECIDE HOW MUCH YOU'RE WILLING TO EMBARRASS YOURSELF AND IF YOU **ARE** WILLING TO EMBARRASS YOURSELF YOU HAVE TO MAKE SURE IT'S NOT JUST TO SHOW WHAT A COOL, HONEST GUY YOU ARE... STUFF LIKE THAT... IT'S AN AGONIZING STRUGGLE!

LIKE JUST THEN I WASN'T BEING HONEST WITH YOU. I DREW MYSELF AS AN **INTROSPECTIVE, WHINING WIMP** JUST SO I COULD MORE EASILY EXPRESS MY **INNER FEELINGS**. IN REALITY I'M A **TAKE-CHARGE** KINDA GUY WHO ISN'T AFRAID TO **KICK ASS** WHEN THE SITUATION DEMANDS IT! I'VE BEEN KNOWN TO FUCK PEOPLE UP WHEN THEY GIVE ME SHIT!

NO GUTS, NO GLORY!

GO AHEAD, BURN **THIS** FLAG!

YOU AND WHAT ARMY?

MAKE MY DAY!

DUKES OF HAZZARD

OPERATION DESERT SHIELD

THE ACTUAL, REALLY REAL CLOWES

CRUMPLE

OKAY, MAYBE THAT'S NOT QUITE RIGHT EITHER... I'M MORE KIND OF A YIPPIE / REVOLUTIONARY / UNDERGROUND TYPE O' GUY... LIKE ONE OF THE **WEATHERMEN**... O-OR THE **FREAK BROTHERS**... ...LIKE AN **IN-THE-TRENCHES**, ANTI-ESTABLISHMENT, COUNTER-CULTURE KIND OF...

CRUMPLE

SSUCK

HAIRCUT INSPIRED BY "BERNIE" FROM "ROOM 222"—ED.

CLOWES, HONEST-TO-GOD

... BUT NOT REALLY, I SUPPOSE... I MEAN, I DON'T HAVE A 'POLITICAL AGENDA'... I'M MORE OF A **DETACHED OBSERVER**...A SCHOLAR OF SORTS, THOUGH I'M CERTAINLY NO EXPERT... KIND OF A STUDIOUS, SELF-EDUCATED... UM... LIKE A... YOU KNOW... A...

RIIPP

UFO'S

HEADSHRIN

JAI-ALAI

YOU GET THE IDEA, RIGHT?

TO BE HONEST, I GUESS I'M EMBARRASSED TO ADMIT IT BUT LOOKING AT IT OBJECTIVELY I'M PROBABLY JUST A TYPICAL, SQUARE, BLAND, AMERICAN 'CARTOONIST'...LIKE CHARLES SCHULZ OR THE GUY WHO DRAWS 'GARFIELD'!

CRUMPLE

ASSISTANT

OKAY, SO I'M A CROSS-DRESSING, ABSYNTHE-DRINKING, NECROPHILIAC SNUFF-BOX COLLECTOR!...

CRUMPLE

ETC., ETC.

86. "Just Another Day," in *Eightball* 5 (1991), Daniel Clowes.

87. *Daddy's Girl* (1996), Debbie Drechsler.

88. "Hypothetical Quandary," in *American Splendor* 9 (1984), Harvey Pekar and Robert Crumb.

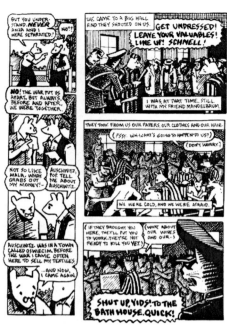

89. *Maus* (1992), Art Spiegelman.

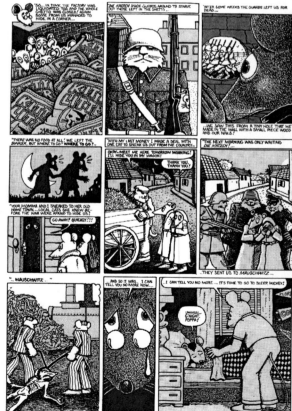

90. "Maus" (1972), Art Spiegelman.

Chapter Five

The Graphic Novel

Comics are appearing in bookstores as novels and in museums as art.[1]
—Chris Ware

The End of the Alternative

With the arrival of the 21st century, the concept of "alternative" is losing meaning, except as a now conventional label that has a certain usefulness for distinguishing between "types of comics" among connoisseurs. The system of oppositions that gave meaning to said term is losing its validity, or is being altered, with the success of the graphic novel in the general interest bookstores through literary publishers, like Pantheon in the United States, Gallimard in France and Random House Mondadori in Spain. If "alternative" had been defined under the category of comic book and by opposition to the dominant genre of superheroes in the specialty bookstores during the 1980s and 1990s, in the new landscape of general interest bookstores and cultural supermarkets a realignment is occurring. The material we had once viewed as alternative, and that often deals with themes related to memoir, autobiography, history, or non-genre fiction is becoming the dominant material for a general and non-specialist reading public, while the dominant material in the specialty bookstores, which is to say, fantasy and superheroes, which follow adult graphic novels into the general interest bookstores, occupies a specialized niche, similar to what is happening in other sectors of cultural consumption, like literature and film, in addition to serving as fodder for Hollywood's overproduction of special effects. This

trend, on the rise over the first decade of the century, coincides with an increasingly pronounced decline of the comic book, including the super-hero comic book, whose presence is waning at the newsstands and mass points of sale. In May of 2009, for the first time in history, no comic book reached 100,000 copies sold.[2] Forty years earlier, in 1968, DC would cancel a collection like *Doom Patrol* because sales had fallen to *only* 250,000.[3]

The comic book's road into the sunset was being announced in the "alternative" world even before this. Peter Bagge's *Hate*, the best selling comic book of the 1990s, and which had been the generational symbol for the new cartoonists, had concluded in 1998. Of Seth's *Palookaville*, only six issues appeared between 2000 and 2009, compared to thirteen between 1991 and 1999, and what was worse, the author still has not managed to finish the picture novella that he serializes under the title *Clyde Fans*. Especially significant have been the changes experienced by the comic books of the two most important figures of the movement: Daniel Clowes and Chris Ware.

Clowes created *Eightball* in 1989 to be "my own version of Mad Magazine, except like a really twisted, dark-spirited version of that."[4] Over the course of its first eighteen issues, *Eightball* maintained that miscellaneous spirit and was rigorously faithful to the comic book format, the only alteration to which was to add increasingly more pages in color as increased sales made this economically viable. In 1998, while *Hate* was dying, *Eightball* was transformed. It retained the staple, but increased its dimensions to a size more comparable to that of a magazine, and its content went from diverse to monographic. Issues 19–21 (1998–2000) were dedicated exclusively to serializing in three parts a complete graphic novel, *David Boring*. The comic book inspired by the comic books of yesteryear was being turned into an installment for the pre-publication of a lengthy work. The next two issues conserved the larger format and accentuated even more the shift to homogeneous content: issue 22 (2001) was dedicated to just one story, *Ice Haven*, which was reissued in 2005 as a hardcover book by Pantheon, changing its format to a landscape layout. Issue 23 (2004) was again a single story, *The Death-Ray*, which still has not been restructured as a graphic novel, perhaps because for its content and purpose—it is Clowes' peculiar vision of a superhero—the current stapled format seems to be the most appropriate one. Significantly, a new *Eightball* has not been issued since 2004.[5] In part, this has been a consequence of external factors—Clowes suffered a cardiac illness that kept him from working for months, and he has also dedicated much of his time to the development of several film projects, following the success of the film adaptation of his graphic novel *Ghost World* (2001)—but

in part this has been a consequence of difficulties presented by re-locating the comic book within the new horizon of adult comics. Clowes recently expressed those doubts:

> Nobody's really—nobody wants to deal with selling the comic format any more in America, it's just an antiquated format. It's mainly because it has to be inexpensive, people expect them to be—to not cost a lot. So stores make no money off of them, so they're not interested in promoting them. And I could do it in that way, but it feels somehow like its time has passed, and it feels like an affectation rather than just doing . . . I always wanted it to just feel like, you know, the comic books of my childhood. And now it just feels like I'm quickly trying to do some old-fashioned thing that doesn't exist anymore, so it feels like I have to modify the way I'm doing comics, you know, packaging the comics, I guess.[6]

The shift in cartooning from the style of "the comic books of my childhood" to the apparent demands of the contemporary graphic novel has not been painless for Clowes. At times, as with *Ice Haven*, this shift could be carried out by simply adapting material to a new format [99]. *Ice Haven* is a choral narrative that, though the premise of its storyline is an alleged child murder (based on the real case of the Leopold and Loeb murder of the 1920s), has as its true purpose the examination of a range of odd characters in the life of a small city. In order to tell this story, Clowes assembled the pages as if they were daily cartoon strips and the Sunday pages of newspapers from the 1950s and 1960s, which is to say, as seemingly heterogeneous and independent units that nonetheless were inter-related. In its book version, or "comic-strip novel," *Ice Haven* went from over-sized stapled comic book to small format, hardcover book in a landscape format. Clowes would comment that "The story works better for me in book format. It seems denser. Flipping through the book, as opposed to the comic, it feels substantial in its own way."[7] The issue of *density* had been a concern for adult cartoonists for a long time. In 1997, Max declared that, compared with literature, the comic "is no less elevated, but I do believe that it has less density. For me it is an issue of density, of the quantity of concepts per square centimeter of page."[8] Of course, the rise of the graphic novel had imposed upon cartoonists the obligation of demonstrating its density in their cartoons. For many years, *Maus* had been an example of a comic capable of being dense, but its prolonged solitude had encouraged the idea that it was an extraordinary and unrepeatable phenomenon, whose merit perhaps lay in the theme it

addressed, and not in the form with which it was addressed. The recouping of the formal ambitions of *Maus* by Chris Ware as well as Clowes, following *David Boring* and *Ice Haven*, required serious cartoonists to pose greater challenges for themselves. For Clowes, that threshold assumed a *preoccupation with density*, which led him to undertake a project that in the end, after putting it in perspective following his recovery from illness, he decided to abandon. In his own words:

> I spent about a year working on that thing that I just—I was trying to write this dense novel all at once, and it just seemed that I was trying too hard to do a *graphic novel*, it felt really restrictive. I had to stop working on that. Since then, I've done a bunch of smaller things. I don't know, it didn't have as much to do with doing the movie stuff as just needing some time to stop doing comics for a while and kind of rethink it. I just felt like the idea of doing a comic book all of a sudden seemed like it didn't feel right anymore. And I had to figure out how to do comics, I didn't necessarily know if I wanted to do single books, I couldn't quite figure out how to do it. Now I feel that I have sort of an idea of how to approach it, and I feel more . . . like I see a future of what I can do ahead of me, and for a few years I just couldn't quite see what I could be doing, I couldn't figure out the terrain of the comic business anymore.[9]

That *tendency toward density*, as we have noted, has a lot to do with the ascension of Chris Ware's cutting edge comic *Acme Novelty Library* into a prominent position within the international scene. *Acme* began in 1993, and its first issue [100] followed the model of the stapled alternative comic book, canonical at that time. However, beginning with issue number 2 (1994), which adopted an unusual gigantic size, *Acme* would never again look like what we identify as a conventional comic book. Until issue 14 (2000), in which the serialization of Jimmy Corrigan was concluded, Chris Ware experimented with every kind of form and format, placing emphasis on design and increasingly distancing himself from anything recognizable as a comic book. But with the turn of the century, the differences between the original standardized format and the direction followed by the publication would be accentuated in the extreme. Issue number 16 (2005) of *Acme* would be the first self-published by Ware—whose demanding attention to detail had caused him to clash even with Fantagraphics, the publisher par excellence of alternative comics, known for giving absolute freedom to its authors—and from then on, *Acme* would appear in hardcover, looking more like an independent book in each edition than like an installment in a

collection of periodical publications. The content of the later issues of *Acme* is also monographic, as in the case of the most recent issues of *Eightball*. Each volume includes pages from one of the graphic novels that Ware has under way, but the cartoonist aims for the included segment to stand on its own as a self-contained reading experience. In other words, each *Acme* is now a miniature graphic novel that contains the seed of a future, larger graphic novel.

The culmination of this process of substituting the comic book with the graphic novel as the preferred format arrives with the appearance of comics that present themselves directly in this form, without having passed previously through pre-publication in a fragmentary and serialized medium. The paradigmatic title of this trend, and one that perhaps confirmed its commercial viability, is *Blankets* (2003) [101], by Craig Thompson. With a length of nearly six hundred pages, *Blankets* was an unusual effort in a medium for which more substantial works were customarily created, bit-by-bit, by accumulation. Moreover, Craig Thompson (1975) was barely twenty-eight years old when he published the book, meaning that the success of *Blankets* served as confirmation that there was a new generation of graphic novelists who had grown up reading the alternative greats of the 1990s, and that this new generation was reaching a new audience, one that had not started out in the specialty bookstores. Works like the recent *Bottomless Belly Button* (2008) [102] by Dash Shaw, corroborate that the avenue remains open. Dash Shaw (1983) was between twenty-two and twenty-four years old when he drew this 720-page book. Never, since Rodolphe Töpffer began to compose his *histoires en estampes*, had such long stories in comics form been published directly as a unitary book.

Masters of the Graphic Novel

The central figure for this new graphic novel is Chris Ware (1967). Born in Omaha (Nebraska), he studied at the University of Austin in Texas and currently lives in Chicago. Ware made himself known at barely twenty-one years of age when Art Spiegelman invited him to collaborate on the last two issues of *Raw* (1990–1991). There he published a comic that would typify his interest in experimenting with the tools of the medium: "Thrilling Adventure Stories" (also known as "I Guess") [103], in which an intimate and autobiographical textual narrative occupied all of the spaces, diegetic or not, dedicated to the word—speech balloons, text boxes, but also

onomatcpoeias—in a pastiche of a superhero cartoon from the 1940s. In 1993 he started his own comic book, *Acme Novelty Library*, on the emblematic Fantagraphics imprint, where Los Bros, Daniel Clowes and Peter Bagge could already be found. In *Acme*, Ware collected the pages he was publishing in a variety of magazines and periodicals, like *The Daily Texan*, *Newcity* and *Chicago Reader*, and gave them new form by adapting them to the extravagant formats he invented for his magazine, heavily influenced by modernist graphic design. Ware established a name for himself with the publication in book form by Pantheon of *Jimmy Corrigan, the Smartest Kid on Earth* (2000) [104], previously serialized in Acme. *Jimmy Corrigan* is the story of three generations of males of the Corrigan family, from a present situated in the 1980s through a past located in 1893, during the World's Columbian Exhibition in Chicago. The main theme of Jimmy Corrigan was abandonment and loneliness—just like his protagonist, Ware was also abandoned by his father as a child, and during the creation of the work he briefly re-established contact with him without having sought it out—but what was truly novel was the way in which Ware reinvented the language of comics in order to express feelings and nuances that up until then seemed out of reach for an art born as vulgar entertainment. This effort to reinvent the language of comics was a very conscious one on Ware's part:

> For example, if somebody wanted to make a film about their life, they probably could. It might not be any good, but because everyone grew up watching movies, everyone is steeped in the language of film, and they could muddle through the process of conveying their intentions. Or if somebody decides to sit down and write their memoir, they can do it. Just look at the size of an English dictionary: we have a huge vocabulary of words and the grammar to express our feelings with subtlety. But whenever you try to write about life using the basic received structure of comics the result ends up generally feeling like a sitcom. The only way to change this is to keep on making comics, again and again, so that the language accrues the means for conveying details and nuances.[10]

That reinventing of the language of comics upon which Ware is embarked passes through a questioning of the film tradition and of the invisible narrative inherited from Milton Caniff by way of the comic book, and through a recuperation of aspects of the comics pioneers, from Winsor McCay and George Herriman to Fran King. In other words, reclaiming the value of the page as a visual element, as a graphic unit that is not only read, but is viewed. Add to this the questioning of the hierarchy of drawing and the

word—in Ware's cartoons, at times the functions of the two are switched [105]—and the importance of the design and materiality of the book as an object, expressed through production values as well as through advertisement parodies—an updating of the legacy of Kurtzman's *Mad*—and the cut-outs it offers.

Ware is, without a doubt, the artist who best reflects his own statement, with which we opened this chapter. His comics are being recognized as literature: *Jimmy Corrigan* won the First Book prize of the British newspaper the *Guardian* in 2001, the first time it was won by a graphic novel; he was asked to contribute a comic to the aforementioned anthology of contemporary narrative, *The Book of Other People*,[11] and has illustrated the cover of the magazine *Granta*.[12] And, of course, his comics are an increasing presence in the museums as well. He has participated in the Whitney's 2002 biennial, and an individual exhibit of his comics pages has been featured at the Chicago Museum of Contemporary Art in 2006. Naturally, Ware's penetration of the temples of institutional culture has not left the more conservative critics indifferent. Referring to this last exhibit, Alan Artner, the art critic for the *Chicago Tribune*, wrote that it would attract "the many adults who have had development arrested by comics and their more muscular relation, graphic novels,"[13] demonstrating how long the road remains for Ware and his contemporaries to travel before a change in the perception of the comics medium can be achieved.

But Ware has not limited himself to being the object of exhibits; he also has carried out an important theorizing role, writing articles, editing anthologies and curating exhibits himself. Thus, he was responsible for number 13 of the literary magazine *McSweeney's*, dedicated to comics, and for the anthology *The Best American Comics 2007*, and directed an exhibit dedicated to cartoonists at the University of Phoenix. His facility for analysis and precise expression, as well as the immense authority arising from his status as author, have made him an authentic oracle of the new literary and cutting edge comic. More than just a key figure in the United States, his importance has international reach. In France, *Jimmy Corrigan* won in 2003 the best book prize at the International Comics Festival of Angulema, the most important in Europe; it had been more than fifteen years since the prize had been awarded to a foreign author. In 2010 a monograph was published focused on the study of his work, beginning with a renunciation of all nationalist chauvinism on the part of the authors: "Chris Ware est sans doute le plus important auteur de bande dessinée de ces dernières années, et pas seulement aux États-Unis, son pays de naissance et de résidence."

(Chris Ware is without a doubt the most important comics author of recent years, and not only in the United States, his country of birth and residence.)

The importance of Ware for the new graphic novel can be measured by the influence he has had on his own contemporaries. Two of the main figures of the movement, Daniel Clowes and Seth, have shown the impact of the author of *Acme*.

Daniel Clowes (Chicago, 1961) was modifying the appearance of *Eightball* and giving greater importance to design, following in Ware's footsteps. The first three graphic novels that he serialized in his own comic book followed the conventions of invisible and coherent narration: *Like a Velvet Glove Cast in Iron*, *Ghost World* and *David Boring*. Only *Ghost World* was structured in self-contained but homogeneous episodes, and this approach appears to have followed the model of the stories of Buddy Bradley that Peter Bagge published in *Hate*. But after the publication of Jimmy Corrigan, Clowes' last two works to appear in *Eightball* were composed through the assemblage of short and heterogeneous comics, which usually expressly quote genres and styles from the history of comics, and foreground for the reader the mechanisms of construction, in the manner of Ware. In fact, in the same way that Ware transforms his pages in their various phases of publication (first, when they appear in the original magazine or newspaper, then, when they are adapted to *Acme Novelty Library*, and finally, when they are published as a book), Clowes created a modified version of *Ice Haven* when it went from its original publication in comic book form in *Eightball* 22 to its publication as a landscape format book of strips.

The Canadian Seth (whose real name is Gregory Gallant, from Clinton, Ontario, 1962) has published since the 1990s his comic book *Palookaville*, in which would appear the graphic novel (or picture novella, as he prefers to call it) that gained him fame, *It's a Good Life, If You Don't Weaken* (1996), a falsely autobiographical work, as we have noted, in which Seth himself tells of his search for an old forgotten cartoonist. Seth's work has always been distinguished by nostalgia for a lost era that he never experienced: he even wears suits and hats in the style of the 1920s. It is that yearning for by-gone periods through their objects and buildings, and through old and lonely characters that lived through them, which appears in the still unfinished *Clyde Fans* and in his last book, *George Sprott* (2009), published originally in installments in *The New York Times Magazine*. *George Sprott* [106] displays a series of elements in common with Ware's projects: the marked importance of the design and materiality of the book, the nostalgia for pre–World War II products and buildings, and, above all, the construction of the story on

the basis of an assemblage of varied materials: single page cartoons in distinct styles, advertisements, illustrations, etc. At a deeper level, Seth also shares with Ware a slow rhythm, an interest in the insignificant details and moments of life, and an obsession with loneliness as a theme, but it is fair to say that these features were already detectable in his work prior to the influence of *Jimmy Corrigan.*

In addition, Seth has developed over recent years the skills of an exquisite book designer and also has written prologues and commentaries. While Ware has written about classics but also has always focused a great deal of attention on recent artists, Seth has been more interested in the masters of the past, like Lynd Ward and Frans Masereel, the woodcut novelists of the 1920s and 1930s, or like the Englishman Raymond Briggs, author of children's stories and comic books for adults since the 1960s, who is now being rediscovered as yet another of the pioneers of the graphic novel. Seth has also followed Ware in his efforts to spruce up re-editions of comics classics with designs adapted to the current taste of cutting-edge comics. If Ware has been responsible for the graphic aspect of collections of George Harriman's *Krazy Kat* [107] and Frank King's *Walt & Skeezix (Gasoline Alley),* Seth has put his name to those of Charles Schulz's *Peanuts (Charlie Brown and Snoopy)* [108], John Stanley's *Nancy* and *Melvin Monster* and a monumental collection of the Canadian humorist Doug Wright. In other words, we might say that Seth not only has found creative possibilities for his own works through the formal discoveries of Ware, he also has repositioned himself within the field of the contemporary graphic novel: not only as an important author, but also as a frame of reference who determines aesthetic and design trends, and who identifies and praises works of the past that are thus canonized as valid examples for the learned artists of the present.

Together with Ware, Clowes and Seth, the principal masters of the graphic novel to emerge from the alternative comic book are the brothers Hernandez, Chester Brown, Charles Burns and Gary Panter. The first of these are situated, as we have seen, at the origin of the entire alternative school. Clowes himself would declare his indebtedness to them, as a source of inspiration: "They were really the first pioneers of my generation."[14] Their continued activity over the past twenty-five years has made them a model for several generations, despite the fact that their production has never been an easy fit with the graphic novel format. The stories of Gilbert and Jaime, always originally published in the varied incarnations of *Love and Rockets* or in other derivative comic books they have launched over the years, are eventually compiled in book form in very different ways, but very rarely

constitute titles with clear autonomy. Only Gilbert, the most adventurous of the family, has produced several completely independent graphic novels in recent years, all of them distant from the fictitious universe of Palomar and its characters, or related only tangentially to it, and frequently not on its mother imprint, Fantagraphics. Nevertheless, the characters, aesthetics and narrative style of the brothers Hernandez have been a constant model for many of the young authors with literary roots, from Adrian Tomine to R. Kikuo Johnson.

Chester Brown (1960), together with Joe Matt and Seth, with whom he maintains a close friendship often reflected in the more autobiographical comics of all of them, is one of the three most important Canadian cartoonists of the 1990s. Brown was one of the first alternative cartoonists to develop stories of substantial length through his comic book, *Yummy Fur*. *Ed the Happy Clown*, an unsettling surrealist odyssey of more than 200 pages, was compiled as a book in 1989. Later, two master works would appear that would have a great influence on subsequent autobiographical comics: *The Playboy* (1992) and *I Never Liked You* (1994), both centered on the emotional experiences of adolescence. The brutal sincerity of Brown's stories has been the standard for the dozens of cartoonists who later set out to recount the experiences of their youth. Following the failure of *Underwater*, the story of a child from birth onward told from the child's own point of view, which the artist abandoned prior to completion, Brown took a surprising turn with Louis Riel (2003) [109], a "comic-strip biography" that narrates with a detached tone of objectivity the life of a nineteenth century Canadian revolutionary.

Charles Burns (1955) and Gary Panter (1950) seem at first glance to be opposites, but the two have a lot in common. Both made themselves known in Art Spiegelman's *Raw*, and they have collaborated on *Facetasm* (1998), an intriguing book where faces drawn by both artists are cut into three sections, so that parts by Burns and parts by Panter can be combined, creating thousands of possible changes. It was Matt Groening, the creator of *The Simpsons* and author of the humor comic *Life in Hell*, and who had gone to school with Burns, who introduced the two artists. Burns made a name for himself with his short stories that reused pastiches from the more conventional comics of the 1950s and 1960s, perverting the rigid rules of standardized genres with his obsession for the monstrous, the bizarre, and the sickly. Although he invented a recurring character, El Borbah, an absurd cross between a Mexican professional wrestler and a private detective, Burns insisted more on the traumas of adolescence, personified in the

Freudian Dog Boy, a well-groomed lad driven by canine instincts. Burns' style replicates in careful detail the techniques of commercial cartoonists of the mid-twentieth century, with inking of a thick and perfect, extremely precise stroke. The culmination of all of Burns' obsessions would come with *Black Hole* [110], published in comic book form over a period of ten years and finally as a book in 2005. *Black Hole* returns to the theme of the disorientation of adolescence through the allegory of illness, in the enigmatic setting of an American town during a 1970s drawn from mythic memory.

Panter's aesthetic is completely distinct from that of Burns. In contrast to Burns' vigorous formalism, Panter renounces all convention in an orgy of doodles that become his image panels in a kind of *comic brut*. In the pages of *Raw*, Panter introduced a recurring character, Jimbo, who serves as a figure and pretext for carrying off all kinds of comics. His last title, the monumental *Jimbo in Purgatory* (2004) [111], led him to paraphrase Dante, whose work he had already approached in *Jimbo's Inferno* (1999, re-issued in a format similar to that of *Purgatory* in 2006). Panter's originality and freedom have exercised a large influence over new generations of cartoonists—many of whom he has shaped directly in his role as professor at the New York School of Visual Arts, where David Mazzucchelli and Art Spiegelman, among others, have also taught classes—such that he can be considered the father of an anti-formalist graphics trend in avant-garde comics and, in a way, the grand paternal figure who counterbalances the attraction exercised by Chris Ware's meticulousness. Ware himself has acknowledged Panter's pioneering role in the shift towards formal experimentation in the service of a new and more artistic sensibility: "The cartoonist Gary Panter has to be given credit more than anyone for this change, in the 1970s and 1980s inventing a new way of visual storytelling that articulated and highlighted the emotional shifts of experience with a pen-on-paper pithing out of synaesthetic sensations of memory into an inseparable alchemy of poetry, calligraphy, and vision that leaves the reader reeling."[15]

What Burns and Panter share is their treatment of mass cultural images—whether that be for Burns the romance comics of the 1950s or for Panter the children's humor series *Nancy*, which he reveres—as a pop artifact readapted for personal expression. Panter relates the process with the typical Situationist strategy, although "it was really only later that I realized that *détournement* is kind of what I do in my comics—taking one source and changing the application."[16] With Burns and Panter the doors to the history of comics were blown open, allowing the new cartoonists to loot at will, reusing conventions, styles, and types in projects of a personal scope.

It was no longer a question of representing reality, but of reprocessing processed images and recognizing the reality created by the symbolic universe of manufactured objects and images in which we live.

The Move toward Reality: From the Individual to the Social

Autobiography, often in its most banal and exhibitionistic form, was the vehicle that set in motion the takeoff of alternative comics on their journey toward the graphic novel. This is why the stature of the great outsider of recent American comics, Harvey Pekar, the author who was neither underground nor commercial, has grown enormously in recent years (the success of the film *American Splendor*, 2003, has also helped). Of course, the roots of this trend start with Robert Crumb, Justin Green and Aline Kominsky, but as R. Fiore observed, "Pekar's career had two vital lessons for the cartoonists that followed: 1) Don't allow anyone to tell you that your experience isn't a valid subject for your art; and 2) Don't take no for an answer."[17] In effect, Pekar not only gave shape to a type of comic that was frequently solipsistic, depressive, and anti-emotional, but also to a cartoonist profile built upon an awareness of the outsider role that was, nonetheless, immune to discouragement. The loser's ethic, the expressed renunciation of success, resonated with the neurotic Generation X that listened to Kurt Cobain during the 1990s, as shocking as that might have been for Pekar, a sophisticated connoisseur and reviewer of avant-garde jazz. Pekar was more of a proletarian intellectual and child of the Beat generation than an eternal teenager and middle class consumer, like most of his followers.

Pekar's blatant exhibitionism, above all in his early period, was followed by previsouly mentioned cartoonists, like Joe Matt, Julie Doucet, and Debbie Drechsler, and others who committed to the page painful or difficult episodes from their pasts. Phoebe Gloeckner recounted in the sordid *A Child's Life* (1998) and *Diary of a Teenage Girl* (2002)—combining text, illustration and cartoon—her own sexual memories through a fictitious character. Gloeckner has always denied that her work is autobiographical, although those assertions have been placed in doubt by criticism. There is an entire current of abject sexual confessions that has been produced by female graphic novelists since the 1990s, perhaps as part of a confrontational gender politics.

The work of Pekar, who, as we have said, does not draw his own cartoons, instead leaving them in the hands of various graphic collaborators of uneven

quality, also put on the table a pressing issue for the most recent wave of authors: the issue of professional trade craft. Although Ware, Clowes, Seth, Burns, the Bros and Tomine, among others, are cartoon artists of outstanding quality who, in addition, have continuously polished their mastery of the drawn image over the years, and have continued to invest ever more effort in the general design of their works, Pekar's cartoonists, who occasionally were not on a par with their best collaborators, and the careless design of their comics suggested that, in autobiography, honesty was the main virtue, and there was no need for much in the way of formal development to bring all of its power to the page. This, along with the explosion of mini-comics—photocopied comic books—during the 1980s and 1990s, and the access to university level artistic education on the part of a growing number of new cartoonists, who thus learned the principles of contemporary anti-academic art, facilitated the development of a whole current of confessional minimalism. These are cartoons that treat life itself seemingly without emotional distance from the content, avoiding whenever possible the censoring of events and feelings, and with great immediacy in the graphic component. James Kochalka, one of the firmest opponents of "trade craft," has developed a diary [112] since 1998 that required him to draw on a daily basis a little cartoon recounting an everyday event. Despite the simplicity of his graphic design, Kochalka chose to represent himself as an elf, in a surprising rhetorical twist that recalls Spiegelman's choice of anthropomorphic animals for the characters in *Maus*. If in *Maus* the mice allow us to *truly* imagine the Holocaust, in *American Elf*, the elf allows us to see the ordinary and routine as if it were new. In the compilation of the first five years of *American Elf*, Kochalka writes, "I am a human being. We all are. And we all do a hundred thousand little things every single day. And each day I pick one of these little experiences and draw a comic strip about it. I've been keeping this diary for over five years now. The days go by. The pages fill up. And the row of black sketchbooks grows on my shelf. Each individual strip might be close to meaningless. But together they gain power. Together they are becoming a fully realized portrait of my life."

Jeffrey Brown debuted with *Clumsy* (2002) [113], which narrated through brief, chronologically out-of-sequence scenes the second important relationship story by the author. The evident lack of professional quality in the drawing—filled with errors and imperfections—made it difficult for Brown to find a publisher. Nonetheless, once the work was published, it became a rapid international sales success, thanks to the spontaneity and immediacy with which it conveyed the author's experiences. Improvisation in the

script and the drawing was consistent with the improvisation with which Brown had staged those same scenes in his real life. John Porcellino and David Heatley are two more of the exponents of this trend of confessional minimalism related to the broader preoccupation with memoir on the part of a considerable group of contemporary American cartoonists.

Thus, in the wake of Chester Brown, with his returns to adolescence, or even of Art Spiegelman, with *Maus*'s recovery of family history, one can find titles by David Small, Alison Bechdel, Lynda Barry, Carol Tyle, R. Kikuo Johnson, Gene Luen Yang, Nate Powell, and Mariko and Jillian Tamaki, among others. In *Stitches* (2009), Small reclaims his traumatic childhood, plunged into silence after an operation to remove a cancerous tumor that damaged his vocal chords. The psychological tension experienced by his family, presided over by his irascible mother, a closeted lesbian, is reminiscent of what Bechdel describes in her dense *Fun Home* (2006) [114], which was received by literary criticism as one of the year's best novels, graphic or not. *Fun Home* tells the tale of the author's discovery of her own homosexuality at the same time as her father's, whose death, attributed to an accident, Bechdel suspects was a suicide. Carol Tyler follows this path of a search for the father in *You'll Never Know* (2009). Lynda Barry, in *One Hundred Demons* (2002), reworks the memories (the "demons") of childhood and adolescence through thematic chapters ("Magic," "Dancing," "Magic Lanterns," "San Francisco," "Common Scents"), produced with a naive color palette, perpetually perplexed by the ever-new emotions of life.

The exploration of adolescence has also brought with it the themes of identity and race, which had remained always in the background of alternative comics, despite that fact that its founding fathers, the brothers Hernandez, would flood *Love and Rockets* with Latino characters and an interesting linguistic mix of English and Spanish. It is worth mentioning a curious distant precursor. *Manga Yonin Shosei* (The Four Immigrants Manga) is a comic of 112 pages written and drawn by Henry Kiyama, a Japanese immigrant to San Francisco who recounts his experiences and those of other expatriates during his stay in the United States between 1904 and 1924.[18] It displays the typical recognizable features of the comic: narration divided in several image panels per page and dialogue balloons. These latter demonstrate an unusual bilingualism, since the American characters speak in English (an incorrect English, it should be noted, lest we forget that those dialogues were written by a Japanese immigrant who was learning the language) while the Japanese characters speak Japanese. Composed of fifty-two episodes, each of which contains a humorous treatment in the

style of American newspaper comics of the time, the book represents at the same time an autobiographical testimony and a portrait of life in San Francisco in the first quarter of the twentieth century.

The remote descendent of *Manga Yonin Shosei* is *American Born Chinese* (2006), by Gene Luen Yang, which questions the dual identity, inherited and acquired, of its protagonist, interweaving teenaged insecurities with the Asian mythology of the Monkey King. A short time before, *Same Difference* (2003) had appeared, a collection of personal stories by Korean-American Derek Kirk Kim, who alludes to the same set of issues. Luen Yang and Kirk Kim have collaborated more recently on *The Eternal Smile* (2009). Perhaps encouraged by this spirit of self-exploration, another cartoon artist who had developed his career with scarce attention to his own roots, Adrian Tomine, of Japanese descent, broaches that issue in his latest graphic novel, *Shortcomings* (2007), featuring as its main character a young Asian-American obsessed with black women and his own feeling of alienation. For his part, R. Kikuo Johnson is Hawaiian, and he redraws in *Night Fisher* (2005) the idyllic Hawaii of postcard fame as a wasteland for the post-teenage failures of his stand-in, a brilliant student stuck in that stage prior to entering into real life that Holden Caulfield represented so well in *The Catcher in the Rye*. Canadians of Japanese origin Jillian and Mariko Tamaki also return to the relationship traumas of high school in *Skim* (2008), as does Nate Powell in *Swallow Me Whole* (2008), in what has begun to distinguish itself almost as a subgenre of its own.

Even so, many comics artists, among them some of the most important of the first alternative generation, have kept their distance from direct personal or family autobiography, constructing their tales with personal elements, but fictionalized ones. Such is the case with the aforementioned Gilbert and Jaime Hernandez, Daniel Clowes, Chris Ware, Charles Burns, Seth, and Adrian Tomine. Jessica Abel is another of those who have made use of their own experiences in order to weave a fiction with one foot in autobiography and the other in genre with *La Perdida* (2005), in which a US girl with a Mexican father travels to Mexico to discover herself and winds up involved in criminal intrigue. But others have also practiced a kind of fiction that hews less to reality. Kim Deitch, for example, is a classic from the underground redeemed for the graphic novel with his mythological stories about the origins of animation, like the *Boulevard of Broken Dreams* (2002). An equally mythological treatment was applied to the history of comics by New Zealander Dylan Horrocks in *Hicksville* (1998), which imagined the existence of a secret town that possesses all of the great works that the

industry had not allowed professional artists to publish. American mythology in its broadest sense is the theme that occupies Tim Lane, who in *Abandoned Cars* (2008) revisits the topics of literary Bohemia—the wanderings of hoboes on freight trains, losers' bars—in the shadow of Hemingway and Kerouac. Richard Sala represents perhaps the limit case of this trend toward the recycling of popular cultural themes, with his highly stylized stories of horror, crime, and mystery that mix in stereotypes from newspaper serials, ironically rehabilitated, with the neo-Gothic graphic distancing of an Edward Gorey.

The move away from personal experience has not only led to fiction, but also to history. Once again, here Art Spiegelman's *Maus* is an unavoidable touchstone, although the underground artist demonstrating the greatest interest in historical themes was Jaxon, who had already begun in the 1970s to draw, based on exhaustive research and with the formal freedom given to him by the comix underground, the history of his state in *Comanche Moon*, *The Alamo*, *Los Tejanos*, and other titles. Of course, the Franco-Belgian industry has a long "historical" tradition since at least the post-war period, but it deals with a type of comic that, although researched, is conceived as a variation on the adventure genre. However, historical comics interested fundamentally in events, which in "historical adventures" serve only as a backdrop, had not had much impact until recently, when more and more artists have been turning their attention to the genre. At times, as we mentioned in the case of Chester Brown's *Louis Riel*, this is done with an air of objectivity, while in other cases, the facts are fictionalized in an abstract historical landscape, as with Frank Santoro's *Storeyville* (1995), which is set in the years of the Great Depression and centered on a vagrant who searches for a friend. More detailed and painstaking in its reconstruction is *Berlin* (2008), by Jason Lutes, who attempts to recapture the ambience of the German capitol in the years prior to the rise of the Nazis. James Sturm is another one of those who have delved into history, and in *Above and Below* (2004) he brings together two tales "of the American frontier." History can also reference more recent events, as with *Laika* (2007), by Nick Abadzis, focused on the life of the dog that was the first space traveler to leave planet Earth.

The historical graphic novel has established a kind of relationship between the comic and reality that had never been seen before, and which is a cousin of a still incipient but very interesting phenomenon: journalistic comics. There are very few cartoon artists with the journalistic training necessary to approach the task rigorously, and the press has not treated

it generally as much more than a mere curiosity, perhaps because of the immediacy that news requires and the extended time commanded by the production of comics, which has resulted in general in the reduction of cartoon journalism to the sporadic forays of authors like Kim Deitch, Jessica Abel, Ted Rall and Peter Bagge, or to isolated protest books like *Addicted to War* (1991, updated in 2002), by Joel Andreas, about the military-industrial complex of the United States, or reportage-books like *9/11 Report: A Graphic Adaptation* (2006), by Sid Jacobson and Ernie Colon, which conveys through cartoons the conclusions of the official commission investigating the terrorist attacks of September 11. In Spain, Pepe Gálvez, Antoni Guiral, Joan Mundet and Francis González undertook a similarly ambitious project with *11-M: La novela gráfica* (2009), which uses as its main narrative storyline the judicial ruling on the terrorist attacks against trains in Madrid in March of 2004. One can also locate on the border between reporting and fiction *Shooting War* (2007), by Anthony Lappé and Dan Goldman, who create a political fantasy based on the media reality of the war in Iraq.

But, most importantly, comics journalism has produced one of the great names of the contemporary graphic novel, risen from the ranks of the alternative cartoon artists of the 1990s. Joe Sacco (1960), a U.S. cartoonist born in Malta and with a degree in journalism, has drawn reportage about the world of rock, but became famous for his comics about conflict zones, especially *Palestine* (1993) [115] and *Safe Area Gorazde* (2000). Rocco Versaci has observed that journalism in comics form has a sincerity superior to that of the conventional media, since the marginal position of the medium allows it to transmit truths that are silenced or manipulated by economic interests in the mainstream press. In fact, Sacco has produced great reporting on his own, and not for journalistic institutions, applying to comics with absolute freedom the subjectivist principles of "New Journalism," in particular "the foregrounding of individual perspective as an organizing consciousness."[19] In effect, Sacco, who is introduced as one of the characters in his stories, linking them in this way with autobiographical comics, exploits all of the resources that comics art places at his disposal and that would be beyond the reach of simple prose reporting: "Sacco foregrounds his role as reporter not simply through his presence but also through his artistic style. That is, Sacco draws himself in a much more cartoonish and exaggerated manner than the others around him, and this strategy causes him to stand out as someone who doesn't quite 'fit' into this landscape or with its native inhabitants."[20]

That same subjectivity is the cement with which *L'Affaire des affaires* (The Business of Businesses, 2009) is constructed by the celebrated investigative

journalist Denis Robert, accompanied by cartoonists Yan Lindingre and Lauren Astier. Robert practices what Mariano Guindal calls in the prologue to the work "black journalism," delving into the deep networks of corruption that implicate European governments and big businesses. The narration is unequivocally positioned: in the private and family life of Robert, in his day-to-day experience, and from his perspective, in the reporting that, first in *Libération* and then as a free agent, leads him to interview judges, bankers, politicians, and front men from the new landscape of the boundary-less capitalism of the 21st century. *L'Affair des affaires* presents a new kind of journalistic comic, tempered by the sensibility of the graphic novel, which contrasts with classic political satire, in the style of *La Face karchée de Sarkozy* (The Hidden Face of Sarkozy, 2006, Philippe Cohen, Richard Malka and Riss), where the research ultimately serves a humorous purpose.

On the other hand *L'Affair des affaires* also exhibits a more direct engagement with reality than other works in which reality has been fictionalized in an almost conventional genre story, as for example with *RG* (two volumes, 2007–2008), based on the experiences of the secret agent Pierre Dragon (an assumed name) and drawn by Frederik Peeters.

Encompassing the full spectrum from the intimately banal to journalistic reportage, passing through memoir, fiction, and history, all of these graphic novels have an essentially narrative base. Some comics, of course, like those of the paradigmatic Chris Ware, remain precisely balanced between the literary and the artistic, between narration and formal and visual experimentation. And in part it is from this inspiration—and from Gary Panter's liberating rupture—that a markedly new tendency has emerged, the wave of cartoonists that is developing what we might call a graphic vanguard. Born in part from Ware's modernist formalism and in part from the surrealism of seminal alternative comics—Daniel Clowes' *Like a Velvet Glove Cast in Iron*, Chester Brown's *Ed the Happy Clown*, most of all Jim Woodring's *Frank* comics—these cartoon artists raise the question like never before whether narrative is a fundamental principle of comics, at the same time as they position the medium in the sphere of contemporary art.

Formalism has always attracted explorers from other spheres of the visual arts, seduced by the potential of cartoons. This is true of Martin Vaughn-James (1943–2009), author of a series of unique books during the 1970s, the most well known of which is *The Cage* (1975) [116], a tale "created from the void,"[21] as the artist himself would state. *The Cage* is lacking in plot, action, and characters. In its pages, interior and exterior landscapes follow one upon another, landscapes in which can be discerned a fascination for

contemporary ruin not unlike that exhibited by Robert Smithson's "Hotel Palenque." Each double image—since each double page is conceived as one, albeit oddly split in two by the panel frame—is accompanied by a text, which finally ends in a liturgical or obsessive canticle ("The cage the cage the cage") before dissipating completely. Vaughn-James was born in Bristol and lived in Sidney, London, Montreal, Paris, Toronto, and Brussels. His books were published originally in Canada and France (which is where they have been reissued recently, and where he has been studied most). Domingos Isabelinho identifies a cosmopolitan spirit as one of the distinctive features of *The Cage*: "He doesn't really belong in any national comics tradition."[22] Not only that, with his references to Robbe-Grillet, Michel Butor, and Godard, it is evident that Vaughn-James' approach to the comic form has little to do with any stylistic tradition in comics. His vision is radically new and original. So much so that, unsurprisingly, he had faded from view until the graphic novel made it possible to reflect on his work on the basis of new approaches. There is something in common between his dead and desolate sceneries, and Chris Ware's obsession with the passage of time.

This same problem presents itself more clearly in "Here," a comic of barely six pages that is, even so, one of the support beams of the contemporary graphic novel. Originally published in *Raw* volume 2, number 1 (1989), it was authored by Richard McGuire, whose work ranges from animation to illustration, as well as toys and music. In "Here," composed of identical panel frames—within which other panel frames are sometimes inserted— a fixed perspective is maintained on a sole limited space, from the year 500,957,406,073 B.C. until 2033 A.D. The sequencing is not chronological, and at times the temporal planes are superimposed. In the same panel frame, we can see a stegosaurus grunting one hundred million years before our time, a father laughing and wearing an Indian feather in 1986 and a rat caught by a trap in 1999 [117]. In that same space there exists a house that is inhabited, that has yet to be built, and that has already been demolished. Chris Ware has stated that McGuire's discoveries for comics are equivalent to those of Cézanne for painting, Stravinsky for music, and Joyce for literature, and: "I don't think there's another strip that's had a greater effect on me or my own comics than 'Here.'"[23] Perhaps because McGuire's great innovation lies in breaking what Ware himself has called the "transparent continuous present" within which the action is always developed in comics.

A third exceptional figure arises in that imprecise territory between graphic and visual arts. "Jerry Moriarty has built a home on the border between painting and comics," as none other than Richard McGuire has

written.[24] Moriarty was another one of the artists attracted by the rabidly modern avant-gardism of *Raw* in the 1980s, and he published there his series *Jack Survives*, in which he displays everyday scenes of a prosaic surrealism. Moriarty has continued exploring the relationship between painting and sequence in his paintings, earning himself the title of paintoonist (a combination of painter and cartoonist). His mastery has been taken up as well by Ware, and the insistence on recognized influences by the latter author is no trivial matter, since through him the works of artists like McGuire and Moriarty have come to the attention of younger graphic novelists.

When we say "through him," we are referring not only to the impact they have had on his own pages, but to his efforts to recover them for the present. *The Complete Jack Survives* (2009) could only be published in the current context of interest in the precursors of experimental comics, and includes a rigorous prologue authored by Ware, which functions as a kind of seal of guarantee.

The Complete Jack Survives is published by Buenaventura Press, which is unsurprising since the influence of these formalists is clearly discernible in the magazine issued by the same publishing house: *Kramer's Ergot*, founded in 2000 and edited by Sammy Harkham and Alvin Buenaventura. *Kramer's Ergot* has reflected in its very form the transformation of cutting-edge comics over the first decade of the 21st century, from timid fringe to dazzling full bloom. The magazine that began as a mini-comic eventually became, in its issue number 7 (2008), a monumental book, forty by fifty-three centimeters, with a hard cover and cloth spine in complete color, a veritable *artistic object*. In its pages the well-established names of alternative comics—Ware, Clowes, Seth, Jaime Hernandez, Tomine, Ben Katchor, Deitch, Ivan Brunetti, Moriarty—sanction with their presence the efforts of the latest generation, within which figure prominently CF, Anders Nilsen, and Ron Regé, Jr., among others. CF has embarked upon a series of graphic novels titled *Powr Mastrs* (two volumes to date, in 2007 and 2008) [118] and set in the imaginary country of New China. Akin to Gary Panter's punk sagas, *Powr Mastrs* oscillates between dream and adolescent nightmare, leaving no possibility for distinguishing between form and content: *Powr Mastrs* does not put into images a script that might have been expressed with a different style or a different strategy; it is, rather, a graphic torrent that flows from image panel to image panel and from page to page following an invisible visual logic.

The work of Anders Nilsen (1973) is more cerebral. *Dogs & Water* (2007) is presented as a conventional graphic novel, with realistic drawing and

orthodox narration, telling the story of the directionless wanderings of a young man and his stuffed bear across a dystopian wasteland, in what ends up looking like a surrealist version of Cormac McCarthy's *The Road*. *Monologues for Calculating the Density of Black Holes* (2008) [119] is completely different. Voluminous and small, it is composed of shorter pieces doodled rapidly with featureless figures, the limited expression of a child's drawing. Occasionally, Nilsen superimposes the drawn figures on photographs or maps, producing a strange tension between the two systems of representation.

Ron Regé, Jr. (1969), for his part, is another product of mini-comics, which he compiled in *Skibber Bee-Bye* (2000), where one can appreciate his deceptively clean and naive, but geometrically complex, style. It is interesting to note that many of these cartoonists of the graphic vanguard, like Regé himself, and Chris Ware—a great aficionado of ragtime—as well as CF and David Heatley, are also musicians, which may explain their tendency toward a more harmonic vision of narrative for comics, where the sequence of visual forms is more important than their representative or narrative content. We might say that they seek out the mute music of the images. The publication of the anthology *Abstract Comics* (2009) [120], edited by Andrei Molotiu, marks the break point of this frontier. The book includes samples of abstract comics from 1967 ("Abstract Expressionist Ultra Super Modernistic Comics," by Robert Crumb, published in the seminal *Zap Comix* number 1) to the present. For Molotiu, abstract comics "reveal something fundamental about the comics medium itself. Reduced to the medium's most basic elements—the panel grid, brushstrokes or pen strokes, and sometimes colors—they highlight the formal mechanisms that underlie all comics, such as the graphic dynamism that leads the eye (and the mind) from panel to panel, or the aesthetically rich interplay between sequentiality and page layout."[25]

The International Graphic Novel

Despite the fact that over the course of its history comics have circulated in insular markets dominated by local industries, in the preceding chapters we have seen how the international flow of influences was decisive in giving shape to adult comics in both the United States and Europe. Harvey Kurtzman, whose role in the development of adult comics was crucial, had a formative influence on René Goscinny, who with *Pilote* would set in motion

the machinery that would bring the author's *bande dessinée* to France. But at the same time, Kurtzman was dazzled by the high quality production values and respect for the author in European comics from the late 1960s on, and he tried to bring those principles to his projects in the United States. The pioneers of the American comix underground had international repercussions and lit the spark of something new throughout the West. As Rosenkranz asserts, "*Zap Comix* had the same impact in Amsterdam and Paris as it did in the United States. It boggled minds and begat illicit off-spring. American comix like *Fritz the Cat* and the *Furry Freak Brothers* were rapidly reprinted in foreign language editions in Spain, Italy, Sweden, and beyond. In France, comics magazines like *Metal Hurlant*, *L'echo des Savanes*, and *Harikiri* likewise spoke with revolutionary voices."[26] Those revolutionary voices of European comics would eventually be heard also in the United States, through, among other channels, the aforementioned American version of *Métal Hurlant*, *Heavy Metal*, which altered the thinking of the young Jaime Hernandez. "A lot of my early fanzine work, before Love *and Rockets*, was influenced by *Heavy Metal* magazine. I was discovering all the European guys."[27] And Jaime Hernandez is one of the most copious sources for American alternative comics that would serve as a model for L'Association in defining French alternative comics and the European graphic novel. Another source, the magazine *Raw*, had long had a pronounced international calling, creating the idea of universal continuity between Art Spiegelman, Joost Swarte, Mariscal, Tardi and Yoshiro Tsuge.

L'Association, which had announced with the international anthology *Comix 2000* that its frontiers were set not by political or geographical limits, but by artistic goals, produced the perfect example of both the contemporary graphic novel and the international graphic novel. *Persepolis* [121], by Marjane Satrapi, was published first in four volumes (2000–2003) and later compiled in a single tome. Sales of hundreds of thousands of copies completely outstripped not only the usual market for L'Association, but of the specialized comics audience. Persepolis was the author's memoir of her childhood and youth in the Iran of the Islamic revolution, her studies in Europe and her experience as an intellectual exiled in present day France. Satrapi had never drawn comics before, but encouraged by David B.—whose autobiographical magnum opus, *L'ascension du haut mal* (The Rise of High Evil, 1996–2003, published in English as *Epileptic*), is clearly the model for *Persepolis*—she presented the project to L'Association. The monumental success that it enjoyed, which would expand even further with the animated film released in 2007, surprised L'Association more than anyone.

Despite this, the success of *Persepolis* is more understandable if we place it within the landscape of globalized cultural consumption and take as point of comparison so-called "transnational film." What Angel Quintana says about the latter could be applied almost word for word to *Persepolis* and to a good number of the graphic novels that have come after it: "At a moment in which that empire of the signs has shifted to a globalized world, contemporary film experiences a permanent tension between the hybridization of cultures and the emergence of the hyper-local. The migration of aesthetic formulas relentlessly proposes a series of symbolic exchanges that have become an essential part of contemporary film, while the local is determined by the way in which the small tales of distant worlds are incessantly imposed as universal."[28] It is easy to imagine an audience at the intersection of viewers of Wong Kar-Wai, Fatih Akin, Kim Ki-Duk or Isabel Coixet and readers of Marjane Satrapi. We could speak even of a new domesticated exoticism. Satrapi offers the remote and fascinating experience of Islamist Iran, but she offers it through her eyes as an assimilated immigrant in France and through the codes of *bande dessinée*, firmly developed by one of her main supporters, namely her mentor David B. The flavor is of the East, but the recipe is unquestionably French. And the same thing happens in the case of numerous graphic novels, often written and drawn by women, who barely participated in traditional comics, that show us stories of *other places* by explaining them with the familiar language of Western comics (which is to say, Franco-Belgian). The Israeli Rutu Modan has simultaneously met with worldwide success with her graphic novel *Exit Wounds* (2006) [122], which, while not autobiographical, does offer a refreshingly different view of everyday life in Israel for an audience accustomed to seeing only news of the Israel-Palestine conflict. The Lebanese Zeina Abirached follows more closely in Satrapi's footsteps in *Mourir Partir Revenir: Le jeu des hirondelles* (*A Game for Swallows: To Die, To Leave, To Return*, 2007), which relives the domestic tension of life in Beirut in the early 1980s. For generational reasons, this decade is a repeated presence in many of these works. For example, in *Meine Mutter war Eine Schöne Frau* (My Mother Was a Beautiful Woman, 2006), by the South African Karlien de Villiers, written originally in Afrikaans and in which the family memoir is drawn upon the canvas of the unraveling of the apartheid regime. The figure of the mother is a steady axis in these graphic novels. Such is the case of *The Story of My Mother* (2008), by Korean Kim Eun-Sung, and of *We Are On Our Own* (2006), by Miriam Katin. This latter work is indicative of how comic art has been opening up new arenas of personal expression

that previously were reserved exclusively for art or literature. *We Are On Our Own* is the autobiographical tale of the flight from Budapest by the author, then a child, and her mother (both Hungarian Jews) in 1944, while escaping from the harassment of the invading Nazi army and later of Soviet troops. Oddly, Katin did not embark on this graphic memoir until she was more than sixty years old, an age at which, traditionally, comics artists have already retired.

The acceptance and assimilation of this kind of graphic novel into commercial formulas is confirmed by titles like *Aya de Yopougon* (*Aya of Yop City*, 2007), by Marguerite Abouet and Clément Oubrerie. With an upbeat, casual and colorful style, it is based on the relational experiences of its scriptwriter, Abouet, on the Ivory Coast of the late 1970s and early 1980s. With the look of a graphic novel, *Aya* is in reality a series to the liking of the traditional French industry, and of course Abouet filters the African experience through her Parisian eyes, since she has lived in France's capital city since she was twelve years old, and works there at a legal practice. *Aya* offers a friendly and sanitized face, a pleasure to consume, of international experience in a narrative idiom accessible to the reader of the metropole.

Of course, exoticism sometimes seeks us out right at home. In *Couleur de peau: miel* (Skin Color: Honey, 2007), Jung recalls his childhood and adolescence as a Korean child adopted by a Belgian family. Autobiography, childhood chronicle, sexual confession, the discovery of artistic vocation and identity problems similar to those presented by Gene Luen Yang and Derek Kirk Kim, but with a European slant, come together in this work which continuously alternates between personal memoir and universally relevant reflection. At one point, Jung expresses an awareness of himself as a comics artist: "Now I am an author of comics, and in all the works I have produced, with or without scriptwriters, I return tirelessly to the same themes. Abandonment, uprooting, identity . . . ?"

On other occasions, it is the citizen of the metropole who seeks out the exotic and tells the tale in his own terms with empathy and puzzlement. Canadian Guy Delisle, resident of Montpelier since 1991, has blazed a trail for these "modern explorers," generally involved in some commercial enterprise or in aid to less developed countries. Delisle's travels, at times embarked on professional animation commissions, at times accompanying his wife, a member of Doctors Without Borders, have resulted in *Shenzhen* (2000), *Pyongyang* (2003), and *Burma Chronicles* (2007). That same tone of informal personal chronicle, exaggerated and a bit cynical, almost absurd, can be found in the two volumes of *Kabul Disco* (2007–2008), by Nicolas

Wild, a comics artist who travels to Afghanistan with the goal of present-
ing to children through comics that country's constitution after the fall of
the Taliban regime at the hands of the US military. Afghanistan is also the
setting for *Le Photographe* (*The Photographer*, 2003–2006), three volumes
drawn by Emmanuel Guibert that adapt the book in which photographer
Didier Lefèvre told of his experiences accompanying expeditions of Doctors
Without Borders in the country during its occupation by the Russians in
the 1980s.

With or without concessions, in order to achieve international success
one unavoidably passes through the channel of the metropolitan model. It
is rare for a local work to reach another audience on the global periphery
without having first gone through a Franco-Belgian or United States edi-
tion, which, apparently, imposes a certain homogenization based on the
tastes of the French and North American audience. Paradigmatic of this is
a rare sample of a Russian comic, *Une jeunesse sovietique* (2005, published
in English as *Siberia*), by Nikolai Maslov. Maslov (1953), a Siberian night
watchman at a warehouse, drew his short, dry and laconic comics, with
their open landscapes, very much in the Russian style, in the bleak publish-
ing context of his country, where the professional comic practically did not
exist. One day he showed up at the Moscow bookstore Pangloss and showed
a sample of his work to the owner, the Frenchman Emmanuel Durand. The
latter financed Maslov's production for three years, which would finally be
published in France in 2005 by Éditions Denoël. Later, the work was pur-
chased by local publishers and translated into other languages; coming to
Spain in 2009. As on so many other occasions, the international graphic
novel only existed as a product of one of the two big national industries.

The popularization of the Internet and the declining cost of travel dur-
ing the past decade also have contributed in great measure to reinforcing
international linkages. By visiting their webpage, today it is as easy to get
to know the work of an author from another hemisphere as it is the work
of one who lives in our own home. And studio visits, or invitations to the
increasingly abundant comics conferences and festivals, represent excellent
means of contact between cartoonists of divergent nationalities but com-
mon interests. R. Kikuo Johnson explains in his *Night Fisher* that he drew
it in Rome, Wailuku, and Brooklyn, and acknowledges that during his stay
in Rome his contact with European comics had affected him profoundly. In
a certain way, he follows in the footsteps of Charles Burns, who also lived
in Italy. Craig Thompson is another example of an international star with
universal influences. He reveres in equal measure the Frenchman Baudoin,

the father of the autobiography in France, and Jeff Smith, the creator of *Bone*, an American youth series of heroic fantasy that has sold millions of copies. The result is a mixed style so attractive to diverse audiences that he has had more success in France than in the United States. In Spain, he has been published in Spanish and in Catalan, and has reached four editions and 6,500 copies, considerable figures for this market.

Within this landscape, one can speak of purely international stars, authors who achieve success directly outside of their native country and who publish simultaneously in a network of local markets. These are authors like the Swiss Frederick Peeters, who triumphed with *Pilules Bleues* (*Blue Pills*, 2001), a graphic novel about his relationship with a single mother who is HIV positive. The aforementioned Rutu Modan has developed a profile in Europe and the United States, almost by necessity, given that Israel lacks a comics industry. The Italian Gipi has become important in the international graphic novel on both sides of the Atlantic, with intimate stories of universal scope, like *S.* (2006), or with the most shameless of autobiographies, like *La mia vita disegnata male* (My Life Badly Drawn, 2008). The most international of all is perhaps the Norwegian Jason [123], who has found success in both France and the United States, and of course in their client markets, such as the Spanish-language market. Jason's distribution has benefited perhaps by his tendency to produce wordless cartoons, and his nomadic spirit has been transferred to his own life, since after leaving his native Molde he has lived in New York and in Montpellier. Jason's stories, which play with genre topics and mix characters and historical periods at his convenience, at times in order to produce surprise endings, are lacking, because of their flotsam-like character, any localist specificity. Any person who shares the common cultural baggage of the West will feel equally familiar with them, regardless of what their maternal language or local culture might be.

The relationship of the Western graphic novel with manga is more complex to analyze. Despite the fact that, as we have seen, American comics were of great importance during the early stages of modern Japanese comics—which the U.S. comics influenced in the nineteenth century through the humor magazines and in the early twentieth century with such widely imitated newspaper series as George McManus' *Bringing Up Father*—Japanese comics have remained over a good part of the twentieth century on a parallel (albeit isolated) trajectory with that of Western comics. In the 1960s Japanese comics experienced a revolution, born from the magazine *Garo*, similar to the revolution of the comix underground in the United

States and Europe, but the Japanese revolution responded more to a set of social and political circumstances comparable to those of the West than to the direct influence of Western comics. It was in the 1980s when manga started to become familiar in the United States and Europe, following the animation series (known as *anime*) broadcast via television. *Akira* (1982–1990), by Katsuhiro Otomo, a spectacular apocalyptic saga, was the first title to cause a sensation among Western readers of comics. It was published in the United States in 1988—the same year in which the film adaptation was produced in a historic animated cartoon that anticipated the ending of the comic version of the story, which would not yet arrive for several years—and in France in 1990. That same year Akira Toriyama's *Dragon Ball* arrived in France, where it had been broadcast on television since 1988, and became one of the most overwhelming successes among the children's audience in recent decades. Manga revolutionized the Western market on both sides of the Atlantic, and from that moment forward the established publishing houses and many of the newer ones, specializing in Japanese comics, flooded the bookstores with titles extracted from the inexhaustible production from the land of the rising sun. Surprisingly, manga, contrary to what it seemed to augur, did not swamp domestic production, but regenerated the audience fabric, injecting renewed vigor into sales. It may be that many of the young buyers of manga will never look at a North American or European comic, but some do wind up doing so. And even those who don't still help to keep in business the specialty bookstores where local comics are sold. The manga phenomenon, in addition, regains the female audience, which had been completely abandoned by Western publishers, and which now plays an important role in the graphic novel boom—we have already seen the increased number of women cartoonists who have appeared in recent years—and imposes other types of format that will be crucial for contemporary adult comics. The *tankobon* or book compilation is the typical format for manga, which tend to be published in volumes of reduced size and many pages—following their pre-publication in magazines of immense thickness and low-quality paper—and generally, in black and white. Those two characteristics would be typical of the graphic novel. The narrative freedom offered by the large number of pages of the manga would represent an epiphany for many serious Western authors who found themselves lacking space in the conventional formats, the Franco-Belgian "48CC," or the American comic book, to delicately express the nuances they sought.

At the beginning of the 1980s, there were already authors influenced by manga, even though they were unable to read them because they had yet to

be translated. But the Japanese manner of narrating and of designing the page soaked into the young Frank Miller, who, as soon as he achieved sufficient prestige to embark on his own authorial project, took up a work of adult science fiction where his formation in American crime and superhero comics flowed into pages conceived in the light of foreign masters like the Japanese Goseki Kojima and the Frenchman Moebius. *Ronin* (1983) condenses that strange hybrid formula, taking on its results as something natural. During the 1990s, with manga already firmly implanted in Europe, the Japanese publishing monster Kodansha set out on an experimental program of recruiting foreign authors, attempting to use their talent to renew its production, which frequently falls into the formulaic, because of its high degree of industrial standardization. Comics artists crucial to the new *bande dessinée*, like Baru and Lewis Trondheim, participated in that venture. In the end, the experiment was cancelled by Kodansha without producing any of the results hoped for by the company, but for the European and American cartoonists who worked with them the memory remained of a way of doing comics that breaks with Western formal conventions.

One of those artists, one who symbolizes perhaps more perfectly than anyone since Miller the encounter between American, Japanese and European sensibilities, is Paul Pope. An elusive and difficult to categorize figure, Pope moves between the worlds of author's comics and commercial comics with equal ease. Capable of self-publishing his own comics—the strange stories of intimate science fiction of *THB*—he is just as likely to be seen illustrating a special Batman project for DC or *La chica biónica* for Dargaud, one of the more important French publishers. Pope leaps over genres, and markets himself as a brand that confers the stamp of authorship to his many projects, all of them unquestionably of *transnational* interest. Taiyou Matsumoto (1967) offers from Japan a mirror image of Pope. His *Tekkon Kinkreet* (2007, published in English as *Black & White*) has been received with astonishment in France, which is not surprising, because he brings a strong Moebius influence together with his indisputably Japanese personality. In *Takemitsu Zamurai* (2007) [124], with scriptwriter Issei Eifuku, the effort to attain a heterodox and international manga aesthetic is even more evident. This rich Euro-Asian bridge has been exploited better than anyone by Frèdèric Boilet (1960), a French cartoonist based in Japan since 1997 who has promoted numerous projects that bring together *literary* cartoonists of both worlds. The most exemplary of these is the volume *Japan: As Viewed by 17 Creators* (2005), in which eight French cartoonists were invited to visit the Nipponese archipelago for fifteen days. Each of them

was to draw a story—fictional, historical or autobiographical—about the locale to which they were assigned. The tome was completed with comics by Japanese authors living in the country (and Boilet himself, of course). Thus, Emmanuel Guibert, Nicolas de Crécy, Benoît Peeters and Joann Sfar joined Matsumoto, Moyoko Anno, Kan Takahama and the central figure for what is now known as *nouvelle manga*, Jiro Taniguchi.

Taniguchi (1947) is a veteran cartoonist with an extensive career in Japan, where he has produced all kinds of comics, including science fiction, Alpine adventures, the crime genre and historical drama. He also has drawn a kind of intimate and sentimental comic, with a slow rhythm and long silences, which has shown many Western authors the keys to creating comics of a quieter tone for which they had no other previous model. One of Taniguchi's most characteristic titles is *Aruku hito* (1992, published in English as *The Walking Man*) [125], a collection of stories in which the anonymous protagonist, a middle-aged man, simply walks around in urban and not especially eye-catching Japanese scenery. *The Walking Man* is lacking in story and drama, and frequently even in dialogue. All that is revealed in its pages is something that is not visually represented in Taniguchi's meticulously drawn panel images, which is to say, the unseen spiritual truth. Other titles have established Taniguchi as a master of the relationship story. In *Chichi no koyomi* (The Almanac of My Father, 1994), the main character returns to his home town because of his father's death, and remembers his family history. In *Haruka-na machi e* (1998, published in English as *A Distant Neighborhood*, 2009) the return to childhood is literal: the protagonist turns into himself during his school years, and relives all of the feelings and sensations of the time but with the mentality of an adult. *Keyaki no ki* (The Elm Tree of the Caucasus, 1993) is a collection of tales that adapts with great emotional power stories by Ryuichiro Utsumi. All of the stories revolve around melancholy, loss, and loneliness, although generally with an eventual redemption that allows for the reprieve of hope. Taniguchi, who was influenced by European artists through their drawings, despite not understanding the text, much like Miller's experience with respect to Japanese artists, translates that influence into a Japanese *clear line* style immediately accessible to the Western reader, which may explain in part his success with European and American readers. In him the "glocal" is evident: the exoticism of the history of the Japanese village together with the modes of representation of contemporary international comics. This idyll reaches its peak in *Maho no yama* (The Magic Mountain, 2005), presented in the West as a hard-cover album in color, in the classic French style, and

which is not just a compendium of Taniguchi's recurring themes—family and the return to the magic of childhood—but also seems to take on the mythic-emotive dimension that has made Hayao Miyazaki one of the most admired Japanese film directors in the West. In truth, in its eagerness to distill the proven components of success, *Maho no yama* falls victim to a premeditated sentimentality. The process of Westernization for Taniguchi has led him to collaborate with French authors like Moebius (*Icaro*, 2000) and Morvan (*Mon année*, or My Year, 2009).

The necessity of internationalization for the graphic novel is clearly demonstrated in the Spanish case. In Spain, the rise of the graphic novel has been slower than in the countries central to world-wide comics, and has had its first success only recently with the publication in late 2007 of *Arrugas* (Wrinkles) [126] by Paco Roca, a story about an old man suffering from Alzheimer's disease who has been moved into a residential facility. *Arrugas*, which after successive re-prints in little more than a year reached the surprising figure of more than twenty thousand copies sold, has conferred upon its creator a long series of awards, chief among them the Premio Nacional de Comic (National Comics Prize) in 2008, the most important of its kind in Spain. What is interesting in this case is that *Arrugas* was produced by a French publisher, Delcourt, and Astiberri, the Spanish publisher, purchased the rights from the French publisher and translated the work as if it were just another French comic. Paco Roca was aware of the fact that he was working for a global market, and therefore had to make some formal accommodations in order to bring the work closer to the liking of his publishers: removing a crucifix from a classroom, since in France education is secular, and adapting the Christmas menu to French tradition. In the Spanish edition, Roca would restore those modifications to their original version.

Carlos Giménez, considered in Spain to be an author of great importance thanks to a range of works that recoup the personal and historical memory of post-war Spain and of the country's transition to democracy, had already accomplished that success *from within* the French market. *Paracuellos* (1976–2003), a remembrance of life in the hospices of Auxilio Social (the dictatorship's welfare service institution) during the Franco years, would receive in 2010 the prestigious Heritage Prize in the International Comics Festival of Angoulême, the most important such festival celebrated in France. Despite its decidedly Spanish character, both in terms of its historical setting and in its tone and narrative tradition, *Paracuellos* has been accepted by the French public as its own—exotic, but its own—ever since it began to be published in the pages of *Fluide Glacial* more than thirty years ago.

Although Spain has seen flashes of adult comics, which have taken shape in unusual works, like Rodrigo's *Manuel no está solo* (Manuel Is Not Alone, 2005, which is a compilation of pages from the 1980s), or in individual trajectories like that of scriptwriter Felipe Hernández Cava, who has collaborated with cartoonists like Ricard Castells and Federico del Barrio, one could not speak of a Spanish graphic novel on a par with the international trend until the appearance of titles like *Modotti, una mujer del siglo veinte* (Modotti, a Woman of the Twentieth Century, 2003), by Ángel de la Calle, *María y yo* (María and Me, 2007) by Gallardo, *Súper Puta* (Super Whore, 2007) by Manel Fontdevila, *Bardín el Superrealista* (*Bardín the Superrealist,* 2006) by Max, *Buñuel en el laberinto de las tortugas* (Buñuel in the Labyrinth of Tortoises, 2008) by Fermín Solís, and *El arte de volar* (The Art of Flying, 2009) by Antonio Altarriba and Kim. To date, Spanish authors appear to be focused on discovering new thematic fields—personal and historical memoir, biography—and relegate formal experimentation to a secondary function. In order to find comics on that border between art and cartoon where Richard McGuire and Jerry Moriarty operate we have to turn to the projects of Francesc Ruiz, like *La visita guiada* (The Guided Visit, 2008) or *Manga Mammoth* (2009), inserted in the art circuit and completely ignored in the world of comics, or to fringe experiences in the comics market like those of Felipe Almendros, Leandro Alzate and Juanjo Sáez.

Today, Spain is a country that exports its talents, and cartoonists who do not work directly for foreign, North American or French, publishers, produce their graphic novels for Spanish publishers who attempt to sell them on the international circuit. Local industries have lost the mass market that nourished the commercial comics of yesteryear, and the only way of making publications profitable is to gain access to a global audience.

91. *Watchmen* (1988), Alan Moore, Dave Gibbons and Mike Higgins.

92. *Batman: The Dark Knight Returns* (1986), Frank Miller, Klaus Janson and Lynn Varley.

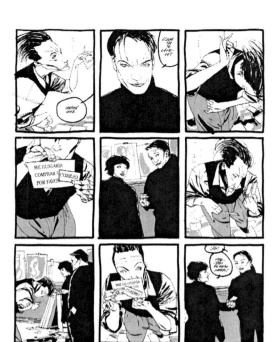

93. A page from a Spanish-language edition of *Cages* (1998), Dave McKean.

94. *City of Glass* (1994), Paul Karasik and David Mazzucchelli.

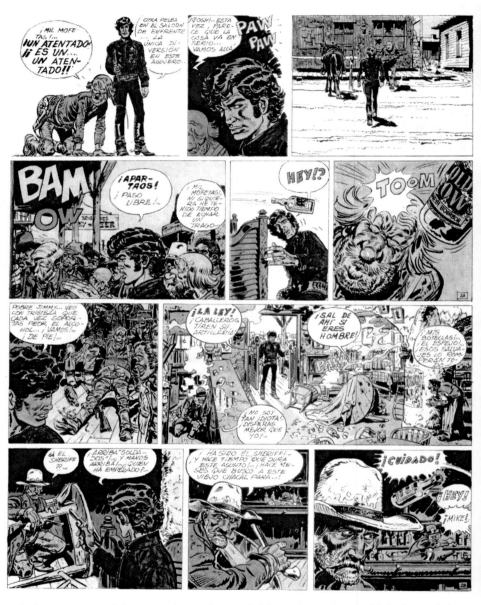

95. Blueberry in a Spanish-language edition of *L'mine de l'allemand perdu* (1972; published in English as *The Lost Dutchman's Mine*, 1991), Jean-Michel Charlier and Jean Giraud.

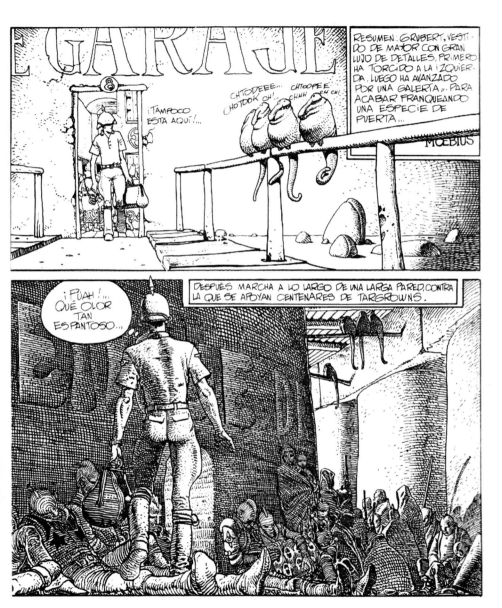

96. A page from a Spanish-language edition of *Le Garage hermétique* (1979; published in English as *The Airtight Garage*, 1987), Moebius.

97. A page from a Spanish-language edition of *La Foire aux immortels* (1980; published in English as *The Carnival of Immortals* in *The Nikopol Trilogy* in 1999), Enki Bilal.

98. *NSLM* 10 (2004), Max.

99. "Ice Haven," in *Eightball* 22 (2001), Daniel Clowes.

100. Covers of several issues of *Acme Novelty Library*, Chris Ware, reproduced at proportional scale.

101. An intimate moment from a Spanish-language edition of *Blankets* (2003), Craig Thompson.

102. *Bottomless Belly Button* (2008), Dash Shaw.

103. "Thrilling Adventure Stories," in *Raw* vol. 2, number 3 (1991), Chris Ware. Color version of *Quimby the Mouse* (2003).

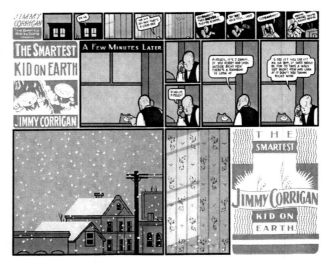

104. *Jimmy Corrigan* (2000), Chris Ware.

105. Cartoon in *Acme Novelty Library* 18 (2007), Chris Ware.

106. In this page from a Spanish-language edition of *George Sprott: 1894-1975* (2009), Seth presents in "An Interview with Sir Grisly Gruesome" an aging television actor's memories of the main character George Sprott.

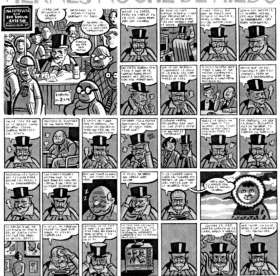

107. *Krazy and Ignatz 1939-1940* (2007), George Herriman. Design by Chris Ware.

108. *The Complete Peanuts 1950–1952* (2004), Charles Schulz. Design by Seth.

109. *Louis Riel* (2003), Chester Brown.

110. A page from a Spanish-language edition of *Black Hole* (2005), Charles Burns.

111. *Jimbo in Purgatory* (2004), Gary Panter.

112. In a Spanish-language edition of *American Elf* (2004), James Kochalka presents simple moments from four days of life, October 23–26, 1999.

113. *Clumsy* (2002), Jeffrey Brown.

114. In a page from a Spanish-language edition of *Fun Home* (2006), Alison Bechdel presents her process of sexual self-discovery.

115. *Palestine* (1993), Joe Sacco.

116. *The Cage* (1975), Martin Vaugh-James.

117. "Here," in *Raw* volume 2, number 1 (1989), Richard McGuire.

118. *Powr Mastrs* 1 (2007), CF.

119. *Mono'ogues for Calculating the Density of Black Holes* (2008), Anders Nilsen.

120. "Un Calligramme," in *Abstract Comics* (2009),
Warren Craighead III.

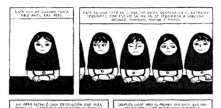

121. In this page from a Spanish-language edition of *Persepolis* (2003), Marjane Satrapi remembers her early experiences with the required use of the veil following Iran's 1979 Islamic revolution.

122. A page from the Spanish-language edition of *Exit Wounds* (2006), Rutu Modan.

123. *I Killed Adolf Hitler* (2006), Jason.

124. A page from a Spanish-language edition of *Takemitsu Zamurai* (2007), Issei Eifuku and Taiyou Matsumoto.

125. *The Walking Man* (1992; English edition 2006), Jiro Taniguchi.

126. *Arrugas* (2007), Paco Roca.

127. A page from a Spanish-language edition of *Isaac le pirate 2: Les Glaces* (2002), Christophe Bain.

128. A page from a Spanish-language edition of *Le Photographe* 3 (2006), Emmanuel Guibert.

129. *Omega the Unknown* (2008), Jonathan Lethem, Karl Rusnak, Farel Dalrymple, and Paul Hornschemeier.

Chapter Six

The Last Avant-garde Art

I suspect that even in the face of utter indifference there are those of us who will continue to create comics, if only because of the vast unexplored prairie between what has been done and the thrilling possibilities that lie around us in all directions.[1]
—Daniel Clowes

Over nearly the entirety of the 180 years of history that we have reviewed in these pages, the comic form has been an art of the masses viewed as vulgar, always and exclusively at the service of commercial interests, often as a product that formed part of the universe of children's and young people's consumption.

Nevertheless, there is nothing vulgar or juvenile about the comic as an artistic form. On the contrary, it is incredibly sophisticated. The comic form is not a hybrid of word and image, a bastard child of literature and visual art incapable of inheriting any of the virtues of its parents. The comic form belongs to a different lineage, and is produced on a different plane than either of those arts. It has its own rules and its own virtues and limitations, which we have only begun to understand.

But an artistic form is not a medium, and the understanding of comics as a medium is essential for comprehending the role it has played over the course of its history. When we speak of medium, we are referring to the definition provided by Mitchell:

A medium, in short, is not just a set of materials, an apparatus, or a code that 'mediates' between individuals. It is a complex social institution that contains

individuals within it, and is constituted by a history of practices, rituals, and habits, skills and techniques, as well as by a set of material objects and spaces (stages, studios, easel paintings, television sets, laptop computers). A medium is as much a guild, a profession, a craft, a conglomerate, a corporate entity as it is a material means for communicating.[2]

In other words, if we want to understand the road travelled by the comic form since its origins, it is not enough to consider it a language shaped by drawings, words and panels on printed paper, because that would not explain its development, its achievements and failures, nor its alleged "maturity" as an art, as if that were simply a natural product of the passage of time. We have to understand comics as a medium comprising the artistic form, but also the publishing enterprises and their economic crises, the networks of distribution and their ups and downs, the decline of the newsstands and the emergence of the specialty bookstores, the rituals and practices of the readers, comics collecting and comics festivals, the variations in format and the effects they have had and the reasons for which they have been produced, the self-awareness or lack thereof on the part of the professional authors who have practiced it. To understand the development of the art is to understand the development of a very broad institution made up of many practitioners, from readers to authors. It is not enough to read the pages. In this case, more than ever, it is necessary to read between the lines, or perhaps we should say, "between the panels."

Such a reading reveals to us traditions, undercurrents of the medium, each one to a certain degree independent of the others, although related. In all of them the artistic form of the comic is present, but not all of them have fulfilled the same functions nor had the same aspirations. The tradition of the newspaper strip born in the United States is perhaps the most important seed for all the worldwide cartoon traditions of the twentieth century, the common ancestor, as it were. The comic book traditions in the United States, the Franco-Belgian album in Europe and the long form magazine stories in Japan have been the hegemonic traditions in the three centers of production for international comics over the first three quarters of the past century. All of these traditions have had at least three very important elements in common: they have been developed as series, they have been based on characters (heroes) and they have been directed at a youth audience. The negation of these three elements offers our first touchstone for understanding the tradition of the graphic novel that begins to emerge in the last quarter of the century out of the tradition of the comix underground.

This new graphic novel tradition finds its opportunity as a result of the failure—to greater or lesser degree—of the previous traditions, whose system, based on supplying a cheap mass entertainment product, entered into crisis, especially when it proved incapable of competing with a technologically superior rival: television. In all the traditions, the establishment of television represents the beginning of the long end of the reign of comics as domestic "audiovisual entertainment," as Smolderen has proposed we could interpret its role since its birth in the American press. The artistic form of the comic is not rendered obsolete in the face of the televisual artistic form, but the medium of comics does find itself supplanted by the medium of the television. What appeared to be a process that would result in the death of the comics medium, has been in reality a process through which the artistic form of the comic has managed to break away from the *mass* medium of comics in order to found a new tradition based on literary and artistic values of its own, an artistic form that no longer competes with television as a mass medium, but instead presents itself as a refined medium with its own identity and its own spaces—the book, general interest bookstores, even the museum—and its new audience, a general audience more accustomed than ever to deciphering texts composed of words and icons superimposed on a rectangular canvas, after fifteen years of mass distribution and consumption of personal computers.

This tradition of the graphic novel recognizes the other traditions and absorbs them into its DNA, but in many senses it is completely new, since nothing like it had been seen until twenty or thirty years ago. One of its defining characteristics is the birth of the comics author, at long last an independent and adult author. Independent with respect to content, but also with respect to format, with a freedom that has not been enjoyed since Rodolphe Töpffer, the first comics artist in history, the only comics artist who was able to work before comics existed as a medium.

Until the appearance of the graphic novel, such freedom was difficult to acquire, and in general, only partial. The medium did not allow it, but it was also difficult for professionals working in comics to seek it. In the 1940s, those who worked in comics, the failed writers, painters and illustrators who found themselves reduced to an embarrassing creative occupation in order to survive, could not find work doing anything else. Nonetheless, as Boltanski notes, beginning in the 1970s the situation begins to change, owing to an expansion of university education. Thus, he indicates, authors like Gotlib, Mandryka, Bretécher, Druillet, Mezières and Fred shared a *habitus* arising from the inequalities in their social and cultural capital. A higher

social berth would have led their ambitions toward painting or literature, but they viewed those fields as closed to them. However, the cultural capital they had acquired in the art schools led them to seek out something beyond the careers in technical drawing to which they seemed destined by their social origins, and they felt an attraction to the comic as a form of symbolic expression that was accessible to them.[3] The same process was experienced, simultaneously, by the young American cartoonists of the underground, S. Clay Wilson, Robert Williams, Spain Rodriguez and others, who were university-trained and expressed themselves through a devalued, but vital, medium that they recognized as their own. Currently, young artists like Dash Shaw voluntarily choose the comic as a preferred form without viewing it as a step on the ladder toward their true ambitions. Their true ambition is, simply, to make *comics art*.

The artists—whether or not they have recognized themselves as such—have been responsible in great measure for the changes in direction experienced by the comic form in its most recent stage. Individual talent has always been the comic form's greatest asset. The talent of Kurtzman, of Crumb, of Spiegelman, of the Bros, of Ware, of the greats rejected by the industry, the talent that grows in the shadows. That talent has adapted to circumstances. The formats of the industry allowed only a precarious balance between the commercial and the personal, such that serious cartoonists found themselves forced to condense their ambitions into brief cartoons that followed conventional formulas. It was like trying to write a great novel in the format of a three-minute pop song. Pop music, in fact, offers the best parallels to comics as a medium, more so than film, with which the comic has a superficial resemblance as artistic form. Pop, like comics, has been a medium dominated by its function as a mass product, and which has been forced to mature grotesquely without losing its youth appeal. Neither pop singers nor cartoonists have known how to age, because the medium was directed at youth. And, nonetheless, they have aged or they have disappeared. Comics as a medium have been torn between the insistence that they remain always linked to a youth imaginary and the necessity of broadening their horizons. But the hegemonic traditions had such a strong presence that any other option seemed *inconceivable*.

The contemporary graphic novel represents, thus, and more than ever, that awareness of authorial freedom, a movement—as Campbell would have it—that founds a tradition related to the others, but distinct. Let us be clear: neither better nor worse, just different. It is not, therefore, a format or a genre, nor is it a content. It is not necessary to draw 200 pages in

order to make a graphic novel, in the same way as making a comic book that is 200 pages long does not turn it into a graphic novel. A short story, like Maguire's "Here," or a story of intermediate length—thirty or forty pages, as with Justin Green's *Binky Brown*—can belong to the tradition of the graphic novel. Nor is it necessary to deal with autobiographical themes in order to make a graphic novel, despite the fact that such themes have been abundant until now. In fact, now that the first steps have been taken toward recognizing the graphic novel, the purist and exclusive attitude maintained for years by promoters of "serious comics" can be relaxed. Eddie Campbell has explained that this defensive tactic is no longer necessary: "We can let the superheroes back in. 'You guys have to leave the hall until we argue this one out. . . . All right, we've achieved this position, you guys can come back in.' So, having despised and disparaged superheroes for the last 30 years, I can quite merrily go away and draw a Batman book and be proud of it."[4] David B. says something similar with reference to the origins of L'Association in France and how the posture of resistance has been able to be relaxed as goals have been achieved in the conquest of spaces for author's comics: "We felt no obligation to create 64-page color hardcover albums, there was no reason to do so. Now we can do it, we're OK with it because L'Association exists."[5]

If the graphic novel is just an agreed-upon term—or a disagreed-upon term—for identifying an adult comic in contrast with the traditional *comic book*, that means we cannot know what road it will follow from here on, since now that its presence has been established its ability to absorb distinct tendencies appears to know no limits. It is easy to be cynical and think that the industry will grind down and turn into pulp the *true* graphic novel. Examples of that phenomenon already abound, some of them quite conspicuous. *Le Combat ordinaire* (published in English as *Ordinary Victories*), by Manu Larcenet, is a highly successful series published in France by Dargaud—one of the more powerful publishers—between 2003 and 2008. Centered on the mid-life crisis of its photographer protagonist, it seems a perfect example of a serious and literary contemporary graphic novel, which at the same time is sold as a hardcover album in color and has a "character" as protagonist. With its relatable traumas and comforting life lessons pre-digested and filtered through the resources of commercial comics for-all-ages, *Le Combat ordinaire* is one of the more notable demonstrations of how the industry is capable of turning into a formula something that was born to escape formulas. Similarly, the aesthetics of the *nouvelle bd*, born from key authors of the European graphic novel, like Joann Sfar,

Lewis Trondheim, Blutch and David B., all of them linked at some point with L'Association, is today best represented by Christophe Blain, a super talented cartoonist who has made a name for himself by reclaiming adventure genre classics: *Isaac le pirate* (*Isaac the Pirate*) [127] and *Gus*, a western. Blain also works in the traditional format of the hardcover album in color, but has never published on the small presses. His talent for revitalizing old genres with a shockingly modern perspective has allowed him to conquer ground within the industry that markets itself as "alternative," but is in fact an alternative sanctioned by the big publishing houses.[6] Despite the family resemblance to the work of the best French *graphic novelists*, one might ask whether what Blain is doing is actually perpetuating the commercial tradition of adventure for-all-ages, if Blain is not in the final analysis the Bourgeon of the twenty-first century, the packager of well-appointed artifacts designed for an audience of faithful fans.

The issue goes beyond format. Another hardcover publication, in color and for a large publishing house is the previously mentioned *The Photographer* [128], by Emmanuel Guibert, a three-volume work that is, nevertheless, one of the most complex and revolutionary graphic novels made to date. *The Photographer*, which presents the travels of the reporter Didier Lefèvre with Doctors Without Borders through Afghanistan in the mid-1980s using a subtle mix of drawing and photography, is to a certain degree a meditation on the adventure genre, but neither a reinvention nor modernization of it. It does not seek a new magical formula for revitalizing the old system, as does Blain, who is probably the most imitated cartoonist in Europe in recent years.

So, we cannot debate—it would be sterile and a matter of fine distinctions—where the limits of the graphic novel begin and end in many current works. In France, more than anywhere, the authors of personal works continuously cross the border toward the old commercial traditions, and later return once again to their own private territories, or remain in both simultaneously, almost without distinguishing between them. In the United States both worlds are more separate—which is why the Americans have been and continue to be the ones leading this international movement—but curious phenomena occur that cannot be dismissed with facile recourse to contemptuous cynicism. A comic like *Omega the Unknown* (2008) would have been unimaginable prior to the consolidation of the graphic novel. *Omega* is a "limited series" published by Marvel that redeems an old superhero—completely forgotten—from the 1960s. Peculiarly, the comic was written by the prestigious novelist Jonathan Lethem (with the help of

Karl Rusnak) and drawn by Farel Dalrymple, an alternative cartoonist, and colored by Paul Hornschemeier, author of one of the most highly-praised graphic novels in recent years, *Mother, Come Home* (2003). In one of the episodes, there are even pages drawn by Gary Panter, the legend of punk comics. *Omega* breaks all the conventions of superhero comics, with long intellectual digressions, an unclear plotline, scarcely attractive characters and approaches contrary to the formulas of the genre: in one of the episodes, for example, attention centers on a dialogue between two characters while a superhero battle is relegated to the background and almost outside the image panel. [129] Because of the complexity of the story, the treatment of the characters and the self-enclosed nature of the universe that it develops, *Omega* can be considered a true graphic novel, despite the fact that there are robots, super villains and caped heroes in its pages. If we think that it is simply a base commercial maneuver by Marvel in order to attract graphic novel readers to its superheroes, we would do well to ask ourselves why then they did not choose a better known character—and in recent years, especially thanks to film adaptations, Marvel has at its disposal a lot of very famous characters—who might have greater effect in the media and seduce a larger audience. The answer is that the project arose more from the opportunity presented by the desire of novelist Lethem, a fan since childhood of the character, to write an *Omega* comic, than from commercial strategies. Lethem needed to write *Omega*, just as he needed to write his other (non-graphic) novels, and in the current circumstances of the contemporary graphic novel—which is to say, of the perception of comics as a medium where *anything* can be done—that kind of an idea can become reality. Deciding in what percentages *Omega* is a hybrid of graphic novel and of superhero comic, in what measure it is a *pure* graphic novel or a *bastard* work is a sterile exercise, and will become more so with the passing of the years. It is quite possible that in the future these mixtures of genres and sensibilities, of formats, authors, traditions, will become increasingly sincere and common.

The graphic novel phenomenon is so young and tender that it still has not solidified, and therefore it is at present undergoing very important processes of change, processes that allow us to venture a guess that we will see a very distinct landscape in very short order. The masters of the graphic novel are very young. Crumb, Spiegelman and Taniguchi, the *grandfathers* of the movement, are still less than seventy years old. Chris Ware, Daniel Clowes, Seth, Emmanuel Guibert, David B. and Blutch have not yet reached their fifties or have just recently done so. They are, in reality, in the early

years of their careers. One gets the impression that many of them have barely begun to work, and that they only now are beginning to understand the medium in which they work. That is one of the most exciting virtues of contemporary comics: as an art form, it is far from exhausting its potential. Menu states that the comic is a delayed artistic form, that "its history is one of retardation compared with literature, painting, etc. I think comics are now maybe in an equivalent state to that of those forms in the years 1910–1920. I assert that avant-garde may still have relevance in relation to *bande dessinée*, and that maybe this is the last art form for which the term makes sense."[7] If Menu is right, the comic is entering now into the era of its Duchamp and Picasso, of its Joyce and Proust. Never before has a comics artist had the opportunity to go so far. In the past, the typical professional of the medium would begin at twenty years old and would be burned out at forty, much like the stars of pop music. This is what happened to Bernard Krigstein, one of the first to attempt it, in the 1950s, and he had to abandon the profession before turning forty. Graphic novelists perhaps must work at a different speed, a speed until now unheard of in comics.

For them, the greatest incentive will be, as Clowes says in the quote that opens these concluding remarks, the vast artistic territory that still remains for them to explore and conquer. But it would be a mistake to think that that exploration is an inevitable accomplishment, signaled by the inertia of destiny or by the alleged *natural* maturity of the medium. Success in that enterprise will depend, as has happened so many times in the history of comics, on the talent and commitment of a few individual authors who will continue making comics—whether or not they are called graphic novels—in the face of it all. Because the new ground they must discover in reality does not exist. That new ground is the trail they leave behind while they are walking in mid air.

Notes

Introduction to the American Edition

1. "'Form,' Nineteenth-Century Metaphysics, and the Problem of Art Historical Description," David Summers, 1989.

2. *"Convergence Culture," Where Old and New Media Collide,* Henry Jenkins, New York University Press, 2006.

3. "Art Spiegelman's Art Obliterates Category," Christopher Borrelli, *Chicago Tribune,* May 25, 2013.

4. "'Form,' Nineteenth-Century Metaphysics, and the Problem of Art Historical Description," David Summers, 1989.

Introduction

1. Panofsky (1955), 22–23.

Chapter One

1. Rosenkranz (2009), 27.

2. Heer and Worcester, eds. (2004), xii.

3. Reitberger and Fuchs (1972), 9.

4. Ibáñez (2007).

5. Witek (1989), 3.

6. Deppey (2006), 79.

7. See www.eddiecampbell.blogspot.com

8. Clowes (1997), 10.

9. Clowes (1997), 4.

10. Eco (1988), 12.

11. Greenberg (1989), 3–21. The original article, "Avant-garde and Kitsch," is from 1939.

12. Lara (1968), 18.

13. Eisner (2002). "I'm here to tell you that I believe strongly that this medium is literature. It's a form of literature, and it's reaching its maturity now."

14. See, for example, the important book by Versaci (2008), whose subtitle is "Comics as Literature." Also Hatfield's book (2005) is subtitled "An Emerging Literature." The phenomenon is explained in part because a good number of the most recent academic studies of the comic have come from literature departments, and not from art departments.

15. Hatfield (2005), 33.

16. Salinas (1984), 317–318.

17. Salinas (1984), 17.

18. Quoted in Versaci (2008), 186.

19. Wertham (2009), 55.

20. McLuhan (2003), 229.

21. Harvey (1994), 8.

22. Mitchell (2009), 116.

23. R. Sikoryak, *RasKol. Crime and Punishment!*, in *Drawn and Quarterly* Volume 3 (2000), pp. 89–99.

24. Miller (2007), 16.

25. Gordon (1998), 9.

26. Harvey (1994), 7.

27. Merino (2003), 11.

28. Rosenkranz (2002), 272.

29. Kunzle (2007), 114.

30. Groensteen (2009), 3.

31. Merino (2003), 32.

32. Schodt (1996), 6.

33. For a broader range of explanations of the concrete meaning of the word *manga*, see Gravett (2004), 21; Schodt (1986), 18; Meca (2008), 151; Koyama-Richard (2008), 6; Power (2009), 8–12.

34. Berchtold (1935), 36.

35. Paul Gravett (2005), 3, credits Richard Kyle with coining the term in the newsletter of the Comic Amateur Press Alliance, *CAPA-ALPHA*, no. 2 (November 1964).

36. *Graphic novel* appears in relation to three comics or pseudo-comics in 1976: *Bloodstar* by Richard Corben, *Beyond Time and Again* by George Metzger, and *Chandler: Red Tide* by Jim Steranko.

37. *Chandler: Red Tide* (1976), by Jim Steranko.

38. Both *graphic album* and *comic novel* appear in *Sabre* (1978), by Don McGregor and Paul Gulacy.

39. *Tantrum* (1979), by Jules Feiffer.

40. *In Comics and Sequential Art* (1985).

41. Barrero notes that the first appearance of the term in Spain corresponds to the collection *La novela gráfica*, published by the Barcelona-based Reguera, in 1948. In www

.literaturas.com/vo10/seco712/suplemento/Articulo8diciembre.html (consulted on May 8, 2009).

42. Ramírez (1975b), 104.

43. Eco (1988), 225–267.

44. Barrero (2008).

45. Gálvez (2008), 71.

46. Deppey (2006), 83.

47. Ibáñez (2007).

48. Seth (2007).

49. Berchtold (1935), 36.

50. Merino (2003), 270.

51. Masotta (1982), 13.

52. Merino (2003), 271.

Chapter Two

1. Sadowski (2002), 1.

2. Groensteen (2007), 12–17.

3. Eisner (1994), 5.

4. McCloud (1993), 8.

5. Harvey (1994), 10.

6. Carrier (2009), 108.

7. McCloud (1993), 20.

8. On this point see, for example, Ramírez (1975b), 229.

9. Barthes (1981), 88.

10. McCloud (1993), 9.

11. In fact, the examples of Trajan's Column and the Bayeux Tapestry have been treated for a long time as predecessors of comics. See Lacassin (1982), 15, who also cites the Parthenon frieze and the stained glass windows of Chartres.

12. McCloud (1993), 10.

13. Quote in Kunzle (1973), preface.

14. Kunzle (1973), 2.

15. Groensteen (2007), 13.

16. Groensteen (2007), 17.

17. We take the concept from Hatfield (2005), 4, who cites Samuel R. Delany as responsible for applying the concept of *social object* (in the sense given the term by sociologist Lucién Goldman) to comics, as part of what are called *packages* or *publishing formats*.

18. Quoted in Jiménez (2002), 51.

19. McCloud (1993), 23.

20. Kunzle (1973), 298.

21. Baudelaire (2001), 133.

22. Gombrich (1972), 350–351.

23. Baudelaire (2001), 150.

24. Kunzle (1990), 314.

25. Sabin (2009), 185.

26. Gravett (2004), 18.

27. "Por un coracero" (Because of a Cigar) by José Luis Pellicer, published in the Madrid magazine *El Mundo Cómico*, no. 22, March 30, 1873. See Martín (2000b), 30–31. Previously, Martín himself had identified as an older comic the anonymous "Un drama desconocido" (An Unknown Drama, 1875), in Martín (1978).

28. Barrero (2004).

29. Kunzle (2007), 52.

30. Assouline (1997), 36.

31. Kunzle (2007), 121.

32. Kunzle (2007), 5.

33. Kunzle (1990), 2.

34. Martín (2005), 17.

35. Smolderen (2006), see "Töpffer's Demonstration," 98–99.

36. Smolderen (2006), 99.

37. Smoldern (2006), 99.

38. Kunzle (2007), 118.

39. Lanier (2008), 122.

40. Gombrich (1972), 356.

41. Gordon (1998), 15.

42. Smolderen (2002).

43. Gardner (2008), 211.

44. Quoted in Baker (2005), viii.

45. Carlin (2005), 28.

46. With some exceptions, like the aforementioned British character Ally Sloper.

47. See Gordon (1998), especially "Comics as Commodity and Agent of Change: Buster Brown," 43–58.

48. Harvey (2009), 43.

49. Berchtold (1935), 35.

50. Smolderen (2006).

51. Smolderen (2006), 112.

52. The most remarkable example is Clare Briggs' *A. Piker Clerk* series, published in the *Chicago American* in 1903, and featuring, as with Fisher's later series, a gambler who laid bets on the horse races. Although Fisher had grown up in Chicago, he left the city before Briggs began his series, and therefore it is unclear whether there was a real influence of *A. Piker Clerk* on *A. Mutt*. Aside from the coincidence of the title and the theme, there was also a common narrative device: the bet that the main character made each day was resolved favorably or unfavorably by the next day.

53. Harvey (1994), 37. The original source of the quote is the article "Confessions of a Cartoonist," by Bud Fisher himself, published on July 28, 1928 in the *Saturday Evening Post*, and continued for the next three weeks.

54. Harvey (1994), 38.

55. Cited in Gordon (1998), 86.

56. Schodt (1996), 45–48.

57. Sadoul (1986), 81.

58. Assouline (1997), 35.

59. Spiegelman (1990), 6.

60. Phelps (2001), 197.

61. *Sundays with Walt and Skeezix*, Sunday Press Books.

62. *Walt and Skeezix*, Drawn & Quarterly. To date, three volumes have been issued, covering 1921 to 1926.

63. García (2008), 28–34.

64. Ware (2005), 5.

65. Deppey (2006), 83.

66. *Krazy & Ignatz* (2002–2008), ten volumes to date, including pages from 1925 to 1944, the point at which the series ended. The project will continue with volumes corresponding to the years prior to 1925.

67. *The Complete Peanuts* (2004–2009), eleven volumes to date, including strips from 1950 to 1972. The collection is open-ended and will continue until it completes the reissuing of *Peanuts*, which concluded in 2000.

68. Kidd, Chip, and Spiegelman, Art. *Jack Cole and Plastic Man* (2001), San Francisco Chronicle Books.

69. Heer (2008), 21.

70. Beronä (2008), 10–12.

71. Beronä (2008), 15.

72. Mann (2004), 16.

73. Seth (2007), 416.

74. Beronä (2005), vi.

75. Beronä (2009), v.

76. Gravett (2009).

77. Beronä (2008), 135.

78. Kiersh (2008), 98.

79. As regards Milt Gross's relationship with Jewish humor and the representation of immigrant speech, see Kelman (2010).

80. Quoted in Elger (2004), p. 74.

81. Ramírez (2008), 502.

82. Eisner (2004), iix.

83. Lanier (2007).

84. Quoted in Harvey (1994), 70.

85. Waugh (1991), 224.

86. Carlin (2005), 58.

87. Benet (2004), 92.

88. Carlin (2005), 84.

89. Gordon (1998), 133.

90. Wright (2003), 4.

91. Steranko (1970), 14.

92. Jenkins (2006).

93. Jones (2004), 144.

94. Nyberg (1998), 16.

95. Benton (1989), 39.

96. Thompson and Groth (2006), 103.

97. Hajdu (2008), 26.

98. Jones (2004), 214.

99. Benton (1989), 48.

100. Gordon (1998), 139.

101. Simon (1990), 122.

102. Benson (2003), 6.

103. Gilbert and Quattro (2006), 79.

104. Gilbert and Quattro (2006), 79.

105. Gilbert and Quattro (2006), 78.

106. Martín (2000), 169.

107. Martín (2000), 170.

108. Tatsumi wrote and drew an auto-biographical comic in which he relates, through an auto-biographical character, the origins of *gekiga* from the post-war period through the 1960s: *A Drifting Life* (two volumes), originally published between 1995 and 2006, and released in English by Drawn and Quarterly in 2009.

109. EC is the paradigmatic publishing house for the movement, but it was not the only one, and it was not even the first one to publish the horror genre. See Watt-Evans (1997).

110. "Foul Play!," in *Haunt of Fear* 19 (May–June 1953). Writer: Bill Gaines and Al Feldstein. Art: Jack Davis.

111. Sadowski (2002), 19.

112. Sadowski (2002), 77.

113. Sadowski (2002), 166.

114. Benson, Kasakove and Spiegelman (2009), 288.

115. Raeburn (2004a), 13.

116. Sadowski (2002), 201.

117. In "From Eternity to Here" (*Mad* 12, June 1954). Later, they would also work together on "Bringing Up Father" (*Mad* 17, November 1954), a parody of *Bringing Up Father* on which Will Elder also participated, and for which once again the result was unsatisfactory for everyone involved.

118. Versaci (2008), chapter 5, "Guerrilla Warfare and Sneak Attacks. Comic Books vs. War Films," pp. 139–181.

119. Benson (2006), 24.

120. Witek (1989), 45.

121. Carlin (2005), 119.

122. Deppey (2006), 81.

123. Nyberg (1998), 3.

124. Nyberg (1998), 60.

125. Nyberg (1998), 63.

126. Ono (2009), 9.

127. Groth (2003), 53.

128. Benton (1989), 54.

Chapter Three

1. Rosenkranz (2002), 4.

2. Groth (2002a), 38.

3. Rosenkranz (2002), 27.

4. Mareema (2004), 31.

5. Mareema (2004), 29.

6. Groth (2004), 28.

7. Rosenkranz (2002), 71.

8. Hatfield (2005a), 12.

9. Rosenkranz (2002), 264.

10. Rosenkranz (2002), 171.

11. Danky and Kitchen (2009), 18.

12. Benton (1989), 74.

13. Raeburn (2004b), 39.

14. Raeburn (2004b), 39.

15. Crumb (1996), viii.

16. Rosenkranz (2009), 24.

17. Pouncey (2008), 7.

18. Robbins (2009), 32.

19. Robbins (2009), 32.

20. Chute (2009), 59.

21. Spiegelman (1995), 4.

22. Hatfield (2005a), 7.

23. Schelly (2001).

24. "Lucky Luke, sus autores" (1973), in Bang! 10, 47.

25. Beaty (2007), 24.

26. And, in fact, its first Spanish-language edition labels it so, as recently as 2006.

27. Our source is the history of the underground Spanish comic in Dopico, Pablo, *El cómic underground español, 1970–1980* (2005).

28. García (1997), 6.

29. Gravett (2004), 42.

30. This is the translation used by Bill Randall in *Comics Journal* 250, February 2003.

31. Randall (2003), 135.

32. Shiratori (2000), 5.

33. Maremaa (2004), 27.

34. Crumb (1996), viii.

35. Rosenkranz (2009), 26.

36. Buhle (2009), 45.

Chapter Four

1. Hatfield (2005), xii.

2. Mullaney (2007), 21.

3. For a detailed history of the direct market, see Beerbohm (1999 and 2000).

4. Eisner (2001), 287.

5. Founded by Jerry Bails and then continued by Thomas.

6. See "The Direct Market and the Consolidation of Fandom" in Hatfield (2005), 20–23.

7. Mullaney (2007), 23.

8. Mullaney (2007), 29.

9. Groth (2004), 55.

10. Crumb (2000), vii.

11. Ibáñez, (2007).

12. Ramírez (2003), 105.

13. Andelman (2005), 183.

14. Benson (2005b), 128.

15. Kaplan (2005), 131.

16. Hatfield (2005), 29.

17. Andelman (2005), 289.

18. Hatfield (2005), 109.

19. Witek (1989), 121.

20. Hatfield (2005), 112.

21. Huyssen (2003), 135.

22. Witek (1989), 109.

23. Wolk (2007), 12.

24. Hatfield (2005), 145.

25. Sabin (2007), 108.

26. Versaci (2008), 92.

27. Didi-Huberman (2008), 3.

28. Huyssen (2003), 12.

29. Epstein (2002).

30. In 1991, in fact, Marvel sold nearly eight million copies of X-men number 1, the launching of a new series featuring its most popular group of superheroes. The sales figure was inflated by the market of speculative collectors, which soon after would precipitously collapse.

31. Miller (2007), 27.

32. Wivel (2006b), 151.

33. Wivel (2006b), 158.

34. Wivel (2006a), 111.

35. Deppey (2006), 71.

36. Wivel (2006b), 156.

37. Beaty (2007).

38. Wivel (2006b), 171.

39. *Nosotros somos los muertos* appeared as a fanzine, photocopied and self-published by Max, in 1993. That fanzine only included a cartoon by Max himself and two texts, one by Pere Joan and the other by Emilio Manzano. The first issue of the magazine, properly so called, which included collaborations by Spanish and foreign cartoonists, appeared in May of 1995. Beginning with issue number 2 (May 1996), it adopted the book format, with more than 100 pages in black and white, which was maintained until issue 6/7 (May 2000). After a prolonged hiatus, the magazine returned with issue 8 (2003), reducing its title to *NSLM*, increasing its size and adding color and the subtitle "gráfica radiante" (radiant graphics). This second phase would end with issue 15 (April 2007). Interestingly, the two phases of *NSLM* can be compared with the two phases of *Raw*, but in reverse order. *Raw* went from large sized graphic magazine format to pocket graphic novel format, and *NSLM* from graphic novel to graphic magazine.

Chapter Five

1. Ware (2007), xvii.

2. "Top 300 Comics Actual (May 2009)," consulted at http://www.icv2.com/articles/news/15147.html, June 25, 2009.

3. Drake (2002), 6.

4. Guilbert (2009).

5. It is also significant that the next important work by Clowes, *Wilson* (Drawn & Quarterly, 2010), announced while this book was going to press, would be published directly in book form.

6. Guilbert (2009).

7. Hignite (2006), 167.

8. García (1997), 24.

9. Guilbert (2009).

10. Raeburn (2004), 17.

11. The two comics included in the original edition of that volume by his editor, Zadie Smith, are lacking in the Spanish translation: *El libro de los otros*, Salamandra, 2009.

12. *Granta* number 108, Fall 2009.

13. Cwikik (2006), 187.

14. Guilbert (2009).

15. Ware (2007), xxi.

16. Hignite (2006), 75.

17. Fiore (1997), 68.

18. See Schodt (1999).

19. Versaci (2008), 111.

20. Versaci (2008), 119.

21. Vaughn-James (2006), 7.

22. Isabelinho (2004).

23. Ware (2006), 7.

24. McGuire (2009), 5.

25. Molotiu (2009), 17.

26. Rosenkranz (2005), 27.

27. Hignite (2006), 163.

28. Quintana (2008), 7.

Chapter Six

1. Clowes (1997), 14.

2. Mitchell (2005), 213.

3. Miller (2007), 31.

4. Deppey (2006), 99.

5. Wivel (2006a), 111.

6. Significantly, he has published in the Poisson Pilote collection, whose name is intended to link it to the origins of the French author's comic tradition in René Goscinny's magazine *Pilote*, which is itself the origin of the modern commercial comic.

7. Wivel (2006b), 157.

Bibliography

Accorsi, Diego (2004). "Un poco de historia," in *Biblioteca Clarín de la Historieta 16. Vito Nervio/Misterix*, pp. 12–13.

Alaniz, José (2010). *Komiks: Comic Art in Russia*, Jackson, University Press of Mississippi.

Altarriba, Antonio (2001). *La España del tebeo. La historieta española de 1940 a 2000*, Madrid, Espasa Calpe.

Andelman, Bob (2005). *Will Eisner: A Spirited Life*, Milwaukie, M Press.

Assouline, Pierre (1997). *Hergé*, Barcelona, Destino [1996].

Baker, Nicholson, and Brentano, Margaret (2005), *The World on Sunday*, in *Graphic Art in Joseph Pulitzer's Newspaper (1898–1911)*, New York, Bulfinch Press.

Barbieri, Daniele (1998). *Los lenguajes del cómic*, Barcelona, Paidós [1991].

Barrero, Manuel (2004). "El bilbaíno Víctor Patricio de Landaluze, pionero del cómic español en Cuba," in *Mundaiz* 68, pp. 53–79.

———(2005). "Trabajos académicos: La historieta y el humor gráfico en la universidad," in *Tebeosfera*, Bilbao, Astiberri, pp. 89–127.

———(2008). "La novela gráfica: Perversión genérica de una etiqueta editorial," in www .literaturas.com/v010/seco712/suplemento/Articulo8diciembre.html.

———(ed.) (2005). *Tebeosfera*, Bilbao, Astiberri.

Barthes, Roland (1981). *Camera Lucida: Reflections on Photography*, New York, Hill and Wang [1980].

Baudelaire, Charles (2001). *Lo cómico y la caricatura*, Madrid, A. Machado Libros.

Beaty, Bart (2005). *Fredric Wertham and the Critique of Mass Culture*, Jackson, University Press of Mississippi.

———(2007). *Unpopular Culture. Transforming the European Comic Book in the 1990s*, Toronto, Buffalo and London, University of Toronto Press.

Beerbohm, Robert L. (1999). "Secret Origins of the Direct Market. Part One: 'Affidavit Returns': The Scourge of Distribution," in *Comic Book Artist* 6, pp. 80–91.

———(2000). "Secret Origins of the Direct Market. Part Two: Phil Seuling and the Undergrounds Emerge," in *Comic Book Artist* 7, pp. 116–125.

Benet, Vicente J. (2004). *La cultura del cine*, Barcelona, Paidós.

Benson, John (2003). "No Fear of Heartaches…," in *Romance Without Tears*, Seattle, Fantagraphics, pp. 6–13.

———(2005a). *Confessions, Romances, Secrets, and Temptations. Archer St. John and the St. John Romance Comics*, Seattle, Fantagraphics.

———(2005b). "Having Something to Say," in *The Comics Journal* 267, pp. 113–122.

———(2006). "A Talk With Harvey Kurtzman," in *The Comics Journal Library Volume 7. Harvey Kurtzman*, pp. 21–37 [1965].

Benson, John, Kasakove, David, and Spiegelman, Art (2009). "An Examination of 'Master Race,'" in Heer, Jeet, and Worcester, Kent (eds.), *A Comics Studies Reader*, Jackson, University Press of Mississippi, pp. 288–305 [1975].

Benton, Mike (1989). *The Comic Book in America. An Illustrated History*, Dallas, Taylor Publishing Company.

Berchtold, William E. (1935). "Men of Comics," in *New Outlook*, April 1935, pp. 34–64.

Beronä, David A. (2005). "Introduction," in Ward, Lynd, *Mad Man's Drum*, New York, Dover.

———(2008). *Wordless Books. The Original Graphic Novels*, New York, Abrams.

———(2009). "Introduction to the Dover Edition," in Ward, Lynd, *Vertigo*, New York, Dover, pp. v–ix.

Bozal, Valeriano (1979). *La ilustración gráfica del siglo XIX en España*, Madrid, Alberto Corazón.

Buhle, Paul (2009). "The Undergrounds," in Danky, James, and Kitchen, Denis (eds.), *Underground Classics. The Transformation of Comics into Comix*, New York, Abrams ComicArts, pp. 36–45.

Canwell, Bruce (2009). "The Comic Capers of Mrs. Nouveau and Mr. Richie," in McManus, George, *Bringing Up Father. From Sea to Shining Sea*, San Diego, IDW, pp.17–26.

Carlin, John (2005). "Masters of American Comics: An Art History of Twentieth-Century American Comic Strips and Books," in Carlin, John, and Karasik, Paul (eds.), *Masters of American Comics*, New Haven and London, The Hammer Museum and The Museum of Contemporary Art, Los Angeles, in association with Yale University Press.

Carrier, David (2009). "Caricature," in Heer, Jeet, and Worcester, Kent (eds.), *A Comics Studies Reader*, Jackson, University Press of Mississippi, pp. 105–115 [2000].

Chute, Hillary (2009). "Aline Kominsky-Crumb," in *The Believer* vol. 7, n. ° 9, pp. 57–68.

Clowes, Daniel (1997). "Modern Cartoonist," in *Eightball* 18, 16-pages insert.

Collins, Max Allan (2006). "Dick Tracy Begins," in Gould, Chester, *The Complete Chester Gould's Dick Tracy Volume One*, San Diego, IDW, pp. 4–7.

Coma, Javier (ed.) (1982). *Historia de los comics 1*, Barcelona, Toutain.

———(ed.) (1982). *Historia de los comics 2*, Barcelona, Toutain.

———(ed.) (1982). *Historia de los comics 3*, Barcelona, Toutain.

———(ed.) (1982). *Historia de los comics 4*, Barcelona, Toutain.

Cooke, Jon B. (2000). "Comix Book: A Marvel Oddity," in *Comic Book Artist* 7, pp. 102–108.

Crumb, Robert (1996). "Introduction," in Crumb, R., *The Complete Crumb Comics Vol. 5*, Seattle, Fantagraphics, pp. vii-viii [1990].

———(2000). "Introduction," in Crumb, R., *The Complete Crumb Comics Vol. 14*, Seattle, Fantagraphics, p. vii.

Cwiklik, Greg (2006). "Chris Ware at the Museum of Contemporary Art in Chicago," in *The Comics Journal* 278, pp. 186–188.

Danky, James, and Kitchen, Denis (2009). "Underground Classics. The Transformation of Comics into Comix, 1963–90," in Dansky, James, and Kitchen, Denis, *Underground Classics. The Transformation of Comics into Comix*, New York, Abrams ComicArts, pp. 17–21.

Dean, Michael (2005). "The Pull of the Graphic Novel," in *The Comics Journal* 268, pp. 18–22.

Deppey, Dirk (2006). "The Eddie Campbell Interview," in *The Comics Journal* 273, pp. 66–114.

Didi-Huberman, Georges (2008). *Images in Spite of All: Four Photographs from Auschwitz*, Shane B. Lillis trans., Chicago, University of Chicago Press.

Dopico, Pablo (2005). *El cómic underground español, 1970–1980*, Madrid, Cátedra.

Drake, Arnold (2002). "Foreword," in *The Doom Patrol Archives Volume 1*, New York, DC Comics, pp. 5–6.

Eco, Umberto (1988). *Apocalípticos e integrados*, Barcelona, Lumen [1965].

Eisner, Will (1990). *Comics and Sequential Art*, Tamarac, Poorhouse Press [1985].

———(2001). *Shop Talk*, Milwaukie, Dark Horse.

———(2002). Keynote Address from the 2002 "Will Eisner Symposium," in www.english .ufl.edu/imagetext/archives/v1_1/eisner/.

———(2004). "Preface," in Eisner, Will, *The Contract with God Trilogy*, New York and London, Norton, pp. xiii-xx.

———(2008) *The Dreamer*, New York, W. W. Norton and Company.

Elger, Dietmar (2004). *Dadaism*, Cologne, Taschen.

Emmert, Lynn (2007). "Life Drawing. An Interview With Alison Bechdel," in *The Comics Journal* 282, pp. 34–52.

Epstein, Dan (2002). "A Trip to Hell: A Discussion with Eddie Campbell," in www .slushfactory.com/features/articles/051402-eddie3.php.

Feiffer, Jules (2003). *The Great Comic Book Heroes*, Seattle, Fantagraphics [1965].

Fiore, R. (1997). "A Nice German Trench," in *The Comics Journal* 200, pp. 67–71.

Gabilliet, Jean-Paul (2010). *Of Comics and Men: A Cultural History of Amercian Comic Books*, translated by Bart Beatty and Nick Nguyen, Jackson, University Press of Mississippi.

Galvez, Pepe, and Fernández, Norman (2008). *Egoístas, egocéntricos y exhibicionistas. La autobiografía en el cómic, una aproximación*, Gijón, Semana Negra.

Galvez, Pepe (2008). "La novela gráfica o la madurez del medio," in Cortés, Nicolás; Galvez, Pepe; Guiral, Antoni; and Meca, Ana María, *De los superhéroes al manga: El lenguaje en los cómics*, Barcelona, Centre D'Estudis i Recerques Social i Metropolitanes and Universitat de Barcelona, pp. 69–110.

García, Alberto (2009). "EC, paradigma del horror pre-Code," in *Tebeosfera* 5, Madrid, www.tebeosfera.com/documentos/textos/ec_paradigma_del_horror_pre-code.html.

García, Santiago (1997). "Max," in *U* 4, pp. 4–35.

———(2008). "Chris Ware: estrategias para un cómic nuevo," in *Mundaiz* 76.

Gardner, Jared (2008). "The Loud Silence of F. M. Howarth's Early Comic Strips," in *The Comics Journal* 292.

Gasca, Luis, and Gubern, Román (2001). *El discurso del cómic*, Madrid, Cátedra.

Gibbons, Dave, Kidd, Chip, and Essl, Mike (2008). *Watching the Watchmen*, London, Titan.

Gifford, Denis (1990). *The International Book of Comics*, London, Hamlyn Publishing Group [1984].

Gilbert, Michael T., and Quattro, Ken (2006). "It Rhymes With Lust," in *The Comics Journal* 277, pp. 78–79.

Gociol, Judith, and Rosemberg, Diego (2003). *La historieta argentina. Una historia*, Buenos Aires, Ediciones de la Flor [2000].

Gombrich, E. H. (1972). *Art and Illusion: A Study in the Psychology of Pictorial Representation*, Princeton, Princeton University Press [1959].

Gordon, Ian (1998). *Comic Strips and Consumer Culture 1890–1945*, Washington and London, Smithsonian Institution Press.

Goulart, Ron (1990). *The Encyclopedia of American Comics*, New York, Facts of File.

Grant, Steven (2007). "Gilbert Hernandez," in *The Comics Journal* 281, pp. 101–103.

Gravett, Paul (2004). *Manga. Sixty Years of Japanese Comics*, London, Laurence King.

———(2005). *Graphic Novels: Stories to Change Your Life*, London, Aurum Press.

———(2009). "Euro-Comics: The Graphic Novel in Europe," in www.paulgravett.com/index.php/articles/graphic_novels1/.

Greenberg Clement (1989). *Art and Culture*, Boston, Beacon [1961].

Groensteen, Thierry (2007). *The System of Comics*, translated by Bart Beatty and Nick Nguyen, Jackson, University Press of Mississippi [1999].

———(2009). "Why Are Comics Still in Search of Cultural Legitimization?," in Heer, Jeet, and Worcester, Kent (eds.), *A Comics Studies Reader*, Jackson, University Press of Mississippi, pp. 3–11 [2000].

Groth, Gary (1997). "Understanding (Chris Ware's) Comics," in *The Comics Journal* 200, pp. 118–17.

———(2002a). "I've Never Done Anything Halfheartedly," in *The Comics Journal Library, Volume One: Jack Kirby*, pp. 18–49 [1990].

———(2002b). "Joe Sacco, Frontline Journalist," in *The Comics Journal Winter 2002 Volume One*, pp. 55–72.

———(2003). "As Far as I Know, The Comics Industry Has Never Done a Fucking Thing for the First Amendment," in *The Comics Journal Library, Volume Two: Frank Miller*, pp. 51–63 [1987].

———(2004). "One Of My Main Reasons To Go On Living Is I Still Think I Haven't Done My Best Works," in *The Comics Journal Library, Volume Three: R. Crumb*, pp. 13–63 [1988].

———(2006). "R. Kikuo Johnson," in *The Comics Journal* 277, pp. 176–193.

———(2007). "Yoshihiro Tatsumi," in *The Comics Journal* 281, pp. 37–51.

Guilbert, Xavier (2009). "Daniel Clowes," in du9.org/Daniel_Clowes.

Guiral, Antoni (ed.) (2007). *Del tebeo al manga: una historia de los cómics 1. Los cómics en la prensa diaria: humor y aventuras*, Girona, Panini.

——(ed.) (2007). *Del tebeo al manga: una historia de los cómics 3. El comic-book: Superhéroes y otros géneros*, Girona, Panini.

——(ed.) (2007). *Del tebeo al manga: una historia de los cómics 2. Tiras de humor crítico para adultos*, Girona, Panini.

——(ed.) (2007). *Del tebeo al manga: una historia de los cómics 4. Marvel Comics: Un universo en constante evolución*, Girona, Panini.

——(ed.) (2007). *Del tebeo al manga: una historia de los cómics 5. Comic-book: de la Silver Age a la Modern Age*, Girona, Panini.

——(ed.) (2007). *Del tebeo al manga: una historia de los cómics 6. Del comix underground al alternativo*, Girona, Panini.

Hadju, David (2008). *The Ten-Cent Plague. The Great Comic-Book Scare and How It Changed América*, New York, Farrar, Strauss and Giroux.

Harvey, Robert C. (1994). *The Art of the Funnies. An Aesthetic History*, Jackson, University Press of Mississippi.

——(1996). *The Art of the Comic Book*, Jackson, University Press of Mississippi.

——(2007). *Meanwhile... A Biography of Milton Caniff*, Seattle, Fantagraphics.

Hatfield, Charles (2005a). *Alternative Comics*, Jackson, University Press of Mississippi.

——(2005b). "The Craig Thompson Interview," in *The Comics Journal* 268, pp. 78–119.

Heer, Jeet (2008). "Dream Big and Work Hard," in Gray, Harold, *The Complete Little Orphan Annie Volume One*, San Diego, IDW Publishing, pp. 11–27.

Heer, Jeet, and Worcester, Kent (eds.) (2004). *Arguing Comics*, Jackson, University Press of Mississippi.

Hignite, Todd (2006). *In The Studio*, New Haven and London, Yale University Press.

Holtz, Allan (2009a). "F. Opper, A. Cartooning Life," in Opper, Frederick Burr, *Happy Hooligan*, New York, NBM, pp. 5–17.

——(2009b). "Mutt, Jeff and Bud: The Trio Who Revolutionized Comics," in Fisher, Bud, *The Early Years of Mutt & Jeff*, New York, NBM, pp. 5–16.

Huyssen, Andreas (2003). *Present Pasts: Urban Palimpsests and the Politics of Memory*, Stanford, Stanford University Press.

Ibáñez, Andrés (2007). "El cómic hecho literatura," in *Revista de libros* 125. Consulted at www.revistadelibros.com.

Infantino, Carmine, and Spurlock, J. David (2000). *The Amazing World of Carmine Infantino: An Autobiography*, Lebanon, Vanguard Productions.

Isabelinho, Domingos (2004). "The Ghost of a Character: The Cage by Martin Vaughn-James," in *Indy Magazine Summer 2004*, www.indyworld.com/indy/summer_2004/isabelinho_cage/.

Jenkins, Henry (2006). *Fans, Bloggers and Gamers. Exploring Participatory Culture*, New York and London, New York University Press.

——(2008). *Convergence Culture. Where Old and New Media Collide*, New York and London, New York University Press.

Jiménez, José (2002). *Teoría del arte*, Madrid, Editorial Tecnos.

Jones, Gerard (2004). *Men of Tomorrow. Geeks, Gangsters and the Birth of the Comic Book*, New York, Basic Books.

Kane, Brian M. (2009). "Harold Rudolf Foster: 1892–1982," in Foster, Hal, *Prince Valiant Volume 1: 1937–1938*, Seattle, Fantagraphics, pp. 4–7.

Kaplan, Arie (2005). "Looking Back," in *The Comics Journal* 267, pp. 124–132.

Kiersh, Dave (2008). "*Skitzy:* An Afterword," in *Skitzy*, Montreal, Drawn & Quarterly.

Kelman, Ari Y. (ed.) (2010). *Is Diss a System? A Milt Gross Comic Reader*, New York and London, New York University Press.

Kitchen, Denis, and Buhle, Paul (2009). *The Art of Harvey Kurtzman*, New York, Abrams Comicarts.

Koyama-Richard, Brigitte (2008). *Mil años de manga*, Barcelona, Electa.

Kunzle, David (1973). *History of the Comic Strip Volume I: The Early Comic Strip. Narrative Strips and Picture Stories in the European Broadsheet from c. 1450 to 1825*, Berkeley, Los Angeles and London, University of California Press.

———(1990). *The History of the Comic Strip. The Nineteenth Century*, Berkeley, Los Angeles, Oxford, University of California Press.

———(2007). *Father of the Comic Strip: Rodolphe Töpffer*, Jackson, University Press of Mississippi.

Kurtzman, Harvey (1991). *From Aargh! To Zap! Harvey Kurtzman's Visual History of the Comics*, New York, Byron Preiss.

Lacassin, Francis (1982). *Pour un neuviéme art. La bande dessinée*, Geneva and Paris, Slatkine [1971].

Lanier, Chris (2007). "An Interview With Eric Drooker," in Drooker, Eric, *Flood!*, Milwaukee, Dark Horse.

———(2008). "Rodolphe Töpffer: The Complete Strips; Father of the Comic Strip: Rodolphe Töpffer," in *The Comics Journal* 294, pp. 116–123.

Lara, Antonio (1968). *El apasionante mundo del tebeo*, Madrid, Cuadernos para el Diálogo.

Levin, Bob (2008). "The S. Clay Wilson Interview," in *The Comics Journal* 293, pp. 28–63.

Lladó, Francesca (2001). *Los comics de la transición. (El boom del cómic adulto 1975–1984)*, Barcelona, Glénat.

Lynch, Jay (2009). "Introduction," in Danky, James, and Kitchen, Denis, *Underground Classics The Transformation of Comics into Comix*, New York, Abrams ComicArts, pp. 13–15.

Mann, Thomas (2004). "Introduction to Frans Masereel, *Passionate Journey: A Novel Told in 165 Woodcuts*," in Heer, Jeet, and Worcester, Kent, *Arguing Comics*, Jackson, University Press of Mississippi, pp. 13–21 [1948].

Maremaa, Thomas (2004). "Who Is This Crumb?" in Holm, D. K. (ed.), *R. Crumb: Conversations*, Jackson, University Press of Mississippi, pp. 16–33 [1972].

Martín, Antonio (1978). *Historia del comic español: 1875–1939*, Barcelona, Gustavo Gili.

———(2000a). *Apuntes para una Historia de los Tebeos*, Barcelona, Glénat [1967–1968].

———(2000b). *Los inventores del cómic español 1873/1900*, Barcelona, Glénat.

———(2005). "La industria editorial del cómic en España," in Barrero, Manuel (ed.), *Tebeosfera*, Bilbao, Astiberri, 2005, pp. 13–32.

———(2007). "Una obra maestra de la Cultura Catalana. Los *Cuentos vivos* de Apeles Mestres, 125 años después…," in Mestres, Apeles, *Cuentos vivos*, Barcelona, Glénat, pp. 5–9.

Masotta, Òscar (1982). *La historieta en el mundo moderno*, Barcelona, Paidós [1970].

McCloud, Scott (1993). *Understanding Comics: The Invisible Art*, Northhampton, Kitchen Sink Press.

———(2006). *Making Comics*, New York, London, Sydney and Toronto, HarperCollins.

McGuire, Richard (2009). "Preface," in Moriarty, Jerry, *The Complete Jack Survives,* New York, Buenaventura Press, p. 5 [1984].

McLuhan, Marshall (2003). *Understanding Media*, Corte Madera, Gingko Press [1964].

Meca, Ana María (2008). "Los mangas: una simbología gráfica muy particular," in Cortés, Nicolás; Gálvez, Pepe; Guiral, Antoni, and Meca, Ana María, *De los superhéroes al manga: El lenguaje en los cómics*, Barcelona, Centre D'Estudis i Recerques Social i Metropolitanes and Universitat de Barcelona, pp. 149–177.

Merino, Ana (2003). *El cómic hispánico*, Madrid, Cátedra.

Michaelis, David (2007). *Schulz and Peanuts: A Biography*, New York, HarperCollins.

Miller, Ann (2007). *Reading Bande Dessinée: Critical Approaches to French-Language Comic Strip*, Bristol and Chicago, Intellect.

Mitchell, W. J. T. (2005). *What Do Pictures Want?*, Chicago and London, University of Chicago Press.

———(2009). "Beyond Comparison," in Heer, Jeet, and Worcester, Kent (eds.), *A Comics Studies Reader*, Jackson, University Press of Mississippi, pp. 116–123 [1994].

Moix, Terenci (2007). *Historia social del cómic*, Barcelona, Bruguera [1968].

Molotiu, Andrei (2009). "Introduction," in Molotiu, Andrei (ed.), *Abstract Comics*, Seattle, Fantagraphics, pp. 8–17.

Mullaney, Dean (2007). "*Raw* Magazine: An Interview with Art Spiegelman and Françoise Mouly," in Witek, Joseph (ed.), *Art Spiegelman. Conversations,* Jackson, University Press of Mississippi, pp. 20–34 [1980].

Nash, Eric P. (2009). *Manga Kamishibai. The Art of Japanese Paper Theater.* New York, Abrams Comicarts.

Nebiolo, Gino, Chesneaux, Jean, and Eco, Umberto (1976). *Los comics de Mao*, translated by Jaume Forga. Barcelona, Gustavo Gili [1971].

Norris, Craig (2009). "Manga, anime and visual art culture," in Sugimoto, Yoshio (ed.), *The Cambridge Companion to Modern Japanese Culture,* Cambridge, Cambridge University Press, pp. 236–260.

Nyberg, Amy Kiste (1998). *Seal of Approval: The History of the Comics Code*, Jackson, University Press of Mississippi.

Ono, Kosei (2009). "Introducción," in Tatsumi, Yoshihiro, *Una vida errante. Volumen uno,* Bilbao, Astiberri.

Panofsky, Erwin (1955). *Meaning in the Visual Arts*, Chicago, New York, Doubleday.

Pekar, Harvey (2006). "Foreword," in *Plastic Man Archives Volume 8*, New York, DC Comics, pp. 5–6.

Peniston, David (2006). "The Joost Swarte Interview," in *The Comics Journal* 279, pp. 36–63.

Phelps, Donald (2001). *Reading the Funnies*, Seattle, Fantagraphics.

Plotwright, Frank (ed.) (1997). *The Slings & Arrows Comic Guide*, London, Aurum Press.

Pouncey, Edwin (2008). "'The Black Eyed Boodle Will Knife Ya Tonight!' The Underground Art of Rory Hayes," in Hayes, Rory, *Where Demented Wented*, Seattle, Fantagraphics, pp. 7–17.

Power, Natsu Onoda (2009). *God of Comics. Osamu Tezuka and the Creation of Post–World War II Manga*, Jackson, University Press of Mississippi.

Quintana, Ángel (2008). "Un cine en tierra de nadie," in *Cahiers du Cinéma España* 10, pp. 6–8.

Raeburn, Daniel (2004a). *Chris Ware*, New Haven, Yale University Press.

———(2004b). "Two Centuries of Underground Comic Books," in Dowd, D. B., and Hignite, Todd (eds.), *Strips, Toons, and Bluesies*, New York, Princeton Architectural Press, p. 34–45.

Ramírez, Juan Antonio (1975a). *La historieta cómica de postguerra*, Madrid, Cuadernos para el Diálogo.

———(1975b). *El "comic" femenino en España. Arte sub y anulación*, Madrid, Cuadernos para el Diálogo.

———(1992). *Medios de masas e historia del arte*, Madrid, Cátedra [1976].

———(2003). *La arquitectura en el cine. Hollywood, la edad de oro*, Madrid, Alianza [1993].

———(2008). "El sueño de los monstruos produce la (sin)razón: Lo emblemático y lo narrativo en las novelas visuales de Max Ernst," in Ernst, Max, *Tres novelas en imágenes*, Girona, Atalanta, pp. 495–518.

———(2009). *El objeto y el aura. (Des)orden visual del arte moderno*, Madrid, Akal.

Randall, Bill (2003). "'Screw-Style' by Yoshiharu Tsuge," in *The Comics Journal* 250, p. 135.

Regueira, Tino (ed.) (2005). *Guía visual de la editorial Bruguera (1940–1986)*, Barcelona, Glénat.

Reitberger, Reinhold, and Fuchs, Wolfgang (1972). *Comics: Anatomy of a Mass Medium*, London, Studio Vista [1971].

Robbins, Trina (2009). "Wimmen's Studies," in Danky, James, and Kitchen, Denis (eds.), *Underground Classics. The Transformation of Comics into Comix*, New York, Abrams ComicArts, pp. 31–33.

Roberts, Tom (2007). *Alex Raymond. His Life and Art*, Silver Spring, Adventure House.

Rosenkranz, Patrick (2002). *Rebel Visions. The Underground Comix Revolution 1936–1975*, Seattle, Fantagraphics.

———(2005). "*Tante Leny* and the Dutch Underground Press," in *Comic Art* 7, pp. 26–45.

———(2009). "The Limited Legacy of Underground Comix," in Danky, James, and Kitchen, Denis (eds.), *Underground Classics. The Transformation of Comics into Comix*, New York, Abrams ComicArts, pp. 23–29.

Sabin, Roger (2007). "Interview With Art Spiegelman," in Witek, Joseph (ed.), *Art Spiegelman. Conversations*, Jackson, University Press of Mississippi, pp.. 95–121 [1989].

———(2009). "Ally Sloper: The First Comics Superstar?," in Heer, Jeet, and Worcester Kent (eds.), *A Comics Studies Reader*, Jackson, University Press of Mississippi, pp. 177–189 [2003].

Sadoul, Numa (1986). *Conversaciones con Hergé*, Barcelona, Juventud [1983].

Sadowski, Greg (2002). *B. Krigstein*, Seattle, Fantagraphics.

Salinas, Pedro (1984). *El defensor*, Madrid, Alianza [1948].

Salisbury, Mark (1999). *Writers On Comics Scriptwriting*, London, Titan.

———(2000). *Artists On Comic Art*, London, Titan.

Samson, Jacques, and Peeters, Benoît (2010). *Chris Ware. La bande dessinée réinventée*, Paris and Brussels, Les Impressions Nouvelles.

Schelly, Bill (2001). "Bill Pearson: The *witzend* Interview," in *Alter Ego* vol. 3, n. ° 8, pp. 37–44.

Schodt, Frederik L. (1986). *Manga! Manga! The World of Japanese Comics*, New York, Kodansha.

———(1996). *Dreamland Japan. Writings on Modern Manga*, Berkeley, Stone Bridge Press.

———(1999). "Henry Kiyama and the Four Immigrants Manga," in Kiyama, Henry, *The Four Immigrants Manga*, Berkeley, Stone Bridge Press, pp. 7–18.

Schwartz, Julius, and Thomsen, Brian M. (2000). *Man of Two Worlds. My Life in Science Fiction and Comics*, New York, HarperCollins.

Seth (2006). "Afterword," in Walker, George A., *Graphic Witness. Four Wordless Graphic Novels*, Buffalo, Firefly Books.

Shiratori, Chikao (2000). "Introduction," in AA. VV., *Secret Comics Japan*, San Francisco, Viz, pp. 4–5.

Simon, Joe, and Simon, Jim (1990). *The Comic Book Makers*, New York, Crestwood.

Smolderen, Thierry (2002). "AB Frost: First Stories and the Photographic Revolution," in www.nwe.ufl.edu/~ronan/ThierryS.html.

———(2006). "Of Labels, Loops, and Bubbles. Solving the Historical Puzzle of the Speech Balloon," in *Comic Art* 8, pp. 90–112.

———(2009). *Naissances de la bande dessinée*, Paris and Brussels, Les Impressions Nouvelles.

Spiegelman, Art (1990). "Polyphonic Polly: Hot and Sweet," in Sterret, Cliff, *The Complete Color Polly & Her Pals* Series 1, Volume 1, Princeton, Kitchen Sink.

Steranko, Jim (1970). *The Steranko History of Comics Volume One*, Reading, Supergraphics.

———(1972). *The Steranko History of Comics Volume Two*, Reading, Supergraphics.

Thompson, Kim, and Groth, Gary (2006). :Harvey Kurtzman: The Man Who Brought Truth to Comics," in *The Comics Journal Library Volume 7. Harvey Kurtzman*, pp. 83–125.

Valenti, Kristy (2007). "Melinda Gebbie," in *The Comics Journal* 281, pp. 56–75.

Varillas, Rubén (2009). *La arquitectura de las viñetas: Texto y discurso en el cómic*, Sevilla, Viaje a Bizancio Ediciones.

Vaughn-James, Martin (2006). "*La Cage* ou la machine à fabriquer des images," in *La Cage*, Paris and Brussels, Les Impressions Nouvelles, pp. 5–7 [1975].

Vázquez de Parga, Salvador (1980). *Los comics del franquismo*, Barcelona, Planeta.

Versaci, Rocco (2008). *This Book Contains Graphic Language. Comics as Literature*, New York and London, Continuum.

Von Bernewitz, Fred, and Geissman, Grant (2000). *Tales of Terror! The EC Companion*, Seattle, Fantagraphics and Gemstone.

Walker, Brian (2009). "Being an Artist is Like Laying Bricks," in McManus, George, *Bringing Up Father. From Sea to Shining Sea*, San Diego, IDW, pp. 9–15.

Walker, George A. (2007). *Graphics Witness*, Buffalo and Richmond Hill, Firefly Books.

Ware, Chris (2005). "Preface, Acknowledgements, & C.," in King, Frank, *Walt & Skeezix 1921 & 1922*, Montreal, Drawn & Quarterly.

———(2005). "Richard McGuire and 'Here': A Grateful Appreciation," in *Comic Art* 8, pp. 4–7.

———(2007). "Introduction," in Ware, C., and Moore, Anne Elizabeth (eds.), *The Best American Comics 2007*, Boston and New York, Houghton Mifflin Company, pp. xvii-xxiv.

———(2009). "Jerry Moriarty," in *The Believer* vol. 7, n. ° 9, pp. 44–54.

Watt-Evans, Lawrence (1997). "Los otros. Breve historia de los cómics de horror pre-Code," in *Tebeosfera* 5. www.tebeosfera.com/documentos/textos/los_otros_breve_historia_de_los_comics_de_horror_pre-code.html.

Waugh, Coulton (1991). *The Comics*, Jackson, University Press of Mississippi [1947].

Wertham, Fredric (2009). "Excerpt from *Seduction of the Innocent*," in Heer, Jeet, and Worcester, Kent, *A Comics Studies Reader*, Jackson, University Press of Mississippi [1954].

Witek, Joseph (1989). *Comic Books as History*, Jackson, University Press of Mississippi.

Wivel, Matthias (2006a). "The David B. Interview," in *The Comics Journal* 275, pp. 102–120.

———(2006b). "Jean-Christophe Menu," in *The Comics Journal 277*, pp. 144–174.

Wolk, Douglas (2007). *Reading Comics. How Graphic Novels Work and What They Mean*, Cambridge, Da Capo Press.

Wright, Bradford W. (2003). *Comic Book Nation. The Transformation of Youth Culture in América*. Baltimore and London, The Johns Hopkins University Press [2001].

Index

211

CPSIA information can be obtained at www.ICGtesting.com
Printed in the USA
LVOW11*1621150316

479255LV00010B/134/P